INVISIBLE HANDS?

The Role and Status of the Painter's Journeyman
in the Low Countries c. 1450 - c. 1650

INVISIBLE HANDS?

*The Role and Status of the Painter's
Journeyman in the Low Countries
c. 1450 - c. 1650*

EDITED BY

Natasja Peeters

PEETERS
LEUVEN - PARIS - DUDLEY, MA
2007

Illustration on cover: Johannes Stradanus, Invention of oil paint in the workshop of Jan van Eyck. Print. National Library, Paris. Photograph © Bibliothèque Nationale de France.

A CIP record for this book is available from the Library of Congress.

D. 2007/0602/80

ISBN: 978-90-429-1937-2
© Peeters, Bondgenotenlaan 153, 3000 Leuven

CONTENTS

vi

PREFACE AND ACKNOWLEDGEMENTS

In 1999, the local Groningen Research School for the Study of the Humanities, and the Groningen members of the national Netherlands Research School for Medieval Studies succeeded in obtaining a grant for an innovative, large-scale, collective research programme entitled *Cultural Change: Dynamics and Diagnosis*. Supported by the faculties of Arts, Philosophy and Theology and financed by the Board of the University of Groningen, the *Cultural Change* programme constitutes an excellent opportunity to promote multidisciplinary approaches to phenomena characteristic of transformation processes in the fields of politics, literature and history, philosophy and theology. In order to enhance programmatic cohesion, three crucial 'moments' in European history were selected: 1) Late Antiquity to Early Middle Ages (*c.*200-*c.*600), 2) Late Medieval to Early Modern (*c.* 1450-*c.*1650) and 3) the 'Long Nineteenth Century' (1789-*c.*1918). In 2000 and 2002 further grants were obtained for *Cultural Change: Impact and Integration* and *Cultural Change: Perception and Representation* respectively. Several international conferences and workshops have already been organised; more are planned before the end of 2007.

The lectures held during the workshop 'Role and Status of Journeymen in Artists' and Craftmens' Workshops in the Low Countries, *c.* 1450-*c.* 1650', testify of multi-focal visions, based on interdisciplinarity. In the course of the research undertaken in the context of the N.W.O.-programme *Antwerp Painting before Iconoclasm: a Socio Economic Approach, c. 1480 -1570* (2000-2003) it became clear that the workshop assistant or journeyman is one of the most difficult links to define in the production of art objects. They often remained invisible. The basic question was: how can socially and economically oriented historical research help art historians, and what can art historical and material and technical research add to corporate history? We hope that these contributions on artistic, social, and economic aspects of the roles and statuses of journeymen in a time of transition offer food for thought and will stimulate further research.

We thank the Board of the University of Groningen for the financial support given to the *Cultural Change* programmes.

The editors are particularly grateful to Marijke Wubbolts for helping to organise the workshop and to Nella Scholtens for preparing the texts for publication.

Martin Gosman, General Editor

ARTISTS OF THE TWILIGHT ZONE

SOME INTRODUCTORY REMARKS ON JOURNEYMEN IN PAINTERS' WORKSHOPS IN THE SOUTHERN NETHERLANDS C. 1450 -C. 1650[1]

Natasja Peeters and Johan Dambruyne

Introduction: methodology and historiography

The topic of the workshop entitled 'Role and status of journeymen in artists' and craftsmen's workshops in the Low Countries c. 1450-c. 1650', held in Groningen, 23-24 May 2003, grew out of archival and material-technical research on workshop practices.[2] As a result of this research it gradually became clear that more knowledge about the social and economic mechanisms of art production was required in order to study the painters' workshop. Such research frequently moves in two or more directions, and in this case the workshop proceeded on the basis of two questions: how can socially and economically oriented historical research help art historians, and what can art historical, and material and technical research add to corporate history of the painter's guild? The Groningen workshop was a venue where, through synergy and the creative linking of art historians, guild and other historians, as well as researchers specializing in material and technical study, the scattered knowledge on journeymen could be reorganized, probed and questioned. Needless to say, this sometimes yielded conflicting evi-

[1] The participants in the workshop were Marten-Jan Bok, Till-Holger Borchert, Johan Dambruyne, Harald Deceulaer, Molly Faries, Lars Hendrikman, Linda Jansen, Micha Leeflang, Max Martens, Natasja Peeters, Maarten Prak, Peter Stabel, Peter vanden Brink, Tinke Van Daalen, Joost Vander Auwera and Hugo van der Velden. We thank them for their input and stimulating discussion.

[2] These aspects were studied during the project *Painting in Antwerp before Iconoclasm (ca. 1480-1566): A Socio-Economic Approach* (2000-2003). The sub-project *Ownership of Paintings in Sixteenth-century Antwerp* was directed by Professor M. Faries and Dr M.P.J. Martens, sponsored by NWO (Netherlands Organisation for Scientific Research) and the University of Groningen.

dence, and also conflicting theories, as is usually the case with work in pro-
gress.

Geographically, the case studies in this volume deal with southern Ne-
therlandish towns, in particular Antwerp, Brussels, Mechelen, Ghent and
Bruges, with the exception of the contribution by Prak, which focuses on
the Dutch Republic. Chronologically, the contributions treat the late Middle
Ages and Early Modern Period, particularly the period between c. 1450 and
c. 1650. From an artistic point of view, this era can be characterized as the
long 'Golden Age' of Flemish painting. The epoch witnessed the apogee of
the art of the Flemish Primitives and the rise of the successful genre of
Antwerp Mannerism. It also witnessed the start of the influence of the Ital-
ian Renaissance on Flemish art, the rise of Antwerp over the course of the
sixteenth century as the vanguard of new genres which were exported all
over the world, and the international triumph of the Flemish Baroque after
1610. At the same time, many economic and social transformations took
place in the production and consumption of art, which changed the face of
the art trade. From an economic point of view, we have chosen a long-term
perspective starting with the boom of the Bruges workshops over the course
of the fifteenth century. Their dominance was ended by the rise of Antwerp
as the artistic centre and major market for art around 1510, a position which
was maintained throughout the first half of the sixteenth century. The period
under concern was not only characterized by economic growth but also by
temporary recessions and crises, such as those of the 1560s and 1580s.
Nonetheless, by the first half of the seventeenth century, feverish activity
could be observed in the southern Netherlandish art market with works be-
ing exported throughout the known world.

The methodological focus of the contributions, reorienting art histo-
rians and historians, is diverse and aims at an interdisciplinary approach
which attempts to obtain greater insight into the practices of artists' assis-
tants and formulate issues for further research. Research into guild history
has advanced considerably during the last decades and accordingly, the
Groningen workshop was in a good position to chart the new ideas and find-
ings of guild and other historians and utilize them in the art historical con-
text. In doing so, the contributions as a whole do not aim to present a com-
prehensive overview of all social, economic or artistic aspects of late me-
dieval and early modern collaboration in painters' workshops in the Low
Countries.[3] The particular focus of each contribution to this book is the

[3] The scope of these proceedings does not allow for an exhaustive overview of histo-
rical publications studying journeymen. We mention Lis, Lucassen and Soly, 'Be-
fore the Unions'; Farr, *Artisans in Europe, 1300-1914*; Prak, Lis, Lucassen and
Soly, *Craft guilds in the early modern Low Countries*. For a general bibliography on
the southern Netherlands we refer to Jacobs and Vanbellinghen, 'Ambachten in de
Zuidelijke Nederlanden'. See also the contribution by Deceulaer and Diels in this

guild of Saint Luke, the corporate institution to which all journeymen, masters and apprentices theoretically belonged until the late seventeenth century. The relationship of the professional artist to the guild lies behind most of the art production in the period under concern, whether within the guild as a master, or at the periphery of the corporation in the cases of journeymen – or assistants – and apprentices.

As stated above, during the last decades, social and economic aspects of late medieval and early modern painting in the Low Countries have slowly found their way into art historical research, together or alongside the more classical topics of research, such as style analysis, iconography, biography and attributions. This new trend was not only created by art historians, but also by historians with art historical interests, researching different aspects of the consumption – or the 'market' – of art, thus giving new impetus to the field of art history. In this respect we mention the 'market studies' by Lorne Campbell,[4] Max Martens,[5] and John Michael Montias,[6] who have worked on the Flemish Primitives and their markets. Also inspiring are studies by Dan Ewing[7] and Filip Vermeylen,[8] concentrating on the early sixteenth century, as well as an important overview by Montias[9] and a recent introduction to art consumption by Neil DeMarchi and Hans van Miegroet.[10] We note a rising awareness among historians and art historians alike of the fact that most artists were primarily artisans or producers of art at least until the second half of the seventeenth century.

Studies of craft guilds and the social and economic status of the artisan, such as those by Catharina Lis and Hugo Soly,[11] Harald Deceulaer,[12] and Johan Dambruyne,[13] have been important in shaping the identity of the early modern artisan, whether we are dealing with tailors, carpenters or, for that matter, painters. This allows us to compare and eventually extrapolate to other professional sectors, for example, the building trades and the printing industry, which have left more adequate records and/or have benefited from more attention in the past.[14] Of course one has to be careful with extrapolations, as every trade has its specific characteristics.

volume.

[4] Campbell, 'The Art Market'.

[5] Martens, 'Some Aspects'.

[6] Montias, 'Socio-Economic Aspects of Netherlandish Art'.

[7] Ewing, 'Marketing Art in Antwerp'.

[8] Vermeylen, 'The Commercialisation of Art'; id., *Painting for the Market*.

[9] Montias, *Le marché de l'art aux pays-Bas*.

[10] De Marchi and Van Miegroet, 'Introduction'.

[11] Lis and Soly, *Werken volgens de regels* and *Werelden van verschil*.

[12] Deceulaer, *Pluriforme patronen*.

[13] Dambruyne, *Corporatieve middengroepen*.

[14] Dambruyne, 'De Gentse bouwvakambachten'; Sabbe, 'De Plantijnsche werkstede'; Voet, *The Golden Compasses*.

Some studies on collaboration and workshop practices are remarkable for their growing sensitivity to the social and economic position of the artist as an artisan. In this regard we note the research undertaken by Jean-Pierre Sosson,[15] Lorne Campbell,[16] and Max Martens and Natasja Peeters,[17] which examines the fifteenth and sixteenth centuries, and by Neil DeMarchi and Hans van Miegroet on the seventeenth century.[18] These studies have been instrumental in showing the increasing complexity of art production during the Early Modern Period (the other side of 'market studies'). During the last decades it has become common knowledge that artists collaborated in Bruges, Antwerp, Mechelen, and other late medieval and early modern towns which boasted a respectable production of luxury products such as paintings. Indeed, already in 1981 Campbell noted that: '... it becomes clear that collaboration on many different levels was commonplace'.[19] Collaboration seems to have been implicit in art production, whether with other masters, journeymen or even apprentices, and to have been accepted by consumers.[20]

Indeed, the hand of the master and that of his qualified assistant are not always easy to distinguish.[21] However, in-depth stylistic research using the trained naked eye, as well as material and technical research, allows us to recognize different hands in a painting, to identify local improvements, mistakes or changes (*pentimenti*), or to recognize an absence of stylistic unity due to collaboration.[22] However, this does not usually lead to any definite identification of the helping hand, as we can usually only recognize the traces of collaboration. The topic has been addressed in general studies on many aspects of the actual day-to-day practice of painting, from designing or inventing the subject, to preparing the panels or canvases, to varnishing

[15] Sosson, 'Une approche'; *idem*, 'A propos des aspects socio-économiques'; *idem*, 'La production artistique'.

[16] Campbell, 'The Early Netherlandish Painters'.

[17] Martens and Peeters, 'Artists by Numbers'.

[18] De Marchi and Van Miegroet, 'Art, Value, and Market Practices'.

[19] Campbell, 'The Early Netherlandish Painters', p. 42.

[20] In written sources such as contracts for commissions, collaborators are hardly ever mentioned. On the other hand, it is rarely mentioned that a painter must execute the whole commission himself. See Van der Stock, 'De organisatie van het beeldsnijders-en schildersatelier', p. 48. Apprentices were probably also put to work on commissions, as the author extrapolates from early sixteenth-century contracts. For other examples of collaboration on sculpted altarpieces: *passim*.

[21] See Campbell, 'The Early Netherlandish Painters', pp. 52-53, for a discussion of this aspect.

[22] Studio procedures and the division of labour within the workshop have now been studied with the help of infrared reflectography (IRR). See Faries, 'Some Thoughts'; *eadem*, 'Reshaping the field'; Faries and Spronk, *Recent Developments*.

the end product.[23] Material and technical research has been used for some decades on questions of attribution, but can also be of use to study the genesis of a work of art, workshop practices and workshop routine. The range of authorship of a painting, from an artist's authentic, 'individual', original creation to studio production, is now taken into account while studying a painter's oeuvre, or in some cases the oeuvre produced by a workshop. This research has focused on specific painters and their workshops, such as Jan van Scorel,[24] Albert Cornelis, [25] Pieter Breughel the Younger[26] and Peter Paul Rubens.[27] The contributions by Leeflang and Jansen in this volume substantially increase our knowledge of relatively large workshops. However, for different reasons the nature of the 'average workshop' has not yet been unveiled: a major reason being the presence of 'invisible hands'. Indeed, journeymen constitute a labour force whose role in the production of luxury goods and art is difficult to grasp.

Journeymen in painters' workshops. Some issues: terminology, numbers, proletarianization, workshop size and the art market

A basic problem to be confronted while studying the identity of journeymen is the terminology.[28] In these proceedings, when using the term 'journeyman' or 'assistant' we mean a trained artisan who has not yet acquired the master's title, or who never will.[29] In archival sources, the words *werck-gesel*, *cnaep*, *gesel* and *knecht* are used indiscriminately.[30] Karel Van Mander, in his artists' biographies of 1604, distinguished disciples (*discipelen*) and journeymen (*werck-gesellen*).[31] This could imply that the first were in the stages of advanced learning and the second were part of the workshop routine. It could also mean that the working journeymen did the heavier tasks such as paint grinding, while the others concentrated on intellectual or artistic work, and yet others filled in backgrounds or made copies. Van Mander's use of the terms remains frustratingly vague and ambiguous. It is as though these artists worked in a twilight zone, never caught by the light.

Although the role of journeymen in painters' workshops is central to these proceedings, their position cannot be adequately studied without pay-

[23] Kirby, 'The Painter's Trade'.

[24] Faries, 'Underdrawings'.

[25] Tamis, 'The Genesis of Albert Cornelis's "Coronation of the Virgin"'.

[26] Currie, 'Technical Study'; *idem*, 'Demystifying the Process'.

[27] Balis, "Fatto da un mio discepolo"; Logan and Plomp, *Peter Paul Rubens*.

[28] Van Werveke, 'De medezeggenschap van de knapen', p. 5.

[29] In this respect, it is interesting to mention that historians prefer 'journeyman' while art historians use 'assistant'. See the contributions in this volume.

[30] See also Miedema, *Kunst, kunstenaars en kunstwerk*, p. 12.

[31] Miedema, *Karel van Mander*, vol. I, fol. 255ʳ.

ing attention to the other members of the workshop: the masters and the apprentices.[32] The triangular relationship is of crucial importance here, not in the least because it is difficult to retrieve information on journeymen from the available written, iconographic and other sources. They simply did not leave many traces. The preserved membership lists of artists' guilds, such as the Antwerp *Liggeren*, provide no information on journeymen. Indeed, within the guild of Saint Luke, unlike the masters, the journeymen did not constitute a privileged group: it is not clear exactly where they stood. As with all the other trades, the guild of Saint Luke was organized hierarchically, the structure consisting of three or four social and legal groups: apprentices, journeymen, master and board member. Every group had specific rights and duties, but only the masters were considered full members of the guild. Masters distinguished themselves from journeymen in many respects. The latter did not possess a legal title, could not pledge the oath of entry, citizenship, obligatory for masters, was not required. As one ascended the social ladder, rights and responsibilities increased, as did duties. It seems to be fairly clear which tasks and duties were undertaken by the masters or the apprentices, but it is less clear which were appropriate for the journeymen: the guild statutes are rather vague. In archives left by craft guilds, more documents refer to masters or apprentices than to journeymen.[33] However, an in-depth analysis of the corporate rules and regulations of the guilds of Saint Luke in late medieval and early modern Netherlandish towns yields some information.[34] In documents held in city archives, such as certificates or alderman's registers, there are scattered references to journeymen, but here again, the primary focus is on the masters and apprentices.

The legal dividing line of the 'trinity' in most cases also coincided with an economic division: only the masters were allowed to run an independent business or shop and enter into contracts. Journeymen were forbidden to work and sell their works under their own name and thus could only be a wage earner employed by a master. This distinction between masters and journeymen manifested itself in social and material affairs: the journeymen were situated on the lower rungs of the social ladder. In times of crisis, with food prices rising, they were often vulnerable, as their purchasing power was unstable. As they did not contribute to the *armenbus* (poor box), they had no right to an allowance in times of illness or unemployment. Also, within the urban community, journeymen lacked the social status of the masters. In short, journeymen and masters belonged to the same professional community but to separate worlds. Furthermore, they were also ex-

[32] De Munck and Dendooven, *Al doende leert men*. See also De Munck, Kaplan and Soly, *Apprenticeship*.

[33] This was also referred to by Campbell, 'The Early Netherlandish Painters', pp. 45-48.

[34] As is shown by Peeters and Martens in this volume.

cluded from many guild-related activities. The executive board of the guild did not invite them to their general meetings, meaning they had no say in guild policy. They were not invited to the receptions, drinks, meals and festivities or masses, nor allowed to participate in processions or public pageants. They also had no say in the election of the board of the guild and could not run for an executive position. Finally, journeymen were denied any share of the political power a guild might have within the city.

Nonetheless, it is not correct to define journeymen as ordinary servants, wage earners or unskilled labourers. In many aspects, professional honour, based on their training and qualifications, accorded journeymen a social standing which one does not encounter with the unskilled or poorly skilled, as was evident, for example, in the Plantin workshop. Some guild historians have shown that journeymen were not only concerned about norms and values (symbolic capital) but fought for the protection of their economic rights. Compared to the unskilled, journeymen enjoyed more rights, were better paid and had priority on the labour market. They carefully guarded this right of preference and made sure that it was not infringed upon by the masters. In many sectors, journeymen monitored the number of apprentices employed per master, as the former were considered to be underpriced competition. However, in most towns the guild of Saint Luke did not follow an especially protectionist policy during the Early Modern Period, played more of a mediatory role. This means that outsiders were often welcome – and needed – and could also acquire a master's title. For the potential masters, the financial entry conditions of the guild were usually quite reasonable, and compared to some other businesses, little capital was required to start up a painter's workshop.

Statistical and prosopographical research of the membership lists of the guild of Saint Luke in Antwerp by Martens and Peeters yield some interesting observations about the professional aspirations of young artists at the very beginning of their career. Studying the apprentices' professional future between 1453 and 1579, they found that for artists in general, some twenty per cent of the apprentices became masters, while for painters, it amounts to about twenty-seven per cent. By way of comparison, Campbell showed that for Tournai around 1480, fifty per cent of painter's apprentices became masters.[35] Martens, examining fifteenth-century Bruges, showed that twenty-nine per cent of the apprentices became masters.[36] The twenty per cent of apprentices overall who eventually did acquire the master's title had to wait five to fifteen years between starting their apprenticeship and acquiring the title. Deducting the average of four[37] years training, this means that the art-

[35] Campbell, 'The Early Netherlandish Painters', p. 48.

[36] Martens, 'Some Aspects', *passim*.

[37] This was an article in the statutes of some artists' corporations, but was often variable.

ists belonging to this twenty per cent waited between one and eleven years before becoming a master, or on average six years.[38] This means that the journeyman's phase was something all aspiring artists would pass through in achieving the position of master. However, what was the fate of the other eighty per cent of Antwerp artists' apprentices who never became masters? As the average mortality in the Early Modern Period hovered around thirty per cent, this means that in Antwerp fifty per cent either dropped out, changed trade, or emigrated, but also without a doubt, a certain number remained journeymen all their lives.

Evidently, it is extremely difficult to measure this last category, as the spirited discussions during the Groningen workshop showed. The fact that they were not registered in the guild ledgers is a problem. Although in some economic sectors journeymen were common, we propose that in the painters' or artists' milieu this group of employees was smaller than hitherto thought.[39] Although there is little direct material, the available sources point to the fact that within the guild of Saint Luke the journeymen were probably a minority group. There are not only relatively few records, but more importantly no listings and few recorded instances of collective action. Indeed, the painters' journeymen used fewer forms of action and fewer collective actions than colleagues from other economic sectors and also brought fewer suits before the city authorities. One of the rare instances is a lawsuit from 1646 in which twelve painters' journeymen from Mechelen complained that art production was under the control of dealers (see below).[40] Even more rare were law suits brought by painters' journeymen before the aldermen or a higher court. Proof of other collective protest actions, such as strikes, is non-existent.

It is common knowledge that minorities in late medieval and early modern society had little opportunity to act as pressure groups or become powers to be reckoned with. Contrary to the hatters' or printers' journeymen, for example, the artists' journeymen apparently never founded any legal or illegal autonomous organizations. Due to their numerical weight, journeymen in the textile and building trades, for example, were in a better position to organize collective demands and take action. Moreover, the existence of many sub-trades within the guild of Saint Luke made it a very heterogeneous professional corporation.[41] Furthermore, perhaps the absence – some exceptions notwithstanding – of strong collective feeling among

[38] See also the contribution of Natasja Peeters with Maximilian Martens.

[39] In many guilds the number of masters was a multiple of the number of journeymen.

[40] Mechelen, City archives, oud archief, fonds DD, notices, serie I nr. 32 (1), fols. 72r-73r (unpublished). See also Lis and Soly, 'Corporatisme'.

[41] As many as 93 different professions were reorganized into the guild of Saint Luke in Antwerp between 1500 and 1579. See Martens and Peeters, 'Artists by numbers'.

painters' journeymen can be linked to the fact that the artists' milieu was more individualist, although this is a matter for discussion.

The question as to the number of journeymen is linked to another: that of the size of the average early modern painter's workshop. The guilds' statutes restricted the number of apprentices a master could train simultaneously.[42] Indeed, besides the master, the only worker in the artist's studio for which there are reliable statistics is the apprentice. Sosson, in 1970, showed in his study of the Bruges *beeldenmakers* guild that the average workshop must have been quite small, based on the number of apprentices each master employed in the course of his career.[43] Some fifty-five per cent of masters worked alone, while forty per cent had one or more apprentices. Sosson also points to a concentration of apprentices in relatively few workshops: some five per cent of the masters provided thirty-six per cent of the apprentices with training and employment. Martens, in a 1998 study of the Bruges painters of the fifteenth century, stipulated that between 1475 and 1530 only twenty-three per cent of the masters had one or more apprentices.[44] The tendency towards a concentration of apprentices in a few workshops is supported by further research by Martens and Peeters on Antwerp.[45] Some sixty-eight per cent of the master painters and some seventy-three per cent of the artists in general between the years 1500–1579 never employed an apprentice. A further nineteen per cent trained only one apprentice. Less than 1.5 per cent had between five and seven apprentices.

Bok's study of the quantitative relationship between the number of master painters and their apprentices in the early seventeenth century in Utrecht also showed apprentices concentrated in the workshops of a few masters, in contrast to the many who did not have an apprentice at all.[46] Based on the number of apprentices, the average workshop seems to have been quite small. However, this hypothesis has been questioned. Sosson's defence of small-scale workshops was nuanced by Montias, who in a 1990 paper[47] argued that sub-contracting in particular – masters working for other masters for wages – was a practice that should also be taken into account. Importantly, this defines the workshop as a more fluid, conceptual unit rather than a purely spatial one. However, although arrangements between masters are undoubtedly an important form of collaboration, at this point it

[42] Van der Straelen, p. 59 art. VII (referring to 1574). A master could have two apprentices at a time, but the second could only be trained after the first had been in training for a year. The hefty fine amounted to 12 carolus guilders.

[43] Sosson, 'Une approche', *passim*.

[44] Martens, 'Some Aspects', tables 2.2 and 2.3.

[45] Martens and Peeters, 'Artists by Numbers', *passim*; Martens and Peeters, 'Masters and Servants'.

[46] Bok, '"Nulla dies sine linie."' pp. 58-68, esp. 'bijlage 1'.

[47] Montias, 'Socio-Economic Aspects of Netherlandish Art', *passim*.

is still difficult to measure on the basis of the available material: more re-search is certainly necessary.

Can we infer anything about the number of journeymen per workshop from the low number of apprentices?[48] This was a much debated issue during the Groningen workshop. Does the 'small workshop' hypothesis change when taking into account evidence about journeymen? Nowhere in the statutes of any guild of Saint Luke is there any limitation on the number of journeymen per master. However, it is supposed that training apprentices and employing journeymen were two quite different ways of thinking and working, or 'two circuits'.

Research undertaken by Martens and Peeters has been used to attempt to extrapolate the number of journeymen from the available statistical evidence.[49] They presented a hypothesis that the average workshop in Antwerp between 1500 and 1579 ranged from a little more than five to seven people (including the master, apprentices and journeymen) over the course of its entire existence. This supports the 'small workshop' hypothesis, at least during a large part of the sixteenth century in Antwerp.

It also suggests that the size of the average workshop was not influenced by the expansion of the art market in the course of the sixteenth century. Large workshops remained an exception even in the seventeenth-century southern Netherlands. Similarly, the expansion of the art market in the northern Netherlands during the seventeenth century did not lead to larger workshops.[50] From this, one can surmise that the situation was mirrored in the north, with a percentage of journeymen eventually becoming masters after a similar period of time. In other words, neither in the south nor the north did the expansion of the art market lead to an increase in the number of permanently trained wage labourers in workshops. The expansion of the market probably caused a rise in the number of workshops, rather than larger workshops. In fact, the spectacular expansion of the Antwerp, and especially the Mechelen painting market in the sixteenth century, encouraged the acquisition of a master's title by many journeymen, especially in periods of boom.[51]

[48] We wish to thank Peter Stabel for pointing out that for Bruges, while there is a labour concentration in some workshops based on the number of apprentices, this does not necessarily reflect the actual number of people working in the workshop.

[49] Martens and Peeters, 'Masters and Servants', *passim*.

[50] See the contribution by Maarten Prak.

[51] De Marchi and Van Miegroet, 'The Antwerp-Mechelen Production and Export Complex'. We thank the authors for sharing their draft with us. See also the contribution by Johan Dambruyne for further ideas on this issue.

A short overview of the contributions

The first section of these proceedings deals with historiography and presents an overview of artists' workshops, whether from the theoretical historical, archival or art historical point of view. The essay by Deceulaer and Diels offers a critical re-evaluation of research into workshop practices and labour division in art historical literature. They single out the neoclassical economic paradigms which have influenced the thinking of many art historians, suggesting that for many it is not clear which theories are still used by historians generally, and which have become obsolete. For the sake of convenience, they suggest, many art historical studies are still based on earlier literature or concepts which other historians have discarded. For example, while the authors do not deny that cost-cutting and labour-saving devices were used in the early modern workshop, they believe that these are less useful than other phenomena for interpreting workshop practices and the role of journeymen. In the second part of their contribution they demonstrate that issues and methods from social and economic research can be stimulating, but at the same time they cannot simply be borrowed. Indeed, some economic concepts such as 'mass production', 'on spec', 'process innovation', but also 'assistant' have been embraced, transposed and interpreted by art historians in various ways. The authors examine the applicability and validity of such concepts for the art historian. In the third part of the paper, they formulate a hypothesis concerning the role of journeymen between the fifteenth and seventeenth centuries. Generally, while suggesting that certain concepts are useful for the art historian and that art historical research can shed light on the historical study of guilds and entrepreneurs, the authors stress that art should be treated as a distinct sector.

The essay by Peeters and Martens is a first step towards defining the artists' and specifically of painters' journeymen, although it is not easy to formulate any generalized statement. The authors focus on the position and career development based on archival sources from Antwerp, as well as other towns. The contribution is based on an overview of various normative, administrative and legal sources (regulations and other guild-related documents such as lawsuits, a variety of administrative and legal documents, and contracts, inventories and court verdicts). Evidence from the guild regulations of many towns in the Low Countries can be tentatively taken to suggest that the journeyman was a common feature of at least some painters' workshops. The article focuses on topics such as their number, hiring, assessment period, resignations, working conditions, escape clauses and wages in order to attain a clearer picture of this shadowy group. As to their status, it is hard to generalize: some had greater material means than others and some had better training. The authors propose that tasks were selected according to the level of training and the technical and intellectual abilities of the journeyman. A competent, loyal journeyman would be

valuable, especially in a successful workshop. He would have reached a similar level of expertise as the master, but would provide the additional benefit of being less expensive. For their own part, the journeyman did not need to make risky investments. The authors propose that many workshops made use of these workers on a temporary basis. In boom times it was an arrangement that would have suited both parties, though in times of economic crisis, the arrangement would have come under severe stress and possibly could have been ended.

The workshop can be understood as an economic and a spatial concept. Peeters's contribution focuses on the interpretation of iconographic material depicting workshops, based on images of Saint Luke in the studio, with the 'angelic assistant' and the pigment grinder, and also taking into account other often allegorical images. In art historical literature, these are frequently used and interpreted as a faithful rendering of reality. The contribution shows that symbolic value had precedence over documentary value. As Sewell showed, eighteenth-century French workshop images frustratingly refused to illustrate any of his theoretical interpretations concerning the organization of the studio or techniques of production.[52] The link between images and what is known about the workshops of painters in normative (guild statutes) and non-normative (inventories) sources seems weak. Furthermore, artists seem to have been somewhat reticent about depicting their own workshops. They presented the grander picture, which was more in accordance with the decorum of the context in which these paintings often appeared, that is, as the altarpieces of chapels or churches. One of the most common features is the pigment grinder, whose status is not firmly delineated.[53] Could this point to a division of labour within the studio?[54] In any case, the images seem to tell us less about any growing self-consciousness of the painter as an individual from the fifteenth century onwards, and point more to the desire to portray oneself as a member of a trade or craft.

The second section of these proceedings focuses on the practical aspects of the execution of paintings by two early modern artists and their workshops. Leeflang and Jansen study the workshops of two highly successful sixteenth-century Antwerp artists – Joos van Cleve and Pieter

[52] Sewell, 'Visions of Labor', p. 259. The activities in the workshop as shown in iconographic material seem to be exclusively male. As Sewell remarks on p. 260: '... whatever the reality of the situation, work was seen as essentially a male activity'. This was also the case for the imagery in the contribution of Peeters.

[53] If one takes the images at face value, paint grinding certainly does not seem always to have been a typical boy's or young man's chore, as is specified in the northern Netherlands contract referred to in the contribution by Maarten Prak.

[54] The same is true of the building trades in which labourers ('metser-dienders') specifically prepared mortar or carried building materials to the mason.

Coecke van Aelst – on a micro level.[55] They focus on information about production methods using material and technical research and infrared reflectography, while at the same time remaining sensitive to social and economic aspects in their analysis of archival information. Both contributions deal with artists who had large and very productive workshops and are thus well-suited to research on the division of labour. They allow us to look more closely into the creative process, whether of a unique piece or a serialized product. The evidence shows that the workshops of Van Cleve and Coecke were well run and efficiently managed. Both painters serve as a case in point on techniques for reproducing compositions and how this influences labour division and workshop procedures. An important aspect in this respect is the existence of a variety of collaborators, servants and relatives. Indeed, both authors stress the importance of family ties in the production process.

Interestingly, both contributions stress the role of women in the workshop: as wives (to strengthen the close links between artists' families), but also in professional roles.[56] By interweaving art historical, material-technical and historical approaches, both authors substantially add to our understanding of the dynamics of the artist's workshop and more specifically the scope of their studios and labour division in the production of paintings. Leeflang makes the 'hands' of the various studio assistants visible by concentrating on their mistakes, while also attempting to collect information about their status. Jansen probes into the routine of the Coecke workshop. Within this studio routine, variations in style demonstrate cooperation between different persons within this workshop. However, while the Van Cleve and Coecke workshops are considered to be large in the artistic corporate milieu, they are quite small compared to other corporate sectors.[57]

The third and last section of the book aims at presenting a broad historical sweep and comparative research on the one hand, and on the other hand a comparison of the situation in the southern Netherlands with that in

[55] We sincerely regret that the contribution by Joost Vander Auwera could not be finished in time to appear in this volume. The paper was entitled 'On how to tighten the information gap between evidence on workshops from the Antwerp Liggeren and from other sources', and contained three insightful case studies of seventeenth-century painters and their methodological implications: Abraham Janssen van Nuyssen (c. 1571/75-Antwerp 1632); Sebastiaen Vrancx (Antwerp, 1573-1647); and Jan Breughel the Younger (Antwerp 1601-1678).

[56] The contributions by Micha Leeflang and Linda Jansen also point to the roles of women in and around the workshop and in corporate institutions, a relatively neglected subject within guild history. See also Dambruyne, 'De corporatief georganiseerde'.

[57] See the contribution by Johan Dambruyne.

the north. Dambruyne presents an overview with a macro-level outlook on artisans' workshops in general. He questions whether the status of the journeyman during the Middle Ages through to the Early Modern Period evolved from an essentially temporary to a largely permanent position within the corporate career. Social historians consider the process of proletarianization one of the most important social aspects of the Early Modern Period. Proletarianization, or the dependency of an increasingly larger group of workers on wages, was a social transformation process linked to urban workers between 1450 and 1800. This phenomenon is put in the context of the history of the guilds, where according to past research access to the master's title became more difficult. As a result, many were doomed to remain wage labourers throughout their lives. The author has questioned this process, and studies professional mobility on the basis of extensive qualitative as well as quantitative data for the Flemish and Brabantine towns of Ghent, Bruges, Antwerp, Brussels and Louvain. The outcome of his research counters the classical vision. A substantial number of journeymen were able to obtain a masters' title: in many cases their time as a wage earner in a workshop was temporary. Indeed, the labour market was the most important factor regulating the social mobility of journeymen, compared to the guild and its policies which had much less control.

The article by Prak focuses on the Dutch Republic but also presents a comparative dimension. His question is whether the increase in the production of paintings was accompanied by a rise in wage labour in painters' workshops. In the southern Netherlands the expansion of the sector coincided to some extent with an increase in workshop size and the mobilization of wage labour, while in the north this seems not to have been the case. With the 'new' expansion of the Dutch economy after 1600, anonymous, small customers dominated the demand for art. Market or 'on spec' production was risky and needed investment. He also remarks that Dutch painters hardly ever employed journeymen. Prak claims that the specific market for commissioned works by church and state remained very significant in the southern Netherlands. This allowed painters such as Rubens to keep a large workshop or become entrepreneurs, outsourcing a regular stream of commissions to smaller masters. The southern Netherlandish market thus remained more diversified, with commissions on the one hand and the market on the other. This continuity which characterizes the southern regions has not been observed in the Dutch Republic. Guilds had an important mediating role in the play of supply and demand in the art market, a role that has been somewhat underestimated.

Tentative conclusions

Earlier literature on guilds states that it became more difficult to become a master during the Early Modern Period. While in the fourteenth and fif-

teenth centuries the status of the journeyman within the corporate structure of the guilds was usually temporary, some scholars argue that it became permanent from the sixteenth century onwards. They consider that a large number of journeymen remained wage earners throughout their careers. However, as the contributions of this volume demonstrate, this classical vision does not correspond with the facts at our disposal. The possibilities of promotion for journeymen in the Early Modern Period does not seem to have been less than during the late Middle Ages. A number of journeymen undoubtedly chose or were forced to remain wage earners throughout their lives: not all would have had entrepreneurial talent or commercial ability. We propose that in the painters' (or artists') milieu, this group of employees was smaller than in other economic sectors such as the building and textile industry, and that it was also smaller than hitherto thought. In our opinion, the rather low numbers of journeymen points to the hypothesis that the process of proletarianization was less marked within the artists' world than elsewhere.[58] Another difference appears to be that, especially in periods of boom, artist journeymen seemed to have risen to become masters more quickly than others in order to satisfy the demand for art. This puts the guilds in a more mediating, less closed and less autocratic position.

The question of whether the expansion of the market for paintings from the late fifteenth century and especially from the sixteenth century onwards had qualitative and quantitative consequences for the role and status of the painter's journeyman cannot be answered completely and definitively at this moment. On the basis of the contributions to this volume as well as available research, it nevertheless seems that the rise in production cannot be linked to an increase in the average size of the workshop, nor is there a tendency towards the concentration of production in a few large workshops. On the contrary, the small workshop seems to have remained the norm within the painters' milieu. This implies that the demand for journeymen was not larger in the sixteenth and seventeenth centuries than earlier. The fact that in the statutes of the guild of Saint Luke no specific articles can be found concerning the number of journeymen per master is an important indication that this problem never presented itself in a major way. The expansion of the market probably caused a rise in the number of workshops, rather than larger workshops.

One has to bear in mind that the expansion of the art market was apparent in the cheaper market sectors. Because these products were of lower quality, the productivity in these workshops was much higher than in workshops catering for the Church and State, that is, commissioned works of art. While the more expensive paintings on panel or canvas were usually more time-consuming, the production time for watercolour paintings in Mechelen

[58] This does not mean that there were no informal or hidden proletarianization processes, such as subcontracting and outsourcing systems.

was very short. A workshop could thus produce many watercolour paintings without the need to hire extra labour. In times of boom, subcontracting – hiring other masters – was a good alternative. The outsourcing system, where masters worked directly for dealers, was also very popular in the course of the seventeenth century. This form of production offered the dealers two major advantages: little investment in fixed capital and thus reduced risk, and the flexibility to react to the changing market. To safeguard their position, these dealers were not in favour of large workshops, fearing that through such expansion the masters could become commercial entrepreneurs and thus competitors. The preference for small workshops as a strategy to safeguard their market position even led to the dealers providing help to the journeymen, as happened in Mechelen in 1562.[59] In this year, the Mechelen guild of painters brought a suit before the municipal council in which they complained that the dealers had lent money to journeymen to pay for their masters' titles, which they considered dishonest competition. The growth of the market thus provided possibilities for the upward professional mobility of the journeymen.

It appears that the expansion of the market for paintings had a larger impact on the working conditions in the studio (qualitative aspect) than on the size of the workshop (quantitative aspect). The slogan 'time is money' was increasingly put into practice, with Mechelen being a case in point. However, the pace of production increased at the expense of quality. Journeymen who worked in studios which only produced for the market had few chances to develop their artistic talent. A poignant case is the above-mentioned suit by twelve journeymen painters from Mechelen brought before the municipal council in 1646. The document shows clearly that each was painting as a *dousijnwercker*.[60] They were frustrated that the guild deans had refused to allow them to complete their training as this meant that they were not allowed to paint anything for themselves.

These contributions do not pretend to be conclusive, and suggest that many more case studies are required. Only after more exhaustive research will it be possible to formulate definitive conclusions on the role and the status of painters' journeymen in the Low Countries between c. 1450 and c. 1650. However, the contributions in this volume have helped visualize the roles of journeymen and workshop assistants in artists' workshops, and the many issues connected to them. We hope that the contributions and the issues taken up here encourage discussion and stimulate further research.

[59] See the contribution by Natasja Peeters and Maximilan Martens.

[60] Mechelen, Stadsarchief, oud archief, fonds DD notices, serie I nr. 32 (1), fol. 72r-73r.

CONTRIBUTORS

Johan Dambruyne is Historian and Archivist, State Archives of Beveren, Belgium.

Harald Deceulaer is Historian at the State Archives of Brussels.

Ann Diels is Art Historian and Assistant at Print Cabinet, Royal Library of Belgium, Brussels.

Linda Jansen is PhD student in Art History, University of Groningen.

Micha Leeflang is PhD student in Art History, University of Groningen, and Researcher at the Rijksmuseum, Amsterdam.

Maximiliaan P. J. Martens is Professor of Art History, University of Ghent.

Natasja Peeters is Art Historian and Conservator at the Arts Collection, Royal Army Museum of Belgium, Brussels.

Maarten Prak is Professor of Social and Economic History, University of Utrecht.

ARTISTS, ARTISANS, WORKSHOP PRACTICES AND ASSISTANTS IN THE LOW COUNTRIES

(FIFTEENTH TO SEVENTEENTH CENTURIES)*

Harald Deceulaer and Ann Diels

To a certain extent, interdisciplinary research is comparable to falling in love: both are thrilling and risky. One needs to depart from old certainties and familiar surroundings and enter into unknown territory, unsure of discovering happiness or disappointment. A balance must be found between opening oneself to new possibilities and not losing one's sense of self. A decade ago, Smit insisted that interdisciplinary exchanges between historians and art historians could yield, at their best, highly stimulating cross-fertilisations, while at their worst they might result in little more than a superficial, reciprocal appropriation of jargon.[1] Although we do not agree with his main conclusion (which could be summarised as 'leave history to the historians'), it is certainly true that each discipline creates its own languages, ways of thinking and specialisms. Just like entering into a relationship, it takes time and serious interaction to become familiar with each other's paradigms and systems of thought. This paper is the result of a dialogue between a historian and an art historian exploring the possibilities and pitfalls of interdisciplinary work between history and art history on the issue of labour and guild organisation in the early modern Low Countries. We focus on artists, artisans and their assistants: apprentices, journeymen and other masters. The paper is not an exhaustive overview of the historiography of artisans and guilds[2], but rather a critical contribution to an ongoing debate.

In the first part of the paper, we review some statements about workshop organisation in the art trades which seem to us the result of a less than happy relationship between history and art history. In particular, we are

* We thank Bert de Munck, Max Martens and Natasja Peeters for their comments and suggestions on earlier versions of this text.

[1] Smit, 'History', pp. 20-21.

[2] The historiography of the guilds in Dutch, German and French is evaluated respectively by Prak, 'Ambachtsgilden', pp. 10-33; Ehmer, 'Traditionelles Denken', pp. 19-77, and Hanne, 'Le travail', pp. 683-710.

critical of the neo-classical economic paradigm that has influenced many art
historical studies in recent years. In the second part of the paper, we intro-
duce some elements from the growing body of social historical research on
artisans, guilds, masters, journeymen and apprentices. We also explore a
few of the myths and (ideologically) biased images of artisans and guilds
that have dominated the literature for a long time. In the final part of the pa-
per, building on some concepts from the revisionist literature on guilds, we
formulate a hypothesis about workshop assistants in the art trades between
the fifteenth and seventeenth centuries. This leads us to more general reflec-
tions about categories which are too often taken for granted, e.g. 'space',
'painting' and even 'art'.

In the last ten to fifteen years, the dominant paradigm in the economic
approaches to art history has centred on the market for art mainly paint-
ings.[3] Whether this dominance is the result of internal evolutions in the dis-
cipline or is related to contemporary political, economic and ideological
evolutions[4] (the fall of communism, the economic boom of the 1990s and
the process of globalisation) need not be resolved here. In this paper, we do
not deny that markets, costs and prices played an important role in the early
modern production, distribution and consumption of art, nor do we intend to
dismiss the stimulating literature on art markets as unhelpful. We will ar-
gue, however, that crucial elements of the market-driven, neo-classical pa-
radigm, such as price competition, cost cutting and labour saving, are less
useful in understanding the central problem of this article and this book: la-
bour organisation, workshop practices and the role of assistants in the art
trades.

Although categories and concepts from economics and social history
may function well as stimulating heuristic devices, they cannot be copied
indiscriminately in early modern art history, especially the notions of 'mass
production', 'process innovations' and 'subcontracting', and even catego-
ries such as 'apprentices', 'journeymen' and 'masters'. These concepts may
be in need of adaptation and refinement in keeping with recent insights
from economic, social and art history. More complex models and perspec-
tives arise when social historical and art historical approaches are combined
in order to explore concepts such as institutions, subcontracting and co-ope-
ration, credit, quality, creativity and innovation. In order to arrive at a better

[3] Recent economic approaches to art are discussed by Ormrod, 'Art and its markets',
pp. 544-551; North and Ormrod, 'Introduction', pp. 1-6. See also Cavaciocchi, *Eco-
nomia e arte*.
[4] Certain approaches to the Italian Renaissance (e.g. Goldthwaite) have recently
been criticised for depicting an ideologically charged preconfiguration of contempo-
rary American society dominated by wealth, demand and consumption. See Alazard,
'Les tempos', p. 27.

understanding of labour organisation and workshop practices in the art trades, we will map a few concepts from the historical literature on journeymen, guilds, industrial districts, innovation, technology and consumption. We believe that some of these results may be useful for the study of early modern artists, and conversely, that the work of art historians can shed an interesting light on the study of artisans and entrepreneurs in the early modern period.

Historiographic traditions and some problematic interdisciplinary interactions

From the 1970s and 1980s onwards, several pioneering contributions have been made to the social and economic history of early modern art in Italy and the Low Countries. Although some art historians and archivists had earlier favoured a historical approach, it can safely be said that this approach was new.[5] Influenced by the selective survival of artworks and by elitist judgements of quality, traditional connoisseurship and intellectual history had largely ignored the social and economic aspects of art. While work on Italian art focuses strongly on the Renaissance *bottega*,[6] studies on Netherlandish art markets have so far not dealt systematically with workshop organisation, although a growing body of technical research can be found.[7] This probably reflects real social and economic differences. The art markets of large Italian towns were dominated by rich patrons, such as popes, cardinals and aristocratic families, who commissioned huge, labour-intensive projects (chapels, frescoes and palazzos). Studies on Netherlandish art generally focussed on the Dutch Republic in the seventeenth century, the most commercialised economy of early modern Europe, and on the Dutch artists who worked more individually for a middle-class market. These classic stereotypes, however, are in need of qualification because large workshops did exist in the Low Countries and recent research has argued that the Italian Renaissance art market was much less elitist than is commonly supposed.[8]

The work of John Michael Montias has been highly influential on the art history of the Low Countries. As an economist, he was generally not that interested in individual artists, style shifts, specific works of art or their

[5] An overview of Dutch art historical literature on the seventeenth century is given by Bok, 'De Schilder', pp. 330-359 and Montias, *Le marché*, pp. 7-24.

[6] See the overview of the literature in Thomas, *The Painter's Practice*, pp. xv-xix, and Penny, 'Le peintre', pp. 31-54.

[7] An overview of technical research is provided in Fairies, 'Reshaping', pp. 70-105.

[8] Thomas, *The Painter's Practice*, p. 15.

meaning, and generally considered paintings as commodities which could be bought and sold like any other product.[9] In the late 1980s and early 1990s, some economists and economic historians (Marten Jan Bok, Wilfried Brulez, Jan de Vries, Neil DeMarchi, Michael North, David Ormrod, Garry Schwarz, Ad Van der Woude) followed Montias's approach. With the exception of Brulez and Ormrod, they also focussed on the Dutch Republic in the seventeenth century. The roles played by increased demand, living standards, 'the market' and art dealers were of key interest, and their approach was often quantitative. Though labour organisation was not the *primary* focus of the literature on art markets, it became clear that the commercialisation of distribution obviously had to have had an effect on production.

With hindsight, we may wonder whether the 'artistic turn' by the economists and economic historians may also have been an attempt (probably unintentional) to transcend the intellectual limitations of their own discipline or to compensate for the erosion of the key intellectual position of economics and economic history since the late 1970s and 1980s. The crisis of many western economies in the 1970s and early 1980s, the parallel crisis of Marxism and modernising theory, and the rise of the new cultural history, *microstoria* and post-modernism deeply questioned traditional assumptions of economic or demographic determinism and quantification, which had more or less held an intellectually dominant position in the postwar period. Art history may have been perceived as an interesting way to regain some of the lost territory.[10]

Art is *par excellence* a field in which elements of 'taste', 'preferences' and culture that matter are precisely those elements that proved difficult to integrate in a traditional neo-classical framework. At the same time, art was and is, of course, connected to economic notions of production, distribution and consumption, fields in which economists or economic historians may have felt they held a 'competitive advantage'. We will review certain elements in the recent literature which are directly related to the problem of labour markets, workshop assistants and journeymen, and which we consider to be problematical, i.e. the concept of 'on spec' production, the notion of labour-saving cost-cutting techniques, and the notion of a concentration of production.

[9] Montias, *Artists,* and many later articles. A synthesis is presented in *idem, Le marché.*

[10] One of the responses of neo-classical economics to the challenges of the 1968-1973 period was to venture into the study of phenomena hitherto considered outside the scope of economic inquiry, e.g. the family, public policy and rational choice approaches. See Eyüp Özveren, 'An institutional alternative', p. 513.

Terminology: the concept of 'on spec'

In new economic approaches to art history, paintings that were not commissioned and were produced to be sold on the open market are often referred to as being produced 'on spec' (an abbreviation of 'speculation').[11] The need for a new term may have been felt because medieval or early modern artisans were traditionally considered to work on commission, i.e. not selling ready-made goods. In this interpretation, it would seem that selling paintings on the open market was an exceptional practice for which a new term, derived from 'speculation', was coined. In fact, however, markets, fairs and shops were part and parcel of medieval and early modern life, and selling non-commissioned goods was not exceptional at all for early modern artisans, at least in the Southern Netherlands. This had nothing to do with speculation or 'speculative production'. Although speculation did exist in the medieval or early modern period, it happened on a completely different level, that of the large capitalist entrepreneurs, sometimes linked to political authorities, for example in the grain or building trade, or in international commerce.[12] In our opinion, associating artists or artisans who sold the products of their own workshop on the open market with 'speculation' is inadequate and misleading.

Process innovation, labour saving and cost cutting?

For the seventeenth-century Dutch Republic, Montias has argued that new techniques of painting were introduced which allowed artists to work much more quickly. Painting rather simple landscapes, for example, saved time and labour costs.[13] Montias's work drew attention to other similar 'process innovations'. Many authors tell us that in the second half of the fifteenth and sixteenth centuries, labour-saving techniques were introduced among artists to save time and money. Workshop models as single-leaf sketches, full-scale perforated designs, woodblock prints and model books were increasingly used in combination with pouncing, tracing or quadrillage.[14] Filip Vermeylen claims that 'through the implementation of various process-innovation strategies, workshops were able to produce paintings and al-

[11] Ewing, 'Marketing Art', p. 558, Jacobs; 'The Marketing', p. 208; and Montias, *Le marché*, pp. 33-34 wrote about 'Art on speculation'. The term 'on spec' has subsequently become such a buzz word among art historians that detailing all the users is superfluous.

[12] Braudel, *Civilisation matérielle*, vol. II, pp. 35, 363-372.

[13] Montias, *Le marché*, pp. 116-117.

[14] See for example Van Uytven, 'Splendour', pp. 109-110; Sosson, 'La production', p. 693.

tarpieces at competitive prices, which ensured their survival'.[15] Montias states that these techniques were introduced because the main production factor, highly skilled labour, was in short supply.[16] Though Vermeylen and Montias disagree on whether pouncing, tracing and the use of models may have been a reaction to growing or shrinking demand, they – and many historians with them – agree that these techniques were essentially cost-cutting, labour-saving strategies which enhanced productivity. This interpretation clearly fits well with the notion of growing markets and alleged tendencies towards mass production, standardisation and price competition.

Yet it is far from clear that cost cutting and price competition were the only, or even the most important elements involved. The idea of labour saving implies that labour was expensive, but we know hardly anything about the costs of workshop assistants. It has not been proven that these so-called 'process innovations' had significant effects on costs and prices, nor that price competition was the driving force behind these innovations. Wilson warns that pouncing of pricked sketches may simply have served as a means of transferring the preliminary conception of a composition from a sketch onto a painting and that there was no intention of producing subsequent versions of either the sketch or the composition.[17] Balis stresses the increased importance of the notion of composition in Renaissance painting and of the concomitant influence of Italian design practices in the Low Countries in the sixteenth century. Designing a composition may thus have required more preparation than in the fifteenth century when underdrawings were usually applied directly onto the primed ground and frequently underwent many changes during the drawing process. Furthermore, motifs of drawings, models or prints which were considered artistically interesting (figures, animals, etc.) were often copied or slightly adapted in one's own compositions to appear original or distinctive.[18] In the competitive art markets of the Low Countries and Italy, such (apparent) product innovations could have been instrumental in carving out a specific market niche or in capturing the interest of the most influential and often highly discerning patrons.[19] Examples abound of successful painters who used models, pouncing

[15] Vermeylen, 'The Commercialisation', p. 53.

[16] Montias, 'Commentary', pp. 64-65.

[17] Wilson, *Painting*, p. 123. See also Fairies, 'Reshaping', p. 98.

[18] 'Maybe this practice should not be seen merely as a labour-saving device; rather it could be an opportunistic manoeuvre to integrate into a composition as many attractive features as possible ...'. (Balis, 'Working', pp. 144, 130); Wilson, *Painting*, p. 119.

[19] Balis, 'De nieuwe genres', p. 238; Wright, 'Mantegna', p. 73.

or tracing even though they worked in high quality market segments and for excessively rich, demanding patrons.[20]

The spread of pouncing and tracing can also be linked to the growing diffusion of prints. From the second half of the fifteenth century onwards (precisely the period when pouncing and tracing seem to have accelerated), the spread of woodblock prints created a broader and more unified visual culture in Europe. Artists, eager to enlarge their stocks of motifs and patterns, were enthusiastic buyers of early prints.[21] Using existing, successful compositions in a 'new' composition may thus not necessarily be explained by the (typically modern) notion of labour-saving, but could also be explained as a risk-reducing strategy. Sixteenth and seventeenth-century engravers, for example, frequently copied parts of or complete best-selling prints.[22] This did not reduce the time it took to engrave a copperplate, but it probably enlarged their commercial chances.

Furthermore, the incidence of pouncing and tracing through space and time casts doubt on the reductionist interpretation of these methods as labour-saving devices developed in reaction to growing or shrinking demand. Recent research on medieval art has shown that pouncing or tracing was already in widespread use in the second half of the fourteenth century. The earliest example dates from Carolingian times![23] In early modern China, artists, who often included motifs from prints in their compositions, also used pouncing.[24]

These examples serve as a warning against an unequivocal reading of pouncing and tracing by economic historians as Schumpeterian process innovations (a lowering of production costs without changing the basic appearance and nature of the object) or as proof of mass production driven by price competition.[25]

[20] Jan Gossaert, who worked for Philip of Burgundy, is known to have made compositions partly based on prints by Albrecht Dürer, and Benozzo Gozzoli, the painter of the chapel frescoes in the Palazzo Medici, used motifs from Netherlandish paintings, prints and Italian model books. See Mensger, *Jan Gossaert*, pp. 137-139; Ames-Lewis, 'Training', pp. 29, 33-34. However, we need to acknowledge that both artists also worked for other clients, see Van den Brink, 'De kunst', pp. 27-28 and Penny, 'L'artiste', pp. 41-43. For artists playing different market segments, see Fontaine, 'Economies et "mondes de l'art"', p. 72.

[21] Van der Stock, *Printing*, p. 15; Wright, 'Mantegna', p. 76; Ames-Lewis, *The Intellectual Life*, pp. 39-44.

[22] See, e.g. Diels, 'Introduction', pp. 60-61.

[23] Scheller, *Exemplum*, pp. 70-74.

[24] Thomas, *The painter's practice*, pp. 91, 102.

[25] Similarly, for the production of carved altarpieces, it has been argued that the use of standardised components or a simple iconography point to serial production with small variations, not to mass production of identical products. See Rommé,

Some workshops, of course, did make a large number of copies of individual paintings, and a certain division of labour and surprisingly efficient organisation of work can sometimes be found, e.g. in the studios of Joos van Cleve and Pieter Coecke van Aelst.[26] However, analytical distinction and fine nuances are preferable to the simple conflation of the use of visual sources with serial production, labour saving, cost cutting, price competition and mass production. We do not intend to deny the importance of labour costs, but the fact that art flourished in towns or regions with the highest wages in Europe – fifteenth-century Bruges, sixteenth-century Antwerp and the seventeenth-century Dutch Republic[27] – renders the notion of price competition via labour saving in art production rather suspect.

The discussion about process innovations has an interesting pendant in the recent economic historiography of innovations and technology. Maxine Berg and Reinhold Reith stress that economic and social historians have, for a long time, been blinded by the light of labour-saving process innovations, while they had a tendency to neglect improvements in quality or a differentiation of products.[28] Furthermore, it can certainly not be assumed *a priori* that labour constituted the dominant cost factor in early modern production. In the clothing trades, the fabric was much more expensive than the labour costs until the late eighteenth century.[29] Raw materials formed about 30% of the costs in the textile industry, and in the metal trades this share was much higher.[30] In the art trades, raw materials also often outstripped labour costs, quite contrary to the claims of some economic historians.[31] The lion's share of the costs of engravers constituted their copperplates.[32] The raw materials for tapestry weavers, sculptors and gold and silversmiths were obviously very expensive as well.[33] In fourteenth and fifteenth-century painting, the use of gold and exclusive pigments such as lapis lazuli, vermilion and ultramarine could lead to an extreme rise in prices. In later periods, the cost of raw materials was probably lower, although not negligible.[34] Resource-

'Rationalisierungstendenzen', pp. 712-717.

[26] Van den Brink, 'De kunst', pp. 20, 28-34. See the contributions by Micha Leeflang and Linda Jansen in this volume.

[27] Blockmans, 'Regionale vielfalt', p. 61; Lucassen, 'Labour', pp. 386-387.

[28] Berg, 'Product Innovation', pp. 141-142; Reith, 'Technische Innovationen', pp. 48-49.

[29] Deceulaer, *Pluriforme patronen*, pp. 72-80.

[30] Reith, 'Technische Innovationen', p. 55.

[31] For example, see Ormrod, 'Art', p. 545.

[32] Van der Stock, *Printing*, pp. 154-157.

[33] Van Uytven, 'Splendour', pp. 110-111. For recent examples, see Van der Velden, *The Donor's Image*, pp. 66-67; Vanwelden, 'Groei', p. 37.

[34] Cassagnes, *D'Art*, pp. 233, 252-255; Thomas, *The Painter's Practice*, pp. 132-

saving innovations may thus have been more important than labour-saving methods in the early modern period.[35] Several authors have explained the wider availability of consumer goods in the period after 1650 by the use of cheaper, less durable, raw materials or by other resource-saving innovations.[36] This is also important for the world of production because cheaper raw materials reduced the necessary amount of liquid capital, which may have lowered the economic barriers to setting up a workshop.

Mass production and larger workshops?

Some authors have argued that a concentration of labour and increasing workshop size can be noted in the late fifteenth and sixteenth centuries. Vermeylen states that 'well-organised workshops with many apprentices sprang up to replace the medieval artist who worked individually. Hence art production was rationalised, standardised and increasingly oriented towards export'.[37] Baetens even speaks about 'the industralisation of the arts' for the period after 1585.[38] For the same period, Hans Vlieghe uses the term 'mass production', but he does not suggest that this implies a concentration of production.[39] It is certainly clear that in some sectors, for example printing or tapestry production, examples of large, rationalised companies can be found.[40] The study of such trades is highly fascinating and, in general, we need to learn much more about trades other than painting.

However, some serious reservations should be noted concerning an unequivocal trend towards a concentration of production. First, it cannot simply be assumed that all medieval artists worked individually. The role of assistants and journeymen has received scarcely any attention despite both archival resources and technical research documenting their presence in many medieval art trades.[41] Second, and even more importantly, Martens

137. For Antwerp in the second half of the seventeenth century, Montias estimated that the cost of raw materials constituted 25% of the cost of a painting on canvas, and 50% of a work on copperplate, *Le marché*, pp. 107-108. Reith cites an investigation for Zürich, where it was claimed that the costs of materials for painters constituted some 50-80% of total costs in the period between 1690 and 1800, 'Technische Innovationen', pp. 48-49, 54-55.

[35] Reith, 'Technische Innovationen', pp. 53-55, 57. In the production of carved altarpieces in Ulm, labour-saving cost-cutting went hand in hand with the use of cheaper wood, see Rommé, 'Rationalisierungstendenzen', p. 711.

[36] Shammas, 'Changes', pp. 191-193; Styles, 'Manufacturing', pp. 537-538.

[37] Vermeylen, 'Marketing paintings', p. 199.

[38] Baetens, 'Indian Summer', p. 14.

[39] Vlieghe, *Flemish Art*, pp. 7-8.

[40] Vanwelden, 'Groei', *passim*.

[41] Cassagnes, *D'Art*, pp. 222-230; Fairies, 'Reshaping', p. 83. For examples, see

has noted a significant increase in the number of one-man businesses, both in late fifteenth-century Bruges (a period of economic crisis) and in six-teenth-century Antwerp (a period of economic growth).[42] This trend is mainly documented by counting the numbers of registered apprentices per master and we need to remember that the distribution of apprentices did not necessarily equal those of journeymen. Separate circuits have been found in certain trades, perhaps especially in those making standardised goods, but not in others.[43] Third, Van den Brink states that the serial production of trip-tychs or copies of the work by Bosch were not made according to standard-ised methods and was not centralised in one large workshop but was painted in several small studios scattered throughout the town.[44] These factors seri-ously undermine the notion of a simple trend towards a concentration of production, and Martens and Peeters therefore raise questions about the ade-quacy of 'mass production' as a concept for early modern art.[45]

Another interesting parallel can be drawn with broader trends in social and economic history in recent decades. In most work on early modern in-dustry (including agriculture), the old notion that large companies were a *conditio sine qua non* for the rationalisation of production has been aban-doned. Countless studies on proto-industrial production in Europe, ranging from the fourteenth to the early nineteenth centuries, have shown that an in-crease in the scale of production is *not* necessarily related to the scale of an individual workshop.[46] A large output can also be realised by scores of one-man (or one-family) businesses co-ordinated by merchants or large entre-preneurs.

More recently, studies of late seventeenth and eighteenth-century mate-rial culture and production have seriously questioned the concept of mass production for the early modern and even for the early industrial period. Mass production is generally associated with low quality, low unit costs, unskilled or de-skilled labour, a limited product range, standardisation of components and automated production lines. But as social and economic

(amongst others) Sosson, 'La production', p. 694; Borchert, 'Inleiding', pp. 14-15, 25.

[42] Martens, 'Some aspects', p. 26.

[43] Carpenters and cabinetmakers with many journeymen were not enthusiastic about training apprentices in eighteenth-century Bruges. Cf. Absolon, 'Prosopografische benadering', pp. 98, 183. Apprentices and journeymen of tailors in eighteenth-century Brussels did follow the same pattern: masters who employed journeymen generally also took apprentices. See Deceulaer, *Pluriforme patronen*, pp. 269-271.

[44] Van den Brink, 'De kunst', pp. 20-22, 39.

[45] Martens and Peeters, 'Artists by numbers' .

[46] For overviews of proto-industrialisation, see Ogilvie and Cerman, *European Pro-to-industrialisation*; Ebeling and Mager, *Protoindustrie*.

historians of early modern trades and industry find themselves confronted with the importance of quality, skills, product diversity, fashion and novelty, they are attempting to 'undo the shackles of the mass production models', which 'have distorted our understanding of the features and achievements of eighteenth-century manufacture'.[47] The roles of design and quality have received much more attention in recent studies of luxury and consumption.[48] Maxine Berg has recently stressed a typically eighteenth-century concept of imitation as invention: not a servile copy in cheaper materials, but an evocation of objects in other forms, in which the new form might well surpass the original in inventiveness, value and rarity.[49] She emphasises the role of import substitution of expensive French or Asian luxury goods, and this may indeed be a specifically late seventeenth and eighteenth-century phenomenon.

The concept of invention through imitation, however, is much older. Inspired by Cicero's rhetorics, several Renaissance art theorists used the concepts of *imitatio, aemulatio* and *translatio*. *Imitatio* was especially important during apprenticeship and preceded *aemulatio* (when the artist competed with his models and with his colleagues), which was eventually followed by *translatio*, when the artist surpassed the original and made a new *inventio*, rooted, however, in tradition. This theory may shed new light on the use of models, both by artists in the sixteenth century and by entrepreneurs in the eighteenth century. It also shows how a dialogue between art historians and historians can offer fruitful perspectives on long-term developments.

In the social and economic historiography of the rise of industrial capitalism, a consensus has risen that there is not a single trajectory towards industrialisation or capitalist development.[50] As research found that the centralised factory, fixed capital and the steam engine played a much smaller role in British industrialisation than previously thought, the industrial revolution became decentred, and linear and teleological models of the 'stages' of economic growth have been dismissed. Historians have become aware that over-stressing those elements which seem to be 'new' or 'modern' (mass production, cost cutting, new technology) led to anachronism. Following Marshal's concept of industrial districts, Charles Sabel and Jonathan Zeitlin have emphasised the role of small workshops or companies run by

[47] Craske and Berg, 'Art', p. 824; Berg, 'From imitation', p. 2.
[48] Styles, 'Manufacturing', pp. 529-534; Berg, 'New Commodities', pp. 67-69; Fox and Turner, *Luxury Trades*; Snodin and Styles, *Design*.
[49] Berg, 'From imitation', pp. 17-21.
[50] See, amongst others, Coquery, Hilaire-Perez, Teisseyre-Salman and Verna, 'Les révolutions industrielles', pp. 7-17, with numerous references to recent literature.

creative, innovative and often highly skilled artisans or employees, which proved to be successful and valuable 'alternatives for mass production'. In these regions, a clustering of critical mass, an elaborate division of labour and sophisticated subcontracting arrangements created product innovation and differentiation, a flexible use of new technology and quality. Furthermore, they emphasised the part played by local or regional institutions in balancing competition and co-operation, regulating skill formation, punishing abuse of local trademarks and overseeing complex wage stabilisation.[51]

Their model has proved highly influential in the revisionist historiography of artisans and guilds. The thought-provoking work of Michael Sonenscher on French artisans in the eighteenth century, which became a leading model for many European guild historians, was to a large extent inspired by Sabel and Zeitlin's model. Their notion of loose, reliable subcontracting relations between medium-sized and small firms seemed an attractive concept to explain the core-periphery structure of larger companies and one-man businesses, which were often found in early modern industry.[52]

In this sense, it is ironic and surprising that some art historians of the sixteenth and seventeenth centuries are unearthing old mass production models, which historians of the eighteenth and nineteenth centuries have abandoned. In a defence against the criticism of Montias, Vermeylen even tried (albeit with some reservations) to apply the 'take-off' phase of Rostow's linear stages theory of economic growth (one of the key texts of modernisation theory, written in 1960) to sixteenth-century Antwerp.[53] We must bear in mind that Rostow's blueprint was a conception of British industrialisation that is now outdated, that he stressed the changing proportions of national income devoted to aggregate capital formation (our knowledge on this point about sixteenth-century Antwerp is scanty to say the least), and that his work must be read in the context of the anti-communist policy of the US during the Cold War.[54] More importantly in this context, Rostow's model was abandoned long ago by economists and economic historians of the Industrial Revolution.[55]

[51] Sabel and Zeitlin, 'Historical alternatives', pp. 144-149, 154. See also Pollard, *Peaceful Conquest*, pp. 7, 32-40.

[52] Sonenscher, *Work*, pp. 140, 145, 147; Farr, *Artisans*, pp. 141-145.

[53] Vermeylen, 'Further Comments', p. 67.

[54] Hunt, *History*, 2002, p. 456; Eyüp Özveren, 'An institutional alternative', p. 511.

[55] Critiques of Rostow's work became abundant when it was discovered that simply injecting capital into the Third World was not enough for development. Moreover, historical research has seriously undermined his premises about the British Industrial Revolution. The literature is copious on this point. For one early example among many, see Crouzet, 'Editor's Introduction', pp. 1-70, especially pp. 12-29. A clear recent overview of the debate is given in King and Timmins, *Making Sense*,

In their search for appropriate intellectual frameworks to tackle a new field, scholars typically borrow concepts, methods and theoretical approaches from other disciplines. In the late 1970s and early 1980s, for example, some historians enthusiastically embraced anthropology to enliven cultural history. No one doubts that this alliance produced some fine, innovative and highly influential work. Yet, certain anthropologists remarked that some historians had a similar tendency to use outdated and questionable anthropological concepts or models that they themselves no longer took seriously.[56]

These examples show that a social and economic approach to the arts could profit from a more intense dialogue with recent social historical research on early modern labour organisation, production and guilds. Therefore, it might be useful to succinctly present some of these results.

Social history and early modern labour organisation

Guilds: myths and images

Traditionally, various authors have framed their thinking about guilds in a theory of post-medieval decay: guilds reached their zenith in the late Middle Ages but apparently declined continuously between the late fifteenth and the eighteenth century. According to this model, in the early modern period rules allegedly rigidified, guilds became closed castes where the position of master was practically only passed on from fathers to sons, and guilds obstinately resisted organisational or technological change.[57] These ideas originated in the late eighteenth century among liberal, political adversaries of the guilds,[58] strengthened in the course of the nineteenth century, and dominated the larger part of the twentieth century. This literature is rooted in a series of bipolar contradictions: corporatism versus capitalism, tradition against renewal, stability against change, collective versus individual. These contradictions were projected on to the societies of the Ancien Régime and the contemporary world in general, where the French Revolution and the Industrial Revolution formed a fundamental watershed.[59] This classic picture of conservative guilds was not limited to nineteenth-century liberalism and was also taken over by classical Marxism. These images strengthened at the

pp. 10-32, 110 and *passim*.
[56] For example, see Cieraad, *De elitaire verbeelding*, pp. 52-67; De Waardt, 'De geschiedenis', pp. 334-354.
[57] Ehmer, 'Traditionelles Denken', pp. 24-26.
[58] See Kaplan, *La fin*, pp. 7-49, for an overview of eighteenth-century French criticism of the guilds.
[59] De Vries, 'Economic Growth', pp. 177-195.

end of the nineteenth century, partly through the research of Gustav Schmoller and his pupils in the German *Historische Schule*.[60] Their careful investigations were mainly focused on normative sources and offered an empirical basis to the classic picture.

Images and myths concerning guilds have often been constructed to serve ideological agendas or to fight other political adversaries: the rhetoric of eighteenth-century critics of the guilds could be aimed at absolutist government, but could be just as instrumental in a strategy to increase the grip of the central authorities on society,[61] and to weaken local or regional powers. Nineteenth-century liberals used images of 'conservative guilds' to undermine the legitimacy of socialist trade unions or competing Catholic organisations. In the 1930s and early 1940s, the images of order and stability in the guilds proved attractive to certain conservative and fascist intellectuals, desperately struggling with modernity, crisis and war. In the post-war period of economic growth in the West, modernisation theories again emphasised the contradiction between tradition and modernity, and historical attention for guilds waned for a long time. The new social history of the 1960s and 1970s did not immediately break with the picture of old-fashioned guilds or artisans. What an older generation perceived as the conservatism of guilds and artisans was rebaptised in the 1960s and 1970s as the resistance of the crowd, eager to restore a moral economy that was endangered by the evil forces of capitalism. More recently, some of the historical attention paid to guilds can partly be explained by the quest for a civil society and by the critique of contemporary global capitalism.[62]

Although later ideological appropriations and biases are probably inevitable, historians agree that early modern artisans and guilds should be studied on their own terms. Even more importantly, it has become clear that general categories such as 'guilds' or 'artisans' should be broken down into precise and detailed analyses of different trades, market segments, labour and commodity markets. A baker, a weaver, a mercer or a cooper may all have been members of guilds but their social status, their use of capital, credit, raw materials and products created highly different social and economic relations, specialisations, vertical hierarchies, behaviour patterns, positions and prospects.[63]

[60] See several publications by Reith, 'Technische Inovationen', pp. 23-33 and *idem*, 'Wage forms', pp. 113-120.

[61] For the multiple motivations to attack the guilds in the eighteenth century, see Kaplan, *La fin*, pp. 11, 49, 51.

[62] An implicit 'sous-texte' in many recent studies, this perspective was explicitly formulated by De Munck in 'Al doende', pp. 51-52.

[63] Ehmer, 'Worlds', p. 174; Deceulaer, 'Guildsmen', pp. 1-27 and *idem*, *Pluriforme Patronen, passim*.

Several strands of research gradually undermined the classic dichotomous view in the 1980s and especially in the 1990s. Historians working on early modern France and Germany took important steps, especially for the eighteenth and early nineteenth centuries, and their revisionist views quickly found echoes elsewhere.[64] First, several historians demystified the free market of nineteenth-century Europe and emphasised the importance of regulation and institutions for quality control. Artisans and small entrepreneurs still constituted a large and dynamic part of the urban population of western Europe.[65] Secondly, historians of the early modern period increasingly found more empirical material which simply did not fit into the old models. Guilds proved to be much more dynamic, practices varied markedly from the rules in the normative sources, and economic growth in the early modern period may have been more important than previously thought. Several historians have claimed that the empirical proof for the guilds' resistance to technological renewal is very weak.[66] Others even think that guilds actually favoured technological innovation through organised apprenticeship, artisan mobility and the provision of quasi-monopoly rents for innovators.[67] Douglas North and other institutional economists have argued that rules and institutions can lessen uncertainty and risk in situations of asymmetrical information, and that they can lower transaction costs.[68] Guilds seem to do this by monitoring quality, controlling intra-industry transaction costs (when several stages of production have to be co-ordinated by different trades and guilds) and by reproducing human capital.[69]

Art historians are just as divided about the role of the guilds, although more positive accounts seem to dominate the recent literature. The argument about quality control is generally accepted by art historians, as they are well acquainted with the rules regarding quality among goldsmiths, in the weaving of tapestries or the making of altarpieces. Van der Stock stressed that many (though not all) printers and publishers in Antwerp wanted to join the guild of Saint Luke, and that there is no evidence of a rigid policy concerning the internal organisation of workshops.[70] Forthcom-

[64] Important contributors include Farr, *Hands*; *idem*, *Artisans*; Kaplan, *Work in France*; Sonenscher, *Work and Wages*; Nunez (Soly, Epstein and Poni), *Guilds*; Lis and Soly, *Werken volgens de regels,* and by the same authors, *Werelden van verschil*; Schulz and Müller-Luckner, *Handwerk*; Crossick, *The artisan*.
[65] Hirsch and Minard, 'Laisser-nous faire', pp. 151-157; Crossick and Haupt, *The Petite Bourgeoisie*.
[66] Reith, 'Technische Innovationen', pp. 23-28.
[67] Epstein, 'Craft Guilds', pp. 687-688, 701-702, 706.
[68] North, *Institutions*, p. 12.
[69] Pfister, 'Craft guilds', pp. 11-24.
[70] Van der Stock, *Printing*, pp. 109-111.

ing work by Diels shows that engravers and publishers gained positions on the board of the guild of Saint Luke in periods when the economic role of engraving grew.[71] Prak stresses the positive aspects of quality control, training and protection of markets in the Dutch Republic, and contrasts these with a lack of indigenous institutions in Spain.[72] Though these and other studies have contributed to our knowledge, we still lack an empirical, systematic study about the guilds of Saint Luke in European towns. This lacuna in the research may be partially explained by other 'ideological' elements. It is well known that since the Renaissance, artists have constructed their images, rhetoric and self-definitions in opposition to artisans and the 'mechanical arts'.[73] Therefore, art historians may have been reluctant to study those organisations that embody the mundane artisan, not the brilliant artist. A similar problem arises in relation to workshop assistants, which may to a certain extent question the notion of the individual genius of the artist.

In search of the workshop assistant. Complicating categories: apprentices, journeymen and masters

Recent research has repeatedly shown that the famous trinity of guild history (apprentices, journeymen and masters) actually masks serious internal divisions. Apprentices could be rich or poor, living with a master or living at home, serving long-term or short-term apprenticeships. Journeymen could be heading for mastership or accept working for wages for their whole life. Masters were sometimes large entrepreneurs, organising subcontracting networks, and buying and selling on regional and even international markets, but masters could also be on the brink of starvation. In the paragraphs below we will compare the historical literature on artisans with art historical studies on artists, with specific regard to apprentices, journeymen and masters.

 Historical studies on apprenticeship have shown that, in the Low Countries, guilds generally prescribed rather short apprenticeships (two to three years) in comparison with England (seven years after 1563), France, Southern Germany and Habsburg Austria (three to six years).[74] However, the ac-

[71] Diels, *De familie Collaert*, pp. 44-49.

[72] Prak, 'Gouden Eeuwen', pp. 35-37. In the seventeenth-century Dutch Republic, guilds of Saint Luke were founded in Gouda and Rotterdam in 1609, in Delft and U-trecht in 1611, in Leiden in 1615, in Alkmaar in 1631 and in Hoorn in 1651, Montias, *Artisans*, p. 74; Prak, 'Gouden eeuwen', pp. 35-37; Sluiter, 'Over Brabantse vodden', pp. 119-120.

[73] Ames-Lewis, *The Intellectual Life, passim*.

[74] Griessinger and Reith, 'Lehrlinge', p. 152; Ehmer, 'Worlds', p. 186; Schultz, *Das Ehrbare Handwerk*, pp. 63, 73.

tual time served as an apprentice was generally longer than the prescribed period. The length of the apprenticeship generally correlated negatively with the payment of 'learning money' to the master. Paying a large sum meant a shorter apprenticeship, while apprentices who paid nothing or only a little money to their masters generally promised to fulfil longer apprenticeships and paid with their work for this transfer of 'cultural capital'.[75] Many apprentices left their master's workshop when they had learnt the trade because it was financially more advantageous to become a (paid) journeyman elsewhere. As the Antwerp hosier Alexander Vinckx explained in 1605, this was a serious problem for some masters 'because the master has no profit from the boy in the first or second year, only great efforts and worries to teach him; he only becomes profitable in the third or fourth year'.[76] In the building trades, apprentices who stayed for a longer time in a workshop were paid drinking money or a low wage, which increased in later years, probably to discourage them from breaking off their apprenticeship.[77]

Although the prescribed apprenticeship in the art trades may have been slightly longer than in other trades,[78] several types of apprentices were found. Many painters fulfilled their apprenticeship with several different masters and, conversely, important artists often preferred to engage older apprentices who had already learnt the basics of the trade elsewhere.[79] The latter were almost 'journeymen', although they were apparently not given that title. Furthermore, apprentices crossed the boundaries of different trades. In Renaissance Tuscany, apprentices often entered the workshop of a master active in one specific craft, learned the basic elements of the trade, but eventually established themselves as independent artists in quite different fields.[80] Recent research has shown similar trends in other trades in the Southern Netherlands.[81]

The historical literature on eighteenth-century journeymen in France, Southern Germany and England has stressed the importance of geographical

[75] De Munck, 'Al doende', pp. 13, 27.

[76] Deceulaer, *Pluriforme patronen*, p. 275. Cf. Krausman Ben-Amos, 'Failure', p. 170.

[77] Absolon, 'Prosopografische benadering', p. 93; Dambruyne, 'De Gentse bouwvakambachten', pp. 63-64.

[78] For example, four years for the Antwerp guild of Saint Luke. See Van der Straelen, *Jaerboek*, p. 7.

[79] Miedema, 'Over vakonderwijs', pp. 271-272; Van der Stichelen, 'Van Dijcks eerste Antwerpse periode', p. 37.

[80] Thomas, *The Painter's Practice*, pp. 5-6. The painter Francesco Salviati, for example, was apprenticed to a goldsmith, Monbeig Goguel, *Franceso Salviati*, p. 9.

[81] De Munck, 'Al doende', pp. 38-39.

mobility, with journeymen's organisations and group cultures operating via a network of inns.[82] In market segments dominated by standardisation, large capital-intensive workshops and skilled labourers who did not have the prospect of becoming a master, workers' organisations or strikes often arose to control the labour market. They especially strove to limit the number of apprentices.[83] This does not mean that all journeymen's organisations (such as confraternities and mutual aid societies) were trade unions in disguise.[84] With the exception of the hatters, the shearers and the typographers,[85] such organisations were non-existent in the Low Countries. Similarly, an obligatory period of working as a journeyman, sometimes linked to a prescribed period of *Wanderung* from city to city,[86] was generally not a condition to attain mastership.[87] To become a master, it was usually enough to fulfil an apprenticeship, pay a sum to the guild and (sometimes) pass a master's test.

In the art trades, with the exception of the tapestry sector,[88] as far as we know, no traces of journeymen's organisations or strikes have yet been found. For painters, limitations on the number of apprentices per master were either nonexistent, very moderate, or frequently transgressed. This may be an argument *ex silentio* against the notion of standardised mass-production, concentration of labour or lack of social mobility in the art trades. Journeymen had a loose relationship with a larger group of masters, working when there was a heavy demand for labour. Some of these journeymen apparently also worked independently. For Italy, Thomas and Penny write that workshop assistants could and did secure commissions in their own right, in other words, as 'masters'.[89] Impressionistic evidence seems to point to similar phenomena in the Low Countries with apprentices or journeymen in some cases allowed to sell their paintings on their own

[82] Ehmer, 'Worlds', pp. 189-191; Lis and Soly, 'An irresistible phalanx', pp. 11-52; Schultz, *Das ehrbare Handwerk*, pp. 91-100.

[83] Lis and Soly, 'An irresistible phalanx', pp. 22, 28, 42.

[84] As is suggested by Farr, *Artisans*, pp. 203-204. The differentiation between 'compagnonnages', confraternities and militant organisations of journeymen is stressed by Garrioch and Sonenscher, 'Compagnonnages, pp. 25-45; Hunt and Sheridan, 'Corporatism', pp. 813-844; Thijs, 'Religieuze rituelen', pp. 231-281.

[85] Dekker, 'Getrouwe broederschap', pp. 1-19; Lis and Soly, 'De macht', pp. 15-50.

[86] Ehmer, 'Worlds', p. 174; Schultz, *Das ehrbare Handwerk*, p. 70.

[87] The only example in the art trades known to us is the Guild of Saint Luke in Haarlem where serving one year as a journeyman was a prerequisite to becoming a master. See Montias, *Le marché*, p. 125.

[88] Vanwelden, 'Groei', p. 54 (strikes in 1545 in Antwerp, Oudenaarde, Valenciennes and Mons).

[89] Thomas, *The Painter's Practice*, p. 2; Penny, 'Le peintre', p. 43.

account, for example during fairs,[90] and some art historians have dated certain works of individual artists earlier than the year in which they became a master.[91]

While journeymen may have operated as illegal or semilegal independent 'masters', historical studies have demonstrated that masters themselves did not always work independently. In the clothing trades in Antwerp, Brussels and Ghent, for example, many master tailors made ready-to-wear clothing for richer colleagues or for 'second-hand' dealers who sold new clothing. Credit was at the heart of their willingness to enter such subcontracting arrangements: some had to bridge the time until their customers paid their bills, while others had borrowed money from richer entrepreneurs in the clothing trades and paid their debts by working for them (at low rates).[92] Thus, masters who lent money may not simply have intended to make a profit through the interest they would receive but may also have used the loans as a strategy to hire and control (cheap) labour for future use. Recent research has found several examples of debts or capital that were paid by work, in both a rural[93] and an urban context. In the tapestry trade of Oudenaarde, journeymen were tied to an entrepreneur through their debts. Similarly, small tapestry-weavers sometimes bought raw materials on credit from their richer colleagues and were forced to do waged work when they could not pay their bills.[94]

In the art trade as well, partnerships, collaboration and subcontracting abounded in medieval and early modern towns.[95] Wilson has pointed out that the words *gezellen* and certainly *medegezellen* in fifteenth-century sources do not unequivocally point to journeymen, but could also refer to masters assisting other masters.[96] In the sixteenth and seventeenth-century

[90] Miedema, 'Over vakonderwijs', p. 271. In the 1520s, the joiners' guild of Breda lost a lawsuit against the churchwardens of the Church of Our Lady, who had hired a woodcarver who was not yet a master. Scholten, 'The world', p. 244; Ewing, 'Marketing Art', p. 580, note 153.

[91] Van der Stichelen, 'Van Dijck's eerste Antwerpse periode', p. 38.

[92] Deceulaer, *Pluriforme patronen*, pp. 49-51, 135-136.

[93] Small peasants in Markegem paid their leases and for the ploughing and transport services of a rich farmer by working on his land or by weaving for him, see Lambrecht, 'Reciprocal exchange', pp. 240-245; idem, *Een grote hoeve*, pp. 109, 113-134, 186-187. Large merchant farmers in certain mountainous regions in Europe lent money to peasants, who then paid back the loan by peddling goods for them in other regions, Fontaine, *History of Pedlars*, pp. 101-104 and *passim*.

[94] Vanwelden, 'Groei', pp. 29-31, 42, 53-54, 62-63.

[95] Lis and Soly, 'Corporatisme', *passim*; Campbell, 'The Art Market', p. 193; Sosson, 'La production', pp. 689, 695.

[96] Wilson, *Painting*, pp. 151-152. See also Campbell, 'The Art Market', pp. 193, 196.

Low Countries, various examples of collaboration have been found at both the high and lower ends of the market.[97]

In early modern trades in general, and in the art trades in particular, workshop assistants may thus have consisted of older apprentices and journeymen as well as masters working in partnerships or subcontracting arrangements. The choice of one or the other type of labour relations was determined by a wide range of elements including the availability and costs of employing apprentices, skilled journeymen or masters, the labour intensity and the quality of the work involved, and the institutional rules influencing labour supply. These parameters, of course, varied according to the time, place and trade or market segment involved (sculpture, painting, printing, gold and silverwork, etc.).

Sources of information on the number of journeymen or subcontracting masters are usually missing or fragmentary at best. Although archival research may yield further empirical results for an inductive approach, it might be useful to use a deductive, analytical model, which tries to map the main flows on the labour market. The diagram below gives a rudimentary illustration of the possible choices that individuals could make in the artisans and artists' labour market.

Fig. 1: Main flows on the labour market (excluding migration and mortality)

The different steps were in no sense automatic, one-way or governed by a uniform chronology. Furthermore, large sections of the urban population remained outside the guilds, both as low-skilled workers and as illegal

[97] Van Mulders, 'Peter Paul Rubens', pp. 111-116; Van der Stighelen, 'De (atelier-) bedrijvigheid', pp. 305, 314-315.

'masters'. An apprentice or a journeyman could, therefore, at all times shift to other ways of making a living.

The inflow of apprentices was largely determined by:
- perceptions of the future evolution of the trade (and that of other trades) among young people (and their families) looking for a way to make a living
- the cost of apprenticeship (the payment to the guild and to the master, and the number of years of training)
- the rules governing the relationship between masters and apprentices (whether a master could employ only one or many apprentices at the same time, and whether or not there was a 'waiting period' between two apprentices which a master had to respect), and the extent to which these rules were observed

The inflow of masters was, of course, determined by:
- perceptions of the future evolution of the trade among aspirant masters
- the cost of master fees
- the length of the prescribed apprenticeship (or possibly a prescribed period as a journeyman)
- the cost of setting up a shop, including the issue of turnover, i.e. how long it took to be paid by clients

The nature of the product should also be inserted in the model. Large, labour-intensive, complex works of art required a larger number of workers than relatively simple, smaller works of art.

Admittedly, the model in the diagram is highly simplified because it excludes migration and mortality. Recent studies in social history have found a high level of migration in the medieval and early modern periods,[98] and art history studies have repeatedly shown that artists were a highly mobile group of craftsmen. Calculations regarding social mobility and mastership based on the number of apprentices may not tell the whole story because early modern towns often functioned as training centres for a much larger area.[99] This may have been especially important for training in the arts because some skills were or were perceived to be better developed in some towns.[100] The effect of having trained in Bruges, Antwerp, Venice, Rome or Florence was not negligible for the reputation of a young artist setting up a shop elsewhere.[101]

[98] For example, see Lucassen, 'Labour', pp. 369-372.

[99] This was argued by Krausman-Ben Amos, 'Failure', pp. 155-172.

[100] Of the 44 new masters in the painters' guild of Tournai between 1440 and 1480, only 18 had done their apprenticeship in the town itself (Sosson, 'La production', p. 67).

[101] Borchert, 'De mobiliteit', pp. 33-45; Scholten, 'The World', pp. 238-239. For artisans, compare Schulz, 'Verflechtungen', p. xii: '... die Reputation, welche die Auslanderfahrung vermittelte ...'. See also De Munck, 'Al doende', p. 43.

Still, *ceteris paribus*, we can assume that in a situation with flexible rules of entry for apprentices and possibilities of training at low costs, but with strong barriers of entry for masters and high costs to set up a shop, a relatively large pool of skilled journeymen is likely to arise. In such a market, dominated by a limited number of masters, workshop assistants will most probably consist of journeymen or long-term apprentices, and a certain pressure on their wages is theoretically possible, but may not necessarily have been desirable in a high quality market.

In situations where barriers to entry for both apprentices and masters are weak, a large number of small masters is likely to arise. In such a market, workshop assistants will most probably consist of small masters. Of course, both situations presuppose a large demand for labour-intensive art products, but the nature of the works involved, and especially their labour and capital intensity, could influence the demand for a specific type of workshop assistant.

Recent literature has rightly emphasised the complexity of multiple identities and the great variety and non-linearity of possible steps on the social ladder in the corporatist world of the Ancien Regime. It is clear that several types of labour relations existed side by side, even in the same town or in the same trade. Is it, however, possible to sketch a few of the larger patterns or long-term shifts in the flows on the labour market? Further detailed research on this is needed and the hypothesis below is presented with many reservations.

Workshop assistants from the fifteenth to the seventeenth centuries

From journeymen to apprentices and masters

Sosson has stressed that in fifteenth-century Bruges the number of artists was relatively low, master fees were rather high, immigration was important before the 1470s and apprentices and probably journeymen played an important role in the workforce.[102] In fifteenth-century ordinances for the guilds of Saint Luke in Antwerp and Bruges, specific rules for journeymen (*knapen* or *knechten*) were enacted.[103] Fifteenth-century art was both labour and capital-intensive: large triptychs with a complex iconography were produced and expensive raw materials were used, with paint often applied in many thin layers. Setting up an independent workshop (renting a studio, investing in raw materials, finding clientele and workshop assistants) was thus

[102] Sosson, 'La production', pp. 679, 697-698.
[103] Van der Straelen, *Jaerboek*, pp. 4, 8. Van de Casteele, 'Documents', pp. 21, 23. These rules do not necessarily refer to *painter's* journeymen.

far from easy for a young painter. For the *pictor doctus* of the sixteenth century or the large studios of the early seventeenth century producing (religious) history paintings, the role of apprentices or journeymen remained very important.[104] If it was necessary to construct a typical workshop style, it might have been desirable to work with a small group of skilled apprentices, journeymen or family members who worked under direct supervision.[105]

Yet the long-term existence of a large pool of skilled journeymen or apprentices was not self-evident. Apprentices or journeymen probably aimed to become masters themselves. More importantly, a fairly constant supply of work with various masters of the town was necessary, otherwise journeymen would migrate, move into other sectors or look for alternative ways to make a living. Maintaining a skilled labour force seems to have been a problem in the art trades. Unlike many of the proto-industrial workers living in the countryside, assistants in artists' workshops did not own a plot of land that could help them to survive periods of unemployment. The cost of the reproduction of labour was met in several ways. A small number of fifteenth-century artists may have been able to shift all or part of of these costs to their patrons. Leonardo da Vinci repeatedly asked princes to cover the wages of his assistants, and in 1421 the sculptor Domenico di Nicolò asked the government of Sienna to support the wages of his apprentices.[106] Seen in this context, it might not be a coincidence that the magistrates of Ghent and Bruges and the Duke of Burgundy gave gifts to Van Eyck's workshop assistants.[107] Other artists internalised production costs by employing a son, a daughter or other members of the household as assistants.[108] These family members were then generally not able to set up an independent household, which made it a temporary solution and only available for masters with a talented child who was willing to sacrifice his own (short-term) ambitions. In the seventeenth century, an equally small number of renowned painters (e.g. Rubens and Rembrandt) were able to shift the costs to the apprentices' families who were happy to pay for such high quality training.[109] The most successful painters could attract a large number of apprentices. In 1609, the dean of the Antwerp guild of Saint Luke accepted

[104] Vlieghe, *Flemish Art*, p. 6.

[105] For example in the studios of Jan Van Eyck, Domenico Ghirlandaio or Frans I Francken, see Borchert, 'Inleiding', pp. 14-15; Penny, 'Le peintre', p. 49; Peeters, 'Marked', p. 75.

[106] Nuland, *Leonardo*, pp. 46-47, 107; Cassanelli, 'L'artiste', pp. 15, 29.

[107] Borchert, 'Inleiding', pp. 14-15.

[108] Paul Vredeman de Vries worked for many years for his father Hans. See Borgreffe, 'Hans Vredeman de Vries, 1526-1609', pp. 18, 22, 26.

[109] Montias, *Le marché*, p. 94.

no fewer than five pupils, amongst them the ten-year old Anthony Van Dijck.[110] Such practices probably swelled the number of aspirant masters quickly, as not all pupils could be kept in the studio. Yet this type of advantage of scale by means of an *économie du renom*[111] was only open to a few artists, and it was not a permanent solution to the problem of producing a stable, skilled labour force of journeymen. Illegal work may have been an option, and a large group of journeymen working as semi-clandestine masters would de facto lead to a labour market dominated by small masters.

Artistic and institutional evolutions in the sixteenth and seventeenth centuries likewise seem to have favoured a labour market of one-man businesses. New genres such as portraits and landscapes arose. Triptychs with complex iconography gave way to chevalet pieces with a simple message that could be grasped at a single glance.[112] A large studio with many assistants was generally not needed to produce such works. Furthermore, guild fees seem clearly lower in relative terms during most of the sixteenth and seventeenth centuries, compared to those in fifteenth and early sixteenth-century Bruges or Ghent. Though we do not know the wages of journeymen-painters, we can relate the entry fees of the guilds of Saint Luke to the wages of skilled journeymen in the building trades.

[110]Van der Stighelen, 'Van Dijck's eerste Antwerpse periode', p. 37.

[111] Fontaine, 'Economies et mondes de l'art', pp. 67-68.

[112] Balis, 'De nieuwe genres', pp. 240-241. Van den Brink argues that large studios seem to have disappeared after the death of Pieter Coecke van Aalst, 'De kunst', p. 35.

Table: Master fees for the guilds of Saint Luke in four towns, 1488-1649[113]

Town	Year	Master fees for the guild of Saint Luke					
		All		Citizen		Non-Citizen	
		Sum	Day Wages	Sum	Day Wages	Sum	Day Wages
Bruges	1497			2p 16gr	92 days	3p 16 gr	134 days
Antwerp	1488	5 R. gld.	35.2 days				
	1535	8 guilders	49 days[114]				
	1562	25 guilders	37 days				
	1617	25 guilders	29 days				
	1649	36 guilders	42 days				
Ghent	1520	63 guilders	212 days				
	1540	6 guilders	20 days				
	1600	6 guilders	6 days				
Delft	1611			6 guild.	4.8/6.6 d.	12 guild.	9.6/13.3 d.

In the second half of the sixteenth and early seventeenth centuries, the entry fees generally rose nominally but declined in relative terms because wages rose.[115] If the wages of skilled painters rose similarly, mastership must have become more accessible. The number of masters rose spectacularly in the sixteenth and early seventeenth centuries, at least in Antwerp, and the number of long-term apprentices or journeymen may have declined proportionately.[116] A painter looking for a (temporary) workshop assistant, or an art

[113] Sources: Wilson, *Painting*, p. 135; Van der Straelen, *Jaerboek*, p. 41; Dambruyne, *Corporatieve middengroepen*, pp. 184-185, 199; Scholliers, 'Lonen te Antwerpen' (10 Brabantine groats in winter and 13.5 in summer in 1488 – we have assumed an average of 11.75 groats; 4 and 5 stuivers a day in 1535 – an average of 4.5 stuivers, 12 and 15 stuivers in 1562, an average of 13.5 stuivers), and by the same author 'Lonen te Brugge' (5 to 6 Flemish groats a day in the fifteenth century, before 1559), 'Lonen te Gent', pp. 356-357 (32 to 36 groats in the seventeenth century, we assumed an average of 34 groats, which we used for Antwerp, as wages for seventeenth-century Antwerp have not been published); Montias, *Artisans*, pp. 132 (18 to 25 stuivers a day), 350.

[114] With an average of 4.5 stuivers a day, he had to work 49.7 days because the tariff was counted in Rhenish guilders, with one Rhenish guilder as the equivalent of 28 stuivers. See the explicit reference in Van der Straelen, *Jaerboek*, p. 41. The 'Carolus guilder' became the dominant form of money used after 1521 but the 'Rhenish guilder' was also used in the sixteenth century, and was sometimes 30 stuivers to a guilder). Cf. Van Gelder, *De Nederlandse munten*, pp. 59, 268.

[115] A similar tendency was noted among carpenters in Brussels. An unskilled labourer had to work 83.5 days to pay the entry fee in 1500 but only 36 days in 1582. Coeckelberghs, 'Peiling', p. 40.

[116] 'Gegenüber dem 15. Jahrhundert war die Gesellenzahl im Reformationszeit ten-

dealer willing to engage painters, would probably have had no problem finding someone among these masters. A pool of small masters may, in the long run, have proved to be a more stable workforce than a group of apprentices or journeymen. Irregularities in the demand for art may have been less problematic because small masters probably had more economic possibilities and social capital to bridge meagre periods than journeymen, who depended almost entirely on the wages paid by their masters. Small masters could combine subcontracting with working independently (e.g. producing for lower market segments), or could diversify their means of subsistence in other ways. Research on artisans has repeatedly found that they often practised a wide range of activities. In the clothing trades, there are examples of tailors making military tents, flags and mattresses in the sixteenth and seventeenth centuries. Tailors are also recorded as running an inn, trading in butter or tobacco, being active in the market for second-hand clothing, weaving, making furniture and enrolling as soldiers at one time during their careers. In 1662, a tailor made some extra money by posting the playbills of theatrical performances in Antwerp.[117] Similar examples could be cited for other trades.

Painters in Italy and the Low Countries (as well as other countries) sometimes had a second profession. Some painted and gilded statues, decorations on doors and walls, banners and organs, for which they were sometimes paid in kind (a pair of shoes, grain, oil, wood).[118] Sixteenth-century artists working in higher market segments, such as Rosso Fiorentino, Barend van Orley, Pieter Coecke van Aelst, Hans Vredeman de Vries and Hans I Collaert, made designs for works in various media including tapestry, glass, jewellery and silverware. This diversity, at both the high and low ends of the art trades, enlarged their economic base. For poor master-artists, the guild box could be a temporary solution. It may not be a coincidence that, in 1537, the Antwerp guild of Saint Luke founded a guild box for mutual aid.[119]

It is revealing that most works produced for the 'Glorious Entry of Ernest of Austria' into Antwerp in 1595 were by master painters who probably did not employ journeymen, but rather collaborated with colleagues.[120] In the Francken family, a shift can be seen from the studio practice of the first generation (Frans I Francken and Ambrosius I Francken),

denziell rucklaufig' (Reininghaus, 'Zur Methodik', pp. 370-371).

[117] Deceulaer, *Pluriforme patronen*, pp. 59-60, 103.

[118] Campbell, 'The Art Market', p. 190; Bornstein, 'Provincial Painters', pp. 439-450; Wilson, *Painting*, pp. 143-147; D'Hondt, *Extraits des comptes, passim*.

[119] Van der Straelen, *Jaerboek*, pp. 42-47.

[120] Diels, 'Van opdracht', pp. 42-43.

who employed many apprentices who stayed for a long time, to the studio practice of the younger generation after 1600 (Frans II Francken), who employed far fewer apprentices and instead collaborated with family members and other painters.[121]

Employing fewer apprentices and journeymen reduced the fixed costs of a workshop, and the extra hand of a master-painter could still be easily found when a large assignment presented itself. The *nominal* wage of a small master may have been higher than that of a journeyman or an apprentice,[122] but as collaboration or subcontracting was more irregular or incidental, *global* wage costs were probably lower. Furthermore, as rates for masters were always negotiable, it was possible to put pressure on masters to lower their rates when their dependence on the entrepreneurs who were organising the subcontracting increased.

Subcontracting or co-operation? 'Industrial standardisation' versus personal relations and reputations

Subcontracting looms large in much recent work on the urban trades.[123] Apparently small-scale, inelastic, independent workshops were often connected to flexible networks of production through subcontracting, for example in the textile or clothing trades. Although subcontracting is a useful and interesting concept, it may be necessary to differentiate between different types of subcontracting in order to apply this concept in the art trades. We cannot simply assume that one-man businesses were nothing but cogs in a larger machine, and we cannot apply the label of 'subcontracting' to all links between small companies.

In the literature, differentiations are usually based on the nature of the entrepreneurs (merchants or large artisans), the control (*Kaufsystem* or putting-out), and the social relationship (vertical versus horizontal). For the art trades, the last element seems particularly crucial. Social historians generally agree that social relations are, to a large extent, related to the nature of the product, its markets and the production process, and here again, the mass-production thesis rears its head. If low-cost mass production dominates price-competitive markets, entrepreneurs will cut costs whenever possible, for example by using child labour or outworkers, or even delocalising

[121] Peeters, 'Marked', pp. 61-72.

[122] Although this is not necessarily so; in the building trades in Ghent, small masters were paid journeymen's rates till the middle of the sixteenth century. See Dambruyne, 'De Gentse bouwvakambachten', p. 87.

[123] See, amongst others, Lis and Soly, 'Corporatisme'; Farr, *Artisans*; Deceulaer, 'Entrepreneurs'.

production to regions with lower wages. There are certainly examples of this in the early modern period, for example in the production of lace, hosiery and certain stages of textile production, especially spinning. Large workshops were sometimes developed but entrepreneurs generally preferred either the putting-out system in which they supplied raw materials to individual workshops, or the *Kaufsystem* in which they simply bought the product at the end of the line. Labour relations were impersonal, based on a rational maximisation of profit and subject to market fluctuations.[124]

Where quality is important, as in the art trades, a different logic is likely to dominate, one in which certain stages or parts of the production are contracted out to specialists. When highly specific, scarce skills are needed, subcontractors are not interchangeable and personal relations of a more collaborative, 'horizontal' kind may be preferable.[125] Some painters, for example, always worked with the same engraver because they knew that his fine burin work contributed to their own reputation throughout Europe (e.g. the relationship between Titian and Cornelis Cort). Publishers also often preferred to work with the same engravers. Printing books with numerous illustrations required the efforts of several highly skilled engravers, the best skilled generally receiving higher wages.[126] In this sense, it is not surprising that the two daughters of the publisher Philip Galle married Adriaan Collaert and Carel de Mallery, two engravers who closely collaborated with him.[127] It is well known that intermarriage, close collaboration and residential proximity were quite common in the world of printers, engravers and, indeed, painters.

As we saw earlier, such collaborative networks also existed among painters. These obviously do not exclude hierarchical or asymmetrical social relations, but nevertheless seem different to the subcontracting or putting-out in the textile or clothing trades. Instead of a monolithic concept of 'subcontracting' it might be useful to use a continuum between subcontracting and collaboration (and between serial production and high quality work), paying attention to geographical and chronological variations.

[124] Blockmans, 'Regionale Vielfalt, pp. 52-54.

[125] When a convention of specialisation is in use, work activity, the tools and objects upon which it depends, and the products ara all strongly identified with persons – a given individual or a specific type of worker skill or production community' (Storper and Salais, *Worlds of Production*, p. 30).

[126] For example, see Veldman, *Crispijn de Passe*, pp. 1, 20, 25, 28; Van der Stock, *Printing*, pp. 88, 144-145. Wage differences are related to the level of skill by Bowen and Imhof ('Reputation', p. 173 and *passim*).

[127] For further details about the family relations of these actors, see Diels, *De familie Collaert*, pp. 140-144 and Introduction, pp. 55-57.

In this sense, it is clear that several questions remain unanswered. The practical organisation of subcontracting or co-operation is generally unclear. Were paintings moved from one workshop to another or did painters work in each other's workshops? Some authors assume the former but the concrete evidence is far from conclusive.[128] The latter solution cannot be ruled out because a constant incidence of natural light may have been preferable.[129] More importantly, who controlled what, who paid which sums to whom, and were subcontractors partly or entirely dependent on one entrepreneur?

Institutional rules influenced these relations. In the literature, various examples show that legal rules and monopolies could function as devices to control the labour market of subcontracting artisans, especially between different occupational groups, e.g. between painters and woodcarvers in fifteenth-century Brussels, and between tailors, second-hand dealers and cloakmakers in sixteenth and seventeenth-century Antwerp.[130]

In the course of the seventeenth century, a predominantly artisan-dominated type of subcontracting probably gave way to relations dominated by merchants, as art dealers increased their control over distribution.[131] The weakening of their control over the sales of their work probably diminished the social position of some painters, who became increasingly dependent on dealers. This seems to have been the case in late seventeenth-century Amsterdam and Antwerp when contemporaries spoke of painters working 'in slavery' or 'painting on the galley' and when they were paid very low rates by art dealers.[132] These examples show that markets and market control were not the products of a harmonious 'invisible hand', and were subject to changes over time. Patterns of collaboration could, indeed, shift to subcontracting; qualities, prices and products were negotiable, especially when other actors entered the scene.

[128] Van der Stighelen hypothesised that paintings were moved from one shop to another because in 1653 the art dealer Musson supplied the painter Cornelis de Bailleur with a painting of garlands of flowers that had been made by Andries Snellinck three years before. Cf. Van der Stichelen, 'De (atelier-)bedrijvigheid', p. 319. This does not prove a *systematic* moving from shop to shop. The moving of the garlands to De Bailleur may be explained as an attempt to make a more marketable product because the painting had remained unsold for three years. Van der Stighelen's hypothesis is presented as a fact by Vlieghe (*Flemish art*, p. 7).

[129] Honig (*Painting*, p. 113) mentions a studio with 12 easels in 1627.

[130] For more details, see Scholten, 'The World', p. 245; Deceulaer, 'Entrepreneurs', pp. 133-149.

[131] See, amongst others, Montias, 'Notes', pp. 129-130; Bok, 'The rise', pp. 203-206.

[132] Bok, 'The rise', p. 203; Filipczack, *Picturing Art*, pp. 128, 147.

Conclusion

During the last two decades, new concepts and approaches have stimulated research in the social and economic history of the arts. This is useful and helpful. Despite stimulating investigations of interesting questions, we have the impression that some of the new 'economic art history' has not yet entirely succeeded in transcending the methodological and theoretical limitations of neo-classical economics.[133] There is, of course, nothing wrong with using concepts from economic theory, as long as this is combined with archival research and a detailed art-historical approach. Problems do arise, however, when it transpires that some of the economic concepts embraced by art historians have since been abandoned by economists and economic historians.

We have argued that the case for mass production or labour-saving process innovations in the fifteenth and sixteenth centuries is far from clear, and that a trend towards larger workshops with many journeymen was only a partial and temporary tendency. Deconcentration, and the combined and uneven development of both large and small workshops, was probably a more important evolution. Small masters working in collaboration or in subcontracting arrangements probably became more important as workshop assistants in the course of the sixteenth and seventeenth centuries. The proletarianisation of small masters may have gone hand in hand with an evolution from more or less horizontal, intra-trade collaboration to vertical subcontracting dominated by art dealers. However, these hypotheses need further, detailed interdisciplinary research by historians and art historians.

Mainstream, neo-classical economics largely ignores variations in space, time, social status, institutional organisation and gender, which are the very building blocks of contemporary social history. Strictly focusing on 'the market' and ignoring the different types of products (seeing works of art as interchangeable commodities) may be less useful in studies about the organisation of labour. Institutional regulations, qualitative differences and the various inputs of both labour and capital all make a difference. A cultural economic history, or an economic history of cultural production, will have to deal with aspects that are not easily quantifiable, such as quality, creativity, innovation, fashion, taste, design and luxury.

Images, self-images and ideological representations of guilds, artisans and artists have shaped, and continue to shape, the conceptualisation of historians and art historians. We will, therefore, have to reflect more critically on the concepts and categories used (space, time and the definition of the

[133] See the pertinent remarks by Fontaine, 'Economies et "mondes de l'art"', pp. 57-58.

arts). On a spatial level, for example, the alleged 'unique' character of the art markets in the Dutch Republic has rightly been questioned,[134] but international comparisons remain largely absent. Relations between the Northern and Southern Netherlands, and between the Low Countries and Italy, have received some attention, but equally important contacts between the Low Countries and Germany or France are still largely *terra incognita*. In this regard, it is interesting to see that a recent study of painters' practices in early modern China has found entrepreneurs organising subcontracting, artists working in collaboration, and painters using techniques such as pouncing (based on prints) and selling their works in shops and during temple fairs.[135]

Furthermore, the strict delineation of concepts such as 'painters', 'painting', or even 'art' may be increasingly obsolete. A simple dichotomy between 'high' and 'low' art (echoing the slightly *passé* notions of an 'elite' and a 'popular' culture) will not solve the problem. Van der Stock's conceptualisation of different 'branching paths' may be an alternative, attractive, heuristic device.[136] The polymorph activities of artists and artisans, contacts between different tradesmen and artists working in a plurality of media, between 'high' and 'low' art, between painting, engraving, sculpture and the decorative arts are increasingly being studied in interdisciplinary research.[137] Recent English research has called attention to the process of 'skeuomorphism', the imitation of a form or a shape in one material in another.[138] Such an eclectic, social, cultural and institutional economic (art) history offers rich perspectives for hybrid, interdisciplinary research.

[134] Blondé, 'Art', pp. 381.

[135] Cahill, *The Painter's Practice,* pp. 26, 48, 91, 102, 109.

[136] Van der Stock, *Printing,* p 19.

[137] In the reorganisation of the Victoria and Albert Museum, design is identified as a complex and multilayered process including research, experimentation, manufacture, marketing and use. Cf. Snodin and Styles, *Design, passim.*

[138] Berg, 'From Imitation', p. 9. Wells-Cole has described in detail how inventions by Maarten de Vos, engraved by Hans and Adriaan Collaert, the Wierickx family, Crispijn de Passe and many other engravers, were used in designs for English tapestry, embroidery, sculpture, plasterwork, masonry, joinery and carving. Cf. Wells-Cole, *Art and Decoration, passim.*

ASSISTANTS IN ARTISTS' WORKSHOPS IN THE SOUTHERN NETHERLANDS (FIFTEENTH AND SIXTEENTH CENTURIES)

OVERVIEW OF THE ARCHIVE SOURCES

Natasja Peeters with the collaboration of Max Martens[1]

Introduction

During recent decades, although art historical research has enabled us to re-think the execution of luxury art objects as a collaborative enterprise involv-ing different people on the artist's ladder, there is still a need for further re-search on the guilds of Saint Luke, their various members and especially the workshop assistant. This article presents a first step in creating a coherent overview of the different normative, administrative and judicial sources, which provide information about the professional situation of workshop as-sistants and help in assessing their social and economic profile.

The participation of various artists in the workshop routine, as in the workshops of Joos van Cleve and Pieter Coecke van Aelst, has been com-mon knowledge for some time.[2] It is evident that workshops housed more than just the master and his apprentice, and a variety of sources prove that many people worked together to finish a painting, a retable or any other lux-ury item produced in Antwerp.

Some of the artists have been 'identified' with the help of technical re-search methods like IRR and X-rays. Yet, in most cases, the identity of the different 'hands' working together on a painting is impossible to establish.[3]

The institutional status of the masters is quite clear. In general, they needed citizenship (*poorterschap*) and to have undergone proper training as

[1] Max Martens has kindly consented to the use of part of his presentation during the workshop for the preparation of this article. I also thank Peter Peeters, Johan Dambruyne, Ria de Boodt and Linda Jansen for their useful comments.

[2] See the contributions by Micha Leeflang and Linda Jansen in the present volume.

[3] Campbell, 'The Early Netherlandish painters'. For recent research on the separa-tion of hands, see Tamis, 'The Genesis'.

prescribed by the guild rules. They also had to pay their entry fee, perform guild duties and be prepared to have their wares tested and controlled. In some cases a master's test was enforced but there is not much evidence that this applied to Antwerp painters.[4] In exchange for their status, they had the right to produce and sell their work, to keep shop, and to receive official commissions. Indeed, most of the evidence on the execution of works of art concerns the masters, whether working alone or together. Sosson calls this last arrangement '*ateliers dispersés mais reliés entre eux*'.[5]

On the other side of the professional spectrum were the apprentices, whose status has been the subject of recent studies.[6] The rights and obligations of apprentices are generally quite clearly codified in the guild rules.[7] Apprentices usually paid masters for their training. Their share in helping the masters must have been rather limited at the beginning of the four-year training period, but increased as the pupil gained experience.

In comparison to free masters and apprentices, artists' assistants (*gezellen, knechten, compagnons* or journeymen) have been little studied from an art historical archival point of view and remain a grey group. Their professional status is far less codified in normative documents, regulations and rules. This article proposes to study some relevant art historical archival data in order to define this group more precisely by analysing issues such as social mobility, vulnerability, migration, institutional regulation and career development of journeymen in the art historical context of fifteenth and sixteenth-century Netherlandish painting.[8] It is the position and career development of this ill-defined group that we aim to chart on the basis of archive material. Besides regulations and other guild-related documents, such as requests, a variety of administrative and judicial documents, including contracts, inventories and court verdicts, can help in assessing the situation of journeymen. Lastly, we look at *sous-traitance* or subcontracting.[9]

[4] There is one article concerning clavichord makers in 1557, which states that unfree persons and those who cannot prove they have passed a master's test (*proeveloose vremdelingen*) are not allowed to make clavichords, see Van der Straelen, *Jaerboek*, p. 49, art. ix.

[5] Sosson, 'La production artistique', pp. 688 and 692.

[6] De Munck and Dendooven (*Al doende leert men*) discuss this issue.

[7] Martens and Peeters, 'Artists by numbers'.

[8] These aspects were studied in the project: 'Painting in Antwerp before iconoclasm (c. 1480-1566): A socio-economic Approach' (2000-2003) sub-project 'Ownership of paintings in sixteenth century Antwerp', which was directed by M. Faries and M.P.J. Martens, and sponsored by the Netherlands Organisation for Scientific Research and the University of Groningen.

[9] Sosson, 'La production artistique', pp. 689-692.

Workshop assistants in archive sources: overview of the fifteenth and sixteenth centuries

Number of journeymen and terminology

There is no mention anywhere of the number of journeymen that masters were allowed to hire at any time within the guild of Saint Luke, nor are there any references to the actual numbers working at any time.[10] The official membership lists of the masters and apprentices of Antwerp, the *Liggeren*, were started in 1453 and are the most complete series of inscriptions available for artists' guilds in the Southern Netherlands.[11] However, the entries only concern masters and apprentices. Previous research for Antwerp has shown that 80.7 per cent of apprentices never attained the status of master.[12] A number of them, probably around 30 per cent, must have died, while others dropped out or migrated. Despite this, the number of apprentices who remained active in their trade (as journeymen) after the four-year training period must have been substantial, possibly up to a maximum of 50 per cent of those who had been inscribed as an apprentice.

In 1561, the guild – not for the first time – requested the city authorities to intervene when the annual income was not enough to fulfil the guild's religious duties, pay for festivities, or relieve the needs of poor and ill members, who were referred to as 'large in number'.[13] Although it is not clear whether this also refers to the guild's journeymen, the 1561 complaint points to the far from rosy professional and financial situation of an unspecified number of members of the guild of Saint Luke. The poor box, founded in 1538,[14] to which masters and their wives and widows contributed, seems not to have provided enough relief, as the situation was apparently still precarious some decades later.

The Antwerp coffer makers, who belonged to the Saint Luke's guild, complained in 1575 about the large number of journeymen, who were apparently spoiling the trade.[15] Although it is not mentioned how many journeymen were working under illegal circumstances, it is clear that they were

[10] In other guilds, there are articles restricting the number of journeymen, e.g. in 1481, a master cloth shearer could have three journeymen. Cf. Des Marez, 'L'Organisation du travail', p. 64.

[11] For specifics on the codicology, see Van de Velde, C., 'The Grotesque initials'.

[12] Martens and Peeters, 'Masters and Servants'.

[13] Van der Straelen, *Jaerboek*, p. 56.

[14] Antwerp, Archive of the Royal Academy of Arts (A.K.A.S.K.A.), Oud archief 243 (4) *Bussenboek der Sint-Lucasgilde inschrijvingsboek van de broederschap van de Armenbus*, 1538-1627 (not published).

[15] Van der Straelen, *Jaerboek*, p. 60ff.

perceived as a threat by the guild board.

In 1558, Philip II introduced a bylaw enforcing the registration of all those involved in book publication, including servants and apprentices. We may assume that some sort of registration of assistants existed, whether through the money paid into the poor relief box, or in their administration. Although the board of the guild stipulated, for example in the Mechelen regulations, that assistants be registered by their masters, the latter do not seem to have been very conscientious in doing this.[16] Yet, it is only the Mechelen regulations that explicitly prescribe such registration and, while so-called 'journeymen books' exist, or have been preserved, they only relate to some of the guilds.[17] That the absence of registration poses problems for assessing the situation is demonstrated by the illustrious case of Frans Floris's workshop, active from c. 1540 to 1570. The sixteenth-century art historian Carel van Mander mentions that 120 assistants were active in this workshop, while only one (real) apprentice, Hans de Mayer, was inscribed in the *Liggeren* throughout these years.[18] Although the precise division of labour is a matter for further research, Carl van de Velde has shown that the painters in Floris's workshop were, for the most part, trained assistants.

The terms *ghesellen, knaepen, werckknechten* or *varlets*[19] are interesting. There seems to have been a difference between a *knaep* and a *werckknecht*, although there is no further specification in the regulations and we can only speculate as to the possible division of tasks.[20] In Antwerp, the terms *knecht* and *gheselle* appear in early documents. The earliest Antwerp regulations, dated 1382, point out that any journeyman could be hired to work for a master *(in cnaepscepen)*.[21] The term *disciple* is used by Van Mander for Floris's assistants, but as Miedema has shown, the art biographer did not use it consistently and it can thus also refer to apprentices.[22]

[16] Van der Stock, 'De organisatie', p. 48.

[17] There are some exceptions, e.g. the tapestry weavers of Brussels in the fifteenth century, where journeymen figure in the '*Groot Ambacht*'. See Cuvelier, 'De tapijt-wevers van Brussel', p. 375. The following article treats the representation of journeymen in the boards of medieval trades. This does not apply to the guild of Saint Luke, however, for which nothing can be deduced from the existing regulations. See Van Werveke, 'De medezeggenschap van de knapen (gezellen)'.

[18] Peeters, *Tussen continuiteit en vernieuwing*, vol. 1, pp. 59-60; Van de Velde, *Frans Floris*, p. 441.

[19] For this last term, see especially the interesting article by Charron, 'Les peintres', pp. 724 and 735. The word *varlet* is not used in Antwerp or Mechelen.

[20] Van der Straelen, *Jaerboek*, pp. 60 and 64. See the introduction to the present volume.

[21] Van der Straelen, *Jaerboek*, pp. 2-3.

[22] See also Miedema ('Over vakonderwijs aan Kunstschilders', p. 270) on the problematic interpretation of the terminology referring to trained journeymen, disciples

Hiring journeymen[23]

The most interesting historical sources that shed light on the social and pro-
fessional status and working conditions of servants in artists' studios are
undoubtedly the regulations of the artists' guilds. Most of the regulations of
the guild of Saint Luke date from the fourteenth century onwards: Brussels
(1306), Ghent (before 1339), Bruges (1358) and Tournai (1364). They are
important written sources that yield invaluable information on the social
and professional status and working conditions of all the officially inscribed
members and, in some cases, also of workshop assistants.

First of all, there are rules on hiring workshop personnel and on sub-
contracting. The regulations of the Antwerp guild of Saint Luke of 1434
state that journeymen, either from the town or foreign, were allowed to
serve a free master.[24] The phrase 'working as a journeyman' (*in knaepscap
wercken*) is explicitly used in these regulations, although the practice must
have been known from much earlier on.[25] The Antwerp regulations of 1382
point out that any journeyman could be hired to work for a master (*in cna-
epscepen*), either by day or by contract.[26] From 1434 onwards, servants had
to pay 6 denieren Brabant groats (or 4 denieren Flemish groats) candle
money (*kaarsgeld*) per year if they worked in Antwerp for a period longer
than two weeks.[27] In 1470 the candle money was raised to 9 denieren Bra-
bant groats (or 6 denieren Flemish groats).[28] Possibly as a result of abuses
and irregularities in the payments of this contribution, in 1534 the guild au-
thorities stated that free masters had to oversee and pay the candle money
for their servants directly, and the amount was then raised to 5 stuivers (or
10 denieren Flemish groats).[29] These and other fees were badly needed for
the guild treasury and the board could not afford to be negligent in collect-
ing them.

In Mechelen, the 1564 guild regulations state that the master had to reg-
ister any assistant working in his workshop with the guild council within 14
days, or pay a penalty of 2 Carolus guilders (or 80 denieren Flemish

and apprentices by Carel van Mander.

[23] For convenience, every currency has been converted into denieren Flemish groats.
I thank Johan Dambruyne for his advice on these conversion rates. See Dambruyne,
Corporatieve middengroepen, p. vii.

[24] Van der Straelen, *Jaerboek*, p. 4ff.

[25] *Ibidem*, p. 4. See also the introduction to the present volume.

[26] Van der Straelen, pp. 2-3.

[27] *Ibidem*, pp. 4-5.

[28] *Ibidem*, pp. 12-18, p. 13, art. ii.

[29] *Ibidem*, pp. 39-42, art. iv.

groats).[30] The regulations also distinguish between male and female servants (*cnapen ende maerten*) with an annual fee of 4 stuivers for men and 2 stuivers for women (or 8 and 4 denieren Flemish groats respectively); their master acted as a guarantor.[31]

In Bruges, servants had to pay an annual contribution to the guild if they worked in the city for more than two weeks. In 1479, this fee was set at 8 denieren Flemish groats for servants who had completed their apprenticeship in Bruges, and at 12 denieren Flemish groats for immigrants.[32] Servants of the Duke of Flanders were explicitly exempted.

The regulations of Tournai, dated 1480, made a distinction between servants of painters and glass-makers, and the *serviteurs ou serviteresses* who worked for illuminators, glass painters, painters of playing cards and painters of *papier de tenture*. The first group had to pay 5 shillings tournois guilders (or 8 denieren Flemish groats) after having lived in the city for longer than a month,[33] while the second group only had to pay an annual fee of 2 shillings 4 denieren tournois guilders (or 3.7 denieren Flemish groats).[34] After one month free masters had to report their servants to the guild authorities.

In all the cities mentioned here, the entry contributions of the journeymen seem to have been rather modest.[35] In most cases, the master probably deducted the fees for the candle money from the wages of the journeyman (see below).

In one instance, a substantial amount of data on journeymen has been preserved. The printing office or *Oficina* of Christopher Plantin is an example of a unique enterprise where a number of documents of the 1560s laid down the rules for journeymen-printers and other servants.[36] Some of the regulations resulted from the large size of the workshop where some forty servants are known to have worked together. The working conditions, the professional organization and especially the social facilities for the servants in Plantin's workshop shed light on the daily working of the enterprise. Plantin's servants also had their own social welfare box (*Armenbus*), to which they contributed. Members of the workshop who fell ill were assisted by this fund, and foreign servants in need could apply for assistance.[37] A number of rules about keeping tools clean and putting them where they belonged, rules

[30] Monballieu, 'Documenten (I)', p. 97, art. xv.

[31] *Ibidem*, pp. 97-98, art. 16.

[32] Van de Casteele, 'Documents divers', pp. 34-35.

[33] Goovaerts, 'Les ordonnances données en 1480', p. 126, art. 19.

[34] *Ibidem*, p. 140, art. 42.

[35] Further research will examine the comparisons between entry fees in the guilds.

[36] Sabbe, 'De Plantijnsche werkstede'.

[37] *Ibidem*, pp. 611-613.

with respect to fire prevention, and general rules on politeness, work ethic and hygiene were clearly formalized into regulations to facilitate the working arrangements of a large group of people. Undoubtedly, variations on such regulations and 'house rules' must have existed in many workshops where different people worked (and often lived) together.

Assessment period

Judging from the documents mentioned above, many servants, journeymen and assistants were available for hire to any enterprising master. Hiring journeymen seems to have been a common practice, but how was one to judge their worth as members of the workshop? Every city imposed an assessment period before any contribution was due. This was generally two weeks, though in Tournai it was one month. The assessment period allowed the master to appraise the talent and skills of the potential worker, and it also allowed the 'wandering' servant to skip places quickly without paying any dues.

In Antwerp's 1434 regulations, fourteen days elapse before any candle money has to be paid, and the same period is repeated in the regulations of 1442.[38] Regulations about the period after which assistants had to be registered in Mechelen, Bruges and Tournai, and the associated fines for failing to do so, have been mentioned above. In Brussels, foreigners could work for 13 days before having to pay a contribution of 5 stuivers (or 10 denieren Flemish groats).[39]

The Tournai Saint Luke's guild regulations explicitly stipulated that foreign journeymen had to show evidence of their skills and of the completion of a training period. Elsewhere, only masters applying for a title were subjected to such a regulation. As far as we know, no journeyman's test was applied in artists' guilds in the Southern Netherlands except in Tournai.[40]

A servant was usually not allowed to leave before the end of his contract. This was an important restriction. Servants skipping between two different masters, and masters stealing each other's journeymen were both restrained by this measure. Only when a servant had completed all his engagements towards his master was he free to leave or be hired by another master. In Antwerp, hiring a servant who had not fulfilled all his obligations to a former employer provoked a fine of 2 Rhenish guilders (or 80 denieren

[38] Van der Straelen, *Jaerboek*, pp 4. and 8, art. v.

[39] Goovaerts, 'Les ordonnances données en 1480', p. 126, note 1.

[40] *Ibidem*, p. 126, art. 19.

Flemish groats) to be paid by the master, with the servant having to contribute another Rhenish guilder (or 40 denieren Flemish groats).[41]

It is also interesting to note an exceptional paragraph in the Mechelen regulations,[42] which stipulates that if a free master accepts an apprentice, the master passes a professional 'frontier', as he is then no longer allowed to work in the position of a servant for another master for daily wages.[43]

An interesting regulation concerns Plantin's enterprise in 1558. Journeymen who stayed longer than one week needed to pay 8 stuivers (or 16 denieren Flemish groats) for *willecom* (welcome) drinking money for the other journeymen and 2 stuivers (or 4 denieren Flemish groats) into the poor relief box, according to the Plantin regulations.[44] After one month, the amount was raised to 30 stuivers (or 60 denieren Flemish groats) for the poor relief box and 5 stuivers (or 10 denieren Flemish groats) to each servant in the *Oficina*.[45]

Resigning of journeymen

A servant was usually not allowed to leave before the end of his contract but if this was the case, there were regulations about giving notice. From 1586 onwards, Antwerp servant-embroiderers (*vrij gesellen*) had to give notice eight days in advance of leaving.[46] Whether this also applied to painters is not known. In Plantin's *Oficina*, servants were expected to announce their resignation two weeks in advance, and the master could only fire a servant by giving him two weeks notice, unless there had been disobedience or misbehaviour.[47]

The Bruges guild of image-makers grouped panel painters, cloth painters, mirror makers and saddlers together. Free masters amongst them were only allowed to hire servants within their own speciality, although the masters themselves were permitted to make objects of the affiliated trades if they were able to do so.[48] This was the result of long-lasting conflicts between the different specialities within the corporation, such as the disputes between the painters and the mirror makers about who was allowed to paint

[41] Van der Straelen, *Jaerboek*, pp. 6-11, art xv.

[42] I thank Johan Dambruyne for pointing out that this measure is exceptional. See the introduction to the present volume.

[43] Monballieu, 'Documenten' (I), p. 96, art. 9. See also the introduction to the present volume.

[44] Sabbe, 'De Plantijnsche werkstede', doc. A, art. iv.

[45] *Ibidem*, doc. A, art. v.

[46] Van der Straelen, *Jaerboek*, pp. 66-70, art. iv.

[47] Sabbe, 'De Plantijnsche werkstede', p. 619.

[48] Van de Casteele, 'Documents divers', p. 22, art. xx.

on mirrors. In other cities, hiring servants from other corporations for specialized work, such as a joiner hiring servant sculptors, was also regulated.[49]

Working conditions of journeymen

Different types of documents provide information about the working conditions of artists' journeymen: workplace, working hours and other practical matters. As stated elsewhere in this volume, it is difficult to cull information from iconographical sources.[50] The sixteenth-century regulations of both the Mechelen painters and the Antwerp embroiderers stipulate that servants were allowed to work only on the premises of their masters, either in their house or workshop.[51] In Tournai, servants were required to work 24 days a month.[52] The working hours were set between 6 o'clock in the morning and 8 o'clock in the evening, with an hour, or an hour and a half, for lunch break.[53] During winter, painters were allowed to work by candlelight. Rules were frequently adapted and changed according to the guild or trade. For example, the Bruges stone-cutters were *not* allowed to work by candlelight.[54] However, painters must frequently have been hampered by the absence of natural light and they probably executed other work, such as drawing, during the darker months. In Mechelen, they were only allowed to work inside the studio (*binnenskamers*).[55]

In a regulation of 1642, the servants of Plantin's press were allowed to have breakfast between 8 and 9 in the morning, and had an afternoon break between 4 and 5 o'clock.[56] They were also permitted to drink as much light beer as they wanted, with regular beer restricted to one pint before noon and one in the afternoon.[57] However, drinks were allowed on many festive occasions in the guild calendar. Other alcoholic beverages like wine and brandy were forbidden at work, and drunk people were certainly not allowed in the *Oficina*. Vomiting was sanctioned with a fine of 3 stuivers (or 6 denieren Flemish groats) and, during the seventeenth century, the fine for smoking tobacco at the Plantin press was double that amount.[58]

[49] Van der Straelen, *Jaerboek*, p. 10, art. xviii.
[50] See the contribution by Natasja Peeters in this present volume.
[51] Monballieu, 'Documenten' (I), p. 99, art. 24; Van der Straelen, *Jaerboek*, p. 68, art. v.
[52] Goovaerts, 'Les ordonnances données en 1480', p. 126, art. 19.
[53] Van der Straelen, *Jaerboek*, pp. 66-70, art. vi.
[54] Parmentier, *Documenten*, pp. ix-xxx, esp. p. xvi.
[55] Monballieu, 'Documenten' (I), p. 99, art. 24.
[56] Sabbe, 'De Plantijnsche werkstede', p. 619.
[57] *Ibidem*, pp. 622-623.
[58] *Ibidem*, p. 627.

Like apprentices, journeymen probably usually received board at their master's house, as is clear from a notary act dated 7 January 1576.[59] In this document, the painters Frans I Francken and Frans Pourbus reminisce about the year 1565 when they were working as journeymen in Floris's workshop and both living there as well.

Sosson has dealt with the fluid and flexible working environment of artists in the fifteenth century. The '*association momentanée*',[60] as he calls it, fits well with the atmosphere of competitive production, sharp prices and high quality work. These temporary labour associations, together with the phenomenon of subcontracting, stimulated the hiring of journeymen. Indeed, the classic image of the 'wandering journeyman' springs to mind. For some assistants, such as the sixteenth-century glass-painter David Joris, this must have been the case. He learned the trade in Delft, worked in Antwerp for several masters, left for Valenciennes, Lille and Calais, embarked for Hampshire, then London, and finally returned to the Netherlands.[61]

Escaping the regulations

The executive boards of the guilds tried to ensure that no-one from within their jurisdiction worked in his own name without being enrolled as a free master. Working and selling illegally and below the price was forbidden. The right to sign paintings and other art objects and to be an independent 'entrepreneur' was one of the pillars of the corporative world. Offenders could expect to pay a substantial fine for working illegally. In 1442 the Antwerp guild of Saint Luke set a fine of 1 Rhenish guilder (or 40 denieren Flemish groats) for foreigners who refused to register within six weeks of their arrival in the city.[62] This gave them ample time to inscribe themselves in the guild and register as a proper citizen (*poorter*). For an active master, this sum was reasonable. Servants who worked on their own account or for someone other than their master could be fined 5 shillings parisis (or 5 denieren Flemish groats) in Bruges, and 10 shillings tournois (or 16 denieren Flemish groats) in Tournai.[63] In Mechelen, in 1564, fines for working illegally were set at 4 Carolus guilders (or 160 denieren Flemish groats),

[59] Stadsarchief Antwerpen (hereafter referred to as S.A.A.) Notaris D. Van den Bossche, N3638, fol. 2ᵛ. Published by Van de Velde, *Frans Floris*, pp. 331-333, and pp. 472-73, doc. 78. See also Van de Velde, 'Frans Pourbus the Elder', p. 11. See Peeters, *Tussen continuiteit en vernieuwing*, p. 67.

[60] Sosson, 'La production artistique', pp. 688-689.

[61] Boon, 'De glasschilder David Joris'.

[62] Van der Straelen, *Jaerboek*, pp. 6-11, art. xiii (esp. pp. 9-10).

[63] Van de Casteele, 'Documents divers', p. 21, art. xiiii; Goovaerts, 'Les ordonnances', pp. 126 and 133, art. 19 and 29.

whether the journeyman worked alone or for his own profit in his master's workshop.[64] Illegally selling paintings or sculpture was also punished. Someone who was not a registered free master in Mechelen, when caught for illegal sales, could be fined 3 Carolus guilders (or 120 denieren Flemish groats).

Court verdicts are highly informative, as is clearly illustrated by a verdict of the Ghent aldermen of the *Keure* in 1441.[65] Segher de Pape, dean of the Ghent tapestry weavers, accused Jan de Sutter and Gillis de Heect, both servants in his corporation, of having made, ordered and sold tapestries in Deinze, without submitting their goods to any quality control. De Pape also claimed that they had infringed the ban on competition within the five-mile radius of the city of Ghent. The defendants Jan de Sutter and Gillis de Heect stated that Deinze belonged to the jurisdiction of Courtrai, which was not subject to the Ghent corporations. The aldermen had no choice other than to let the defendants off the hook. The servants could have added to their defence that, unlike weavers and some other textile-related corporations, the Ghent tapestry weavers were not protected by a five-mile privilege.[66]

In another case, the Bruges aldermen, on 19 March 1472, resolved a conflict between the corporation of the image-makers on the one hand, and the court painter Pierre Coustain and his servant, Jan de Hervy, on the other.[67] The plaintiffs accused De Hervy of having worked within the city walls for people other than courtiers. Because of his status as court painter, Pierre Coustain and his servants were allowed to work in Bruges for the duke, aristocrats at the court and all other courtiers without violating the rights of the Bruges guild. However, Jan de Hervy, who worked at different locations for people outside the court, was forced to become a free master of the Bruges guild.

Another famous case, a dispute between Gerard David and his servant, Ambrosius Benson, gives us an insight into the relationship between masters and their servants.[68] On 11 February 1519, Benson took the matter before the court of law. He asked for the return of two chests belonging to him, which contained many drawings and models for paintings and miniatures. Gerard David had apparently stored these trunks. When Benson left David's employment, he had given David the keys so he could open the

[64] Monballieu, 'Documenten' (I), p. 99, art. 23, 25 and 26.

[65] Martens, 'Architectuur en beeldende kunsten', p. 450.

[66] Espinas and Pirenne, *Recueil*, p. 413; Dambruyne *Corporatieve middengroepen*, p. 26, note 7.

[67] Ainsworth and Martens, *Petrus Christus*, pp. 19, 22 (note 52), pp. 207-208 (doc. 21).

[68] Van Miegroet, *Gerard David*, pp. 344-345, doc. 44 and 45; Ainsworth, *Gerard David*, pp. 7-8.

chests to check if there was anything in them that belonged to him. David had indeed – or so he claimed in his defence – found designs in the chests that had belonged to him but which he had believed lost. David did not dispute the other possessions Benson had left at his house and workshop, which included a small model book containing studies of heads and nudes, a *Virgin and Child* Benson had painted for his father, a small *Lamentation,* a *Magdalen* for which the underpainting had already been executed, and a pigment-box. In the document, Benson also demanded the return of patterns which he had lent to Adriaen Isenbrant and which David had collected behind Benson's back, as well as other patterns which Albrecht Cornelis had borrowed from Benson. It is not until we reach the court's verdict of 28 January 1520, which sentenced David to imprisonment in connection with the affair, that we find out why he had held onto the two chests and the other items. Benson owed him 7 pounds Flemish groats (or 1,680 denieren Flemish groats) and had agreed to repay the debt by working in David's workshop three days a week, a deal which fell through when Benson left after 20 days.[69]

The fact that Ambrosius Benson owned a model book, workshop drawings and painting materials is not surprising. He may have owned these since his apprenticeship. However, evidence that he also owned finished and unfinished paintings possibly shows that he worked for his own profit, which was strictly prohibited in Bruges. Moreover, information that he had lent model drawings to Isenbrant and Cornelis implies that he maintained professional contact with other free masters besides David, which was also an infringement of the guild's regulations.

In 1562, the Mechelen guild of Saint Luke addressed a request to the aldermen. They complained that capable assistants were lured away from their masters by the meddling of art dealers, who advanced the assistants part of the entrance fee to become free masters.[70] They thus spoiled the trade. The free masters feared competition from these new masters who were free and independent and had – according to the writers of the document – no family or other obligations. The masters of the Mechelen guild of Saint Luke asked the aldermen to change the policies of payment of the entry money in order to make quick entry of new masters more difficult.[71]

In the 1570s, the Antwerp coffer makers, who were part of the Saint Luke's guild, also complained about problems with journeymen in their trade.[72] A large number of them were said to spoil the trade by making cof-

[69] Martens, Exh. cat.: *Bruges and the Renaissance*, p. 59.
[70] Monballieu, 'Documenten' (II), p. 75.
[71] *Ibidem*, pp. 71-82, esp. p. 77.
[72] Van der Straelen, *Jaerboek*, p. 60ff.

fers in public as well as in secret for their own profit, using poor quality materials and selling them at a lower price. They thus attributed to these journeymen all the infractions one could possibly make, probably in order to protect themselves.

Wages of journeymen

One aspect that distinguished journeymen from apprentices, besides the evident completion of a basic training, was that they worked for wages.[73] The Brussels regulations contain information on the flexibility of hiring journeymen, who could be hired for a day, a month or much longer.[74] The Antwerp regulations of 1382 state that a journeyman could be hired for pay or work in the service of a master for payment either by day or by contract.[75]

As they were not allowed to sell their work or any other object in public, the journeymen's income was restricted to their daily wages.[76] The guild regulations do not inform us about these wages and very few administrative documents, such as contracts, have survived to shed light on artists' journeymen's earnings.[77] These suggest that journeymen were paid like skilled workers in other trades.[78] In some cases, the wages were probably rather flexible. It is entirely plausible that the price paid varied according to the specifics of the work for which a journeyman was hired. Grinding paint, preparing panels and painting compositions after the master are quite different matters, involving different levels of experience and talent. Recent research may corroborate this.[79]

Painters involved in decorative work during the rebuilding of the Palace of the Bruges Franc between 1435 and 1440 seem to have been paid at the standard rate of 12 denieren Flemish groats per day for masters. The assistants were paid half that amount.[80]

[73] The Lille regulations explain that a varlet of the painters' and glaziers' guild in 1510 could be working for a fee, but this was not necessarily so, see Charron, 'Les peintres, peintres verriers', p. 735, art. 3: '... *tous varletz des maistres lesditz mestiers, gaignans sallaires ou non ...*'.

[74] Des Marez, 'L'Organisation du travail', p. 61.

[75] Van der Stock, 'De organisatie', p. 47.

[76] Monballieu, 'Documenten' (II), p. 99, art. 25 and 26.

[77] For fifteenth-century Ghent, Els Cornelis has gathered interesting information in this respect, see Cornelis, 'De Kunstenaar in het laat-Middeleeuwse Gent', pp. 96-97.

[78] Martens, 'The Position of the Artist', passim.

[79] Tamis, 'The Genesis'.

[80] Martens, 'The Position of the Artist', p. 401.

In 1454, dozens of artists and artisans, among whom were 39 painters, were called to Lille to collaborate in the decorations for the famous *Banquet du Faisan*. The payments have been recorded in the *Recette générale* of the Chamber of Accounts.[81] The painters in this project were divided into seven categories. Two of these were for journeymen (*varlets*), who were paid daily wages of 6 and 4 stuivers (12 and 8 denieren Flemish groats respectively). There were as many servants as free masters working on the project, but the servants executed 6 per cent more work than the masters and were paid about only half of what the latter received.[82]

A rare document that mentions both daily wages and the working hours of a servant painter dates from 1544. In that year Jean de Chesne, an Antwerp journeyman painter and playing card maker, drew up a contract with Jean Maillaert, from whom he had borrowed 7 Carolus guilders (or 280 denieren Flemish groats).[83] He could pay off his debt by working for Maillaert from 6 a.m. until 8 p.m., for a wage of 3 stuivers per day (or 6 denieren Flemish groats). This is the same as the amount earned by skilled construction workers in the fifteenth century, which had not changed. Of course, it is difficult to interpret the specific results of the document for both parties. On the face of it, of these earnings, Maillaert was allowed to keep 6 stuivers (or 12 denieren Flemish groats) a week until the debt had been cleared, which happened after 23 weeks. Thus, a large portion of De Chesne's wages was not paid, and De Chesne himself was left with a pittance.

Other administrative sources for estimating the social and economic position of artists' servants are inventories. For example, there is an inventory, dated 26 September 1566, of two trunks belonging to Jan de Momper, a member of a large and famous family of artists.[84] These trunks contained four paintings on canvas, frames, the wooden boards of a bed, a bellows, a box and a few plates. Another inventory, of Nicasius de Beste, was compiled in the same year.[85] Most of his furniture was old and worn, and he owned some cheap basic kitchen utensils. His professional tools were so poor that the clerk wrote that they were a pile of worthless painters' tools (*enen hoop prundelingen van schildersgereetschap*). Judging on the basis of another inventory from 1567, the servant painter Hans Recht was better

[81] De Laborde, *Les Ducs de Bourgogne*, pp. 422-425, nos. 1533-54, 1570-71.

[82] Martens, 'The Position of the Artist', p. 404ff. Like the free masters, most servants were paid much more in this courtly feast than they normally earned when they participated in public civic projects. It is, however, possible that the daily wages included travel expenses and a *per diem* for meals.

[83] S.A.A., Notaris 's Hertoghen, N 2072, fols. 28-28ᵛ, 17 March 1544 (not published).

[84] S.A.A., Vierschaar, V 258, fol. 51 (not published).

[85] *Ibidem*, fol. 48ᵛ (not published).

equipped.[86] He owned Parisian benches, a table, carpets, a bedstead, tin u-
tensils, a pistol and a halberd (*hellebaard*), some tools, and even a supply of
wine. It needs to be stressed here that no paintings or other works of art
were found in the two latter inventories. The scarce information on the ma-
terial possessions of these three servant painters indicates at least that their
individual prosperity varied. Family relations probably played an important
role in helping artists survive. Thus De Momper, unlike the other two, could
probably expect support from his artist relatives. These examples also show
that the socioeconomic profile of artists' servants seems to have been di-
verse, ranging from near poverty to a rather comfortable standard of living.

Tentative conclusions

It remains difficult to make any general statements on the role and status of
journeymen within the guild of Saint Luke and the sub-trades it comprised.
Yet, some tentative conclusions can be made concerning their numbers, role
and status.

More than 80 per cent of the apprentices who were inscribed in the
Antwerp *Liggeren* between 1453 and 1579 never acquired a master's title.
After subtracting those who died (mortality was estimated at some 30 per
cent), left the area or dropped out, presumably a certain number remained
locked within the position as a journeyman. It is difficult to measure the
group of journeymen who never acquired the master's title. Of the remain-
ing 50 per cent who never made it, their number could amount to three
quarters just as well as one quarter. Large scale prosopographical research
could possibly shed light on this issue. For those who eventually acquired
the master's title, the interval between apprenticeship and mastership was
between 5 and 15 years, during which time they presumably worked as
journeymen. These were the ones making the 'leap' to the other side, i.e.
mastership.

Due to the lack of (complete) inscription records, like the Antwerp *Lig-
geren*, no statistical research on membership of artists' guilds has been done
for other cities, although information does exist for Ghent. Sixteenth-
century Antwerp was an exceptionally productive town where art objects
were concerned, which makes comparisons difficult. Yet evidence in the
guild regulations of towns such as Bruges, Mechelen and others in the Low
Countries tentatively suggests that the journeyman was a common feature
of at least some artists' workshops. Some trained artists probably stayed in
the workshop as journeymen for many years after their apprenticeship. The
journeyman-artist could be relied upon to work efficiently. He was also

[86] *Ibidem*, V 259, fol. 18ᵛ (not published).

cheaper than a master. The painting process involved many different tasks such as grinding paint, preparing panels, painting (parts of) compositions after the master's inventions, making copies, and so on, but it remains difficult to judge how the work was divided in the workshop, although material and technical research can provide some answers in this respect, as is shown elsewhere in this volume.[87]

The master only had to register a journeyman after a fortnight, which means there was no financial obligation if the work was of a very temporary nature, such as one or several days. This implies that some journeymen might have been hired repeatedly for a specific commission that took a limited amount of time while they went round the same workshops over again. They could be hired at short notice whenever a commission came in, thus evading the dues for the guild. It could also mean that tasks were selected according to the level of training and technical and intellectual talent of the journeyman, although this remains a hypothesis and more research is necessary.

Various types of documents, such as guild regulations, contracts, inventories and court verdicts, shed light on the flexible but precarious position of these assistants. They were evidently not free and only allowed to work inside the studio (*binnenskamers*). Thus the journeyman may have had the frustration of not being able to work independently. However, what could be a drawback could also be turned into an asset.

Although there are many instances of independent masters working together, we can assume that a good and loyal journeyman would certainly be valuable, especially in a successful workshop. He had mastered the same training level, but had the additional advantage of not being as expensive as a master. The journeyman, for his part, did not need to run the risk of investing in a workshop, buying materials and selling the paintings, along with all the other difficulties and financial problems this responsibility could entail. The small scale of most workshops in sixteenth-century Antwerp doubtless implies that many artists, besides working with their fellow masters, made use of these workers on a temporary basis. In boom times, it was an arrangement that suited both parties.

As the historian Herman van der Wee stated:

> precisely during such periods [of boom] it was particularly possible for the less able to take a dependent status as wage earner (*knaepscap*). Although they lacked commercial profits, they had a stable daily wage and were freed of responsibility and worries.[88]

[87] See the papers by Micha Leeflang and Linda Jansen in this volume.
[88] Van der Wee, *The Growth of the Antwerp market*, p. 195.

The scarce information on the material possessions of the three servant painters mentioned above indicates that their individual prosperity varied. Although personal wealth accumulates for many reasons and family networks play a role, the evidence seems to suggest that not all journeymen were poor.

Furthermore, one needs to be sensitive about the difference between norm (guild regulations, ...), rhetoric and everyday practice.

This paper has tried to shed light on various aspects of the working and living conditions of the artist's journeyman. Due to the lack of clear regulations and registration, the evidence remains patchy and vague. The same holds true for the identities of the majority of those who assisted master painters in the production of high quality art objects for which the Low Countries were famous. Most are simply a name in a document, but some did manage to escape anonymity and climb the ladder of fame. Indeed, although many journeymen who assisted painters such as Frans Floris in his famous Antwerp workshop remain unknown, others like Frans Pourbus and the Francken brothers embarked on prestigious careers.

PAINTERS' WORKSHOPS AND ASSISTANTS IN NETHERLANDISH IMAGERY

(MID-FIFTEENTH TO EARLY SEVENTEENTH CENTURY)

Natasja Peeters

Painters' portraits and self-portraits are among the most attractive and lively images that have come down to us. Their appeal is immediate and personal. Painters with their palettes, or as gentlemen in beautiful garments stare down at us, such as Otto van Veen, Frans I Francken, Peter Paul Rubens, Antony Van Dijck and many others. Miniaturists, painters and engravers were also painted at work in their studios, sometimes in the guise of religious or mythological figures, for instance in *Saint Luke painting the Madonna, Zeuxis painting Helen of Troy,*[1] or *Apelles painting Campaspe* or *Pictura.*[2] They form a distinct and rich iconographical category, the source of which is found in ancient literature: apocryphal texts of the saints, the *Legenda Aurea* and various passages taken from the classics. During the fifteenth and sixteenth centuries, religious scenes, and to a lesser extent allegorical scenes, dominated the category, while 'genre' images were rare. However, in the seventeenth century the latter became popular and were to remain so.[3]

This paper focuses on the workshop routine of the artists and especially on the activities of workshop assistants. It investigates what the images of workshops tell us about working methods, division of labour and the actual production process of paintings. These images have already been studied from the 'technical' point of view (the presence of palettes, easels, brushes,

[1] A miniature from the manuscript *Rhétorique de Cicéron* (c. 1500) (University Library Ghent), Ms 10 fol. 69ᵛ, depicts a workshop with Zeuxis painting Helen of Troy. On the right, a paint grinder is working. See Campbell, 'The Early Netherlandish Painters', note 13.

[2] For Pictura, see Winner, *Die Quellen.*

[3] For overviews of religious and profane studios, see Klein, *St. Lukas*; Kraut, *Lucas Malt die Madonna*; Asemissen and Schweikhart, *Malerei*; Spike *et al.*, *Portrait de l'artiste*; Eckardt, *Selbstbildnisse.*

etc.)[4], and are a welcome complementary source as written descriptions of
studios dating from the fifteenth and sixteenth centuries are rare.

Not all the imagery is relevant to this study. This essay is restricted to
images of painters' workshops where assistants are visible and to the period
when the artist's studio is not yet a genre in itself, as it became in the mid-
seventeenth century with David Rijckaert[5], Joos van Craesbeeck[6] and oth-
ers. Some engravings and drawings are included in this paper, although the
painterly medium appears to be best suited for this study – painters were the
largest group of artists in the guild of Saint Luke. This article does not aim
to present an exhaustive overview of, for example, Saint Luke-imagery, but
rather to focus on the working of the workshop. In what follows we shall
see what information these images provide about the status of workshop as-
sistants in the fifteenth, sixteenth and early seventeenth centuries.

The angelic assistant in the workshop of Saint Luke

As an evangelist, Saint Luke wrote in a precise, detailed way, carefully de-
scribing what he saw and what was said.[7] It was almost as if drew or paint-
ed the life of Christ with words, which has resulted in him becoming the
favoured patron saint of artists.[8] He was chosen as the patron of the artists'
guilds founded in northern European towns in the course of the fourteenth
and fifteenth centuries.[9] His representation as an artist is consequently no
more than a part of the total symbolism connected with the saint, who was
also a healer. He is usually found depicted in the company of an ox, an an-
gel, artists' attributes and the bible. Of all the scenes of this saint's *vita*,
Saint Luke painting the Madonna seems to have provided the most popular
imagery for artists.[10] It became an appropriate subject for books of hours

[4] Campbell, Foister, Roy *et al.*, 'Methods and materials', pp. 12-13.

[5] David Rijckaert, *Painter's workshop*, Dijon, Musée des Beaux-Arts.

[6] Joos van Craesbeeck, *The artist's studio*, Paris, Musée du Louvre.

[7] Ryan, *Jacobus de Voragine, The Golden Legend*: vol. 2, pp. 248, 252-253.

[8] Early on Saint Luke was confused with a ninth-century Florentine painter Luca,
called 'Il Santo', see Reau, *Iconographie*, vol. III/II, pp. 827-832. *Acta Sanctorum*
18 oktober (Oct VIII), p. 71: [*perperam S. Lucæ attributas fuisse, adminiculatur.*]
*Ex hactenus dictis id tamen consequitur, quod rejicienda sit interpretatio eorum, qui
volunt vulgarem opinionem de S.* Luca *pictore manasse ex quadam confusione cum
altero homonymo, nempe* [col. 0298E] *quodam monacho Florentino, qui sæculo
nono aliquas imagines Deiparæ Virginis depinxit.* I wish to thank Victor Schmidt
for the reference.

[9] The Southern Netherlands were among the first to institutionalise artists' craft
guilds: Brussels in 1306, Ghent before 1339, Bruges in 1358, Tournai in 1364,
Antwerp in 1382 and Mechlin in 1439.

[10] Réau, *Iconographie*, vol. III/ii, p. 828.

and other illuminated manuscripts. He is shown as either a scribe or a draughtsman at his desk. No assistants or pupils are visible when the saint is creating his heavenly portrait in these miniatures.[11] Saint Luke seems fully concentrated on his model, which he draws either from the vision before his eyes or, more rarely, from life, with the Virgin sitting in front of him. *Saint Luke painting* (or *drawing*) *the Virgin* is also the theme of many of the larger and more costly panel paintings which were most probably used as altarpieces for the chapels of the guilds of Saint Luke, although the absence of documents makes it difficult to state this with certainty in some cases.[12] Some Saint Luke altarpieces have been destroyed, the most notorious example being the one painted by Quinten Metsys for the chapel of the Saint Luke's guild in the Church of Our Lady in Antwerp.[13]

The first painting that should be mentioned here because of its great influence is Rogier van der Weyden's (c. 1399-1464) *Saint Luke drawing the Virgin* (Boston, Museum of Fine Arts) painted around 1436-38 (fig. 1).[14] At least three copies are known, and parts of the composition were repeated in other paintings in fifteenth and sixteenth-century Flanders. This painting diverges from earlier images in which the saint is alone in his studio and draws from memory, or rather from the vision in his mind. Rogier's severely symmetrical composition, showing the model in 'real' life, thus constitutes a prototype, especially for altarpieces. He has painted the saint drawing his model, alone in his studio with the Virgin and Child. Some people are visible outside the studio, standing in a *loggia* with columns, through which a river can be seen. The saint is looking at his model but seems lost in thought and, as the inspiration forms in his mind, he lifts the

[11] One exception (albeit French) is the miniature from the 'Cité des dames' workshop, *The Paintress Tamara*, from Boccaccio's *De Claris Mulieribus* (Paris, BnF, Ms. Fr. 12420), fol. 86ʳ, where a boy is grinding pigments on a low worktable next to the female painter.

[12] See Borchert, 'Rogier's St. Luke', pp. 61-88.

[13] Although it was undoubtedly one of the more famous paintings of the sixteenth century, it presents many problems that are beyond the scope of this paper. Cf. Silver, *The Paintings of Quinten Massys*, pp. 240-241, no. 7 ('Documented Lost Works'); Friedländer, *Early Netherlandish Painting, Quentin Massys*, vol. VII, plate 134b, shows an engraving by A. Wiericx, which according to Friedländer possibly replicates the Metsys altarpiece of *Saint Luke drawing the Virgin*, although Silver, *The Paintings*, p. 240) doubts this.

[14] Oil on panel; 137.7 x 110.8; Friedländer, *Early Netherlandish Painting*, vol. 2, pl. 118, 119; De Vos, *Rogier van der Weyden*, cat. 8, pp. 200-206; Borchert, 'Rogier's St. Luke', pp. 61-88. The Boston version is generally accepted as the original. De Vos, *Rogier van der Weyden*, cat. 8, pp. 200-206, states that the altarpiece may have come from the Chapel of Saint Catherine in the Church of Saint Gudule in Brussels (now the Cathedral of Saint Michael and Gudule), where the painters had their altar.

stylus to continue his drawing on a small sheet of vellum or paper on which
her traits have already been drawn. The scene is an intimate portrayal of the
special relationship between Saint Luke and the Virgin: she is present as the
sublime model. The setting is suitably spacious and sumptuous, being in the
first place meant for devotion. Saint Luke is depicted as the 'ideal' Christian
protopictor. The image does not look like a painter's workshop, nor is it
meant to be. It may be considered as a 'proud pictorial demonstration of the
painter's own aspiration',[15] but it was certainly primarily destined to be an
instrument for devotion.

The influence of Rogier's prototype continued into the sixteenth cen-
tury. A case in point is Gossaert's *Saint Luke painting the Madonna* (Pra-
gue, National Museum), dating from 1512-15 (fig. 2).[16] The panel was
painted by the artist (c. 1478-1532) for the guild of Saint Luke of Mechelen,
which had its chapel in the Church of Saint Romuald.[17] In the foreground,
the Virgin is sitting with her Child on her lap, her dark blue cloak draped
around her and falling in big folds on the floor. On the right is Saint Luke
who is seated with a drawing sheet on his knees, preparing the Virgin's por-
trait. In the background, he is depicted again, in a simultaneous situation,
this time writing down the words which the Virgin is dictating to him.[18] No
assistants are present: the saint is alone with the source of his inspiration.
Gossaert also used the symmetric compositional scheme of Rogier's proto-
type, although it differs from that of his illustrious predecessor. Whereas
Rogier's workshop is sumptuous but still somewhat intimate, Gossaert's
Saint Luke puts himself at a respectful distance from his model. The space
is huge and the architectural setting more suited to a palace than a work-
shop.

In Gossaert's second painting on the same theme, *Saint Luke painting
the Madonna* (Vienna, Kunsthistorisches Museum) from c. 1520, an angelic
assistant is depicted behind the saint (fig. 3).[19] The angel literally guides the
saint in his evangelical vision as it guides his right hand drawing the Ma-
donna on a piece of paper lying on a lectern.

In Jan de Beer's work (c.1475-c.1528) we again encounter an angelic
assistant. The artist composed two versions of his *Saint Luke painting the
Virgin and Child* that are of interest for the present paper. The first painting
(Milan, Pinacoteca di Brera), dated before 1520 (fig. 4), is on canvas, small

[15] Borchert, 1997, p. 73.

[16] Mensger, *Jan Gossaert*, p. 62ff.

[17] Monballieu, 'Bij de interpretatie' vol. I, pp. 125-138.

[18] Silver, *The Paintings*, p. 182.

[19] Krönig, 'Gossarts Prager Lukasmadonna', pp. 300-301; Mensger, *Jan Gossaert*,
p. 201ff.

and rather light.[20] Ewing has plausibly suggested that it was used in processions rather than as an altarpiece. De Beer is the only painter who places the scene in a town house. The space is cramped. On the right, an angelic assistant is grinding pigments in the presence of the saint, the Virgin and the ox.[21] The angelic assistant does not appear heavenly like Gossaert's angel, but is more prosaic and worldly. The interior is that of everyday life and certainly bears no comparison to the palace-like surroundings of Gossaert's *Saint Luke*.

According to Ewing, De Beer based his depiction on a composition by Robert Campin.[22] Robert Campin's (c. 1375/9-1444) original *Saint Luke painting the Virgin* is not preserved and only known through three variants.[23] His scene was situated in a small ordinary room, not in a lofty palace. Ewing notes appropriately that the subject of *Saint Luke painting the Virgin* expresses veneration for the Virgin just as much as it constitutes sanctification of the evangelist's craft.[24] Apart from the painting, there is a pricked model drawing from c. 1520 (London, British Museum), in which De Beer also depicts an angelic assistant preparing the pigments. The drawing was used as a *modello* for a glass window and shows the heraldry of the guild of Saint Luke.[25] The angelic assistant, however, is something of a rarity. Apart from Jan de Beer and Jan Gossaert, no-one else seems to have depicted the workshop assistant in this way.

The ascendancy of the pigment grinder in the workshop of Saint Luke (1530s-1605).[26]

In the early sixteenth century, some paintings begin to deviate from the Rogier prototype in various aspects, such as composition, division of space

[20] I wish to thank Dan Ewing for his help. Tempera or watercolour on canvas, 84 x 144 cm; Ewing, *The Paintings*, pp. 210-216, no. 2; Friedländer, *Early Netherlandish painting*, vol. 11, pl. 11, no. 11. See also Meyer, *Repertory*, vol. II: Lombardy, p. 59.

[21] Ewing, *The Paintings*, pp. 81-87, p. 94, note 24.

[22] *Ibidem*, p. 82.

[23] Châtelet, *Robert Campin*, pp. 315-316, nos. C 16a-c. Three versions of the lost Campin original are repertoried by Châtelet: the first is by Colyn de Coter (Vieure, Parish church); a second is by Derick Baegert (Münster, Westfälisches Landesmuseum); and the last is attributed to Derick Baegert and his workshop (Stolzenhain, Evangelic church). It is not clear whether the angel on the right in the version by Derick Baegert (Münster, Westfälisches Landesmuseum) is an angelic assistant.

[24] Ewing, *The Paintings*, pp. 83-84.

[25] Black ink on gray paper (289 mm diameter); Ewing 2003, pp. 213-216, no. 3, London, British Museum, Department of Prints and Drawings.

[26] A panel by N.M. Deutsch, *Saint Luke painting the Virgin* (1515) (Bern Kunstmuseum) also depits the Swiss artist as a pigment grinder, but will not be treated here.

and symmetry. The most important difference is that we are allowed to see the presence of others, particularly workshop personnel. At a discrete distance from the venerable subject and her painter, a workshop assistant or pupil is sometimes depicted, often in a separate room situated at the back of the studio.

A woodcut of *Saint Luke painting the Virgin* (fig. 5) by glassmaker and artist Dirk Vellert (c.1480/85-after Dec. 1547), presents something new. The scene is mannered, with classical ornaments visible everywhere. On the left is a window through which light filters. The painter is putting the *mahlstick* in place and concentrating on the painting, while the Madonna is holding Jesus on her lap. The assistant is in a room at the back, which can be reached by some stairs and an elaborately carved doorway. A cat sits on the stairs. The sumptuously mannerist decoration notwithstanding, the numerous objects make this studio an agreeably cluttered place to work. The monogram '*DV*' is visible on a low bench in front. It has the date '*1526. IN. IULI. 28*' underneath it; this was the year Dirk Vellert became dean of the Antwerp guild of Saint Luke.[27]

Another example, from a later date, is an ornate *Saint Luke painting the Virgin* (Bruges, Groeningemuseum) by Lancelot Blondeel (1488-1581), monogrammed and dated '*1545*' (fig. 6). The roundel is framed in an elaborately painted mock-gilded cartouche with fruit, festoons, curls and *putti*. A small depiction of the Madonna, sitting on a throne on a dais and holding Jesus in a loving embrace, is visible inside the ornate frame. The painter's work is on show on an easel, turned towards the viewer, with only the faintest traces of outlines and the faces of the Madonna and her Child. On the right is a separate room in which a man can be seen grinding pigments.[28] As is the case in Vellert's woodcut, the assistant is not participating in his master's work but working separately.

A painting by Maarten van Heemskerck (1498-1574), *Saint Luke painting the Virgin* (Rennes, Musée des Beaux-Arts), also shows workshop procedures. It is signed '*M(a)rtinus Heem.../Fecit*' and is generally dated after 1550/51-1553 (fig. 7).[29] Following the Gossaert tradition, the Virgin and the saint are seated in a spacious hall in a domed house, which has been identified as a depiction of the Casa Sassi in Rome.[30] The medical books lying open on the floor refer to the saint's original calling as a physician. The por-

[27] Konowitz, 'D. Vellert'.

[28] Jansen, 'Lancelot Blondeel', p. 179, fig. 82.

[29] Grosshans, *Maerten van Heemskerck*, pp. 195-201, no. 75; Veldman, *Maarten van Heemskerck*, p. 115, note 1. The signature is partly unreadable.

[30] Veldman, 'Maarten van Heemskerck and St. Luke's medical books', pp. 91-100, esp. p. 100.

trait of the Virgin is already partly sketched and the head painted in. Another scene is taking place at the back of the hall: in the *loggia*, a man is busy carving a male figure, which is an image of a statue of Apollo at Casa Sassi that was seen and recorded by Van Heemskerck. Comparison with a woodcut by Sigismondo Fanti, *Triompho di Fortuna*, of 1527, allows the sculptor to be identified as Michelangelo.[31] At the back of the hall, three men are busy executing prints; long strips of paper are hanging from a table in what seems to be a studio for engravers and draughtsmen.[32] It is tempting to interpret Saint Luke as an entrepreneur and manager of an all-round studio. Yet, the great number of medical and anatomical books and treatises – as analysed in detail by Veldman – can also indicate the importance of the study of the human body and respect for its proportions for all art trades.[33] This was especially the case for Van Heemskerck, who mixed elements of 'modernity' with his religious imagery.

One of the more famous examples, described by Carel van Mander in 1604, is a panel depicting *Saint Luke painting the Virgin* (Antwerp, Royal Museum of Fine Arts) by the Antwerp painter Frans Floris (1519/20-1571) (fig. 8). It is monogrammed and dated on the grinding stone on the right with '*FF.IV ET T. 1556*'.[34] Its precise destination is not known, although Van de Velde has argued that it was probably not an altarpiece but destined to decorate the painters' guild house.[35]

The saint is seated in a large wicker chair on a podium of awkwardly painted wooden boards, facing the viewer. He is painting a panel placed on an easel. The pigment grinder is standing at the right. According to Van Mander, the model for the saint was supposedly the painter Rijckaert Aertsen (possibly c. 1480-supposedly before 1560).[36] When gathering material for the preparation of his artists' biographies in the early 1580s, the biographer must have visited the guild house and seen Floris's painting; undoubtedly, a member of the guild supplied Van Mander with information.

The ingenious and illusionistic idea of placing the Virgin outside the space of the painting is somewhat hampered by the poor spatial construction

[31] Grosshans, *Maarten van Heemskerck*, pp. 196-197; see also Exh.cat.: *Kunst voor de Beeldenstorm*, no. 146.

[32] See Lavin, 'David's Sling', p. 168.

[33] Veldman, 'Maarten van Heemskerck, p. 100.

[34] Miedema, *Karel van Mander*, vol. I, pp. 248-249, fol. 247ᵛ; Van de Velde, *Frans Floris*, pp. 237-238, no. 91.

[35] Piot, *Rapport à Mr. Le Ministre de l'Intérieur*, annexe LXXIII, p. 261; Van de Velde, 1975, p. 238.

[36] Rijckaert Aertsen is not a well-known artist, although snippets of his life and information about his work have come down to us via Carel van Mander. Cf. Miedema, *Karel van Mander*, vol. IV, pp. 95-98.

of the painting. This is not helped by the subsequent enlargement of the painting through the addition of four planks (one underneath and three on top). The panel that the saint is painting is not visible and, as a result, the Virgin is possibly present only in the mind of the painter or standing where the viewer is standing. Floris thus reaches back to earlier fifteenth-century images and miniatures, which usually show the saint without his model, by-passing the 'Rogier tradition'.

Floris's quickly drawn model sketch for the painting *Saint Luke painting the Virgin* (Göttingen, Kunstsammlungen der Universität) presents an analogous theme but in a different composition.[37] The grinder is sketched without personalised features; the face of Aertsen has not yet been filled in.

Two examples from the beginning of the seventeenth century constitute the end of a rich tradition of images of Saint Luke in his workshop. Marten de Vos, Ambrosius I Francken and Otto van Veen painted the altarpiece of *Saint Luke painting the Virgin* (Antwerp, Koninklijk Museum voor Schone Kunsten). It was started in 1602 by Marten de Vos (1532-1603) but not completed at the time of his death.[38] The wings were painted by Ambrosius Francken (1544/45-1618) and Otto van Veen (c. 1556-1629). *Saint Luke painting the Virgin* was the central panel of the altarpiece for the chapel of Saint Luke in the Cathedral of Our Lady in Antwerp (fig. 9).[39] We see Saint Luke in a large, comfortable and richly decorated room, sitting on the edge of his chair in front of his easel, painting the Virgin with Jesus on her lap. The workshop boasts a wide space and classical interior with a central vanishing point. On the right, a globe and an open bible are prominently displayed. The upper part of the composition is crowded with *putti*. Behind the saint, a man is grinding pigments. The model for this '*portrait historié*' was Abraham de Greef I (or Grapheus) (?-1624),[40] who was the servant and messenger of the Antwerp guild of Saint Luke. It was his task to organise the banquets, sales and auctions, and he generally did all kinds of chores, but he was not a journeyman or workshop assistant. Van de Velde mentions that he filled in the *lacunae* in the *Liggeren* (the membership lists of the artists inscribed in the guild), where the deans had forgotten names during in-

[37] Drawing in black chalk, 190 x 232 mm; Van de Velde, *Frans Floris*, pp. 374-75, no. 41; Unverfehrt, *Zeichnungen*, p. 78, cat no. 22. I wish to thank Nils Büttner for the information.

[38] Triptych. Central panel 270 cm x 217 cm; wings 253 cm x 101; predella 2 x 32 cm x 70 cm. Date and monogram on central panel lower right *1602 F.M.D.VOS.*; writing on right wing: *Lucas est mecum solus*; date on right wing lower left: *1589*. On the hypothesis of the date see Peeters, 'A corporate image?'.

[39] Zweite, *Marten de Vos*, cat. no. 103.

[40] Peeters, 'A corporate image?'.

scription.[41] Grapheus is thus, in fact, the living memory of the guild. In the painting, Grapheus is symbolically in the service of Saint Luke, the patron saint of the guild, just as he was in the service of the guild in real life.[42] Marten de Vos also made a *vidimus* for the central panel of the altarpiece (Vienna, Albertina), in which the pigment grinder is unidentified.[43]

The last example to feature here is a panel of *Saint Luke painting the Virgin* by Abraham Janssen (c. 1571/1575-1632), made for the chapel of Saint Luke in the Church of Saint Romuald in Mechelen (fig. 10). The altarpiece replaced an older work by Gossaert (the *Saint Luke painting the Virgin* now in Prague, referred to earlier) with which it has much in common. Although different dates of origin have been proposed, Van der Auwera has convincingly argued for a date between 1601-1603, which places it around the time the Antwerp Saint Luke's altarpiece must have been completed.[44] The central panel depicts a large studio with a view into a small high room at the back. The saint is busy working in this studio, holding a stylus of black chalk, with some pencils in his other hand. He is looking up from his sketch. He looks very much like Abraham Janssen himself. An old man with a sword, identified as Saint Lambert (also a patron saint of the guild), points at the model.[45] In the middle at the right, a pigment grinder is busy at his chore. Along with Janssen taking Gossaert's legacy into account, Vander Auwera also notes Janssen's emulation of Marten de Vos's venerable central panel for the Antwerp altarpiece which had just been finished.[46]

The rich tradition of imagery of Saint Luke ends here. Not only were there changes in the fashions in devotional painting and the composition of the altars, but in 1673, the secularised Academy of Arts was installed in Antwerp, thereby ending the Christian tradition of the *protopictor*.

[41] Van de Velde, 'The grotesque initials'.

[42] Peeters, 'A corporate image?'.

[43] Drawing, 381 x 301 mm; D'Hulst, 'Over enkele tekeningen van Marten de Vos', pp. 513-514.

[44] I wish to thank Joost Vander Auwera for permission to consult his PhD thesis. Triptych. Central panel (oil on panel) 294 x 247 cm. See Van der Auwera, *Leven*, pp. 753-765, no. 5 [unpublished PhD thesis University of Ghent] (in print).

[45] Vander Auwera, *Leven*, p. 764. Saint Lambert is the most reasonable identification as he had been the patron saint of the altar where the painters chose to build their own.

[46] *Ibidem*, pp. 180-196, pp. 753-765, no. 5. Monogrammed *A.I.*, on the leg of the chair the saint is sitting on.

The 'profane' workshop in the sixteenth century: a new genre

In the sixteenth century, a new type of studio appears in paintings: the profane studio. These depictions have no religious content and form a small but distinct category. They are, however, not devoid of allegorical or other symbolism. In contrast to the 'Rogier prototype' where the workshop was an empty place of serene craftsmanship, the profane workshop is often filled with people, a place of busy, bustling activity.

The most famous of these secular images is Pieter Bruegel's *Painter at his easel* (before 1569), a composition only known through copies (such as the one in Paris, Louvre, Cabinet des Dessins) (fig. 11).[47] In a sparsely drawn interior, a painter is busy; on the panel in front of him, the outlines of a jester can be seen.[48] At the back on the left a young boy is sitting, labouring over a drawing.[49] The boy seems to be an apprentice, too young to be a journeyman. The fact that he is drawing seems to imply that he is still studying his craft.

The paper on which the drawing is made is folded – as if for a letter – and carries the address of *'Eersame Merten Verhulst/ [in] de Catelijnen Straet naest /het ghulden/pert'* ['Honourable Maarten Verhulst of Catelijne Street next to the Golden Horse'], and beneath it are the words: *'betaelt den bode'* ['paid to the messenger']. Written vertically below is *'P BRUEGEL/4'*.[50] Merten Verhulst (c. 1536-after Jan. 1596) was Bruegel's uncle by marriage.[51] The late Bruegel scholar Hans Mielke doubted the attribution to Pieter Bruegel the Elder (c.1525/30-1569) and attributed it to Pieter Breughel the Younger (1564/65-1637/38). There are two other slightly different drawings (Paris, Louvre, Cabinet des Dessins and Bayonne, Musée Bonnat). According to Mielke, the drawings are based on a lost original by Pieter Bruegel the Elder himself.[52]

A second 'secular' image of a workshop is a drawing by Marcus Gheeraerts the Elder (c.1520-c.1590) depicting *The Unhappy Painter and his Family* [or 'The Unlucky Painter'] (Bibliothèque nationale de France) from 1577 (fig 12).[53] The picture is charged with allegorical symbolism.

[47] Muylle, 'Pieter Bruegel' pp. 189-202; Winner, catalogue entry in (exh. cat.) *Pieter Bruegel der Ältere*, pp. 82-83.

[48] Drawing, 265 x 200 mm; De Vries, 'With a coarse brush', pp. 38-48, and Onclincx, 'A propos d'un dessin-message du Louvre', pp. 272-284.

[49] Mielke, *Pieter Bruegel*, pp. 72-73, 'probl. 6 a'. The boy is possibly an addition.

[50] The '4' is probably the number of stuivers for the mail delivery along the road Brussels-Malines, see Onclincx, *Pieter Bruegel*, 1989, passim.

[51] Monballieu, 'De kunstenaarsfamilie Verhulst-Bessemeers'.

[52] Mielke, *Pieter Bruegel*, pp. 72-73, 'probl. 6 a'.

[53] Hodnett, *Marcus Gheeraerts the Elder*, no. 57; Martens, Exh. cat.: *Bruges and the*

The scene depicts the desperate painter being distracted from his work by two women, with Amor and Mercury also trying hard to get his attention. The artist's expression is ravaged, sad and worried.[54] At the back of the room, a paint grinder can be seen. The artist has signed '*Marcus Geerartz va[n] brugge*' and added the words '*Haud facile emergunt quorum Virtutibus obstat Res angusta domi ex dono Marcs gerards brugensis*'. The quote is from the *Satires* of Juvenalis and refers to the difficulties people encounter in trying to break through, especially when merit and talent are stifled by straightened circumstances.[55] Chapter III of the *Satires* touches upon the moral and actual humiliation of those who have to demean themselves for money, and declares financial insecurity a misery. The quotation clarifies the content of the drawing. The first woman is pointing at the hungry children whom the husband is not managing to feed by his labours. The painting being prepared is an allegory of Melancholy for which the second woman at the left is posing. Mercury is behind, trying to inspire the artist, and the *putto* with the *mahlstick* symbolises the love of art. The hour-glass signifies that time is short. It should be noted that Gheeraerts himself lived in troubled times; being a Protestant, he shuttled between the Netherlands and England.[56]

Another example is provided by the series *Nova Reperta*, consisting of twenty prints executed by Theodore and Philip Galle and Hans Collaert after Johannes Stradanus, also known as Jan van der Straet (1523-1605), and published by Philip Galle. The series was started between 1588 and 1589.[57] It was meant to show how inventions had altered people's lives, since the Renaissance, by depicting workshops, crafts, routines and techniques. It sheds light on various aspects of the workshop, hitherto not seen.[58] The prints depict different types of workshops: printers, distillers, watchmakers, engravers, geographers and others. The *Invention of oil paint in the workshop of Jan van Eyck* (BnF) (fig. 13) deals with a painter's workshop. The inscription underneath reads *Colorem olivi commodum pictoribus, invenit insignis magister Eyckius*. The invention and practical uses of oil paint are shown in various stages of preparation; underdrawings of paintings, awaiting execution, are visible. The engraving gives us an interpretation of a co-

Renaissance, 1998, p. 158.

[54] Asemissen and Schweikhart, *Malerei*, p. 103, no. 7.

[55] See Juvenal, *Satires*, (ed. and transl. De Labriolle and Villeneuve), pp. 30-31. 164-165: *haut facile emergunt quorum virtutibus opstat / res angusta domi*.

[56] Martens and Peeters, 'A tale of two cities', pp. 31-42.

[57] Baroni-Vannucci, *Jan Van Der Straet*, p. 398.

[58] Martens, Exh. cat.: *Bruges and the Renaissance*, nos. 133, 171-173; Baroni-Vannucci, *Jan Van Der Straet*, p. 399. See also Hollstein, *Dutch & Flemish etchings*, p. 87.

operative structure, showing a busy workshop. It is the first example of a studio as a hive of activity. Eight people are depicted: one master and seven assistants, among whom some are apprentices while others are studio assistants or journeymen. The master is painting an image of Saint George on the canvas; one pupil prepares the palette, a second is painting a bust on a panel, while a third is making studies of eyes on a panel. A second fully trained artist is drawing a portrait from life on a panel. Two older assistants are grinding pigments on a stone, while the last assistant is fetching a printing plate. Although not much information about Jan van Eyck's workshop is conveyed, the image presents a very busy studio and shows how Stradanus and Galle saw the ideal workshop.

Other compositions by Stradanus shed further light on the didactic function of workshop depiction. For the drawing *Academy of Arts*, signed *Iò STRADANENSIS FLANDRUS IN. 1573 CORNELIE CORT EXCV*,[59] executed in print by Cornelis Cort in Rome in 1578 (fig. 14),[60] it has been suggested that the work depicts either the Accademia di San Luca in Rome or the Accademia del Disegno in Florence. As is the case in Bruegel's drawing, those at the drawing boards are young apprentices making anatomical studies of a skeleton. Older men are practising engraving while, on the right, a painter is busy painting an allegory of Pictura on the wall. In the middle, a sculptor is creating a large composition with Neptune in it.

The drawing entitled *The Practice of Art*[61] displays another scene of diligent activity; it is a composition comparable to the *Academy of Arts*. One difference is that, while the latter contains only boys and men, the *Practice of Art* has some women executing various artistic tasks. Lastly, Stradanus's drawing of his *Self-Portrait in a Medallion*, in which he is surrounded by people working on architecture, perspective, drawing and painting, is the last of his workshop depictions.[62] In the lower right-hand corner, sketchily drawn, a pigment grinder and a painter can be seen working.

From the second half of the sixteenth century onwards, these secular images interpret the studio in a different but no less complex light than the depictions of Saint Luke painting the Virgin. It is not easy to extract the

[59] Baroni-Vannucci, *Jan Van Der Straet*, no. 313, 437 x 293, London, British Museum.

[60] Baroni-Vanucci 1997, no. 772, 437 x 298, print of 1578, drawing 1573 (London, British Museum). See Hollstein, *Dutch & Flemish etchings* (Fouceel-Gole), Amsterdam n.d. (Dutch & Flemish etchings engravings and woodcuts c. 1450-1700), p. 87 and p. 58; Sellink, *Cornelis Cort*, p. 119, no. 210.

[61] Baroni-Vannucci 1997, no. 314, Heidelberg, Kurpfalzisches Museum, 465 x 365.

[62] Baroni-Vannucci, *Jan Van Der Straet*, no. 373, Paris, Fondation Custodia, (Lugt inv. 3748); 190 x 275. See Boon, *The Netherlandish and German Drawings*, vol. 1, pp. 345-346.

documentary value because they are not simple depictions of workshops and their practices. In this respect, they are also significantly different from depictions of other craft workshops, e.g. the *Interior of a Carpenter's Workshop* by an an anonymous Dutch master of 1565 (Gouda, Stedelijk Museum Sint-Catharina Gasthuis). In the examples discussed here, one or more men are assisting the master in his work but their status is often far from clear. It seems obvious, though, that learning how to draw, grinding paint and doing other chores were all part of the production process. The Stradanus-print is enlightening in this respect, and has a certain didactic value in that the younger assistants draw and the older assistants grind pigments. But the print is exceptional because the workshop depicted is not only very large but also very populated when compared to the fact that most masters worked alone.[63] Is this wishful thinking on the part of the artist? Does this represent Stradanus's idealised view of the perfect and legendary (i.e. Eyckian) workshop where everyone had his task?

Conclusion

Ludovico Guicciardini wrote that there were some 300 painters in the metropolis of Antwerp around the middle of the sixteenth century.[64] Although they left us a rich legacy of images in different mediums, for a trade that was so popular and employed so many people, surprisingly few images of their own workshops from before the middle of the seventeenth century have come down to us. Artists chose to depict all kinds of settings, from the sumptuous to the humble, but seem not to have thought about depicting their own workshops or work routine. Preferably, and understandably, they presented a much grander picture, one more on a level with the saintly endeavours of Saint Luke (e.g. Gossaert), or one in which the intellectual vision of the Renaissance was present in the ornaments (e.g. Vellert). Most of the panels depicting Saint Luke were official images for devotional use, altarpieces for the saint's chapel in the main church of the town. They seem to say little about the perceived growing self-consciousness of the painter as an individual from the fifteenth century onwards and seem to be little concerned with the desire to profile the artist as a member of the intelligentsia. The main origin of these works lies in the need to decorate chapels in an appropriate and decorous manner, and Saint Luke presented a powerful visual subject. On the other hand, the profane images present all kinds of activities.

[63] Martens and Peeters, 'Artists by numbers'.

[64] Guicciardini, *Beschrijvinghe*, p. 113.

As for the workshop assistants, they are shown sometimes at the back, or else in a separate room. These may have a more didactic value, especially those invented by Stradanus, and can be seen as examples of the ideal academy where the accent is placed on teaching, not on the routine itself.

Where an assistant is present, it appears that he is there to embellish the composition or to enliven the painting. The chores depicted consist mostly of grinding pigments. The iconography of the workshop assistant's task seems limited. Furthermore, their status (apprentice, workshop assistant and/or journeyman) is not clear. Where we have additional external information on the grinder, such as in De Vos's *Saint Luke,* the man posing as the assistant is in reality the messenger of the guild and, strictly speaking, not an assistant. In Van Heemskerck's *Saint Luke*, which shows no pigment grinders, the status of the men in the workshop is far from obvious. Are they independent masters? The position of the 'angelic assistant' depicted in a number of works is even more problematic and certainly does not convey the impression that the iconography of the workshop assistant in images of Saint Luke has much documentary value. Younger boys, when present, are always drawing and are probably apprentices copying their master's work or trying out compositions.

It has to be borne in mind that the symbolic value takes precedence over the documentary value. All parts of the iconography either belong to a tradition or have originated in the mind of the artist. Thus we can conclude that the grinder is indeed more a *topos* rooted in the art of book illumination and carried on into the sixteenth century. The grinder is also an interesting compositional detail that enlivens the scene and makes the eye wander from Saint Luke and his model to secondary scenes. The inclusion of the grinder also stresses the distinction between creative work (done by the master) and manual work (done by the paint grinder) and in this way clarifies the hierarchy of tasks in the workshop. In separating invention and inspiration from the more lowly (though by no means less important) chores dealt with by the assistants, sixteenth-century free master painters possibly may have wanted to upgrade their trade with added value and prestige.[65]

Yet the pigment grinder's job was also important. The grinding of minerals and other substances to obtain a good colour was a continuous, laborious and time-consuming process. Cennini mentioned that a porphyry slab and stone were best suited for this work and that half an hour or an hour of grinding was prescribed when making the colour black. This would have made it a heavy chore for a young boy but an easy one for a strong man. Perhaps in the larger workshops there were trained paint grinders at work,

[65] This is a point also made by Vander Auwera, *Leven, Milieu en Œuvre van Abraham Janssen*, pp. 190-192.

as paid labourers, who concentrated only on this task, while others did artistic work. Knowing that paint had to be produced continually and could not be stored indefinitely, this seems a plausible hypothesis.[66]

The link with what is known about the workshops of those painters whose names appear in normative (guild statutes) and non-normative (inventories) sources seems limited. The large workshop (such as the one managed by Frans Floris) was an exception, even in a boom town like Antwerp.

Yet these depictions of certain aspects of the workshop routine do constitute an independent source of information. Although it is difficult to extract precise practical knowledge from them, and we cannot take them at face value, they are the only images of what constituted the core of an extremely important production process.

[66] Cennini, C., (transl. Thompson), *The Craftsman's Handbook*, pp. 9-10 and 20ff.

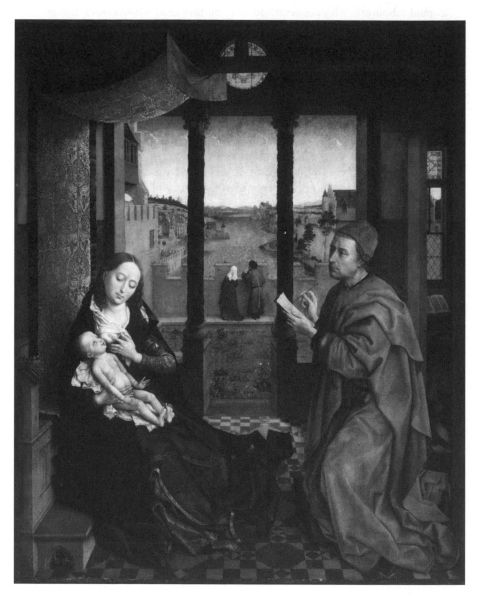

1. Rogier van der Weyden, Saint Luke drawing the Virgin, about 1435-1440. Museum of Fine Arts, Boston. Gift of Mr. and Mrs. Henry Lee Higginson. Photograph © 2005 Museum of Fine Arts, Boston.

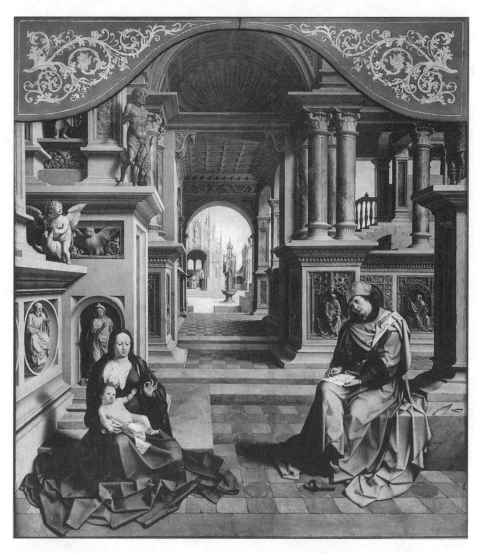

2. Jan Gossaert, Saint Luke painting the Madonna. National Gallery, Prague on permanent loan of the Chapter of Saint Vitus, Prague. Photograph © 2005 National Gallery, Prague.

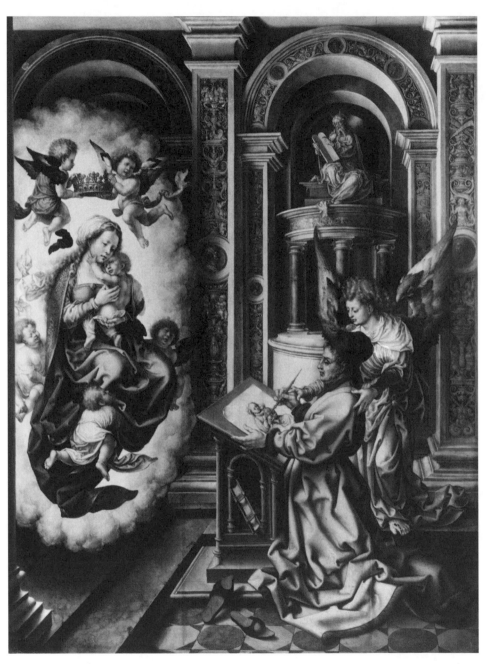

3. Jan Gossaert, Saint Luke painting the Madonna. Kunsthistorisches Museum Wien, Vienna.

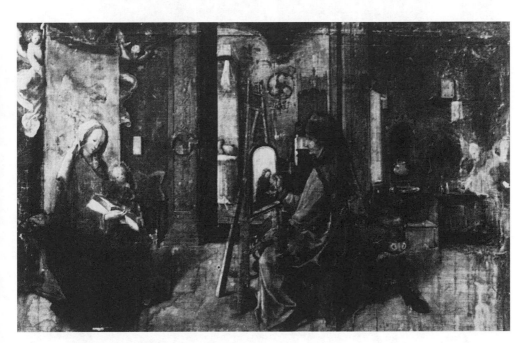

4. Jan de Beer, Saint Luke painting the Virgin. Pinacoteca di Brera, Milan.

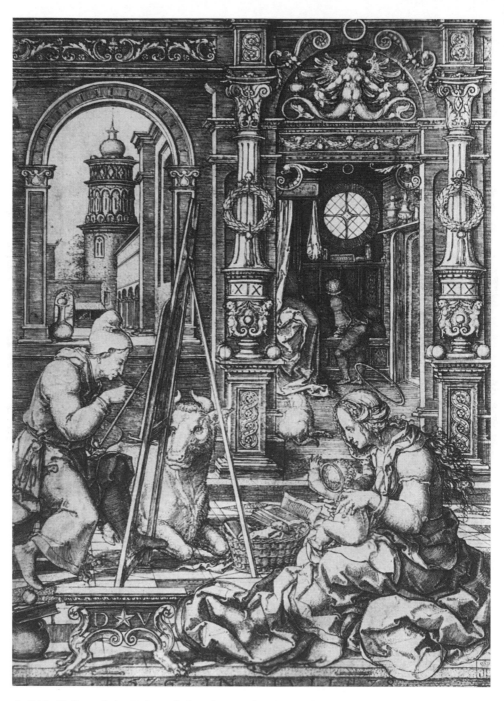

5. Dirk Vellert, Saint Luke painting the Virgin. Print. Photograph © IRPA-KIK, Brussels.

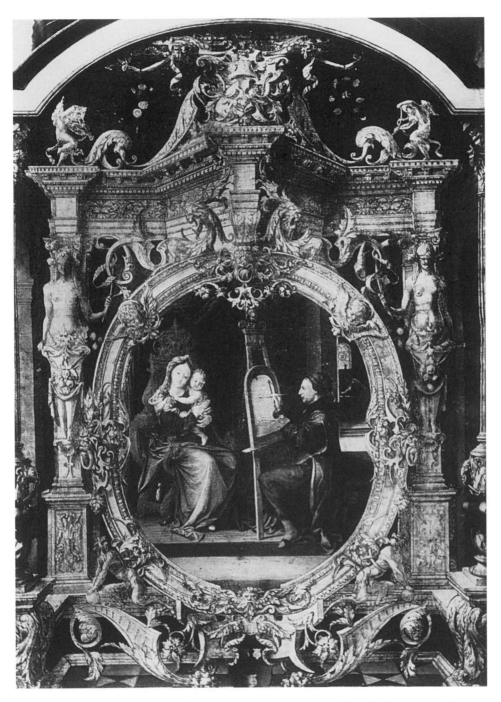

6. Lancelot Blondeel, Saint Luke painting the Virgin. Groeningemuseum, Bruges. Photograph © IRPA-KIK, Brussels.

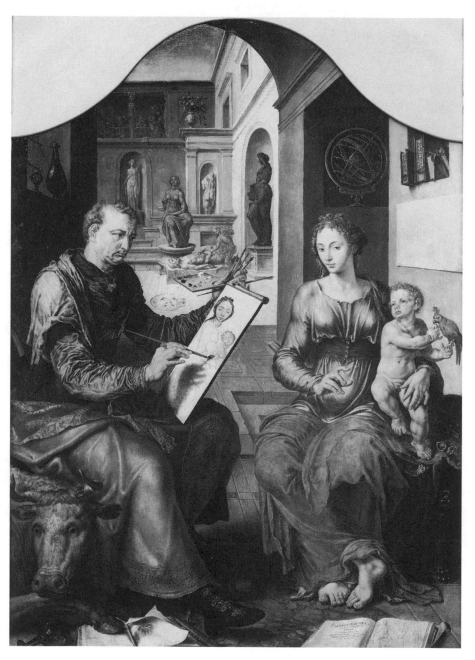

7. Maarten van Heemskerck, Saint Luke painting the Virgin. Musée des Beaux Arts, Rennes. © Photo RMN.

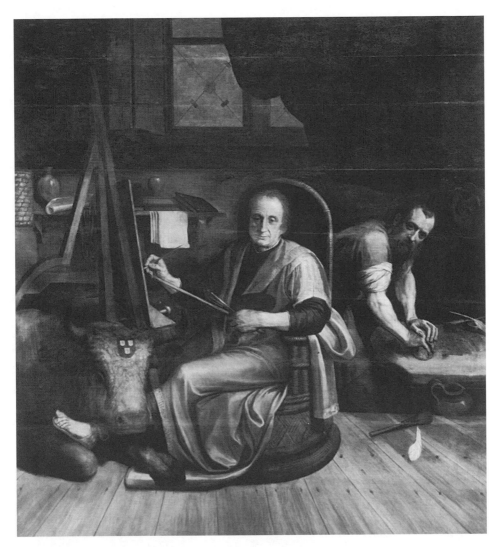

8. Frans Floris, Saint Luke painting the Virgin. Royal Museum of Fine Arts, Antwerp. Photograph © IRPA-KIK, Brussels.

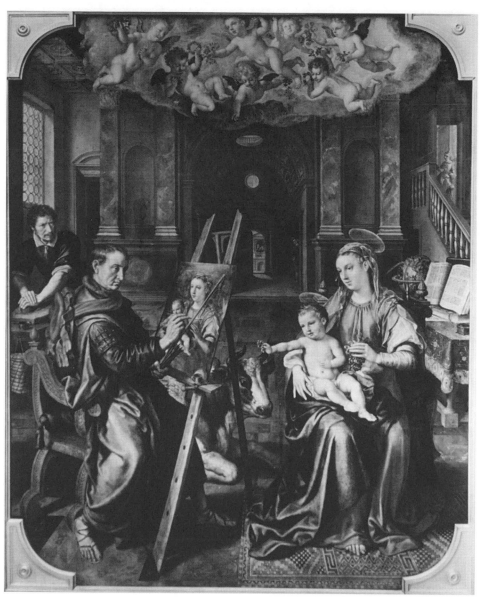

9. Marten de Vos, Saint Luke painting the Virgin. Royal Museum of Fine Arts, Antwerp. Photograph © IRPA-KIK, Brussels.

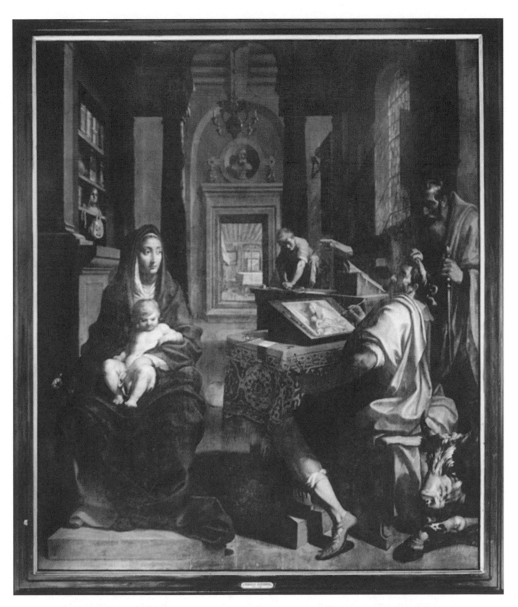

10. Abraham Janssen, Saint Luke painting the Virgin. Church of Saint Romuald, Mechelen. Photograph © IRPA-KIK, Brussels.

11. Pieter Bruegel I (attributed to), Painter at his easel. Drawing. Louvre, Paris.
Photograph © RMN.

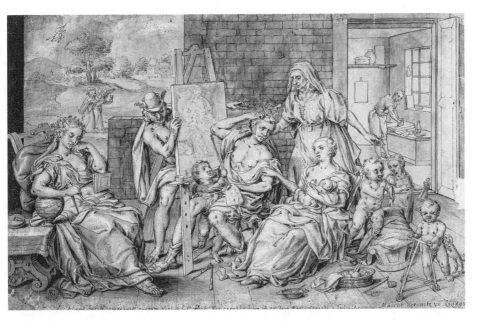

12. Marcus Gheeraerts the Elder, The unhappy painter and his family. Drawing. National Library, Paris. Photograph © Bibliothèque Nationale de France.

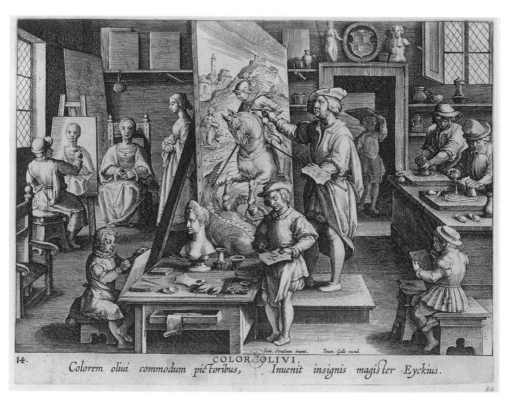

13. Johannes Stradanus, Invention of oil paint in the workshop of Jan van Eyck. Print. National Library, Paris. Photograph © Bibliothèque Nationale de France.

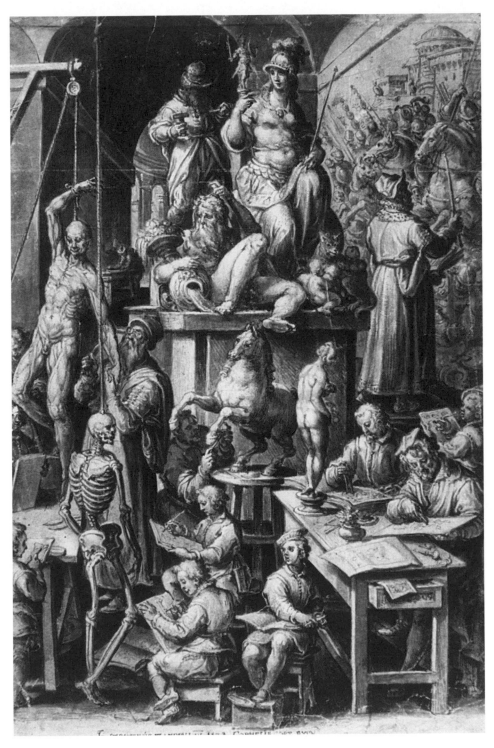

14. Johannes Stradanus, Academy of Arts. Drawing. The British Museum, London.
Photograph © The British Museum.

JOOS VAN CLEVE AND HIS ASSISTANTS

QUESTIONS OF IDENTITY BY 'FAULTS OR VIRTUES'

(*FEHLER ODER TUGENDEN*)?

Micha Leeflang

Joos van Cleve was born around 1485, became a free master in the Antwerp Saint Luke's guild in 1511 and was active in the city until his death in 1540/41. Today more than three hundred works are attributed to the Joos van Cleve group. Besides the altarpieces and commissioned portraits, he produced works in series. For example, there are a number of known versions of *The Holy Family*, the *Madonna of the Cherries, Christ and Saint John the Baptist as Children* and *The Adoration of the Magi*. Even taking paintings produced outside the workshop and later copies into account, there are still a great many works that originated in Joos van Cleve's workshop. How was it possible for Joos van Cleve to paint this considerable number of artworks?

Insight into this question can be provided via an analytical method developed in the social sciences called 'Event History Analysis'. The method is used for longitudinal and transverse study of dynamically evolving data sets, recording every change in the status of individuals throughout their lives, e.g. birth and marriage (fig. 1).[1] At the beginning of the chart, the digit '1' indicates each year of Joos van Cleve's activity in Antwerp. At the time of his wedding in 1518, his status becomes '2'. Anna Vijdt, his first wife, is then considered as the second head of the 'hearth' or house. Van Cleve's children, Cornelis (b. 1520) and Jozijne (b. 1522), are recorded as follows: at the birth of each child, his status is raised by '1'. Later, apprentices are also recorded in the graph because most pupils received board and lodging at their master's place in Antwerp.[2] When a pupil was accepted in the studio, Van Cleve's status is again raised by '1', until that apprentice became a free master or left the workshop for another studio,[3] as for example

[1] I wish to thank Natasja Peeters for introducing me to this method of analysis, which she first applied for art historical purposes in her research on the Brueghel family (Peeters, 'Family matters').

[2] Van der Stock, 'De organisatie', p. 49.

[3] In the EHA-graph I did not take into account the mortality of approximately 33%

Claas van Brugge did in 1522. In other cases, following their four-year training period, apprentices probably stayed on as workshop assistants (also called *gezellen*).[4] A pupil who remained in the workshop as a journeyman after his training was a good investment.[5] The Event History Analysis graph, which records the 'hearth', shows changes both in the family and in the workshop.

According to the *Liggeren*, the membership list of the Antwerp guild of Saint Luke, five painters were trained in the workshop of Joos van Cleve.[6] In 1516 Joos van Cleve accepted his first pupil, Claas van Brugge. Three years later, in 1519, Joos van Cleve probably married Anna Vijdts.[7] In 1520 their son Cornelis was born, and two years later, in 1522, their daughter Jozijne. Jacob Tomasz entered the workshop in 1523, one year after Claas van Brugge left the studio. In 1528/1529 Anna died and in the same year Joos married Katlijne van Mispelteeren. Frans Dussy and Willem de Stomme were accepted as pupils in the workshop in 1535 and Joost Diericksz in 1536. Cornelis van Cleve, Joos' son, was presumably also active in his father's workshop during the 1530s. Although Cornelis is not mentioned as a pupil in the *Liggeren*, this was nevertheless a common practice because when a master's son was trained in his father's workshop he was not required to pay a contribution to the guild. Besides Cornelis' activity in the studio, it is possible that Joos van Cleve's wives and daughter also assisted in the workshop. It is not known whether they helped with the production of paintings, but it is likely, for example, that they cleaned the studio.

Besides Claas van Brugge and Cornelis van Cleve, we have no information on Joos van Cleve's other four pupils. As Friedländer wrote:

> *Die Gehilfen machen sich mit Fehlern bemerkbar, nicht mit Tugenden. Von den Besten unter ihnen weiß man nichts, weil sie so gute Hilfe geleistet haben, daß ihre Arbeit in diejenige ihres Meisters aufgegangen ist.*[8]

of sixteenth-century men. (I thank Peter Stabel for pointing this out to me).
[4] Floerke, *Studien*, p. 130.
[5] Martens and Peeters, 'Artists by numbers'.
[6] Rombouts and Van Lerius, *De Liggeren*, p. 86 (Claas van Brugge), p. 103 (Jacob Tomasz), p. 125 (Frans Dussy), p. 126 (Willem de Stomme), p. 129 (Joost Dierickz.).
[7] Van den Branden, *Geschiedenis*, p. 128.
[8] Friedländer, *Die altniederländische Malerei*, p. 67. English translation: 'Assistants make their presence felt by faults rather than virtues. The best among them remain unidentified because their work merges into that of their master'.

No paintings are attributed to Jacob Tomasz, Frans Dussy, Willem de Stomme and Joost Diericksz, therefore, their works were most likely attributed either to the workshop of Joos van Cleve or to 'Joos van Cleve (?)'.

The main questions for this article are as follows: Is the co-operation of a *gezel* visible in the works attributed to Joos van Cleve? Can we attribute paintings, for example, to Claas van Brugge or Cornelis van Cleve? How long did Claas van Brugge and the other pupils stay in Joos van Cleve's workshop? What was Cornelis van Cleve's position in the studio? Did Cornelis van Cleve continue in the workshop after his father's death in 1540/1541? What working methods were used by Cornelis van Cleve and the other apprentices in Van Cleve's workshop? Can these workshop practices be a source of evidence for distinguishing the different hands?

Workshop assistants: apprentices, and registered 'gezellen'

Claas van Brugge started as Joos van Cleve's assistant in 1516. Although the length of apprenticeships varied, four years was the norm in Antwerp.[9] In 1522, Claas entered the workshop of a second master, Adriaan Tack, again as a pupil, six years after he started his training with Joos van Cleve. One year later, in 1523, Joos accepted a new pupil. Does this mean that Claas van Brugge was active as Joos van Cleve's apprentice for six years or that, after the training period of four years, he worked as a fully qualified painter, in other words as a *gezel*? It is, after all, remarkable that Van Cleve accepted a new pupil only one year after his first employee had entered Adriaan Tack's workshop.[10] There are five other known examples in the years between 1500 and 1540 of artists who, after a training period with another master, entered a different workshop and started again as a pupil.[11]

There are no references to Claas van Brugge as a free master. Could this mean that he remained a journeyman or an assistant during his whole career? It is striking that Claas was registered again as a pupil because we can assume that he was, at that moment in 1522, already trained to do all the different activities in a workshop. His case is contrary to the idea that an apprentice entering a workshop was at the beginning of his training and not able to make paintings himself. Claas van Brugge was capable of producing

[9] Floerke, *Studien*, p. 130.
[10] Rombouts and Van Lerius, *De Liggeren*, p. 100.
[11] Other artists who registered twice as a pupil include Jan Bouwens alias Minicus (1504 and 1507), Cornelis Geerts (1508 and 1516), Adriaan Pieters (1511 and 1523), Gillis Cornelis (1532 and 1535) and Hans Schrivers (1551 and 1558). For this information I wish to thank Max Martens and Natasja Peeters.

paintings from the start of his apprenticeship at Adriaan Tack's studio. He was, however, probably an exception.

Workshop assistants: non registered 'gezellen'

It is remarkable that Joos van Cleve obtained so many important commissions at the beginning of his career in Antwerp.[12] In addition, we have to reckon with the altarpieces which have been lost over time. In 1515 Joos van Cleve produced the triptych of *The Death of the Virgin*, which had been commissioned by the brothers Nicasius and Georg Hackeney in Cologne.[13] Shortly afterwards, another, much larger, altarpiece of *The Death of the Virgin* was also made for this family (now in Munich, Alte Pinakothek).[14] Around the same time, Van Cleve painted *The Adoration of the Magi*, the so-called *Small Adoration* in Dresden.[15] In 1516 the *Reinhold altarpiece* was installed in the Sankt Marienkirche in Gdansk[16] and in about 1520 the *San Donato altarpiece* was made for Stefano Raggio.[17]

These altarpieces, which Joos van Cleve made on commission, could not have been produced without the co-operation of assistants.[18] In some cases the amount of help is quite obvious, as for example in the *Reinhold altarpiece* (now in the Muzeum Narodowe in Warsaw). This compound altarpiece with a double pair of painted wings by Joos van Cleve and his workshop contains work of varying quality. The outer wings and some details on the inner wings are of much higher quality than the rest of the panels. For example, Joos van Cleve seems to have corrected the work of an assistant in the face of Christ in the panel of *The Baptism*.[19] The underdraw-

[12] In my forthcoming dissertation (*Joos van Cleve*) a chapter will deal with the commissioned altarpieces.

[13] *Death of the Virgin*, Cologne, Wallraf-Richartz Museum, inv. WRM 430, dated 1515 and signed with the IvaB-monogram (central panel: 63 x 123 cm ; wings: approximately 63 x 57 cm).

[14] *Death of the Virgin*, Munich, Bayerische Staatsgemäldesammlungen, Alte Pinakothek, inv. WAF 150, 151, 152 (central panel: 132 x 154 cm; wings approximately: 132 x 73 cm). The triptych can be dated after 1515 and before 1523.

[15] *The Adoration of the Magi*, Dresden, Staatliche Gemäldegalerie, inv. 809 (110 x 70,5 cm).

[16] *Reinhold altarpiece*, Warsaw, Muzeum Narodowe, inv. 185.007 (central panel: 194 x 158 cm; each wing: approximately 194 x 158 cm).

[17] *San Donato altarpiece*, Genoa, Chiesa di San Donato (Leeflang, 'The San Donato altarpiece', pp. 35-47; Leeflang and Klein, 'Information on the Dating').

[18] Leeflang, 'The Reinhold altarpiece'.

[19] *Ibidem*. M. Faries, M. Leeflang, P.B.R. van den Brink, L. Jansen and D. Meuwissen examined the *Reinhold altarpiece* in Warsaw on 17-20 April 2001. Indiana University's Grundig equipment: a Grundig 70 H television camera set at 875

ing and probably also the paint layers, which had been applied by an assistant in this specific area, have been scratched away. Judging by the painting technique, it seems that the master himself painted the face of Christ. The pattern of cracks is continuous, so it must be an original change. This proves the hierarchy of Joos van Cleve as master and the anonymous *gezel* or specialist. On the right outer wing, Van Cleve painted his self-portrait as Saint Reinhold. The painting technique of the outer wings and of some details on the inner wings is typical of the master himself, while the other panels were made by a different hand. Who was responsible for these other parts of the altarpiece?

Aside from the difference in quality mentioned above, the very detailed and exact underdrawing of these inner wings most likely functioned as *vidimus* for the commissioners and as a guide for the workshop assistants (fig. 2). Forty-three colour notations have been found on the inner wings, which may have been indications for the assistants. At the time of the realisation of the *Reinhold altarpiece*, Joos van Cleve had only one pupil, Claas van Brugge. It is, however, unlikely that an apprentice who had just started in the workshop would have been allowed to paint the inner wings for such an important commission, unless he had already been trained in another workshop. Normally students started their training with the grinding of pigments, making drawings after the compositions of their master, and so on.[20] Helping the master with the painting process was part of a later stage of the training. We cannot prove whether Claas van Brugge was qualified to paint the inner wings or not. Assuming that Claas van Brugge did not contribute extensively to the production of the *Reinhold altarpiece*, there must have been another painter in the workshop, who was not registered in the *Liggeren* as an apprentice of Joos van Cleve and who was probably a *gezel*. This assistant may have been a specialist in the production of wings in the Antwerp Mannerist style for compound altarpieces, who moved from one workshop to another,[21] which could explain the corresponding working methods detected during research with IRR on works by The Master of 1518, Adriaan van Overbeke and The Master of the Antwerp Adoration.[22]

lines and outfitted with a Hamamatsu N 214 infrared vidicon, a TV Macromar 1:2.8/36 mm lens, and Kodak 87 A filter, with Grundig BG 12 monitor; documentation with a Canon A-1 35 mm camera, a 50 mm Macrolens, and Kodak Plus X Film. M. Leeflang made the IRR assemblies with Vips 6.7 and Adobe Photoshop 5.0. I wish to thank M. Kluk and M. Monkiewics from the Muzeum Narodowe for their assistance during our research.

[20] Ceninni, *Het handboek*.

[21] Leeflang, 'Workshop practices'.

[22] I wish to thank Peter van den Brink (see for example: Van den Brink, 'Two Unknown Wings', pp. 6-20) and Molly Faries for this information.

Another example for consideration is the *San Donato altarpiece*, which consists of a central panel showing *The Adoration of the Magi*, a left wing depicting the donor and Saint Stephan, a right wing with Magdalen, a lunette with *The Crucifixion*, and two small panels above the wings containing clouds.[23] This is another example of a work that could not have been made without the help of assistants. Indications of co-operation, however, are not as decisive as those in the *Reinhold altarpiece*. The underdrawing in the main panels (the central panel and the wings) is not as detailed as the altarpiece in Warsaw and could not, therefore, have been a guideline for the assistants.[24] There is, however, a drawing in Amsterdam (Rijksprentenkabinet) with the same composition as the central panel and which could have functioned as a preparatory drawing for the master himself or for his collaborators. In this context, the question of whether Joos van Cleve could have executed this large altarpiece (central panel: 156.5 x 138 cm; left wing: 162.5 x 66.5 cm; right wing: 162.5 x 67 cm) alone, is more significant. The artist was also working on other commissions during the same period.

The lunette with *The Crucifixion* was certainly made by an assistant. Both underdrawing and the painting technique deviate from the rest of the altarpiece: it is executed with less detail, the underdrawing is very sketchy and easy to detect with the IRR-camera, the paint layers are thin and quickly applied, and details, such as the lines between fingers and toes, are not indicated.

Is the participation of a *gezel* always visible? If his labour was limited, for example, to the grinding of pigments or the application of the first layers of paint, his work would not be discernible. On the other hand, for example, the excellent execution of the brocade cloth in the *San Donato altarpiece* is remarkable and does infer that a specialist was at work. Without documents that prove the collaboration of *gezellen* or specialists in the workshop of Joos van Cleve, the examination of the painting technique and the under-

[23] M. Leeflang, 'The San Donato altarpiece'.

[24] M. Faries, M. Leeflang, M. Galassi, L. Jansen and D. Meuwissen carried out this research with IRR on 8-10 April 2002. Also present were Chiara Masi and Daniele Mignonege, whom I wish to thank for their help. Equipment of M. Galassi: Hamamatsu camera with a Nikon 55 mm lens, Hamamatsu C 2400 control box camera and a Sony 12 inch monitor. Any documentation is done with a Canon A-1 35 mm camera, a 50 mm Macro lens, and Kodak Plus X Film. The author made the assemblies with Vips 7.6 and Adobe Photoshop 5.0 (2002). I wish to thank M. Galassi for her assistance during my stay in Genoa and also for discussing the underdrawings of Joos van Cleve. On 17 March 2003 M. Leeflang, M.C. Galassi, C. Masi and D. Mignonege used IRR to study the *San Donato* lunette in the exhibition *Joos van Cleve e Genova*.

drawing can only give indications of the presence of assistants, who are not registered in the *Liggeren*.

Joos van Cleve's connection with other artists

In 1522 Claas van Brugge moved to the workshop of Adriaan Tack.[25] There are no works attributed to this master but it is known that he knew Joos van Cleve well. In 1538 Adriaan Tack and Joos van Cleve became members of the *Armenbus*, the poor relief fund of the Saint Luke's guild.[26] The most important reference to the relationship between the two painters is the fact that Tack was one of the three guardians of Joos van Cleve's children, Jozijne and Cornelis, following their father's death in 1540/41. In the archival document, Adriaan Tack, Henrik Ulen and Joris van Yserloo are called *vriende ende maghe ende geleverde momboren* ['friend, relative and guardian'].[27] Perhaps Adriaan Tack and Joos van Cleve often shared the same artists.[28] Perhaps Van Cleve hired Claas van Brugge after 1522 for important commissions. There are no other references to Adriaan Tack's workshop. Besides Claas van Brugge no other pupils were registered. Claas did not become a free master, so we may assume that he stayed in Tack's studio as a collaborator.

Another artist, who was also a friend of Joos van Cleve and Adriaan Tack, was the much younger Pieter Coecke van Aelst. He was born in 1502 in Brussels and became a free master of the Antwerp Saint Luke's guild in 1527.[29] Adriaan Tack and Pieter Coecke founded the Armenbus in 1538. Maarten (Merten) Tymens, a glassmaker, was also registered as one of the members in that year. Tymens, who was related to Joos van Cleve, acted together with Pieter Coecke as a witness on 10 November 1540 when a notary

[25] Adriaan Tack also became a free master in 1522 (Rombouts and Van Lerius, *De Liggeren* , p. 99).
[26] Antwerp, Archive of the Royal Academy of Arts (hereafter as: A.K.A.S.K.A.), Oud archief 243 (4), *Bussenboek der Sint-Lucasgilde inschrijvingsboek van de broederschap van de Armenbus*, 1538-1627, fol. 8 (unpublished).
[27] Antwerp, City Archives (hereafter as S.A.A.), Aldermen's Registers, SR 204 RH I, 1541, fol. 51.
[28] Van der Straelen, *Jaerboek*, p. 10. Cf. statute XV: *Item dat nymant des anders knape hueren en sal moghen, ten waere dat die knape van zynen meester hescheyden ware, ende voldaen hadde, op te peyne van twee rynssche gulden ende knape eenen rynsschen gulden bekeeren in dryen als vore.* This statute seems to confirm the working situation in which one master hired apprentices from another master's workshop. If this had not been the case there would have been no need for this statute.
[29] Campbell Hutchison, 'Coecke van Aelst', p. 518. Linda Jansen is preparing a PhD-dissertation on Pieter Coecke van Aelst (see paper by Jansen in this volume).

drew up an act to arrange financial support for Van Cleve's illegitimate daughter, Tanneke.[30]

The close relations between artists probably promoted the circulation of ideas. I do not intend to imply that different masters shared workshop models,[31] but Adriaan Tack, Joos van Cleve and Pieter Coecke must have seen each other's works. Of course they could have made the decision to keep on working in their own style, and perhaps the works of their colleagues and friends did not have the influence on their own products that might be expected. As there are no works attributed to Adriaan Tack, it is impossible to study the mutual influences of Tack and Van Cleve. Pieter Coecke van Aelst is, however, a different case. Many artworks are attributed to this master, and the paintings, like the oeuvre of Joos van Cleve, differ in style and technique. The division between Joos van Cleve and Pieter Coecke is, in most cases, quite clear. However, in several important photo archives, such as the Rijksbureau voor Kunsthistorische Documentatie (RKD) in The Hague and the Koninklijk Instituut voor het Kunstpatrimonium (KIK) in Brussels, photographs of paintings by Pieter Coecke are classified as Joos van Cleve's work and vice versa. Indeed, in some figure types, Van Cleve and Coecke seem to have been influenced by each other or by the same sources.[32] The panels depicting *Saint Jerome in his study* copied after Albrecht Dürer (Lisbon, Museo Nacional de Arte Antiga), for example, are attributed to both artists.[33] The pose of the Virgin with her hands crossed on her breast is similar in the panel of *The Crucifixion* by Joos van Cleve in Boston (Museum of Fine Arts) and in *The Crucifixion* by Pieter Coecke in Neuss (Clemens-Sels-Museum). The influence of The Master of 1518, Pieter Coecke's putative master, is also present in the work of Van Cleve. In particular, close similarities can be seen in scenes produced by each of these three painters of *The Adoration of the Magi*. The black king on the right wing of the triptych of *The Adoration of the Magi* by Pieter Coecke in Madrid (Museo del Prado) and Baltasar on the right wing of Joos van Cleve's work in Naples (Museo di Capodimonte) are, for instance, represented in the same pose and with similar rich garments.[34]

[30] S.A.A., Notaris 's Hertoghen, N. 2071 (1540-43), fols. 234ᵛ-235ᵛ.

[31] More research is needed on the exclusive rights of, for example, popular compositions.

[32] Both artists were influenced by, for example, the Master of 1518. I will deal with this issue in my dissertation. See also my article 'Workshop convention'.

[33] One of the best versions of this painting by Joos van Cleve is in the collection of the Fogg Art Museum, Boston, inv. 1961.26. A typical Pieter Coecke version is located in the Musée d'Art et d'Histoire in Geneva.

[34] Baltasar is painted in the same clothes and pose in the triptych by the Master of 1518 (workshop), Paris, private collection (illustration in Marlier, *La Renaissance*

Works attributed to pupils of Joos van Cleve: imitator A, Claas van Brugge (?) and The Master of the Antwerp Adoration, Cornelis van Cleve

It has been possible to group paintings by two of Joos van Cleve's pupils. Friedländer wrote that: '[Imitator A]

> *an dem kalten, weißlichen, opaken Fleischton, an den schwarzen Schatten im Fleische, die fleckig eingesetzt sind. Die Pupille ist dunkle und lichtlos, die Brauen sitzen übermäßig hoch oder fehlen. Alle Köpfe haben etwas Ältliches, Verkümmertes. Die Finger sind breit und plump. Wenn ich recht sehe, läßt sich die Unmanier dieses Gehilfen in Bildern nachweisen, die in der Werkstätte des Meisters von Cleve und zwar ziemlich früh entstanden sind.*[35]

Based on stylistic elements, the works attributed to this Imitator A were probably painted between 1516 and 1522. Friedländer therefore identified this Imitator A as Claas van Brugge, who was the only pupil in the Van Cleve workshop at that time. According to the author, the *Lying Christ Child* in Antwerp (Koninklijk Museum voor Schone Kunsten) is a typical example of the paintings made by Imitator A, Claas van Brugge. It is, however, still possible that another pupil or *gezel*, who was not registered in the *Liggeren*, painted this work.

Friedländer's description also applies to some other works attributed to Joos van Cleve. For example, in the two panels of *Virgin and Child with Joachim and Anna* in Paris (fig. 3), the figures have dark eyes, the shadows are mixed with black paint, and so on. Perhaps Imitator A made these paintings as well.[36] When we compare these Paris panels with the work in Poznan (fig. 4) of the same composition, it becomes clear that this latter painting is more similar to the products made by Joos van Cleve himself.[37]

flamande, fig. 51, p. 127).

[35] Friedländer, *Die altniederländische Malerei*, pp. 66-67. English transl.: '[Imitator A, Claas van Brugge] is identified by his cold, whitish, opaque flesh tints, and the black shadows patchily inserted into flesh. The pupils are dead and dark, the eyebrows either absent or placed excessively high. All his faces have an aged and stunted look. The fingers are broad and blunt ... The vagaries of this assistant appear in pictures done in the workshop of Joos van Cleve at a rather early stage' (Friedländer, *Early Netherlandish Painting*, p. 43).

[36] The panels are located in the Musée des arts décoratifs and Musée d'Histoire de la Médecine. I wish to thank M. Blanc (Musée des Arts Décoratifs) and H.V. Clin (Musée d'Histoire de la Médecine) for the opportunity to study the paintings.

[37] This panel was, however, also painted by an assistant. The painting technique is nevertheless more similar to that of Joos van Cleve. The assistant, who was responsible for the execution, was trained to use the working method which is typical of Joos van Cleve. I wish to thank P. Michalowski of the Muzeum Naradowe at Poznan

The painting technique of the Poznan panel is totally different to the Paris paintings. The colours of the work in Poznan, for example, are soft, the blushes on the cheeks are painted with a *sfumato* effect, and the transparent and dry use of brown paint for the hair and fur is highly characteristic of Van Cleve. However, the main lines of composition in the three paintings correspond, which indicates the use of the same cartoon.[38] It is therefore most likely that the paintings were executed in the same workshop.

Another painter whose work can be distinguished from his master's is Joos van Cleve's son, Cornelis. Whitish fleshtones and softness in the faces are typical of his work. The painting of the *Adoration of the Magi* in Antwerp functioned as a starting point for Friedländer in selecting the group of works which he attributed to the anonymous Master of the Antwerp Adoration. He wrote that:

> *der offenbar um 1550 tätige Nachfolger in der Formensprache durch Breite, Größe, Weichheit und gesteigertes Helldunkel entscheiden abweicht von seinem Vorgänger, aber in gewissen Einzelheiten, dem metallischen Schmuckwerke sowie in der kleinlich und altertümlich gestalteten Landschaft der Hintergrundes von Vorbildern, die etwa 25 Jahre zurückliegen, nicht losgekommen ist. Dies Verhältnis erklärt sich am leichtesten, wenn wir annehmen, daß der Meister der Antwerpener Epiphanie Zeichnungen aus dem Atelier des Meisters van Cleve geerbt hatte, als der Sohn.[39]*

Friedländer suggested a comparison between the *Adoration of the Magi* by Cornelis van Cleve (fig. 5) and those by Joos van Cleve in the central panel of the Prague altarpiece and in the *San Donato altarpiece* in Genoa.[40] The

for allowing me to study the painting (26 April 2002).

[38] Leeflang, 'Serial Production'.

[39] Friedländer, *Die altniederländische Malerei, Pieter Bruegel*, p. 116. English transl. p. 49: 'this follower, presumably working about 1550, while departing quite sharply from his predecessor in formal idiom – breadth, format, softness, enhanced chiaroscuro – never rid himself of certain details that marked models from some 25 years in the past such as the metallic style of ornamentation, and the fussy and old-fashioned background landscape. The relationship is most plausibly explained by the assumption that the Master of the Antwerp *Adoration* inherited drawings from the studio of Joos van Cleve and was his son'.

[40] Friedländer, *Die altniederländische Malerei, Pieter Bruegel*, p. 49. The *Adoration of the Magi*, Prague, Narodni Gallery and the *San Donato altarpiece* have been examined with IRR. M. Faries, M. Leeflang, P. van den Brink and L. Jansen studied the Prague triptych on 27 May 2001 using Indiana University's Grundig equipment: a Grundig 70 H television camera set at 875 lines and outfitted with a Hamamatsu N 214 infrared vidicon, a TV Macromar 1:2.8/36 mm lens, and Kodak 87 A filter, with Grundig BG 12 monitor; documentation with a Canon A-1 35 mm camera, a 50 mm

most significant difference between the paintings of *The Adoration of the Magi* by Joos and the work by Cornelis in Antwerp is the half-sized figures of Cornelis. Furthermore the faces of the Virgin and the Child are notably whitish and the king with the brown beard is probably Cornelis' own invention. Joos van Cleve painted this character with a pointed hat, often decorated with tassels and beads, and a long light-brown beard, while his son gave this king a short dark-brown beard and more simple headgear. Despite the differences, there are many similarities which are probably more significant. Cornelis van Cleve adapted the figure of Joseph from the Prague central panel by his father for his own *Adoration of the Magi*. The figure's pose with the straw hat in the right hand, the red coat over a dark blue garment and the greyish beard is comparable. Cornelis' black king on the right corresponds, for example, to Baltasar on the right wing of the triptychs of *The Adoration of the Magi* in Naples and Detroit, the *San Donato altarpiece* in Genoa and *The Adoration of the Magi*, the so-called *Large Adoration* in Dresden. The rich cloth, golden necklace, ermine fur and red headgear correspond in the five paintings. The building in the background of the panel by Cornelis van Cleve is exactly the same as, for instance, the building in the triptych in Prague and the altarpiece of the Chiesa di San Donato in Genoa (figs. 6-7). As well as comparable compositional elements, the *San Donato altarpiece* also reveals similarities in painting techniques. When we compare the man with the brown beard in the central panel in Genoa and, for example, Joseph and the kneeling king painted by Cornelis, it is clear that Cornelis studied his father's paintings carefully. Both artists used a very fine brush to paint individual hairs and concentrated on small details, for instance, the wrinkles on faces and hands. The dry and transparent use of brown paint for fur and hair is also characteristic of both painters.

The background figure with the turban on the left side of the Antwerp panel seems to be adapted from the man behind the standing king in the *San Donato altarpiece*.[41] More important, however, are the similarities that can

Macrolens, and Kodak Plus X Film. M. Leeflang made the digital IRR assemblies with Vips and Adobe Photoshop. The examination took place in the Bonnefantenmuseum in Maastricht during the exhibition *Imperial Paintings from Prague*. I wish to thank Olga Kotková for her permission to study the painting. M. Faries, M. Leeflang, M.C. Galassi, L. Jansen and D. Meuwissen examined the *San Donato altarpiece* on 8-10 April 2002 using Galassi's equipment: Hamamatsu camera with a Nikon 55 mm lens, Hamamatsu C 2400 control box camera and a Sony 12 inch monitor. Any documentation is done with a Canon A-1 35 mm camera, a 50 mm Macro lens, and Kodak Plus X Film. The author made the assemblies with Vips 7.6 and Adobe Photoshop 5.0 (2002). First results of the IRR-research on the last mentioned panel are published in Leeflang, 'The San Donato altarpiece'.

[41] The *San Donato altarpiece* was made between approximately 1514 and 1520. It

be seen in the underdrawing of these two figures. In both paintings, the man
is a background figure and the underdrawing is limited to a contour for the
face, nose, eyes and mouth. The cheekbone is clearly indicated, as is the
form of the turban. These similarities in the method used for the underdraw-
ing are, however, even more clear when we compare, for example, the king
with the short brown beard[42] with the Virgin Mary in the panel of the *Virgin
and Child with Joachim and Anna* in Brussels (figs. 8-10).[43] Like most un-
derdrawings by Joos van Cleve, the layout of the Antwerp *Adoration of the
Magi* was done in a dry medium, chalk or charcoal. Both artists used hori-
zontal and diagonal hatching to indicate shadow and volume in the faces.
Next to the eye on the right side, both Cornelis and Joos placed short hori-
zontal hatchings, the same diagonal hatching that is found in the beard of
the king by Cornelis and in the neck of the Virgin underdrawn by Joos.
Summarising these findings, it seems obvious that Cornelis not only made
use of the same compositional elements and painting techniques as his fa-
ther, but he also made his underdrawings in Joos van Cleve's manner. Re-
search done with IRR on *The Adoration of the Magi,* the key work by Cor-
nelis van Cleve, proves that pupils were trained to work in exactly the same
way as their master, which makes the identification of apprentices compli-
cated.

Serial production

During the 1530s there was an increase in the number of works produced in
series in Joos van Cleve's workshop. Van Cleve would have needed more
assistance and probably had the financial means to accept many students. In
1535 Joos van Cleve accepted two pupils and then another one in 1536. At
the time the workshop often made use of cartoons to trace the main lines of
the compositions and, in the paintings produced in series, it is not possible

was commissioned by Stefano Raggio in Genoa and the altarpiece was shipped to
Italy immediately after execution. Cornelis could not have seen the original painting
because he was only born in 1520. There was, however, probably a model drawing
that remained in the workshop (now in the Rijksprentenkabinet in Amsterdam),
which could have been used by Cornelis.

[42] M. Faries, M. Leeflang, L. Jansen and D. Meuwissen did the IRR-examination of
the *Lying Christ Child* and *The Adoration of the Magi* in Antwerp on 13-14 March
2001, using the Indiana University equipment mentioned in note 30. I wish to thank
Paul Huvenne for his permission to study the paintings and L. Klaasen and G.
Steyaert for their help during the research. In the *Lying Christ Child* no under-
drawing was detected.

[43] My dissertation will contain further discussion of the group of paintings with a ty-
pical Joos van Cleve underdrawing.

to use the underdrawing to assist in the attribution or division of hands. A underdrawing traced by the master himself looks the same as an underdrawing made by one of his apprentices.

Cornelis used the same models as his father, as for example in *The Madonna of the Cherries* in Munich.[44] In this painting the Virgin's face is painted in the manner characteristic of Cornelis, i.e. with a strong '*sfumato*' effect and a pale whitish flesh tone. Although the varnish has yellowed with age, it is plausible that the flesh tones in this painting were as pale as those, for instance, in the *Holy Family with Elisabeth and Saint John* (Bruges).[45] If we compare the Munich panel, which is certainly based on his father's composition, with, for example, the *Madonna of the Cherries* in Aachen[46] and the version in the collection of Hester Diamond,[47] which are most likely painted for the greater part by Joos van Cleve himself, some points have to be noted. There are a few differences in both composition and painting technique. The head of Christ is smaller in the panel by Cornelis, and the position of the Child's head and body is more realistic. The '*sfumato*' effect is more pronounced than in Aachen, and the Hester Diamond Collection, and the landscape typical of Joos van Cleve is missing in the variant painted by Cornelis. In place of the window with a view which appears in the Aachen and Hester Diamond panels, Cornelis painted an evenly toned brown background wall with an almost modern vase in a brownish-grey tone on the left-hand side. The colours used by Cornelis for the Virgin's garments are sombre compared to the bright, especially primary colours applied by Joos van Cleve. Possibly Cornelis adapted his father's compositions in response to requests from clients who preferred a stronger Italian influence.

Cornelis van Cleve probably became a free master in 1541 in order to continue the workshop of his deceased father. The year 1541 is, however, missing in the *Liggeren*.[48] A reference in the *Bussenboek* for the registered persons in the years between 1544 and 1547 proves that he was indeed a free master; otherwise he would not be allowed to become a member of the *Armenbus*.[49] Perhaps, after the death of their master, Jacob Tomasz, Frans Dussy, Willem de Stomme and Joost Diericksz stayed in the workshop un-

[44] *Madonna of the Cherries*, Munich, Alte Pinakothek, inv. WAF 489, dimensions: 102 x 73 cm.

[45] *Holy Family with Elisabeth and Saint John*, Bruges, Groeningemuseum, inv. 375, dimensions: 95 x 74 cm.

[46] *Madonna of the Cherries* is part of the Hester Diamond Collection (New York). Formerly Colnaghi Collection (2003), 71 x 51 cm.

[47] *Madonna of the Cherries*, Colnaghi Collection (2003), 71 x 51 cm.

[48] Rombouts and Van Lerius, *De Liggeren*, p. 141.

[49] A.K.A.S.K.A., Busboek, fol. 11 (unpublished).

der the guidance of Cornelis van Cleve.[50] This could partly explain the
enormous number of works attributed to the Joos van Cleve group. These
artists had Joos van Cleve's cartoons at their disposal, knew the working
methods, and so on. The dendrochronological information of some of these
works produced in series could partially confirm this hypothesis.[51]

Conclusion

Research on the *Liggeren,* presented by Martens and Peeters at the confer-
ence of *Historians of Netherlandish Art*, demonstrates that workshops with
five pupils can be considered large for the period 1500-1539.[52] Presumably
there were also *gezellen* or specialists active in Joos van Cleve's workshop.
The *Reinhold altarpiece* and the *San Donato altarpiece* seem to uphold this
presumption.

Most of the pupils probably remained active as a *gezel* following their
training in their master's workshop.[53] Presumably because of a lack of
money, the *gezellen* or journeymen were not able to start their own work-
shops. An artist needed starting capital to establish a workshop: to buy ma-
terials, to rent or buy a studio, to pay assistants or *gezellen*, and so on. This
could be the reason why Claas van Brugge started again as a pupil in an-
other workshop and why there are no references in the *Liggeren* regarding
Joos van Cleve's other four apprentices obtaining their master titles. Of
course it is possible that these artists set up a workshop in another town, or
that the year that they were admitted as free masters is missing from the
Liggeren, or that they dropped out or died. There is, however, a good possi-
bility that Jacob Tomasz, Frans Dussy, Willem de Stomme and Joost
Diericksz carried on working in Joos van Cleve's workshop.

Joos van Cleve's contacts with other artists like Adriaan Tack and
Pieter Coecke were probably an important factor in the presence of *gezellen*
and specialists in the Van Cleve workshop. It is likely that Joos hired assis-
tants that he knew were qualified. Claas van Brugge was trained and
worked in Van Cleve's workshop before moving to the workshop of Joos's
acquaintance Adriaan Tack. Therefore, it is possible that Claas van Brugge
helped Joos van Cleve with important commissions after 1522, if Tack's
workshop allowed this.

[50] Leeflang, 'Serial Production'.
[51] Leeflang and Klein, 'Information on the Dating'.
[52] Martens and Peeters, 'Artists by Numbers'.
[53] See the contribution by Natasja Peeters (with the collaboration of Max Martens)
in this volume.

From the analysis of the many works of Van Cleve, it seems that the artist hired a specialist for certain areas of the paintings, for instance, for the landscape and the brocade cloth in the *San Donato altarpiece* and in the *Adoration of the Magi* in Naples. The *Linsky Madonna* in New York contains a landscape of the same quality and the still life with fruits in the foreground could also be the work of a specialist. Van Mander has mentioned a painting by Van Cleve: '... *van zijner handt een seer schoon Mary-beeldt/ waer achter dat van Ioachim Patenier is een seer schoon Landt-schap'*.[54] Collaboration between Joos van Cleve and a landscape specialist has been suggested more than once in the literature since then.[55] This co-operation between masters, which has been coined 'horizontal or prestige collaboration', was most likely the result of economic circumstances.[56] As Ainsworth wrote: 'The changes in the workshop structure and day-to-day operations that took place in the first half of the sixteenth century were tied to economic concerns'.[57] Most artists seem to have specialised in specific market segments and this stimulated co-operation between different masters. Joos van Cleve's paintings seem to demonstrate this, although no documents provide information about which masters worked with him. The identification of the assumed specialists can, therefore, only be based on stylistic comparisons.

Between 1516 and 1535 Joos had only one person as a pupil in his workshop (first Claas van Brugge from 1516 until 1522, and then Jacob Tomasz from 1523 until the end?). In my opinion pupils probably cost more than the employment of specialists or *gezellen* because, as mentioned above, students were given board and lodging at their master's place. On the other hand, we can assume that specialists or *gezellen* received more money for their activities because they were skilled artists. In contrast, the apprentices who were still in training were given board and lodging but probably no salary. Nevertheless I assume that it was cheaper to hire a specialist or *gezel* for a short period because the master of a workshop knew that these assistants were qualified to execute specific work and could finish the job within a fixed period. Therefore, at the beginning of his career in Antwerp when he received many commissions, especially for triptychs, Joos

[54] Van Mander, *The Lives*, pp. 166-167.

[55] For example, it has been suggested that a landscape specialist worked on *Saint John on Patmos* (Michigan, The University of Michigan Museum of Art) and *The Crucifixion* (Boston, Museum of Fine Arts). Conway, *The Van Eycks*, p. 404 (Patenier); Gibson, *Mirror of the Earth*, pp. 17-18 (Gassel); Ainsworth, in Ainsworth and Christiansen, *From van Eyck to Bruegel*, pp. 356-362.

[56] Faries, 'Reshaping the Field', p. 99.

[57] Ainsworth, in Ainsworth and Christiansen, *From van Eyck to Bruegel*, pp. 211.

van Cleve probably employed *gezellen* and specialists for the production of altarpieces. Apprentices would not have been able to help the master with this work because they did not have the skills.

When there was an increase in the number of works produced in series during the 1530s, Joos needed more assistance and therefore took on two pupils in 1535 and another in 1536. He could use these apprentices in the early stages of the production of these paintings because tracing a cartoon and filling in the first layers of paint in the underdrawings of works made for the open market was not difficult. Therefore I assume that Van Cleve did not need so many *gezellen* or specialists during the period when he was engaged in serial production.

Cartoons were often used in the production of such panels, making it impossible to use the underdrawing for the attribution or division of hands. As previously mentioned, traced underdrawings, although made by different artists, look the same. Although different hands can be revealed on the basis of the paint layers in these serially produced works, it is nevertheless difficult to differentiate between the work of the registered assistants and the unregistered *gezellen*. Scholars have so far divided the work of all of Joos' students into two groups of paintings, the first being attributed to Imitator A (Claas van Brugge?), and the second being attributed to The Master of the Antwerp Adoration, Cornelis van Cleve. More research is required on the underdrawings of these two groups of paintings.

Joos van Cleve seems to have trained his pupils to do the underdrawing in a characteristic and recognisable manner, employing copious hatching in different directions and multiple contour lines. This style of underdrawing became typical of the workshop process and was continued after the master's death in 1540/41. Indeed, Cornelis van Cleve's paintings show these same working methods. Furthermore, Joos van Cleve's apprentices probably also used this painting technique. Consequently, the identification of both the students and the *gezellen*, who tried to adopt the working methods of the master who hired them, is very difficult and, as Friedländer wrote, '*Die Gehilfen machen sich mit Fehlern bemerkbar, nicht mit Tugenden*'.

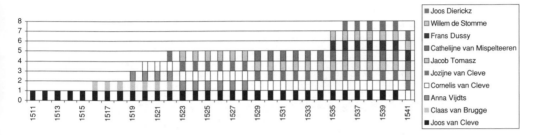

1. Event History Analysis-graph: Joos van Cleve's hearth and workshop.

2. IRR-detail of the Reinhold-altarpiece (panel with The Crucifixion) by Joos van Cleve and his workshop, Muzeum Narodowe Warsaw, (IRR Faries/ Leeflang; digital composite: Leeflang). In the middle a colour notation: 'rgl' or 'rood geel' (red yellow).

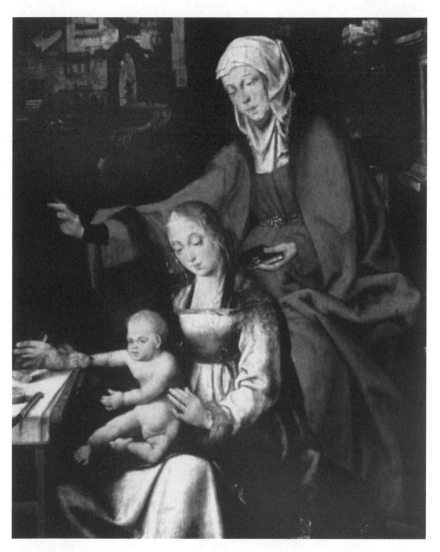

3. Workshop Joos van Cleve, probably Imitator A (Claas van Brugge?), detail of Virgin and Child with Joachim and Anna, Paris, Musée de Médecine (© Musée de Médecine).

4. Joos van Cleve and workshop, detail of Virgin and Child with Joachim and Anna, Poznan, Muzeum Narodowe (photo: Leeflang).

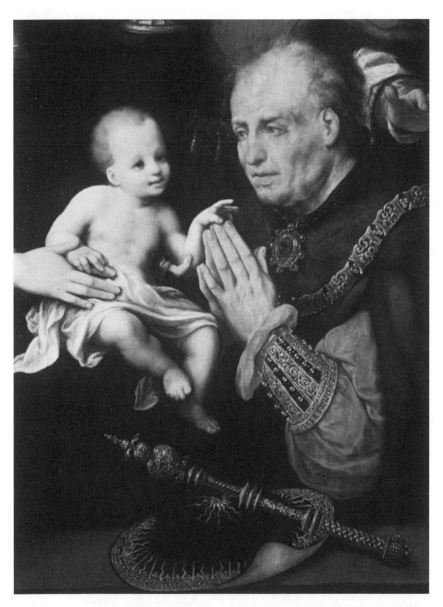

5. Cornelis van Cleve, detail of The Adoration of the Magi, Antwerp, Koninklijk Museum voor Schone Kunsten (photo: Leeflang).

6. Background building of The Adoration of the Magi, Antwerp, Koninklijk Museum voor Schone Kunsten (photo: Leeflang).

7. Background building of the San Donato-altarpiece, Genoa, Chiesa di San Donato (photo: Leeflang).

8. IRR-detail of the face of Melchior, the king with the short brown beard, The Adoration of the Magi by Cornelis van Cleve, Antwerp, Koninklijk Museum voor Schone Kunsten (IRR Faries/ Leeflang; digital composite: Leeflang).

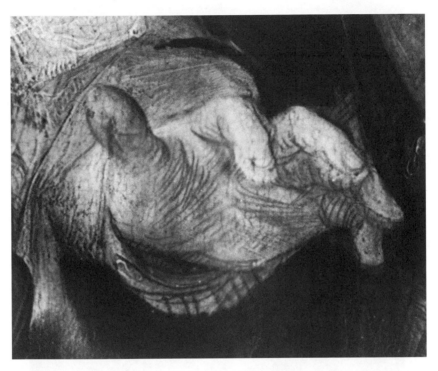

9. IRR-detail of the left hand of Melchior, the king with the short brown beard, The Adoration of the Magi by Cornelis van Cleve, Antwerp, Koninklijk Museum voor Schone Kunsten (IRR Faries/ Leeflang; digital composite: Leeflang).

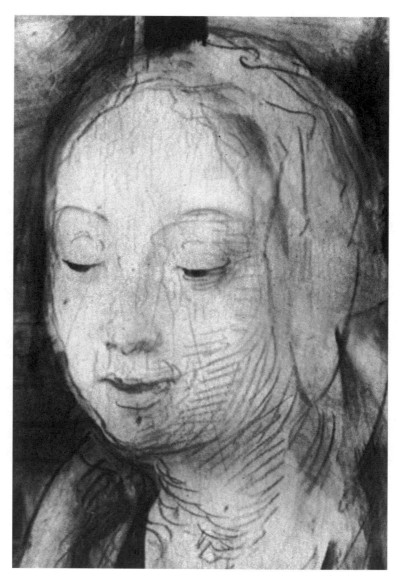

10. IRR-detail of the face of Mary of the panel with the Virgin and Child
with Joachim and Anna by Joos van Cleve, Brussels, Koninklijke Musea
voor Schone Kunsten van België (IRR Faries/ Leeflang; digital compos-
ite: Leeflang).

CONSIDERATIONS ON THE SIZE OF PIETER COECKE'S WORKSHOP: APPRENTICES, FAMILY AND JOURNEYMEN

A CONTRIBUTION TO THE STUDY OF JOURNEYMEN ON A MICRO LEVEL[1]

Linda Jansen

The versatile Antwerp painter Pieter Coecke van Aelst (active 1527-1550) is said to have had a large workshop with many assistants producing the bulk of the serial products that are attributed to him. This idea was first launched by Max Friedländer in 1917 and was further elaborated in the monograph on Coecke by George Marlier in 1966.[2] Both authors stated that the many paintings with so many stylistic differences and sometimes mediocre painting technique were made with the help of workshop assistants. However, they did not elaborate on how the workshop was organised. How big was Coecke's workshop and who worked there? Who were the workshop assistants and how many worked for Coecke? What were their exact activities and how was the collaboration organised?

These questions are not easy to answer. Information on Coecke's workshop from archival sources is scarce. Apart from some documents dealing with interests and other juridical matters, the most important information is contained in the enrolment lists of the Antwerp Guild of Saint Luke, the so-called *Liggeren*. However, following recent insights on the *Liggeren* and the organisation of sixteenth-century workshops, it is worthwhile reinterpreting the archival information on Coecke. This present study gives a more complete idea of his workshop and is more precise on its structure and size.

[1] This article is part of my forthcoming PhD thesis on the workshop of Pieter Coecke van Aelst. The study is part of the NWO-sponsored project *Painting in Antwerp before iconoclasm: a socioeconomic approach*, at the University of Groningen under the co-direction of Molly Faries and Maximilian Martens.

[2] Friedländer, 'Pieter Coecke van Alost', pp. 73-91; Marlier, *La Renaissance flamande*.

In addition, many of the questions refer to the subject of this volume, the role and status of the journeyman. This micro-level study can be used to evaluate the results generated by the survey of the guild statutes and the statistical analyses of the *Liggeren*,[3] which reflect more general trends, and can present an image of the journeyman as an individual artist.

Starting the workshop: from journeyman to master

Pieter Coecke van Aelst started his workshop in 1527 when he became a master in the Antwerp Guild of Saint Luke. The foundation for his successful studio, which would become one of the largest in Antwerp, was laid some time earlier during his apprenticeship with Bernard van Orley and during his work as a journeyman for his father-in-law, Jan Martens van Dornicke.

In his *Schilderboeck* of 1604, the sixteenth-century art biographer Carel van Mander writes that Pieter Coecke van Aelst was trained by Bernard of Brussels, which could only have been the Brussels painter Bernard van Orley.[4] Even though this cannot be certified by further archival evidence, the stylistic correspondences between the art of the two masters, especially in the designs for tapestry, lend credibility to Van Mander's statement. Coecke's apprenticeship could have taken place between 1517-18 and 1521-22. Born in 1502, he would have been fifteen years old in 1517. Although there are no guidelines for the minimum age to become an apprentice, the average age could well have been fifteen.[5] In the same period, Bernard van Orley's career received an impulse that might have caused him to take on an apprentice. His brother Everard left the Brussels workshop to start his career in Antwerp, thus creating a vacancy in the workshop,[6] and in

[3] See the contribution by Peeters with Martens in this volume. See also Martens and Peeters, 'Artists by numbers'.

[4] Van Mander, *The Lives of the illustrious Netherlandish and German Painters*, vol. 1, p. 131 (fol. 218r). In his book *Entretiens* (1668-88), Félibien also mentions Pieter Coecke van Aelst as an apprentice of Bernard van Orley as well (quoted from Marlier 1966, pp. 31-32).

[5] Miedema, 'Over vakonderwijs', p. 271. Based on the references of Van Mander, Miedema takes the age of fourteen as an average.

[6] Farmer, *Bernard van Orley of Brussels*, pp. 15-17. Farmer suggests that Bernard van Orley was active in Antwerp at the time. He considers the artist called *Bernaert* in the *Liggeren* of 1517 to be identical with Bernard van Orley because the entry precedes the one about his father Valentijn taking on a pupil. In that year this *Bernaert* takes on a pupil Peeter van Goes. However, Bernard van Orley was not registered in the Guild of Saint Luke as a master, and therefore he had no right to work in the city of Antwerp and to take on apprentices. In my opinion, this *Bernaert* is not identical with Bernard van Orley. In 1998 L. Hendrikman was also critical of the

1518 Bernard was employed as a court painter for Margaret of Austria, which probably brought in new commissions and economic resources.[7] The length of apprenticeships varied from city to city, but was set at four years in Brussels.[8] His apprenticeship in Van Orley's studio was of fundamental importance for Coecke's career. Here, he learned not only the basic artistic skills of a painter but also how to make cartoons for tapestry, and came into contact with the Brussels tapestry industry. Above all, he came into contact with the Habsburg court, where his master held the position of court painter, and became familiar with working in a large versatile workshop. Even the economic possibilities in Antwerp might have been brought to his attention in Van Orley's workshop, because both Bernard's father Valentijn and his brother Everard worked there from 1512 and 1517, respectively.[9]

At a certain point Coecke went to Antwerp, where the economic climate for artists was more profitable with an ever-growing market for paintings and other fine arts. The first time we come across Pieter Coecke in Antwerp is in a document from 1526.[10] He was already married by then and it is plausible that he had been in Antwerp for some time prior to this year. What happened exactly between *c.* 1522 and *c.* 1526, the dates of the end of the presumed apprenticeship with Van Orley and of his appearance in Antwerp, is not known. He might have stayed in Brussels to work for his master Van Orley or, if Van Mander's accounts are credible, he might even have gone to Rome during this period.[11] In the *Poorterboeken* (Citizen's

identification of *Bernaert* with Bernard van Orley. He suggested that the *Bernaert* from the *Liggeren* of 1517 might be identical with Bernard *glaesmaeker*, the artist taking on an (second) apprentice in 1519 (*Elx syne tyt*, unpublished Master's thesis, University of Groningen, 1998, p. 21). Hendrikman's suggestion is confirmed by the entry of Peter Goes, *Bernaert*'s first apprentice, as a master in 1528, when he too is called *glaesmakere* (Rombouts and Van Lerius, *De Liggeren en andere historische archieven der Antwerpsche Sint Lucasgilde*, vol. II, p. 110).

[7] Farmer, *Bernard van Orley*, p. 19.

[8] Campbell, 'The Early Netherlandish Painters and their workshops', p. 46; Mathieu, 'Le métier des peintres', p. 225. Brussels master painters were restricted to one apprentice at the time; a second apprentice was only allowed in the fourth year.

[9] Rombouts and Van Lerius, *De Liggeren*, vol. II., pp. 77 and 88.

[10] Antwerp, City Archives, Schepenregisters, sub Keyser en Ballinck (1526), fol. 147: *Anna martens alias van Doernicken Jan sdochtere, met peteren coecke alias van/ aelst schildere eius marito et tutore]*

[11] Van Mander tells us that Coecke spent some time in Italy at the general school for painters (*de gemeen Schilder-school*), where he learned about architecture as well, Van Mander *The Lives*, vol. 1, p. 131 (fol. 218ʳ). Again Van Mander's statement cannot be confirmed by archival evidence. However, in the rest of Coecke's biography, Van Mander's information is detailed and mostly correct. This Italian sojourn must then have taken place any time between his leaving Van Orley's workshop in *c.* 1522 and his appearance in Antwerp in 1526 or probably even earlier.

registry ledgers) of Antwerp, a *Peeter van Aelst* was registered in 1522.[12] Since no profession or any further information was mentioned, it is not certain whether this Peeter was indeed Pieter Coecke van Aelst. The year 1522 does not contradict any known information about Coecke's career, but there were other people with *Van Aelst* as a toponym in the same period. Furthermore, citizenship or *poorterschap* was a condition to become a member of the guild.[13] Since Coecke did not become a member of the guild right away, he had no need to register as a *poorter*. Once in Antwerp, Coecke – perhaps strategically – married Anna, the daughter of the painter Jan Martens van Dornicke (fig. 1: pedigree).[14] Marrying an Antwerp woman would have made him a *poorter* automatically, and thus he did not need to buy his citizenship.

The aforementioned document of 1526 refers to Coecke as a painter,[15] even though he was not registered either as an apprentice or as a master in the *Liggeren* of the Guild of Saint Luke in Antwerp at that time. Thus far, it has been supposed that Coecke worked in the studio of his father-in-law Jan van Dornicke.[16] Although documentary evidence is lacking, it is not unlikely that Coecke worked for his father-in-law. If Jan van Dornicke's own sons were not employed as workshop assistants – they were probably still too young at the time – it would have been a logical step to obtain assistants by marrying off his daughters to painters. The importance of the family, both as part of the professional network and as employees in painters' workshops, cannot be underestimated. Other well-known painters' families include the Van Orleys and the Van Coninxloos in Brussels and Antwerp, the Bruegels, and somewhat later in the sixteenth century, the Franckens, and the evidence that they all had a good family network is very

[12] Antwerp, City Archives, *Alfabetische index op de Poorterboeken* (typescript).

[13] Van der Straelen, *Jaerboek*, p. 2 (coming from the earliest statutes of 1382).

[14] See note 10.

[15] See note 10.

[16] Marlier, *Renaissance flamande*, pp. 109-116. Marlier even identified Coecke's father-in-law with the anonymous Master of 1518, whose oeuvre has many correspondences with Coecke's works. This hypothesis has gained a lot of approval, although Peter van den Brink has recently doubted Marlier's theory (I would like to thank him for sharing his views on this complicated matter, which will be further discussed in his forthcoming dissertation on the Antwerp Mannerists). The many triptychs with *The Adoration of the Magi*, which according to Marlier form the link between Coecke and the Master of 1518, have little in common with the key work of the Master of 1518, the dated altarpiece with the *Life of the Virgin* in the Marienkirche in Lübeck. The oeuvre of this anonymous master is, however, very complex and most likely built up around several hands. It cannot be ruled out that Jan van Dornicke can be identified as one of those.

rich. Pieter Coecke's work in the studio of Jan van Dornicke was an opportunity to earn money to pay his entry fee as a master in the guild in order to start his own workshop, and an opportunity to get to know the Antwerp market for paintings.

What would his legal position have been if he worked as a trained painter but evidently did not possess the status of master painter? It is evident that Coecke must have worked as a journeyman. From the statutes of the Guild of Saint Luke, it becomes clear that one was allowed to work in *cnaepscepen* for a master and was paid per hour or for the time of the contract.[17] These *cnaepen*, or skilled craftsmen, did not need to register in the Guild of Saint Luke if they worked for less than a fortnight.[18] If they did register, they had to pay candle money (so-called *keersgeld*), but only scarce information on this has been preserved. For this reason many of these journeymen remain anonymous to us. Only sporadically do we get to know such an anonymous journeyman and, in the document from 1526, we come face-to-face with Pieter Coecke van Aelst as a journeyman. How did Coecke organise his work as a journeyman? Did he work only occasionally for Jan van Dornicke? Did Coecke also work for other masters? Although highly speculative, it is temping to assume that Coecke used his contacts with the Van Orley family, and that he might have worked as a workshop assistant for Valentijn and Everard as well. Longer co-operation was certainly a possibility, as long as both parties paid their dues: the master, his master's fee and the journeyman, his candle money. A more structured form of employment would have been more profitable for both Jan van Dornicke and Pieter Coecke.

In 1527 Pieter Coecke van Aelst became a master in the Antwerp Guild of Saint Luke.[19] It is generally assumed that he took over the workshop of Jan van Dornicke after his death in 1526-27.[20] Usually the widow or sons inherited the workshop from the deceased, with all its painting materials, patterns, drawings and also the right to sell paintings.[21] In this case, Jan van

[17] Van der Straelen, *Jaerboek*, pp. 2-3 (from the statutes of 1382).

[18] *Ibidem*, p. 4. In the guild regulations of 1434 it was determined that whenever a *cnaep* worked for a certain master for a period longer than fourteen days, he was required to pay an annual fee to the guild, *keersgeld*. See also Van der Stock, 'De organisatie van het beeldsnijders- en schildersatelier te Antwerp', p. 47, and the contribution by Natasja Peeters with Maximilian Martens elsewhere in this volume.

[19] Rombouts and Van Lerius, *De Liggeren*, p. 108.

[20] Marlier, *Renaissance flamande*, p. 115.

[21] Campbell, 'Early Netherlandish Painters', p. 50. This was a regulation in the Bruges Guild of Saint Luke in 1444. It is known that the patterns were bequeathed to sons or favourite pupils (Campbell, 'Early Netherlandish Painters', p. 53).

Dornicke's wife, Lysbeth Puynder, had already died in 1515.[22] Jan van Dornicke had two sons and three daughters. From a document of 1527, in which the hereditary interests of Jan van Dornicke were bequeathed to his remaining children, Adriana, Frans, Marten and Lysbette, it is clear that Pieter Coecke's wife Anna had also passed away.[23] Coecke is present as a guardian of Frans, Marten and Lysbette, from which we can conclude that those children were still underage. Neither son was registered as a painter in the guild later on, so they probably did not start a workshop of their own nor pursue careers as painters at all.

The same document tells us that Van Dornicke's other daughter, Adriana, was married to a painter, Jan van Amstel.[24] According to recent theories, he may be identical to the artist with the phonetically similar name of *Jan van Anestelle*, who became a master in 1528, only a year after the death of his father-in-law.[25] Van Amstel found himself in the same position as Coecke. He was active as a painter but had not registered with the guild, and was also married to a daughter of Van Dornicke. He too, then, must have been working as a journeyman prior to his entry as a master in the Guild of Saint Luke. However, it has not been suggested that Jan van Amstel, as a son-in-law, ever worked in Van Dornicke's workshop. It is difficult to say who actually inherited the workshop, Adriana and her husband Jan van Amstel, or Pieter Coecke as a widowed son-in-law. Yet, all this makes it clear that there was at least one other serious candidate, besides Coecke, to take over the workshop.[26]

[22] Bergmans, 'Jan van Amstel', p. 27; Marlier, *Renaissance flamande*, p. 114.

[23] Antwerp, City Archives, Schepenregisters, sub Keyser en Ballinck, (1527), fol. 279: *Adriane martens alias van doernicke Jans dochtere met Janne van Amstel/ schildere eius marito et tutore, exultra, Cornelis spruyt tymmerman, mathys/ punters barbier, Mathys bode bonnetvercoopere ende peter van aelst als naeste vriende/ ende mage ende geleverde momboren metten Rechte van fransen martens/ ende lysbetten martens, der voers. adrianen bruederen ende susteren*

[24] See note 23.

[25] Van Mander, *The Lives*, vol. 3, p. 32. On the family relationship between Pieter Coecke and Jan van Amstel see also Jansen, 'Shop Collaboration'.

[26] Jan van Dornicke also took on three apprentices during his life. Only one of them, Jeroen (Jeronimus) Boels (apprentice in 1511), obtained the title of master painter. His entry in the Guild of Saint Luke was in the year 1526-1527, slightly before his master's death, which excludes him as a potential heir to Van Dornicke's workshop. Boels took on two pupils: Simon van Geldere in 1528 and Hanneken Quecborne in 1536 (Rombouts and Van Lerius, *De Liggeren*, pp. 76, 107, 111 and 129). Jeroen Boels must have died in or before 1543, because in this year his widow Cornelia Willems married the painter and art dealer Philip Lisaert. As Boels may have followed his master's style or used similar compositions, it is possible that, among the numerous paintings attributed to the Master 1518/ Pieter Coecke group, some

Still, Coecke remained closely involved with the Van Dornicke family, as is shown by his guardianship of the underage family members in 1527. Besides the administrative links, there are also artistic links. Coecke's painted oeuvre shows many correspondences with the Antwerp painting tradition. The large numbers of devotional triptychs that were produced in his apparently prosperous workshop were based on the successful compositional types that were popular with the previous generation of Antwerp painters. In any case, Coecke had a flying start and it is very likely that he relied on the intellectual and physical heritage of his father-in-law, at least in this part of his work. Coecke probably not only used his compositions but, more importantly, also his niche in the Antwerp market.

Expanding the workshop: apprentices and assistants of Pieter Coecke van Aelst

During the next 'phase' Pieter Coecke expanded his workshop; it would become one of the largest workshops in Antwerp. In 1529, two years after his entry into the guild as a master, a first apprentice entered his workshop: Willem van Breda. He is probably identical with the successful painter Willem Key, who came from Breda.[27] Keeping in mind that the average training would have been four years, Key probably finished his training in about 1533, which was the same year that Coecke left on a journey to Constantinople.[28] Did Willem stay in the workshop after 1533 to deputise for Coecke? Or did he leave at that time to finish his apprenticeship or to continue his career elsewhere? According to Van Mander, Willem Key was also '*een mede-discipel van Frans Floris by Lambert Lombardus van Luyck*'.[29] The Liège master Lombard had stayed in Italy during the 1530s and returned only in 1538, which means that Key could only have worked in Lombard's studio from that year onwards.[30] In 1542 Willem Key returned to Antwerp, as he became a master painter in the Guild of Saint Luke there.[31] With the term *discipel* Van Mander does not simply mean 'apprentice'. In several cases he uses it to indicate a schooled painter, for instance for Maarten van Heemskerck, who after training with two previous masters went to work

paintings are by his hand.

[27] Tillemans, 'Willem Key – Biografische gegevens', p. 68.

[28] Tillemans erroneously writes that Willem's training ended in 1531 when Coecke left for Italy. Her information on Hans Vredeman de Vries being an apprentice of Coecke is not correct either.

[29] Van Mander, *The Lives*, p. 188 (fol. 232ᵛ).

[30] Exh. cat., *Kunst voor de Beeldenstorm*, p. 331.

[31] Rombouts and Van Lerius, *De Liggeren*, vol. II, p. 143. Van Mander, however, incorrectly reported that Key became a master in 1540.

with Jan van Scorel in Haarlem.[32] Van Heemskerck probably worked as a
workshop assistant and in return received a sort of 'higher education'.[33]
However, Van Mander is not consistent in his use of this terminology, ap-
parently using this term for all 'boys' or young men in the learning phase,
which means both skilled and unskilled apprentices and journeymen.[34]

During the years between 1533 and 1538, it is possible that Key con-
tinued to work for Coecke as a workshop assistant. For Coecke, it was far
more profitable to hire an assistant who had trained in his workshop and
was familiar with his workshop routine, than to hire an 'outsider'. In return
it might have been profitable for Key to continue to work for his previous
master because these contacts would have given him more certainty of ob-
taining work especially in the economically less flourishing times of the
1530s. It cannot be ruled out that Willem Key worked for other masters as
well, notably for his older brother Wouter.[35] Wouter Key had arrived in
Antwerp as early as 1516, when he became an apprentice of Jan Cock, and
was enrolled as a master in the Antwerp Guild of Saint Luke in 1531.[36]

After ten years, which seems a relatively long interval, Pieter Coecke
took on a second apprentice in 1539.[37] The new pupil, Colyn Nieucastel,
could have been accepted to replace Willem Key, who probably left a year
earlier, as we have seen above. Colyn Nieucastel is better known under his
French name Nicolas Neufchâtel, also nicknamed Lucidel. He became a
successful portrait painter in Germany in the 1560s.[38] After five years, in
1544, a third apprentice entered Coecke's shop, Pauwels Claisz. Colve.[39] It
seems that Pauwels was accepted after Nicolas had finished his training.[40]
Whether Nicolas left the workshop after his training is not certain, but it is
possible that he too stayed as a journeyman. The shorter interval between
accepting new apprentices could be a sign of the growing prosperity of the

[32] Van Mander, *The Lives*, p. 239 (fol. 245ʳ). Faries and Jansen, 'Ecce Rex Vester',
pp. 65-66.
[33] See also the introduction to this volume.
[34] Miedema, 'Over vakonderwijs', p. 270. See also the contribution by Peeters and
Martens elsewhere in this volume.
[35] Hoogewerff, 'De werken van Willem Key', p. 42; Tillemans, 'Willem Key', p.
68.
[36] Rombouts and Van Lerius, *De Liggeren*, pp. 87 and 117.
[37] *Ibidem*, p. 135.
[38] Smith, 'Neufchâtel, Nicolas'.
[39] Rombouts and Van Lerius, *De Liggeren*, p. 150.
[40] Antwerp only had a specific restriction on the number of apprentices (two, with a
clause) from 1574 onwards. The painter Jan de Prince took on three apprentices in
1561 (Rombouts and Van Lerius, *De Liggeren*, p. 227).

workshop because, even though pupils had to pay for their training, a master had to have the capacity to lodge and train pupils.

Van Mander mentions yet another pupil of Pieter Coecke: the famous Pieter Bruegel the Elder.[41] In the art-historical literature about Van Mander, the credibility of this statement is an issue of debate.[42] In the *Liggeren* of the Antwerp Guild of Saint Luke, Bruegel is not mentioned as an apprentice of Coecke. However, Van Mander had relatively close contacts with the descendants of Coecke and therefore it is very likely that his information on Coecke is correct.[43] Besides Van Mander's statement, there is a definite relationship between Pieter Bruegel and Pieter Coecke: in 1563 Pieter Bruegel married Coecke's daughter Mayken.[44] Although this marriage took place long after Pieter Coecke's death, it is likely that the contacts between the two artists were laid much earlier, during the time Pieter Bruegel worked with Coecke.[45] Later on, Pieter Coecke's widow and Mayken's mother, Marie Verhulst, remained very influential in the Brueghel family business. According to Van Mander, she taught Jan Brueghel, the son of Pieter Bruegel, the art of miniature painting.[46]

Despite such family facts, the exact artistic relationship between the two artists remains unknown. In Coecke's biography, Van Mander calls Bruegel '*zijnen discipel*' (his disciple), and in Bruegel's biography he states that '*hij heeft de const gheleert by Pieter Koeck van Aelst*' (he learned art with Pieter Coecke van Aelst).[47] What would Bruegel's position have been in Coecke's workshop? As mentioned above, the term *discipel* is often used by Van Mander to indicate a trained artist receiving a higher education. It is possible that Pieter Bruegel got his training elsewhere and came to work

[41] Van Mander, *The Lives*, vol. 1, p. 132 (fol. 218v).

[42] Genaille, 'Carel van Mander et la jeunesse de Bruegel l'Ancien', pp. 124-128; Miedema, 'Pieter Bruegel weer', pp. 310-311.

[43] Van Mander might have had personal contact with Gillis II van Coninxloo, who was the son of Adriana van Hermans van Dornicke and Gillis I Coninxloo. This Adriana might be identical with Adriana Martens van Dornicke, the sister of Coecke's first wife Anna van Dornicke. Gillis II married Paul Coecke's widow Mayken Roebroecx after Paul's death in 1569 (Van Mander, *The Lives*, vol. 5, pp. 74-75). Van Mander had also known Hendrick and Hubert Goltzius. Hendrick made an engraving after Coecke's *Last Supper* in 1585 (Marlier, *Renaissance flamande*, p. 93), and Hubert was married to Elisabeth Verhulst, a sister of Coecke's second wife Marie Verhulst (Genaille, 'Carel van Mander', pp. 127-128).

[44] Marlier, *Renaissance flamande*, p. 42.

[45] A famous anecdote of Van Mander's tells us that Pieter Bruegel worked (and lived) in Coecke's workshop while holding his master's daughter Mayken on his arm. Cf. Van Mander, *The Lives*, vol. 1, p. 191 (fol. 233r).

[46] Van Mander, *The Lives*, vol. 1, p. 195 (fol. 234r).

[47] *Ibidem*, vol. 1, p. 132 (fol. 218v) and p. 191 (fol. 233r).

with Coecke later on. He would thus not have been registered in the ledgers of the Guild of Saint Luke.[48] His position as a *discipel*, however, is not known through archival documents. One can wonder whether these artists paid for their education as apprentices did, or whether they worked as assistants and were paid for their work while receiving further training.[49] It is not known when Bruegel worked in Coecke's studio, but this may have well been in the late 1540s. Interestingly, Pieter Bruegel became a master in the Antwerp Guild of Saint Luke only a year after Coecke's death in 1551.[50]

From the 1540s onwards, Coecke's shop grew explosively in the number of collaborators. Around 1540 he married the painter Marie Verhulst Bessemers.[51] Guicciardini[52] lists her as one of only four female painters and according to Van Mander she was a miniature painter.[53] She probably learned the art from her father. Like Anna, Coecke's first wife, Marie came from a family of artists (fig. 2: pedigree of the Bessemers-Verhulst family).[54] Her father Peeter Verhulst was a painter in Mechelen and all five of her brothers followed in his footsteps, one of them even in Antwerp.[55] Though many of Marie's artistic activities become apparent after Coecke's death in 1550 (see below), it is likely that she played an active role in the workshop during his life as well.

More importantly, from *c.* 1540 onwards, Pieter Coecke's three sons were also taken on as apprentices. The two sons from his first marriage, Pieter and Michiel, both born before 1527, would have been about fifteen in 1541-42, an age fit to start as an apprentice. It is likely, however, that masters' sons started earlier, since they were surrounded by the art of

[48] In only a few cases is an apprentice training with two masters mentioned in the *Liggeren* (see the contribution by Leeflang elsewhere in this volume).

[49] See the introduction, and the contribution by Peeters and Martens, in this volume.

[50] Rombouts and Van Lerius, *De Liggeren*, p. 175.

[51] Bergmans and Marlier both state that Coecke married Marie Verhulst between 1538 and 1540 (Bergmans, 'Le problème Jan van Hemessen', p. 148; Marlier, *La renaissance flamande*, pp. 41-42). However, two documents from the City Archives in Aalst, date 14 november 1547 and 18 february 1548 (n.s.), make it clear that Anthonette, Coecke's legal daughter from his affair with Antonia van 't Sant, was eight years old at that time (City Archives Aalst, *Schepenregisters 1547*, fols. 63ᵛ - 64ʳ and 115ᵛ-116ʳ). This means she was born c. 1539, and it is most likely that Coecke did not marry Marie Verhulst before 1540.

[52] Guicciardini, *Descrittione di tutti I paesi bassi*, p. 225.

[53] Van Mander, *The Lives*, vol. 1, p. 195 (fol. 234r).

[54] Monballieu, 'De kunstenaarsfamilie Verhulst Bessemeers'.

[55] Rombouts and Van Lerius, *De Liggeren*, p. 153. Christoffel Verhulst became a master in 1545. A year earlier his uncle Anthonis Bessemers enrolled as a master in the Antwerp guild (Rombouts and Van Lerius, *De Liggeren*, p. 147; Monballieu, 'De kunstenaarsfamilie', p. 110).

painting from the moment they were born. It is generally assumed that Paul, Coecke's natural son from his relation with Anthonia van 't Sant, was born ca 1530.[56] In a document from 1555 Pieter II Coecke and Michiel acted as guardians for their younger half-brother and -sister Paul and Anthonette.[57] This would mean that they were still underage at that time, younger than twenty-five, which means that Paul would have been born after 1530. However, from the earlier mentioned documents from 1547 and 1548 in the archives in Aalst, we know that Paul's sister Anthonette was born in 1539.[58] From this we can conclude that Coecke's affair with Anthonia may have taken place later in time, most likely after Coecke's journey to Turkey in 1533, thus from 1534 onwards. Paul then could have been ready to learn his profession as a painter from ca 1548. With his father already passing away in 1550, he probably continued his training with one of his brothers or with his stepmother Marie Verhulst.

Coecke's workshop did not only rely on apprentices and family. Just like many other artists, Coecke would also have hired journeymen. Apart from the apprentices who might have stayed on to work as journeymen after their training, the other workshop assistants remain hypothetical and anonymous. Nothing can be said with certainty about their number, the period of time they worked in the studio or their exact activities for Coecke. In this case, the paintings themselves might provide some information to bridge the gap in the archival sources.[59]

At its peak, between 1545 and 1550, the workshop could have included eight collaborators: Pieter Coecke himself, his wife Marie Verhulst, his sons Pieter II Coecke, Michiel Coecke, Paul Coecke, Coecke's apprentice Paul Claisz. Colve, and probably Coecke's workshop assistants, Nicolas Neuf-

[56] Overview of opinions on Paul's year of birth see: E. Duverger, 'Enkele gegevens over de Antwerpse schilder Pauwels Coecke van Aelst (+1569), zoon van Pieter en Anthonette van Sant', *Jaarboek Koninklijk Museum voor Schone Kunsten Antwerpen*, (1979), pp. 212-213.

[57] Antwerp, City Archives, Schepenregisters. Sub Wesembeek en Grapheus 2 (1555), fol. 31: *Adriana hermans alias van dornicke weduwe was wylen gielis van / coninxloo met peteren van else alias vande winckele uuter tyt eius marito / et tutor vercocht peteren ende michiel coeck alias van aelst als momboiren ende tot behoeff / van pauwelse ende Anthonien coeck alias van aelst natuerlicke kinderen / wylen peters coeck alias van aelst ende moeder aff is Anthonette vander sant*

[58] See note 51.

[59] Infrared reflectography and careful examination of the paint surface has revealed that, especially in the serial products, there was a lot of variation in the workshop routine. This can be interpreted as interference by many different workshop assistants in these types of products. See Jansen, 'The place of serial products'. However, more research will be published in my forthcoming PhD thesis (University of Groningen).

châtel and Pieter I Bruegel. Besides these more or less 'fixed employees', there may have been a variable number of anonymous workshop assistants, the number of which we unfortunately cannot determine.

In the 1540s, Coecke's workshop expanded not only in the number of personnel, but also in physical space and activities. In the *Stadsrekeningen* (City Accounts) of the years 1541-1542 there is a small reference to Pieter Coecke van Aelst. As an artist bringing new trade to the city of Antwerp, he was paid 12 pounds and 10 shillings to contribute to his house rent.[60] It is remarkable that this *Peeteren van Aelst* is referred to as an artist from outside the city – Coecke was evidently a citizen of Antwerp; his first marriage was to an Antwerp woman and he was registered as a member of the guild from 1527 onwards. Still, it is not likely that this person was another Peeter van Aelst and also a painter. Nevertheless, Coecke frequently resided in Brussels and thus could have been seen as an outsider.[61] Since Coecke is referred to as a painter and cartoon-maker, the payment is interpreted as Coecke having introduced the new trade of cartoon-making.[62] Schneebalg-Perelman and Campbell both noticed that the payment coincided with the death of Bernard van Orley in Brussels in 1541, thus creating a vacancy for a prominent tapestry designer and cartoon-maker in Brussels.[63] The city council may have lured Coecke to Antwerp by providing these financial contributions. The painter and designer Michiel Coxcie seems to have filled the void in Brussels from that time onwards.

What is often overlooked is the purpose of this funding by the city of Antwerp in the form of a subsidy to contribute to his house rent. Can this be interpreted as Coecke having expanded his workshop in a physical sense as well? If it was indeed the art of cartoon-making he was to practise in Antwerp, he might have needed a bigger studio. The cartoons were life-size models for tapestries, sometimes measuring up to 3.5 metres in height and 4 metres in width.[64] The archival documents unfortunately remain silent on

[60] Antwerp City Archives, Stadsrekeningen (1541-1542), fol. 86ᵛ: *Men gheeft diversen consteneeren alhier van/ buten comende ende nyeuwe neeringhe brenghende/ ende der goeden lieden kinderen leerende tot behulpe/ van huerder huyshueren Ierst peeteren van aelst/ schildere ende patroon makere, xij lb x s.* First published in Van den Branden, *De Geschiedenis der Antwerpsche schilderschool*, p. 154.

[61] Marlier reckons that Coecke brought the new trade of cartoon-making in from Brussels, and therefore is considered as coming from outside the city (Marlier, *Renaissance flamande*, p. 45).

[62] Van den Branden, *De Geschiedenis*, p. 154; Denucé, *Bronnen*, p. xvii; Marlier, *Renaissance flamande*, pp. 44-45.

[63] Schneebalg-Perelman, *Les Chasses de Maximilien*, p. 210; Campbell, 'Netherlandish designers, 1530-1560', p. 384.

[64] Only one cartoon (fragment) for a tapestry has been preserved: *The Beheading of*

where Coecke's residence and workshop – or workshops – were situated.[65] Monballieu makes an interesting remark on the family members of Pieter Coecke's second wife Marie Verhulst. He suggests that some of them might have been attracted to Antwerp by Pieter Coecke to work as cartoon painters.[66] Two of them, Marie's brother Christoffel and their uncle Anthonis Bessemers, were inscribed as *doeckschilders* (painters on canvas) in the Antwerp Guild of Saint Luke in the 1540s.[67]

It is generally assumed that the growing market for paintings in sixteenth-century Antwerp led to larger workshops that operated in a more and more standardised way to produce large quantities of replicas and copies. But how big is big? In order to make any statements about this, we need to have an idea of the average size of the Antwerp workshops during the sixteenth century. Recent statistical analysis of the *Liggeren* by Martens and Peeters has shed new light on this matter and has put the legendary 'large' workshops, for which Antwerp is known, in context.[68] One of the important outcomes is that only a relatively small number of masters concentrated on hiring many of the apprentices and journeymen, thus creating the big workshops Antwerp is usually associated with.[69] In the period 1500-1579, the majority of the master painters, as much as 67.6 per cent, never took on an apprentice, and presumably remained one-man businesses during their careers. Of the masters who did take on apprentices, 18.7 per cent took on one apprentice during their career, 7.4 per cent two apprentices, and only 3.5 per cent of the master painters took on three apprentices. From these figures it can be concluded that workshops with three apprentices were fairly rare and belonged to the bigger workshops of the period. Coecke's workshop, with 'only' three recorded apprentices during his whole career, thus belongs to the bigger ones. If we include his three sons as apprentices as well, he falls into the segment of 0.16 per cent of the master painters who took on six ap-

Saint Paul (Brussels, Museum Broodhuis), measuring 342 x 384 cm.

[65] Van der Stock, quoting Rouzet, mentions that Marie Verhulst worked in the house *De Schildpadde* on the Lombardenvest, which was the centre of the printmaking industry. Van der Stock suggests that Coecke might have worked there during his active period as well. Rouzet unfortunately gives no reference for the source. See Van der Stock, *Printing images in Antwerp*, p. 66; Rouzet, *Dictionnaire*, p. 43.

[66] Monballieu, De kunstenaarsfamilie', pp. 110-111.

[67] Rombouts and Van Lerius, *De Liggeren*, pp. 147, 153; Anthonis Bessemers later took on three apprentices: in 1549 Pauwel Smidt (p. 168), in 1554 Hansken Verhagen (p. 188: in 1555 Hans Verhagen was inscribed with Anthonis again), and in 1556 Aert Keyser (p. 199).

[68] Martens and Peeters, 'Artists by numbers'.

[69] Sosson, 'Une approche des structures économiques d'un métier d'art'. Sosson noticed a similar trend in Bruges for the period 1454-1530, where only a total of 38.7 per cent of all the masters took on apprentices.

prentices during their careers, whether in series or at the same time.[70] In the calculations of Martens and Peeters, these masters' sons are not included as apprentices, which might distort the results somewhat. However, family ties have proven to be important, so many of these one-man businesses could have been flourishing small-scale family businesses after all.

Continuing the workshop: family business

In 1550 Pieter Coecke died and was buried in the Brussels Saint Gery Church, where his former master Bernard van Orley had been buried in 1541.[71] From this we may conclude that he must have resided in Brussels at the time of his death. Unfortunately nothing is known about Coecke's activities in Brussels since the fire after the bombardments of 1695 destroyed much of the archives.[72] We do know that he was connected to the imperial court of Charles V, although the exact nature of his function is not clear.[73] Did he have dual citizenship and was he active in both Antwerp and Brussels? Were Coecke's activities concerning tapestry design and the translation of architectural treatises situated in Brussels while the Antwerp work-

[70] If masters' sons were included in the calculations this figure would obviously have been higher. Nonetheless, masters with six apprentices or more remain scarce and Coecke's workshop with six apprentices remains exceptionally large for the time.

[71] Marlier, *Renaissance flamande*, pp. 29-31; for Van Orley see Farmer, *Bernard van Orley*, p. 30.

[72] Ainsworth, *Bernart van Orley as a designer of tapestry*, p. 11.

[73] The only archival information about his contacts with the Brussels courts comes from a document from *c.* 1548 in which he is called *Pieter van aelst schildere vander Conninghinne douagiere van hongeryen etc* (Brussels, State Archives, *Chambre de Comptes. Acquits*, no. 3729 5A; also published in Cuvelier, 'Le graveur Corneille van den Bossche', pp. 29-32). The title 'painter of the emperor Charles V' is only known through secondary sources, the most important being Van Mander (Van Mander *The Lives*, vol. 1, fol. 218v (p. 133). Further evidence is the description of Coecke's epitaph by Sweertius in 1613 and the print by Gillis Hendrickx in 1665 (Marlier, *Renaissance flamande*, pp. 29, 42). In the Brussels Archives a *Peeter van Aelst* is mentioned several times, but it is not always clear whether this was Pieter Coecke van Aelst or a person with a similar name. For instance Schneebalg-Perelman and Szmydki both consider *meester Peeter van Aelst, artiste*, who designed the four mantelpieces in the new gallery of the emperor's palace in 1539, to be Pieter Coecke (Brussels, State Archives, *Chambres de Comptes. Acquites*, no. 1106; Schneebalg-Perelman, *Les Chasses*; Szmydki, 'Pieter Coecke van Aelst'). However, in another document about the same commission, the same person is called *Pierre fabri aultrement dict van aelst*. Szmydki, in my opinion erroneously, considers the addition *fabri (fabry)* to be a title derived from the Latin term *faber*, meaning artist, instead of a family name (p. 149).

shop was solely devoted to painting? What is of interest here is what happened to his Antwerp workshop after his death.

As mentioned above, it was not uncommon for a widow to inherit the workshop of her late husband. In the case of Marie Verhulst this was quite likely since she was a painter herself. However, at the moment of Coecke's death she resided in Brussels. She was still there in 1552[74] and later on in 1563 when her daughter married Pieter Bruegel in the *Kapellekerk* in Brussels. It is possible that she concentrated on the printing of Coecke's work, and that she inherited the rights to his prints. After all, she did continue to publish Coecke's translations of Serlio's treatises as late as 1558.[75] In 1553 she got a printing licence herself.[76] This may have concerned the printing of the *Moeurs et Fachons de Faire de Turcs* that was published in the same year.[77]

After their father's death, Pieter Coecke's sons, Pieter II and Michiel, started their careers as master painters. Pieter II became a free master in 1550, when he was accepted in the Guild of Saint Luke as a master's son.[78] In 1552 he accepted his first and only apprentice, Dilken de la Heele.[79] Pieter II died in 1559,[80] and a year later his apprentice De la Heele enrolled as a master.[81] Van Mander mentions in his biography of the famous painter Gillis van Coninxloo that this artist too was trained by Pieter Coecke II, but this is not supported by other sources.[82] In 1551, Pieter's second son Michiel enrolled as a master.[83] He was also registered as a master's son. He

[74] Brussels, State Archives, *Chambre de Comptes, Compte de la Recepte Generalle des Finances. Compte Septieme de Robert de Bouloingne ... 1552*, no. 1893. Also published in Schneebalg-Perelman, *Les Chasses*, p. 292.

[75] De La Fontaine Verwey, 'Pieter Coecke van Aelst', p. 191; Rolf, *Pieter Coecke van Aelst*, p. 45.

[76] Van den Branden, 'Drukoctrooien', pp. 7 and 37, no. 168; Van der Stock, 'Printing images', p. 45.

[77] Marlier, *Renaissance flamande*, p. 55.

[78] Rombouts and Van Lerius, *De Liggeren*, p. 171: *Dit syn meesters sonen [...] Peeter Cockx*. Roubouts and Van Lerius did not identify him with Pieter II Coecke, nor did Marlier. The name Cockx might very well be a variant of Coecke. However there are many other artists with a variant of this name: Cock, Kock, Kockx, Coeckx, etc.

[79] Rombouts and Van Lerius, *De Liggeren*, p. 182: *Dilken de la Heele by Peeter Coeck schilder*.

[80] Antwerp, City Archives, Schepenregisters, sub Grapheus en Asseliers 2, (1559), fol. 69ʳ. Marlier, *Renaissance flamande*, p. 47; Duverger, 'Enkele gegevens', p. 213.

[81] Rombouts and Van Lerius, *De Liggeren*, p. 219: *Dit zyn de vrymeesters die zy ontfangen hebben ... Gielies del Hee*.

[82] Van Mander, *The Lives*, vol 1. p. 330 (fol 268ʳ).

[83] Rombouts and Van Lerius, *De Liggeren*, p. 176: *Dit syn meesterssonen, hebben betaelt v sc. Brabants ... Machiel Koeck*. See also Marlier, *Renaissance flamande*,

took on two apprentices, Hans Droeshout in 1554 and Frans Meys in 1556.[84] Meys became a master in 1560.[85] Because so little is known about the activities of Pieter II and Michiel, it is difficult to make any concrete statements about the continuation of Coecke's workshop. It is tempting to assume that among the many serial products, which in some cases were produced years after Coecke's death,[86] some were made by Pieter Coecke's sons who continued to paint in his well-established tradition. The fact that they both became masters soon after the death of their father, in my opinion, proves that Marie did not continue to manage Coecke's workshop with his sons as journeymen. Did they inherit the actual workshop with all its materials, paintings and drawings, while Marie concentrated her activities on printing and disseminating her late husband's humanist ideas?

However, in a document of 1551, Marie is said to have bought out Pieter II and that he consequently did not inherit houses or grounds or other property in the city of Antwerp.[87] Three years later this transaction is brought up again and it is further specified that she bought out both Pieter II and Michiel for the sum of 300 Carolus guilders.[88] This would mean that Pieter II Coecke did not inherit the workshop, at least not the physical studio. However, Pieter II and Michiel could have obtained any painter's materials or models their father used as a gift during their father's lifetime. The transaction was not entirely unprofitable for Coecke's sons: with this considerable sum of money, Pieter II and Michiel were able to start their own workshops. Other properties of Pieter Coecke, such as land he had owned in Aalst, were also bequeathed to Marie, and after her death, in around 1600, came into the hands of the Breughel family.[89] Evidently the ways of Pieter Coecke's sons and his widow parted after his death and it was Marie who continued the Coecke legacy and made her name and her husband's lasting.

We know more about Pieter Coecke's natural son Paul. There is a note by Van Mander in his *Schilderboeck* and also an inventory of Paul's estate, written up after his death in 1569. Although he was not mentioned in the *Liggeren* as a master and never took on apprentices, Paul was certainly ac-

p. 48, who also identifies this Machiel with Michiel Coecke.

[84] Rombouts and Van Lerius, *De Liggeren*, pp. 188, 199.

[85] *Ibidem*, p. 219.

[86] Jansen, 'The Last Supper'.

[87] Antwerp, City Archives, Schepenregisters, sub Wesembeke en Grapheus 2, (1551), fol. 74ᵛ.

[88] Antwerp, City Archives, Schepenregisters, sub Wesembeke en Grapheus 1, (1554), fol. 310.

[89] Peeters, 'Family matters'. With Pieter Bruegel the Elder dying in 1567 and her daughter Mayken in 1576, Marie Verhulst played a crucial role in the family enterprise of the Breughels (see Peeters, 'Family matters').

tive as a painter. Van Mander mentions him as a copyist of Jan Gossaert and wrote that he was a painter of flower pieces.[90] Some of the so-called *Madonna with the Veil* compositions – an emulation of a Gossaert composition – are attributed to Paul.[91] The inventory of his estate makes it very clear that Paul was a painter.[92] Many painting materials are mentioned in this document. His widow, Mayken Roebroekcx, still had to pay the costs *voer dachueren van de knechten die hueren man in zyn werck ende ambacht van schilderen binnen zyne levene hebene behulpich gewees'* ['for the daily wages of the journeymen who helped her husband in the craft of painting during his life']. It does not become clear what his status as a painter was. He was not a master of the Antwerp guild, so he might have been a journeyman. However, Paul himself had hired journeymen, who were only allowed to work for a master painter registered with the guild. Are we confronted with a complex kind of sub contracting here? Did Paul work as a journeyman for a master, maybe one of his brothers, and did he subcontract journeymen on his master's behalf? Or was he a master in the Guild of Saint Luke after all, maybe after the death of Pieter II in 1559, and has his enrolment been lost?[93]

A closer look at the inventory of his estate sheds more light on his status as a painter and also gives us valuable insight into the physical situation of the painter's workshop. Paul's workshop was situated in the attic of the house of the tailor Lambrecht van der Velst in the Korte Gasthuisstraat. This studio could obviously not be used as a shop with a window to sell from. Besides this attic-studio, Paul and his wife rented an *achtercamere* ['back room'], where they lived, and a *camere aen straete* ['room near the street side'], which may have been Paul's shop. It is here that most of the paintings were, and also twelve *patroonen* ['patterns']. Of these paintings, three were *van Daneel*, which Erik Duverger interpreted as 'by another painter by the name of Daneel', which could have meant that Paul was also an art dealer on a small scale.[94] It is more likely, though, that *van Daneel* meant a depiction of Daniel, since all other subjects of paintings were mentioned in this way.[95] Duverger presumed that the patterns might have been

[90] Van Mander, *The Lives*, vol. 1, p. 132 (fol 218ᵛ).

[91] Jansen, 'Unveiling the production method'.

[92] Brussels, State Archives, *Chambre de Comptes. Acquits*, no. 1754, 18 April 1569 and 6 May 1569. Published by Duverger, 'Enkele gegevens', pp. 211-266.

[93] In the years 1562, 1563, 1565 and 1566 the pages of the *Liggeren* were left blank. Furthermore, there are several other examples of people who claimed to be registered with the guild but cannot be found in the *Liggeren* (for instance Digne Zierix, the widow of Jan de Costere, Van der Stock, 'De organisatie', p. 48).

[94] Duverger, 'Enkele gegevens', p. 219.

[95] For instance *een tafereel van Suzanna* (a picture of Susanna), *een schoon stuck*

designs for tapestries or glass windows.[96] The word *patroon* was used not only in the context of tapestry but also in the context of illumination and painting. They might have been models for paintings from which patrons or prospective buyers could choose and which served as examples for the actual paintings. In Paul's studio there were six easels, painter's materials such as grinding stones, several paintings in different stages of completion[97] and sketches on paper. The explicit mention of unfinished paintings makes the function of both spaces as a shop with finished paintings and a studio with work in progress even more credible. Furthermore, the presence of a shop forms an additional argument for Paul's status as a master, since only masters had the right to sell their works from a shop.[98]

There is a remarkable continuity in the careers of the Coecke family and their apprentices. The earlier mentioned analytical study of the Antwerp *Liggeren* by Martens and Peeters showed that the road to mastership was not easy and that most apprentices never attained the status of master.[99] According to their calculations only 28 per cent of the painter's apprentices eventually became master painters. At least one of the three pupils of Pieter Coecke, Willem Key, enrolled as a master and another one, Nicolas Neufchâtel, emigrated at a certain point and pursued a flourishing career abroad. Two of Pieter's sons, and perhaps all of them, became masters as well. So at least 50 per cent, and maybe even 83 per cent of Coecke's apprentices (including his sons) became master painters. They too had the opportunity to hire apprentices, which considering the statistics was not obvious since many masters remained one-man businesses. The line continues with the apprentices of Coecke's sons Pieter and Michiel again registering as masters. The journeymen in their entourage, such as Pieter Bruegel and Gillis van Coninxloo, also pursued successful careers.

In many instances, the death of the master was an opportunity to become a master themselves. Pieter Coecke probably followed in the footsteps of his father-in-law Van Dornicke, a year after his death in 1527, and his son Pieter II followed in 1550, just after Coecke's death, while his second son Michiel followed a year later. Dilken de la Heele followed in 1560 right

schilderyen van Sampson de stercke (a fine painting of Samson the Strong) and *een cleyn stucxken van een Lantscap* (a small piece with a landscape).

[96] Duverger, 'Enkele gegevens', p. 218.

[97] *Noch een stucxken onvolmaect van Peys ende Liefde* (another unfinished piece with *Peace and Love*), *noch XXV rou paneelkens* (another 25 unprepared panels), *thien gedootverfde paneelkens* (ten panels in dead colouring), and *een taefereel met dueren begonst daerop te wercken* (a painting with wings on which someone had started to paint) and *eenen rouwen doeck* (an unprepared canvas).

[98] Campbell, 'Early Netherlandish Painters', p. 4.

[99] Martens and Peeters, 'Artists by numbers'.

after the death of Pieter II in 1559. Furthermore, we must not forget Pieter Coecke's widow Marie Verhulst, who after his death seems to have had a flourishing career of her own. Not only did she continue his work, she also used her influence and the prominence of her late husband's name to further the success of the Breughel family.

Concluding remarks

With the reinterpretation of the few archival sources on Pieter Coecke, it is possible to give a more complete picture of the size and organisation of his workshop, despite the remaining – and frustrating – lacunae.[100]

Pieter Coecke's workshop was indeed one of the biggest in Antwerp in the first half of the sixteenth century. During his career, from 1527 to 1550, he hired three apprentices and also trained his three sons: Pieter II, Michiel and Paul. Coecke's workshop belonged to the 3.5 per cent of Antwerp workshops that had three apprentices. Taking his sons into account, Coecke's workshop even belonged to the 0.16 per cent of Antwerp workshops that had six apprentices. Both figures are exceptionally high. At its peak, in the years 1545-1550, Coecke's workshop could possibly have housed seven to eight members, including Pieter himself and his wife, the painter Marie Verhulst, and possibly his workshop assistant Pieter Bruegel the Elder.

Besides apprentices and family members, Coecke would also have hired journeymen, including former apprentices who possibly would have stayed in the shop after their training to continue to work for him. According to Van Mander, Pieter Bruegel also trained with Coecke, although he was not inscribed as an apprentice. He too might have been a workshop assistant, meanwhile receiving a higher education as a *discipel*. Besides those known journeymen, Coecke most likely employed an unknown number of workshop assistants, as Marlier and Friedländer have suggested. At this point it is not possible to be more precise about their number and activities. Their collaboration might be further traced by carefully analysing the paintings that came from Coecke's shop.

Pieter Coecke relied heavily on his family network when starting, expanding and continuing his workshop. When he married Anna van Dornicke, the daughter of an established Antwerp artist, he had the opportunity to work as an assistant for his father-in-law, thus obtaining a profound knowledge of the Antwerp market for paintings. After Van Dornicke's

[100] The extent and impact of Coecke's professional network will be further studied in my PhD thesis, University of Groningen.

death in 1527, Coecke possibly took over the workshop, which would have given him a flying start.

When Coecke expanded his workshop he not only relied on apprentices, he also trained his sons to become painters. After a while they might have been his most important employees, along with his second wife Marie Verhulst. The Coecke heritage was only temporarily ensured by his sons, and found its way through his widow into the family enterprise of the Breughels. This heritage may not just have been an artistic one, it was above all the continuation of knowledge and resources. Pieter Coecke's family network largely overlapped his professional network, which again underscores its importance.

It is remarkable that many of Pieter Coecke's family and/or professional contacts also had flourishing careers with relatively large workshops. As we have seen, 67.6 per cent of master painters remained one-man businesses or small-scale family enterprises. That Coecke's apprentices and Coecke's sons also took on apprentices can be noted as a remarkable continuity. His two fathers-in-law, Jan van Dornicke and Peeter Verhulst-Bessemers, also headed thriving businesses with an above average number of employees. Many of his contacts held important positions in the guilds, for instance Willem Key and the painter Marten Peeters, who frequently appear as witnesses or guardians in juridical matters in the Antwerp Guild of Saint Luke, and several members of the Verhulst-Bessemers family in Mechelen. Did the success and esteem of Pieter Coecke reflect on his apprentices and family? Or was it the other way around? Did Coecke know how to mingle with important fellow artists for the benefit of his own career? The close contacts between the painters of the Antwerp artistic environment, as well as the Brussels and Mechelen environments, shows that the circle of successful painters was apparently a small and closed network.

What can be said about the journeyman from this micro-level study? As the studies elsewhere in this volume show, journeymen formed a heterogeneous group. Because of the lack of information, it is difficult to distinguish their artistic and biographical personalities, which often remain vague. However, this contribution shows that some journeymen rose from anonymity into successful careers, among them none other than Pieter Coecke van Aelst himself, as well as Coecke's brother-in-law Jan van Amstel, Coecke's *discipel* Pieter Bruegel, and possibly his former apprentices Willem Key and Nicolas Neufchâtel. All of them were trained painters who either continued to work for their masters after their training had finished, or worked as assistants in the studios of their family members. Their position as a journeyman and the skills they displayed early on provided all of them with a stepping stone to their own workshops and a fruitful career. Still, we must

keep in mind that they were exceptional, since many apprentices never made it to the status of master painter and remained journeymen.

Did this group of highly talented and skilled ex-apprentices work on a more structural basis in the studios of master painters as part of the permanent staff? Did they distinguish themselves from the presumably large group of now anonymous journeymen working for different masters on a temporary basis for wages? Another interesting issue is whether a similar distinction can be made for the various activities of journeymen. Many questions remain as a basis for further research. Although the case of Pieter Coecke van Aelst cannot answer these questions, it does show that micro-level studies provide a valuable addition to the information gained from more generic sources.

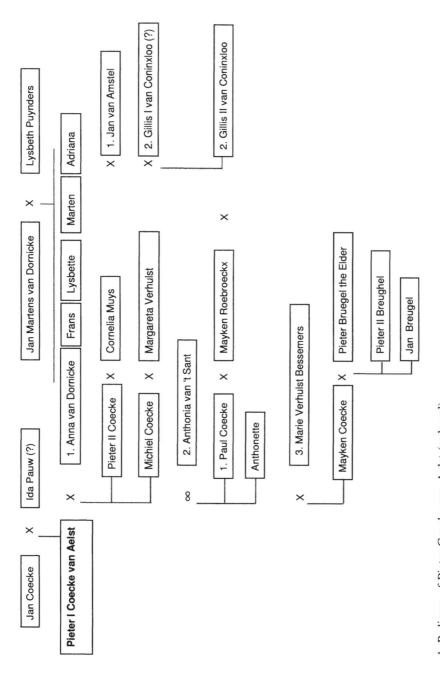

1. Pedigree of Pieter Coecke van Aelst (reduced).
By: Linda Jansen; sources: City Archives Antwerp, City Archives Alost, Marlier 1966.

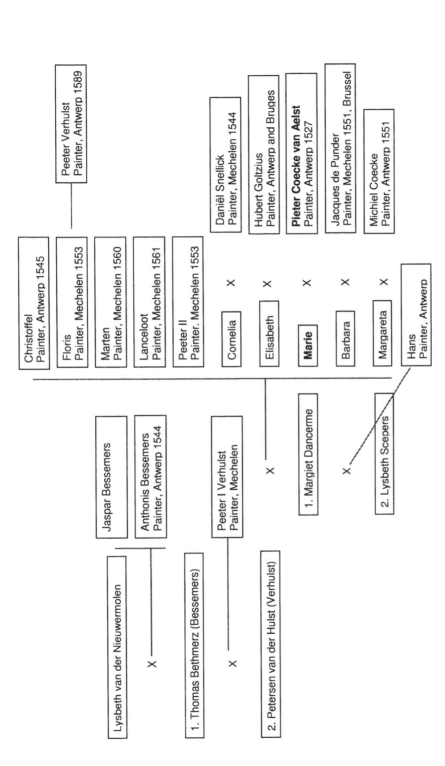

2. Pedigree Verhulst – Bessemeers family. By: Linda Jansen; source: Monballieu 1974.

JOURNEYMEN, SOCIAL RISE AND THE URBAN LABOUR MARKET IN THE SOUTHERN NETHERLANDS DURING THE TRANSITION FROM THE MIDDLE AGES TO THE EARLY MODERN PERIOD

Johan Dambruyne

The massive proletarianisation of the working population can probably be considered one of the most important social changes that took place in Europe during the Early Modern Period. Proletarianisation indicates the process whereby more and more households became partially or totally dependent on earning a wage for their livelihood.[1] According to calculations by the American sociologist and historian Charles Tilly, 24.3 per cent of the total European population (with the exception of Russia) was already dependent on wages by the middle of the sixteenth century. Around 1750, the number of people who were partially or totally dependent on wages had grown to 58 per cent of the total European population.[2] Of course, these are necessarily inaccurate estimates, but the trend one can deduce from them is clear. Tilly's estimates further show that the percentage of wage-earners was higher in the country than in the city, but they also show that the proletarianisation in towns increasing more rapidly than in the country between the middle of the sixteenth and the middle of the eighteenth centuries. The proportion of urban wage-earners nearly tripled from 15.5 per cent in 1550 to 44.8 per cent in 1750.[3] This means that the process of urban proletarianisation itself progressed more spectacularly in the Early Modern Period.[4] According to Tilly and other authors, capitalist-oriented merchants and entrepreneurs were responsible for this important social transformation.[5]

[1] Soly, 'Proletarisering', pp. 106-107.

[2] Tilly, 'Demographic origins', p. 33.

[3] In the country, the number of people dependent on wage labour rose from 25.6 per cent in 1550 to 60.6 per cent in 1750.

[4] On the basis of the number of towns with a minimum of 10,000 inhabitants, De Vries, *European urbanization, 1500-1800* p. 39, calculated that the number of Europeans living in cities rose from 5.6 per cent in 1500 to 9.5 per cent in 1750.

[5] Tilly, 'Demographic origins', pp. 53-54.

Wage labour was a widespread phenomenon in the urban guild world. From the origins of the guild system there had been a hierarchic distinction between the juridical-economic status of the master and that of the journeyman. Only artisans who obtained the master's title were allowed to establish themselves as independent entrepreneurs in the town. The others had to work as qualified and skilled workers in the service of a master. Most journeymen therefore obtained their income solely from selling their labour. They usually did not own other means of production (real estate, tools, raw materials or capital). The juridical and economic inequality between the independent producers and/or retailers, on the one hand, and the wage-earners on the other, was also reflected in material, fiscal, political and social areas. Journeymen usually earned less than their master, paid less taxes, lived in cheaper houses, spent less on consumer goods and were not represented in the political systems of the town.[6] In short, they did not enjoy the same social prestige as the masters within urban society.[7] Although journeymen had fewer social and financial obligations towards the corporate community than the masters, they also had fewer rights. Thus, in most guilds, they were excluded from participation in meetings, had no vote in the election of the executive board, were not allowed to be promoted to sitting on the board and had little or no right to the social benefits of the guild.

Although there has, so far, been no systematic and exhaustive research, the thesis prevailing in the existing literature is that fewer and fewer urban artisans succeeded in making a career during the course of the Early Modern Era.[8] Specifically, the promotion of qualified journeymen to mastership became more and more difficult, resulting in an increase in the number of wage-earners and a decrease in the number of corporately organised and independent masters.[9] According to the classic vision, the characteristics of European corporatism were protectionism, conservatism and exclusivism

[6] All these aspects are treated in depth in Dambruyne, *Corporatieve middengroepen.*

[7] Although I do not deny that there are common characteristics between masters and journeymen, I fundamentally disagree with Rosser, 'Craft, guilds and the negotiation of work', who writes that the dividing line between both categories was very small. I favour more the hypothesis of Friedrichs, 'Capitalism, mobility and class formation', who states that masters and journeymen were two different social classes. Also Farr, *Artisans*, pp. 225-226, points out in his recent synthesis that the masters considered the journeymen as a lower social group.

[8] Cowan, *Urban Europe*, p. 83. For the Southern Netherlands specifically, see Scholliers and Vandenbroeke, 'Structuren', pp. 302-303.

[9] Farr, *Artisans*, pp. 247-250, has a more nuanced vision on the fifteenth and sixteenth centuries. He points out that the degree of openness or reticence differed strongly from craft to craft and from town to town. Contrary to the other authors, he sees in the seventeenth and eighteenth centuries a rising tendency to corporate openness in mastership.

from the fifteenth century onwards. The strategy of the guild masters was aimed at consolidating their position and those of their descendants by impeding newcomers from entering the guild and especially from obtaining a master's title. To this end, they systematically prolonged training, increased entrance fees and established a final master's test, which was subsequently toughened. According to the Ghent medievalist Hans Van Werveke, many guilds aimed at becoming a hereditary caste of masters, where the master's title could only be obtained through descent.[10] Thus, many journeymen were doomed to remain wage-earners for their entire life. Guild historians, such as Van Werveke, linked the process of corporate exclusiveness to the demographic and economic decline or stagnation that hit many European towns during the fifteenth century. As a reaction to the fall in employment, the guilds – especially those active on the local market – favoured a policy that limited the number of members, while privileging family members. This resulted in the unequal treatment of masters' sons and outsiders. The outcome of this development was that the social gap between masters and journeymen widened, tension increased and corporate solidarity eroded. This ultimately led to the estrangement of the journeymen from the guild and to journeymen forming their own – often illegal – trade organisations.[11]

Some years ago, the Canadian urban historian Christopher Friedrichs, though not entirely rejecting this established view, proposed some significant modifications.[12] He does not deny that, during some periods, entrance to the guild was harder and that this led to tensions within the corporate world. However, according to Friedrichs, one cannot speak of a linear continuous process where things went from bad to worse. On the contrary, he considers the situation a recurrent structural problem that was inherent in the European corporate system. According to him, the prevailing economic situation profoundly influenced the level of upward social mobility and the quality of the social relations within the guilds. During periods of economic expansion, the chances for social and professional ascent were better and the relations between masters and journeymen were more harmonious than in periods of economic recession or crisis. As all early modern corporate economies were confronted with such economic ups and downs, this im-

[10] Van Werveke, 'Ambachten en erfelijkheid'. There is a difference between the craft organisations which acquired the juridic status of hereditary guild from the sovereign in different towns in the course of the fourteenth century (usually the butchers and the bargees) and those that did not have this status but strove for it.

[11] Lis and Soly, 'An irresistible phalanx'. Although companies of journeymen were present in the Low Countries, they were less numerous than in French or German towns and they had a more informal character (e.g. as a relief fund).

[12] Friedrichs, *The early modern city*, p. 99.

plies that social mobility, solidarity and social relations within the corporate world were also changing according to a wave pattern.[13]

This essay aims at throwing some light on the real or supposed process of proletarianisation that manifested itself in the corporate world of the Southern Netherlands during the transition from the Middle Ages to the Early Modern Era. Specifically, an attempt is made to find out whether the position of journeymen evolved from being essentially temporary (an intermediate phase in the career of a certified artisan) to being predominantly permanent (a final stage) in the corporate career. Contrary to masters, journeymen left few written archival traces. This professional group is therefore difficult to study and some insight into the professional options of journeymen will be obtained in an indirect way. On the basis of statutes, petitions, membership lists and accounts drawn up by guild masters, the article will probe the career prospects of skilled wage-earners in some important towns of Flanders and Brabant (Ghent, Bruges, Antwerp, Brussels and Louvain) during the so-called 'long sixteenth century' (c. 1450-1650). As this issue has, so far, been most exhaustively studied for Ghent, this town will be referred to frequently.

This essay consists of three parts. Since most guild historians take the gradual increase of the corporate membership threshold to be clear proof that the masters deliberately strove to admit fewer journeymen to mastership, I will start by looking closely at the terms of entrance. I will examine whether they became effectively more difficult over the years and whether there were differences between the development of the guilds and the towns. In relation to this, I will examine whether the discrimination between masters' sons and non-masters' sons increased. Next, I will discuss whether most authors have not come to the wrong conclusions in examining the eventual toughening of membership conditions. Can one deduce automatically that, by imposing more financial, material and other costs on journeymen interested in obtaining the master's title, the executive boards aimed at a protectionist policy concerning social promotion? I think that this was not the case and that historians have often interpreted the archival material in an erroneous way in the past. I aim to show that the motivation for adapting the membership conditions was not only social and economic but that financial, religious or political motives also often played an important role. Finally, using concrete examples from some guilds, I will analyse the nature of the impact which an increase or decrease in the membership conditions had on the inscription of new masters. Furthermore, I will check whether shifts in the urban labour market, as a result of economic and/or demographic changes, were not more important in determining the professional prospects

[13] Farr, *Artisans*, pp. 36, 224, shares this vision.

of journeymen than the financial and other conditions imposed on the aspiring masters by the executive boards.

Stricter membership conditions: fiction or reality?

In nearly all guilds, access to mastership was regulated. Unfortunately, for many guilds, the statutes have been lost or only partially preserved. When we consider the membership conditions we need to make a clear distinction between masters' sons, on the one hand, and non-masters' sons, on the other.[14] We shall start with the latter group.

What specific conditions did the guilds impose on those journeymen who aspired to obtain a master's title? In all Flemish and Brabantine towns, citizenship and mastership were inextricably linked. Anyone wishing to become a master needed to possess the status of citizen. When a journeyman had not been born in the town, he could obtain citizenship by registering. In a town like Ghent citizenship was free, but in many other towns one needed to pay citizen's entry money.[15] Furthermore, in most guilds one could only become a master after an obligatory period of training in the town in question or in another recognised town.[16] In purely commercial guilds (retail), one did not need to pass through a period of schooling to obtain a master's title.

However, journeymen who were registered citizens and had completed their training did not automatically obtain the status of master. All guilds imposed some additional financial and social obligations on potential masters. Consequently, the master's title acquired a high social prestige. However, this also meant that the guilds had an instrument at their disposal with which to regulate the urban labour market as every guild had a professional monopoly. By raising or lowering admission conditions, they could either make it harder to obtain a mastership or facilitate the accession. It also enabled them to show whether the guild had vacancies or not (whether there were places for newcomers).

The admission fee was undoubtedly the most important financial obligation that guilds imposed on new masters. It was also the oldest obligation, being traceable back to the fourteenth century. According to the existing literature, this fee initially involved a small amount of money but, from the

[14] For clarity's sake: non-masters' sons were masters who had a different profession than their father. Father and son did not belong to the same craft guild.

[15] One example: in Antwerp in 1544 the citizen's money corresponded to no less than 68 daily wages of an unskilled labourer. Thijs, 'Minderheden', p. 19.

[16] I will not elaborate further on the training periods as this article treats only the transition from journeyman to master. On corporate training see the recent publication of De Munck and Dendooven, *Al doende leert men.*

fifteenth century onwards, it was systematically increased to finally reach exorbitant levels in Early Modern Times. But does this supposed rise of the admission fees agree with reality? While studying the literature, my attention was attracted by the absence of concrete and actual facts concerning the evolution of admission fees in different guilds in the Southern Netherlands, from the Late Middle Ages until the end of the Ancien Régime. I have sampled the available material for some Flemish and Brabantine cities for the period of c. 1450-1650 in two tables.

Table 1. Comparison of admission fees of non-masters' sons in Ghent, Bruges and Antwerp guilds (expressed in Flemish groats) fifteenth to seventeenth centuries.[17]

Guild/period	Ghent	Bruges	Antwerp
Carpenters			
1450-1478	1920	792	160
1479-1539	1920	1080	160
1540-1542	240	1080	160
1543-1577	240	1080	500
1577-1584	3840	1080	500
1585-1600	240	1080	1800
Joiners			
1460	1920	732	-
1479	1920	1200	-
1497	1920	1200	400
1515	1920	1200	600
1540	240	1200	-

[17] Source: For Ghent see Dambruyne, *Corporatieve middengroepen*, pp. 184-185; for Bruges, Sosson, *Les travaux publics de la ville de Bruges*, pp. 140-141; *idem*, 'Corporation et paupérisme', p. 566; Van de Velde, *De ambachten*, p. 23; Gilté, *Het Brugse bakkersambacht*, p. 162; Van Quathem, 'Sociale mobiliteit', p. 115; Sosson, 'La structure sociale', p. 460; for Antwerp: Scholliers, *Loonarbeid en honger*, pp. 96-98; *idem*, 'De lagere klassen', p. 167; Neelen, *Het Antwerpse meerseniersambacht*, pp. 61-62; Lauwaert. 'Ambachten en nieuwe nijverheden', p. 160; Soly, 'Sociale relaties', pp. 43-44; Thijs, *Van "werkwinkel" tot "fabriek"*, pp. 258-259; Willems, 'Loon naar werken?', p. 42; Antwerp, City Archives, A4002, fol. 9ᵛ. The income fees referred to here concern the non-masters' sons who had their training in the town where they bought the master's title or where they were born. For foreigners the entry fees were generally higher. All amounts in this essay are expressed in Flemish groats (Fl. gr.). 1 Flemish groat = ½ stuiver.

Guild/period	Ghent	Bruges	Antwerp
Smiths			
1479	1920	1560	-
1530	1920	1560	-
1540	240	1560	674
1563	240	1560	800
Thatchers			
1431	-	-	40
1520	2400	-	40
1543	240	-	64
1580	2400	-	720
1590	240	-	720
Plumbers			
1445	-	792	-
1479	1920	1032	-
1530	1920	1032	-
1540	240	1032	-
Bakers			
1478	2400	1440	-
1530	2400	1440	-
1557	240	1440	810
1586	240	1440	1500
1635	240	1920	-
1695	240	1920	4000
Shoemakers			
1500-1539	1560	720	-
1540-1577	240	720	-
1584-1630	240	720	-
1631-1674	240	1200	-
1675	240	1680	-
Old Shoemakers			
1500-1539	1752	720	-
1540-1555	240	720	-
1556	240	720	17

Guild/period	Ghent	Bruges	Antwerp
Mercers			
1588	240	-	422
1597	240	-	502
Linen-weavers			
1535	1200	-	400
1560	240	-	400
1644	240	-	1600
Silk weavers			
1533	-	-	40
1583	-	-	320
1621	-	-	1320
1651	-	-	1800
Coopers			
1478	1920	1466	-
1500-1539	1920	1466	-
1540	240	1466	-
1577	240	-	1920
1580	3360	-	960
1635	240	-	2400
1653	240	-	3200

Table 2. Comparison of the admission fees of non-masters' sons in some guilds in Ghent and Louvain, expressed in summer day wages of a journeyman bricklayer, 1425-1614.[18]

	Bakers		Second-hand vendors		Smiths		Barbers	
Year	Ghent	Louvain	Ghent	Louvain	Ghent	Louvain	Ghent	Louvain
1425	-	67	-	55	-	67	-	-
1440	-	78	-	66	-	62	400	25
1487	400	108	480	84	320	107	480	72
1530	400	108	480	84	320	107	480	72
1540	40	108	40	84	40	107	40	72

[18] Source: for Ghent: Dambruyne, *Corporatieve middengroepen*, p. 199; for Louvain: Van Uytven, *Leuven*, p. 201.

	Bakers		Second-hand vendors		Smiths		Barbers	
Year	Ghent	Louvain	Ghent	Louvain	Ghent	Louvain	Ghent	Louvain
1550	40	108	40	56	40	60	40	72
1559	30	100	30	52	30	56	30	67
1565	24	97	24	50	24	54	24	65
1580	150	49	180	25	150	27	180	33
1608	10	27	10	21	10	16	10	24
1614	10	27	10	21	10	16	10	24

The available data for the Brussels guilds were not taken into account in this comparison due to problems with calculating the exchange rates. From facts collected by Guillaume Des Marez, it seems that in many Brussels guilds the nominal admission fees showed a trend of increasing during the fifteenth century.[19] What conclusions can we draw from both tables? The fragmented data suggest that there was no linear rise in admission fees during the period c. 1450-1650 for every town. Unlike Antwerp, Brussels and Bruges, in Louvain and especially in Ghent there is no trace of a continuous toughening of the admission fees. In Ghent, the capital of the county of Flanders, there are four recognisable trends: between 1450 and 1540 the admission fees increased systematically, after 1540 they decreased spectacularly, during the Calvinist republic (1577-1584) there was again a considerable rise, followed by a substantial decrease after the reconciliation of 1584. It is therefore not correct to study the progress of corporative admission fees in Ghent separately from the political and institutional history of the town.

In order to diminish Ghent's political autonomy, the central government interfered directly in setting admission fees in 1540 and again in 1584.[20] In Louvain, we see an increase in the fees in the fifteenth century and in the first half of the sixteenth century, followed by a decrease during the second half of the sixteenth century and stagnation during the first decades of the seventeenth century.[21]

Tables 1 and 2 show further that there were substantial differences between different towns and guilds concerning the admission fees, and that

[19] Des Marez, L'organisation du travail, pp. 75-80.

[20] For the meaning of the entry fees in the global strategy of submission, which the central government designed especially for Ghent in 1540, see Dambruyne, Corporatieve middengroepen, pp. 337-338.

[21] Taking into account the evolution in the white leather curriers' guild (between 1619 and 1681 the entry fees increased sixfold), it seems that the entry fees in Louvain again experienced a rising trend from about the second quarter of the seventeenth century. See Verhavert, Het ambachtswezen, p. 84. The decrease in the entry fees during the second half of the sixteenth century was caused by the demographic and economic decline of the city. Van Uytven, Leuven, pp. 125, 127, 165.

there was no synchronisation between the towns during the period under concern. Before 1540, the admission fees were without doubt highest in Ghent followed by Bruges. Compared to the admission fees in Ghent, those of Antwerp were very low. However, by the beginning of the seventeenth century, the order had completely changed. By then the guilds of Antwerp and Brussels, on average, demanded higher income fees than corporations of Bruges and Ghent. From being the most expensive town, Ghent then became the cheapest.

In some guilds, admission involved not only an actual fee in money but also a part that had to be paid in kind. For example, admission to the Brussels guilds included the donation of a quantity of wine, whilst many Ghent guilds had a tradition whereby the aspiring master had to donate one or more silver drinking vessels decorated with a gilded border and a heraldic guild ensign, a practice that was common until 1540 and again during the Calvinist republic (1577-1584). These drinking vessels represented a value of 480 Fl.gr. or the equivalent of 40 daily summer wages of a journeyman bricklayer.[22]

Besides paying an admission fee, some guilds demanded the passing of a master's test as a second condition to acquiring the status of master. Like the increase in the admission fee, many guild historians have interpreted the imposition and gradual toughening of the master's test as a means of impeding entry into the guild. It needs to be remarked that, unlike the entrance fee, the master's test was not a widespread practice during the Middle Ages. The first master's tests appeared around the middle of the fifteenth century in Flemish and Brabantine towns.[23] It was only during the course of the sixteenth century that more guilds imposed a master's test. In Antwerp, Bruges, Brussels and Louvain, the guilds themselves took the initiative, while in Ghent this was forced on the guilds by the central government in 1540. Although the *Concessio Carolina* explicitly prescribed a master's test, very few Ghent guilds required an assessment test in the sixteenth century.[24] It was only in the seventeenth century that the test became compul-

[22] Dambruyne, *Corporatieve middengroepen*, p. 188.

[23] In Ghent, the master's test is mentioned for the first time in the statutes of the joiners in 1447. Daenens, 'De meubelkunst', p. 445. In Brussels, the coopers, joiners, locksmiths and tailors were the first guilds to set up a master's test in 1466. Des Marez, *L'organisation du travail*, p. 95. Of the different Antwerp textile guilds, only the cloth manufacturers had a master's test in the fifteenth century, see Thijs, *Van "werkwinkel" tot "fabriek"*, p. 208.

[24] Schulz, *Handwerkgesellen*, pp. 297-302, also states that for the Upper and Middle Rhine areas, the master's test existed only on paper in the fifteenth and first half of the sixteenth century.

sory.[25] In Antwerp, Bruges, Brussels and Louvain, the master's tests were neither generally accepted nor clearly defined until the seventeenth century. It also needs to be pointed out that corporations with a predominantly commercial character (like the mercers, grocers and second-hand vendors) never introduced a test.

It cannot be denied that the financial threshold to attain the status of master was raised by establishing a master's test. Not only did the potential master have to buy the necessary materials, but he also needed to invest sufficient time and energy in the production of a masterpiece. In Antwerp, the coopers raised the cost of the test in 1664 to 7,680 Fl.gr.,[26] with the test representing two thirds of the total sum that was demanded of the new master. On top of this, the members of the jury had to be remunerated for the time they spent inspecting the masterpiece. From their candidates for mastership, for instance, the board of the Bruges carpenters' guild received 60 Fl.gr. (1565), the Antwerp cloth dyers 400 Fl.gr. (1563), and the Brussels kettlers 1,200 Fl.gr. (1650).[27]

Sociability has always occupied an important place in the corporative world,[28] which is why the offering of a meal to the guild board by a new master need not surprise us. In many guilds, this custom already existed in the fifteenth century, while for others, it was introduced in the course of the sixteenth century.[29] Although there were large differences between the different guilds, the expenses thereby incurred were reasonable until the end of the sixteenth century.

In Ghent, between the years 1500 and 1540, the banqueting expenses varied from a minimum of 30 Fl.gr. (fruit vendors) to a maximum of 480 Fl.gr. (bakers).[30] In comparison, a bricklayer's journeyman had to work 2.5 and 40 days respectively to earn these sums. In 1540, Emperor Charles V forbade the Ghent guilds to demand banquets of the new masters. For the Antwerp smiths in 1563, the price for the compulsory banquet was fixed at 240 Fl.gr.[31] The Brussels mercers, in 1613, demanded exactly 400 Fl.gr.[32] From the seventeenth century onwards, there was a noticeable increase in the costs of the required banquet in many of the guilds. Thus, for the Ant-

[25] Dambruyne, *Corporatieve middengroepen*, pp. 196-197.

[26] Willems, 'Loon naar werken?, p. 44.

[27] Van de Velde, *De ambachten*, p. 43; Thijs, *Van "werkwinkel" tot "fabriek"*, p. 288; Des Marez, *L'organisation*, p. 79.

[28] On this topic, see *Actes du colloque la sociabilité urbaine en Europe*.

[29] In the Antwerp coopers' guild the new masters only needed to give a banquet to the board from 1570 onwards. Willems, 'Loon naar werken?', p. 41.

[30] Dambruyne, *Corporatieve middengroepen*, p. 189.

[31] Antwerp, City Archives, A4002, fol. 10ʳ.

[32] Des Marez, *L'organisation du travail*, p. 77.

werp coopers, the total costs for entertaining the board rose from 720 Fl.gr. in 1580 to 1,200 Fl.gr. in 1602 and to 1,680 Fl.gr. in 1635.[33] For the Brussels kettlers, the cost of the meal in 1650 was 1,200 Fl.gr.[34]

Apart from the admission fee, the master's test and the banquet, many guilds imposed further, albeit less heavy, financial obligations on mastership candidates, such as compensation for the board and the guild messenger, and a contribution to the relief box. For some guilds in sixteenth-century Ghent, I have calculated the total amount needed to obtain the master's title. In the plasterers' guild, probably the cheapest corporation in town, one had to pay a total of 1,200 Fl.gr. (which was equal to 100 daily summer's wages) to acquire the master's title during the years 1500-1540. The acquisition of the status of master tailor cost a total of 2,400 Fl.gr., which was equal to 200 daily summer's wages, i.e. more than four-fifths of the total yearly wages of a bricklayer's journeyman). To become a master baker, a candidate had to pay even more: the master's title cost a total of 4,320 Fl.gr. (which was equal to 360 daily summer's wages, which corresponds to about one and a half year's wages of a bricklayer's journeyman).[35] Assuming that a journeyman could put aside 5 per cent of his wages per year, a plasterer's journeyman had to save up for eight years before he would be able to raise the cash to buy the master's title. A tailor's journeyman would have to wait some 16 years and a baker's journeyman some 29 years.[36] Looked at it from this angle, it is clear that many journeymen were not able to buy the master's title without outside financial help. That family ties, the circle of friends and other social relations were of capital importance if an outsider wanted to become a master is obvious in many contracts and acts. In 1536, the Antwerp cloth makers stated that many journeymen were unable to come up with the mastership fee '*sonder vrienden te moyen*'.[37]

So far, we have studied the admission conditions for non-masters' sons. Let us now look at the entrance conditions for masters' sons in the large Flemish and Brabantine towns, in order to find out whether admission fees, banquet costs and the master's test favoured them.

[33] Willems, 'Loon naar werken?', p. 43.

[34] Des Marez, *L'organisation du travail*, p. 79.

[35] Dambruyne, *Corporatieve middengroepen*, p. 191.

[36] The low wages earned by the journeymen did not allow for a higher percentage of saving. The wages were usually just enough to live on. Also, one needs to take into account that even a very good skilled labourer, time and again, was out of work.

[37] Thijs, *Van "werkwinkel" tot "fabriek"*, p. 299.

Table 3. Relation of the admission fees of non-masters' sons and registration fees of masters' sons in Ghent 1500-1540.[38]

Guild	Entry fees in Fl.gr.	Registration money in Fl.gr.	Relation
White leather curriers	2880	1	x 2880
Wine-tasters	1920	1.7	x 1129
Coopers	1920	2	x 960
Brewers	3840	10	x 384
Carpenters	1920	5	x 384
Beltmakers	1680	5	x 336
Mercers	1200	5	x 240
Stocking makers	1440	8	x 180
Old Shoemakers	1752	12	x 146
Rope-makers	2544	25	x 102
Woodworkers	1920	24	x 80
Weaponmakers	1920	36	x 53
Shoemakers	1560	48	x 33

The financial discrimination between masters' sons and non-masters' sons was larger in Ghent than in any other city. The masters' sons were not subjected to an admission fee, nor to a master's test, nor to a banquet during the fifteenth and sixteenth centuries. In practice, they acquired the admission into the guild by birth. For this to be legally valid, they just had to register and pay a modest fee which, even in the guild that demanded the highest registration fees (the shoemakers), represented no more than four summer's day wages of a journeyman bricklayer. Table 3 shows that the registration fees of the masters' sons were, in fact, negligible compared to the admission fees of the non-masters' sons.

The *Concessio Carolina* of 1540 did not put an end to this favoured status of masters' sons as they remained exempt from the master's test, but it did make the financial gap between masters' sons and non-masters' sons measurably smaller. This did not happen by increasing the registration fees for masters' sons but by substantially decreasing the admission for outsiders. Only in the seventeenth century did the inequality between the two groups gradually disappear. In a first stage, masters' sons submitted themselves to the master's test. In the early seventeenth century, under increas-

[38] Source: Dambruyne, *Corporatieve middengroepen*, p. 210.

ing pressure from the non-hereditary masters, the urban authorities imposed the qualification test on masters' sons.[39] Then, the financial aspects were levelled. On 7 April 1636, the city council issued an ordinance that forced masters' sons to pay the entry fee of 240 Fl.gr.[40]

Table 4. Relation between the admission fees of non-masters' sons and masters' sons in Bruges, fifteenth to seventeenth centuries.[41]

Guild	Admission fees		Relation
	Non-masters' sons	Masters' sons	
	in Fl.gr.	in Fl.gr.	
Smiths (1479-1600)	1560	26	x 60
Coopers (1478-1600)	1466	26	x 56
Bakers (1478-1634)	1440	26	x 55
Carpenters (1479-1600)	1080	26	x 42
Shoemakers (1631-1675)	1200	60	x 20
Old Shoemakers (1631-1675)	1200	60	x 20
Shoemakers (1489-1630)	720	60	x 12
Old Shoemakers (1489-1630)	720	60	x 12

Table 4 shows that masters' sons were also financially privileged in Bruges. Depending on the guild, the admission money of the masters' sons was 12 to 60 times lower than that of the non-masters' sons. When we compare the situations in Bruges and Ghent, it appears that the financial discrimination between masters' sons and other candidates was substantially smaller in Bruges. The difference between both categories was even smaller in the Brabantine towns. The available data suggest that masters' sons were probably obliged to pay at least half of the entry fee in most Antwerp and Brussels guilds.[42]

[39] In the bricklayers' guild, this happened in 1601; in the carpenters' guild the masters' sons were subjected to it from 1608 onwards. Dambruyne, 'De Gentse bouwvakambachten', p. 71.

[40] Ghent, City Archives, series 93, register VV, fol. 78v.

[41] Source: Sosson, Les travaux publics, pp. 139-141; idem, 'La structure sociale', p. 460; idem, 'Corporation et paupérisme', p. 566; Gilté, Het Brugse bakkersambacht, p. 162; Van de Velde, De ambachten, p. 23; Van Quathem, 'Sociale mobiliteit', p. 115.

[42] In some Brussels guilds (barbers, shoe repairers, tanners and weavers) masters' sons only had to offer wine to the guild in the fifteenth century. Des Marez, L'organisation du travail, p. 81.

Table 5. Relation between admission fees of non-masters' sons and masters' sons in Antwerp and Brussels, sixteenth to eighteenth centuries.[43]

Guild	Entry fees		Relation
	Non-masters' sons	Masters' sons	
	in Fl.gr.	in Fl.gr.	
Antwerp			
Joiners (1515)	600	300	x 2,0
Cloth-manufacturers (1536)	720	360	x 2,0
Carpenters (1543)	500	250	x 2,0
Carpenters (1585)	1800	900	x 2,0
Thatchers (1543)	64	32	x 2,0
Thatchers (1580)	720	360	x 2,0
Plasterers (1543)	64	32	x 2,0
Plasterers (1580)	720	360	x 2,0
Bakers (1557)	810	405	x 2,0
Bakers (1586)	1500	750	x 2,0
Mercers (1588)	422	222	x 1,9
Mercers (1597)	502	262	x 1,9
Coopers (1577)	1920	1440	x 1,3
Coopers (1580)	960	480	x 2,0
Coopers (1635)	2400	1920	x 1,3
Coopers (1653)	3200	1920	x 1,7
Tailors (after 1743)	2800	1400	x 2,0
Second-hand vendors (after 1728)	4000	2000	x 2,0
Brussels			
Tailors (until 1695)	2000	1000	x 2,0
Tailors (from 1696)	6000	3000	x 2,0
Second-hand vendors (after 1738)	6000	3000	x 2,0

[43] Source: Scholliers, *Loonarbeid*, pp. 96-98; *idem*, 'De lagere klassen', p. 167; Neelen, *Het Antwerpse meerseniersambacht*, pp. 61-62; Deceulaer, *Pluriforme patronen*, p. 329; Willems, 'Loon naar werken', p. 42.

Unlike in Ghent, masters' sons in Antwerp, Bruges and Brussels were not all exempted from the master's test during the fifteenth and sixteenth centuries.[44] Although systematic research is not yet available, it seems that the financial discrepancy between masters' sons and non-masters' sons in the Antwerp guild world diminished in the course of the seventeenth century.[45] Thus, in the Antwerp coopers' guild, a non-master's son had to pay a total of 12,080 Fl.gr. for his master's title and a master's son 11,480 Fl.gr., which amounts to a difference of only 5 per cent.[46]

A policy of openness or of closure?

In what has been stated above, we have seen that in all large Flemish and Brabantine towns, the conditions of admission into mastership were toughened or extended between c. 1400 and 1540. In Antwerp, Brussels and Bruges, this trend continued during the second half of the sixteenth and first half of the seventeenth centuries. But does this development prove that the guilds conducted an outspoken policy of protectionism? I do not think so. Historians have made this connection too quickly in the past. In the next section I want to put the admission conditions into a broader corporative perspective and present some arguments to demonstrate that the tougher entry modalities were not primarily meant to hermetically shut the guild to outsiders.

First, it needs to be said that the higher admission fees, the more expensive master's tests and the costly banquets were a partial result of the so-called sixteenth-century price revolution.[47] As a result of strong inflation between the end of the fifteenth century and the beginning of the seventeenth century, grain prices rose six- to sevenfold and the daily wages of, for example, a journeyman bricklayer in Ghent and Bruges increased from 12 to 40 Fl.gr. and in Antwerp from 8 to 48 Fl.gr. It is therefore logical that

[44] From the moment of institution of a master's test in the Bruges carpenters' guild in 1565, masters' sons were also subjected to it. Van de Velde, *De ambachten*, p. 42.

[45] While in the sixteenth century, only non-masters' sons needed to pass a master's test in the Antwerp cloth manufacturers' guild, the test had become compulsory to the masters' sons as well by the end of the seventeenth century. Thijs, *Van "werkwinkel" tot "fabriek"*, p. 208.

[46] Willems, 'Loon naar werken?', p. 44.

[47] The Antwerp smiths clearly alluded to this in a request of 1563: *"... hoe dat den tyt daghelycx seer verandert ende costelicker wordt soo in maeltyden, reparatien van huysingen als anderssins dan in voorledenen tyden gheweest is"*. Antwerp, City Archives, A 4002, fol. 9ᵛ.

the admission fees and other financial obligations connected to the master's title had to follow suit.[48]

Second, in many guilds new masters enjoyed payment facilities for the admission money, which made the high admission fees easier to bear. Indeed, an analysis of masters' contracts in the Ghent aldermen's registers shows that the largest part of the financial obligations were not supposed to be paid upon admission but could be spread out over several years. Postponement of payment was granted in particular for admission.[49] Some corporative institutions determined that one half of the admission fee was to be paid in annual installments, while the other half was converted into a mortgage (a hereditary rent with an interest rate of 6.25 per cent). In other guilds, the candidate for mastership paid a small part of the admission fee in cash and the rest in equal annual sums. This system of payment had the great advantage that the new master did not have to pay interest. This is why this system of credit was preferred to the selling of hereditary rents. In the Bruges textile guilds, these installments were generalised from 1547 onwards.[50] As to the payment conditions for the new masters in the Antwerp cloth makers' guild, it is noted:

> dat de dekens hunlieden dickwils termynen van betalinghe van deselve somme hebben moeten gheven, mits dyen deselve schamele ghesellen soo vele gelts qualycken hebben connen verspaeren.[51]

In the Brussels cloth makers' guild too, this spreading of payment was common.[52] The existence of such a corporative credit system proves that it cannot have been the prime intention of the guilds to admit as few journeymen as possible to the master status.

It seems to me that few historians up to now have paid attention to the rhetoric of the guilds' admission policy. Yet text analysis of preserved requests and statutes clarify the situation. The motivation for establishing higher admission fees had little or nothing to do with the regulation of the urban labour market but was nearly always related to the need for more ample financial resources and the poor financial state in which many guilds found themselves.[53] Many trade organisations closed their yearly accounts

[48] Dambruyne, *Corporatieve middengroepen*, p. 690.

[49] For example see *ibidem*, pp. 191-192.

[50] From 1584 onwards, this could grow to 8 years. Vermaut, *De textielnijverheid*, pp. 425-427. For the Bruges shoemakers, see Van Quathem, p. 133.

[51] Thijs, *Van "werkwinkel" tot "fabriek"*, p. 281.

[52] Des Marez, *L'organisation du travail*, p. 77.

[53] There were exceptions. The Brussels cloth makers increased the entry fees in 1481 to 6 Rhenish guilders with the aim of preventing the apprentices from settling as

with a deficit. Most corporations had access to only a limited amount of money, which was usually not enough to cover the average expenses. In order to tax their members as little as possible, the guilds in many towns opted to keep financial expenses at a minimum. In some towns such a policy was imposed from above. In Ghent, for instance, the central authority kept a steady eye on guild finances from 1540 onwards. This was part of a strategy of limiting the political power of the guilds. The immediate consequence of this minimalistic financial policy was that when guilds were confronted with extraordinary expenses, they usually found themselves in financial difficulties. They then had no other option but to petition the city authorities to be allowed to collect supplementary new revenues. In cases of acute shortage of money, some guilds opted for an increase in their admission fees, shifting the burden to the new masters, whilst other corporations opted to increase the membership fees of established masters. In some cases these measures were temporary, but sometimes they became permanent. The example of the Bruges shoemakers shows clearly that increases in admission fees and registration fees were always caused by financial difficulties.[54] Because of the deplorable financial situation of the guild in 1469, the Bruges aldermen granted the shoemakers permission to collect an extra entry fee of 240 Fl.gr. during 5 years.[55] In 1526, the Bruges aldermen consented to the levying of a weekly contribution of 1½ pound from every master shoemaker and of 12 shillings from every apprentice. This was needed to rebuild the large guild house in Steenstraat. In 1609, the board of the guild again demanded an increase in the entry fee in order to pay for repairs to the guild house and chapel.[56] In 1631, the guild again put in a request to the city magistrate for financing for the restoration of their chapel, which ran from 24,000 to 28,000 Fl.gr. They requested an increase in the admission fees of new masters as well as new apprentices.[57]

For the Antwerp guilds as well, the large amount of preserved requests leave few doubts as to the relation between increases in fees and the high maintenance and renovation costs of the guilds' houses, chapels and altars. As a result of the rebuilding of their burned altar in the Church of Our Lady, the Antwerp woodworkers incurred a substantial debt in 1538 and therefore petitioned the city magistrate to increase the admission fees for new mas-

masters immediately after their training. Des Marez, *L'organisation du travail*, p. 77.

[54] The increase of the entry fees of the Brussels grocers in 1471 and of the Brussels mercers in 1483 and 1613 was linked to the lack of adequate financial means to fulfill the corporate tasks. Des Marez, *L'organisation du travail*, pp. 76-77.

[55] Vandewalle, *Brugse ambachten*, p. 206.

[56] Van Quathem, *Het Brugse schoenmakersambacht*, p. 39.

[57] Vandewalle, *Brugse ambachten*, p. 206.

ters.[58] The saddlers' altar too had perished in the large fire of 6 October 1533 and, because of this, they raised their admission fees that year by 240 Fl.gr.[59] In 1563, the Antwerp smiths notified the city magistrate that they were planning to renew the façade of their guild house and that they needed to raise the entry fee for new masters from 674 to 800 Fl.gr. in order to finance this.[60] A year later, the Antwerp barbers' and surgeons' guild explicitly pointed to the large maintenance costs of their altar in their request for higher admission fees. Furthermore, the board of the guild stressed that the two annual meals that were offered to their members also taxed the corporative budget heavily.[61] During the iconoclasm of 1566, most of the guilds' altars in the parish and cloister churches were heavily battered and, in order to finance their rebuilding, the guilds specifically opted for higher admission fees as a solution. The same scenario repeated itself at the end of the sixteenth and the beginning of the seventeenth centuries.[62] As had been the case before the iconoclasm of 1566, the guild altar once more became one of the most important symbols of corporative religiosity after the reconciliation of 1585.[63] As the altars contributed to the strengthening of the group solidarity of the masters, it need not surprise us that the guilds were prepared to invest heavily in their altars.[64] During this period, the increases in the entry fees were more the result of growing corporate devotional practices than of a deliberate policy of complicating the social promotion of the journeyman. Some guilds, such as the Antwerp bricklayers, left their admission fees unchanged but increased the yearly contributions of the registered masters (the so-called candle and box money) in order to rebuild their altars after the iconoclasm of 1566 and 1581.[65] How close the link between admission fees and religious practices was in different Antwerp guilds is evident from the 1544 ordinances of the carpenters' guild. This document states explicitly that part of the admission fees was intended exclusively for

[58] Prims, 'Het altaar der houtbrekers', p. 334.

[59] Prims, 'Het altaar van de zadelmakers', pp. 435-436.

[60] Antwerp, City Archives, A4002, fol. 9v.

[61] Prims, 'Het altaar van de chirurgijns', p. 317.

[62] During the Calvinist republic, many guild altars were destroyed or sold. The bakers, stocking makers, carpenters and saddlers are some of the many Antwerp guilds who increased their entry fees to be able to finance a new altar. See Prims in *Antwerpiensia* 1939, pp. 303, 347, 416-417 and 437.

[63] On this topic, see Verleysen, 'Pretense Confrerieën?'.

[64] Peeters, *Tussen continuïteit en vernieuwing*, vol. 1, pp. 130-136, pointed to the fact that the restoration of the altars got many Antwerp guilds into financial problems.

[65] Prims, 'Het altaar van de metsers', pp. 353-354.

the upkeep of their chapel and altar.[66] Supplementary proof that the increases in admission fees in sixteenth-century Antwerp had nothing much to do with corporate protectionism, is given by the linen-weavers' guild. To collect the necessary funds for the burned altar, the guild decided in 1534 to increase not only the admission money of non-masters' sons to 400 Fl.gr., but also that of masters' sons from 100 to 120 Fl.gr.[67]

The statement by Guillaume Des Marez that the master's test was '*un nouvel et puissant instrument de protectionisme*' is, in my opinion, not applicable for the whole of the period 1450-1650. One needs to distinguish between the years before and after 1600. Although the introduction of the test for potential masters undoubtedly meant extra costs, it appears that the guilds initially considered the master's test a means to assure quality. After all, the guilds were concerned about the quality of their goods and services. The aptitude test had to show whether the journeyman had reached a sufficient level of technical schooling to establish himself as an independent artisan in town. The introduction of a master's test was often caused by complaints about lack of qualification of some masters and the low quality of the products.[68] The introduction of a master's test need not be associated immediately with a protectionist policy, as is shown by sixteenth-century Ghent. The Emperor Charles V established the master's test in Ghent in 1540 specifically with the aim of giving more outsiders the chance to obtain the master's title. However, it appears that from the seventeenth century onwards, the financial burden of the master's test began to grow in many guilds. Tests became more complicated or were extended, so that they took longer and became more expensive.[69] That this development was the consequence of an increasing concern for corporate quality cannot be ruled out, but it has not yet been proved. I do not, however, attach much credence to the thesis that the production of a masterpiece was imposed with the intention of restricting the number of masters from the seventeenth century onwards. On the contrary, I take the view that within the world of the guilds, the master's test increasingly became the material expression of a ritual process of transition through which every journeyman with aspirations had to pass. The test was a social and cultural ritual of initiation into mastership,

[66] Prims, 'Het altaar van de timmerlieden', p. 415.

[67] Prims, 'Het altaar der linnenwevers', pp. 316-317.

[68] Des Marez, *L'organisation du travail*, p. 96; Van de Velde, *De ambachten*, p. 42; Van Quathem, 'Sociale mobiliteit', p. 116.

[69] One example: at first the journeymen in the Bruges carpenters' guild needed to make only one masterpiece, but from 1666 onwards, they were subjected to making two masterpieces. Van de Velde, *De ambachten*, p. 42. Vandewalle, *Brugse ambachten*, p. 178.

and a visual means of distinguishing the status of master from that of the journeyman.

The phenomenon of banquets and drinking also cannot be taken as proof of a protectionist guild policy – at least for the fifteenth and sixteenth centuries. Their function in many guilds was above all social. They served to introduce the new master to the board and his colleagues in a relaxed atmosphere. In many guilds, for example the Antwerp linen-weavers and smiths (until 1563) and the Brussels hatters, the board paid for the banquet.[70] It seems that the sums that were spent on meals or drink only became exorbitant from the seventeenth century onwards. Thus, the Brussels bakers' guild demanded not one but two banquets in 1685: one trial banquet costing 2,000 Fl.gr. and one master's banquet of 8,000 Fl.gr.[71] Such high sums leave few doubts as to the underlying reasons. Yet not all the guilds strove for social exclusiveness in the same way. Indeed, there were cases during the seventeenth century where the corporations themselves put an end to the payment of extravagant sums spent on feasting. Thus, the board of the Antwerp coopers decided in 1664 that, from then onwards, the cost of the banquet was not to exceed the sum of 960 Fl.gr., instead of the usual 1,680 Fl.gr.[72]

The real possibilities and determinants of the professional mobility of journeymen

Statutes, ordinances and requests on corporate admission conditions cannot tell us anything about the real chances journeymen had to become masters. These normative sources only suggest developments but do not prove them. To do this, we need other archival sources. Based on the inscription registers for new masters, I will look at whether the changes in the admission conditions for certain guilds had an effective influence on the mobility of journeymen.

The literature has often cited the Ghent brewers' guild as evidence for the classical thesis that guilds strove to admit as few outsiders as possible in the fifteenth century and that the imposition of high admission conditions was an effective means to achieve this (see Graph 1 at the end of this contribution).

Indeed, the Ghent brewers' guild evolved gradually towards a hereditary guild from the second half of the fifteenth century onwards, and the

[70] Thijs, *Van "werkwinkel" tot "fabriek"*, p. 209; Antwerp, City Archives, A4002, fol. 9ᵛ; Des Marez, *L'organisation du travail*, p. 105.

[71] Des Marez, *L'organisation du travail*, p. 102.

[72] Willems, 'Loon naar werken?', p. 43.

imposition of high admission conditions for non-masters' sons certainly
contributed to this.[73] From 1505 onwards, the brewers' guild was a com-
pletely closed professional association where mastership was exclusively
passed from father to son. Graph 1, however, shows that in 1540, the prac-
tice of heredity in the brewers' guild suddenly ended. The average yearly
number of journeymen (non-masters' children) that were promoted to mas-
tership suddenly rose from 0.1 during the years 1500-1540 to the high value
of 4.3 during the years 1540-1577. This spectacular increase was the result
of an intervention by Emperor Charles V in the guild system in Ghent by
means of the *Concessio Carolina*. For essentially political motives, the em-
peror drastically lowered the threshold of admission to corporations, mak-
ing it substantially easier for outsiders to rise from journeyman to master in
guilds that required little starting capital. During the Calvinist republic
(1577-1584), when the much higher, pre-1540 admission conditions were
reinstated, the average yearly number of inscriptions of non-masters' sons
fell again to 1.2. When the threshold of entry was again considerably low-
ered after the reconciliation, 3.4 journeymen (non-masters' sons) on average
became master brewer every year in the period 1584-1600. The example of
the brewers' guild shows that in sixteenth-century Ghent a journeyman's
possibilities of attaining mastership were largely determined by the suc-
ceeding political regimes of the town.[74] During the period in which urban
autonomy was greatest and the guilds had considerable political power, the
possibilities for non-masters' children were lowest. In this respect, it needs
to be said that the participation of the guilds in the political power of the
town probably heightened the tendency towards exclusion and monopoly in
the guilds. In these circumstances, being a member of the guilds not only
opened the door to the labour market but also to a political career.[75] This
positive correlation certainly applies to the brewers, who were strongly rep-
resented in the city council during the period 1500-1540.[76] In sixteenth-cen-
tury Ghent, the conditions of admission to the brewers' guild had a much
greater impact on the moving up possibilities of journeymen than the eco-
nomic climate. The progress of beer production in Ghent was inversely re-
lated to the number of outsiders that became master brewers: the beer out-
put rose from an average of 84,742 tonnes in the years 1570-1578 to

[73] The entry fees of the brewers' guild in 1520 corresponded to 320 daily summer's
wages of a bricklayer's journeyman. Dambruyne, *Corporatieve middengroepen*, p.
199.
[74] For this topic see Dambruyne, 'Guilds, social mobility and status'.
[75] Boone, 'Métiers', p. 16.
[76] Dambruyne, *Corporatieve middengroepen*, p. 523.

104,224 tonnes in the years 1582-1584 but descended to an average of 57,477 tonnes in the years 1592-1600.[77]

The closed and hereditary situation in which the brewers'guild found itself between c. 1450 and 1540, however, cannot be generalised to all the Ghent guilds. A study of the tailors' (see Graph 2) and the tick-weavers' guilds (see Graph 3) shows that a considerable number of non-masters' children obtained the status of master before 1540. In the tick-weavers' guild, an average of three outsiders per year received the title of master during the period 1500-1540; in the tailors' guild the number was 3.1 (see Graph 2 at the end of this article).

Different elements can be cited as to why the tailors' and the tick-weavers' guilds were less closed than the brewers' guild. They were both amongst the corporations with the largest number of members and the greatest economic power in town. This implies that the demand for tailors and tick-weavers on the urban labour market was much larger than that for brewers, which is why these guilds felt less need to limit the number of masters. Linked to this is the fact that the financial threshold for the tick-weavers and tailors was much lower than for the brewers.[78]

Most of the guilds in Flanders and Brabant regulated the admission to mastership and thus also the corporate labour market in a liberal way, only imposing high financial conditions but otherwise applying the law of supply and demand. The Ghent tick-weavers diverted from this rule. By introducing a *numerus clausus*, this guild tried to acquire full control over the labour market. Although no single document explicitly mentions the existence of a strict numerical limit to the number of admitted outsiders, Graph 3 (see at the end of this essay) leaves no doubt as to the effective application of this rule.

With few exceptions, from the guild year 1478-1479 until 1539-1540, the tick-weavers' guild did not admit more than three new masters every year from the group of non-masters' children. The guild applied this mechanism to regulate mobility again during the second half of the fifteenth century, having already experimented with the rigid system of *numerus clausus*.

As with the brewers' guild, many more journeymen (non-masters' children) acquired the master's title in the tailors' guild after 1540. The yearly average rose during the years 1540-1577 to 8.4, but it decreased during the Calvinist republic 1578-1584 to a yearly average of 3.4. When the admission conditions were again drastically lowered from 1584, the tailors' guild

[77] De Commer, 'De brouwindustrie te Gent', p. 118.
[78] For example: the tick-weavers and the tailors demanded 1,200 and 1,920 Fl.gr. entry money respectively, the brewers 3,840 Fl.gr.

saw a hitherto unknown influx of outsiders, with a yearly average between 1584 and 1600 of 16.8, and many more non-masters' children obtained the master's title than masters' children with a yearly average of 6.2. How close the link was between corporate admission conditions and the number of new masters (non-masters' children) in Ghent is effectively illustrated in Graphs 1 and 5. The urban ordinance of 4 November 1577 led to an enormous rise in the number of buyers of masters' titles in all guilds. Before returning to the situation of hereditary mastership and the high admission conditions, through this ordinance the Ghent city authorities gave their citizens fourteen days in which to acquire personal freedom in whichever guild (except for the three hereditary corporations) at the cheap rate of 240 Fl.gr. A massive acquisition of masterships was the result. Compared to the years 1572-1576, the number of buyers was increased sixfold on average in 1577.[79] In sixteenth-century Ghent, the influence of the admission conditions on the number of new masters was thus very high. It needs to be said, however, that Ghent was a special case, as the adjustments of corporate admission conditions always coincided with political-institutional fault lines and political changes that had far-reaching consequences.[80]

Graph 4 shows that in towns that did not experience changes in their political regime, or that were not subjected to social tranformations, the increases in the entry fees also influenced the number of new inscriptions. In 1631, in the Bruges shoemakers' guild, the admission fee for non-masters' children who had completed their apprenticeship with a Bruges master was raised from 720 to 1,200 Fl. gr (an increase of 67 per cent). For non-masters' children who had learned the trade outside the city walls, it was raised from 1,200 to 1,920 Fl.gr. (an increase of 60 per cent).[81] Moreover, in 1636, the fee to be paid in order to enter for the master's test was raised from 48 to 240 Fl.gr.[82] It turns out that the number of journeymen (non-masters' children) who bought the master's title was 29 per cent lower during the years 1631-1639 (with a yearly average of 5.4) than during the years 1620-1630 (yearly average, 7.6). As these measures were not applicable to masters' children, their number did not decrease during the 1630s. On the contrary, their number increased a little from an average of 3.2 in the 1620s to an average of 3.8 in the 1630s. The effects of the tough new measures for admission in 1675 made themselves felt even more. The admission fee for non-masters' children rose from 1,200 to 1,680 Fl.gr. (an increase of 40 per

[79] Although for many guilds, the inscriptions are spread over two guild years in their accounts (1576-1577 and 1577-1578), they all refer to the year 1577.
[80] Dambruyne, 'Guilds, social mobility and status', pp. 71-72.
[81] Van Quathem 'Sociale mobiliteit', p. 115.
[82] Van Quathem, *Het Brugse schoenmakersambacht*, p. 136.

cent) and for the out-of-town journeymen from 1,920 to 2,880 Fl.gr. (an increase of 50 per cent). Furthermore, in that same year, a new master's test was introduced.[83] The number of new inscriptions of non-masters' children decreased spectacularly from 1675 onwards: during the years 1665-1674 some 75 journeymen bought the master's title, but during the following ten years (1675-1684) only 28 did so (a reduction of 63 per cent). The admission of masters' children also fell by more than half (from 55 to 26), which was unmistakably the result of the sudden quadrupling of the admission fees for masters' children in 1675 (from 60 to 240 Fl.gr.).[84] The substantial fall in the number of new masters can be attributed mainly to the higher admission fees, since the demographic evolution in no way suggests that the Bruges economy in general or the shoemaking trade in particular had to deal with a recession or crisis.[85]

Jean-Pierre Sosson, however, showed a long time ago, related to another Bruges guild and in an earlier period, that there is no absolute law for the link between corporate admission conditions and the number of new masters. Regardless of the considerable increase in admission fees for non-masters' children (from 506 to 1,466 Fl.gr., i.e. increasing the amount by 2.9 times the previous amount) in 1478, twice as many non-masters' children (a total number of 65) bought the master's title of the Bruges coopers guild during the years 1478-1487 as had bought the title during the years 1468-1477 (a total number of 31).[86] The number of masters' children entering the guild decreased during that period. This example shows that higher admission fees did not necessarily discourage the journeymen from seeking a master's title, as long as the guild's economic prospects were good. For this reason, I propose that the journeymen were led by the employment situation more than by the institutional admission conditions that were imposed on the new masters by the guild. Furthermore, one should not forget that the corporate admission conditions were only one of the investments that journeymen had to undertake when they made the transition to independence. Potential masters had to invest in a workshop, tools, equipment, materials and, eventually, in hiring labour. The starting capital varied considerably from trade to trade, with, for example, tailors and tick-weavers needing to invest much less in durable means of production than brewers. This implies that for guilds where little starting capital was needed, the ad-

[83] Van Quathem, 'Sociale mobiliteit', p. 116.

[84] *Ibidem*, p. 115.

[85] The Bruges population figure was not lower during the years 1675-1684 than during the years 1665-1674. Cf. Wyffels, 'De omvang', p. 1273.

[86] Sosson, 'La structure sociale', p. 465.

mission conditions were more severe than for those that required high start-
ing capital.

The urban labour market was very much dependent on the economic
and demographic situation. Strong economic and demographic growth re-
sulted in higher production and consumption and a greater need for labour,
which increased the chances for a journeyman to move up the professional
ladder and become a master. When the economic climate was not favour-
able, the opposite happened, i.e. the labour market contracted. Research for
the Antwerp coopers and the Bruges shoemakers, respectively, has shown
that the severe economic and demographic crisis of the Flemish and Bra-
bantine towns at the end of the sixteenth century resulted in a sharp fall in
the number of inscriptions of masters. Reflecting the general demographic
trend, the number of new masters (both masters' and non-masters' children)
in the Antwerp coopers' guild decreased by more than half in the late six-
teenth century, from 43 during the years 1577-1580 to 21 during the years
1591-1595.[87] The large reduction in the admission fees in 1580 (see Table
1) thus had no effect on the number of new registrations. The same sharp
fall can be noted for the Bruges shoemakers' guild, with the number of new
inscriptions falling by 42 per cent during the 1590s.[88]

Graph 5 proves beyond doubt that, even in sixteenth-century Ghent, the
prospects for journeymen moving up the social ladder were dependent not
only on the corporate admission conditions but also on the situation of the
urban labour market.[89] The period 1584-1600 provides the best example.
Notwithstanding the fact that Ghent's population was smaller than before
1584 and that the town was not really favoured by economic circumstances,
every year after 1584 many more journeymen (non-masters' children)
bought the master's title than had done during the years 1540-1577 (with
the exception of the extraordinary year 1577).[90] How does this rhyme with
the opposite trend in the Antwerp coopers'guild and the Bruges shoemak-
ers' guild?

Apparently, the economic and demographic crisis of the late sixteenth
century destabilised the Ghent labour market differently from that of Ant-
werp and Bruges. The explanation must be found in a combination of fac-
tors. First, the huge emigration of Ghent citizens after 1584 led to a severe
shortage of schooled artisans and corporately organised retailers. Amongst

[87] Willems, 'Loon naar werken?', p. 46.

[88] Van Quathem, 'Sociale mobiliteit', p. 118.

[89] Graph 5 only has an indicative value, as we do not have data for every year of
each of the 9 guilds.

[90] While Ghent had about 42,000 inhabitants around 1572, this number fell to
27,000 around 1590. See Dambruyne, *Mensen en centen*, pp. 349, 351.

the approximately 15,000 Ghent citizens who left the town after 1584 for religious, political and/or economic reasons, a proportionally larger number were master craftsmen compared to other social and professional groups. Second, the exodus resulted in an internal shift within the Ghent corporate world, as many more hereditary masters than non-hereditary masters left the town. Before 1584 new masters had to compete with workshops and shops which had been owned by the same families for generations and which had built up a loyal customer base. This uneven competition largely disappeared after 1584. In addition, the fact that, at the end of the sixteenth century, the financial threshold of admission as a master was extremely low cannot be overlooked. At the time, the admission fee in all guilds represented only some six to seven summer day wages of a journeyman bricklayer, and the master's test and banquet were not compulsory. In other words, during this period journeymen had a unique opportunity to move up the social ladder and become independent masters.

Conclusion

This essay does not pretend to present definitive conclusions on the real or apparent process of proletarianisation that took place within the world of the guilds in the Southern Netherlands during the Early Modern Period. Research is still in progress at this moment. In addition, this article focuses on only one aspect of corporate proletarianisation. It does not consider the many informal forms of wage-dependency on guild masters, such as subcontracting and the 'putting-out system'.[91] Yet, this short overview yields some provisional but important conclusions. It seems obvious that the picture of an ever-increasing waged proletariat of journeymen during the Early Modern Period does not fit historical reality. In the absence of quantitative guild documents for the fifteenth, sixteenth and seventeenth centuries, it is not possible to follow up the absolute number of journeymen nor the numerical relation of masters to journeymen in the most important Flemish and Brabantine towns throughout those centuries. It is only in 1738 that the sources enlighten us in this respect. The fact that Brussels counted as many masters (3,813) as journeymen (3,883) and that in Ghent the masters (3,614) were clearly in the majority (2,443 journeymen) suggests that a substantial number of journeymen was still able to obtain the master's title.[92] The number of masters was lower in 1738 than in the sixteenth and seven-

[91] This kind of proletarianisation is mentioned by Lis and Soly, 'Corporatisme' as well as by Friedrichs, 'Capitalism, mobility'.
[92] For the Brussels data see De Peuter, *Brussel*, p. 91; for the Ghent data see Dambruyne, *Corporatieve middengroepen*, pp. 755-756.

teenth centuries, but the differences are not spectacular.[93] The classical the-
sis that the status of the journeyman evolved in broad lines, from being a
temporary wage labourer in the Middle Ages to becoming a life-long wage
labourer in the Early Modern Period, therefore needs to be revised. The re-
sults of my research point in the direction suggested by Christopher Frie-
drichs, namely that there has not been a linear and continuous process of
proletarianisation, and that one should rather speak of a recurrent process.

The real chances of social and professional advancement for journey-
men were primarily determined by the changing economic and demographic
circumstances and by the influence of the latter on the urban labour market.
The journeyman's prospects were at their best when there was a shortage of
skilled labour during periods of substantial growth in the urban economy.
During such propitious periods, journeymen were eager to pay high admis-
sion costs. On the other hand, when the labour market was saturated and/or
during a period of economic recession, the journeyman's chances of promo-
tion were few. The labour market can therefore be identified as the most
important factor regulating the social mobility of the journeyman, but it
cannot be denied that corporate admission conditions had a distinct effect
on the career prospects of the journeyman during certain periods. The best
proof of this can be found in sixteenth-century Ghent.

In addition, my research shows that the guilds probably interfered much
less in the mechanisms affecting the social mobility of the journeyman than
has hitherto been supposed. It is not correct to automatically link the grad-
ual toughening of corporate admission conditions in different towns be-
tween 1450 and 1650 to protectionism in guild policy. The former often had
nothing to do with the latter. In most guilds, the systematic raising of the
cost of admission was not done for social and professional motives but was
necessary for financial reasons only. The normal revenues were usually in-
sufficient to cover extraordinary expenses, such as repairs to guild houses
and chapels and the expenses of lawsuits. Thus, trade organisations tried to
balance their accounts by imposing either higher admission fees on candi-
dates for mastership or higher subscription fees on their members. This does
not preclude the possibility that some guilds at certain times clearly opted
for a well-aimed protectionist policy. The *numerus clausus* policy of the
Ghent tick-weavers' guild during the fifteenth and first half of the sixteenth
centuries is beyond doubt an example of this, but it would be a mistake to
generalise such examples.

[93] In Ghent about 4,000 guild masters were active in 1572; this is only 10 per cent
more than in 1738. Dambruyne, *Corporatieve middengroepen*, p. 40.

Graph 1. Annual number of registrations of new masters in the Ghent brewers' guild, 1399-1600.

Graph 2. Annual number of registrations of new masters in the Ghent tailors' guild, 1423-1600.

Graph 3. Annual number of registrations of new masters in the Ghent tick weavers' guild, 1400-1584.

Graph 4. Annual number of registrations of new masters in the Bruges shoemakers' guild, 1620-1639 and 1665-1684.

Graph 5. Annual number of registrations of new masters (non-masters' children only) in nine Ghent guilds (brewers, tailors, mercers, stocking makers, cheese mongers, grocers, candle makers, coopers and second-hand dealers), 1540-1600.

PAINTINGS, JOURNEYMAN PAINTERS AND PAINTERS' GUILDS DURING THE DUTCH GOLDEN AGE

Maarten Prak

Between the middle of the fifteenth century and the middle of the seventeenth century, European markets for industrial products and for industrial labour both expanded significantly.[1] For a variety of reasons demand for a whole range of products was increasing, and the Low Countries were especially well placed to cater to this growing demand. As a result, the towns, first in Flanders, then in Brabant, and finally in Holland, developed into centres of industry and commerce during the course of the late Middle Ages and the early modern period. The Low Countries became a core region in the European and world economies taking shape at that time. These changes also affected the production of paintings during the period. This essay presents a survey of our present knowledge of these processes in the arts sector. More specifically it will look at the production of paintings and at the role of wage labour (journeymen) in that production during the Dutch Golden Age, with particular attention to the role of the guilds. The question the paper tries to answer is whether, and to what extent, the expansion of the production of paintings was accompanied by an increase in the use of wage labour in painters' workshops in the Dutch Republic.

The production of paintings

During the period under consideration, paintings changed from being exclusive, luxury goods into so-called populuxe products.[2] In the original definition populuxe products are 'cheap copies of luxury items'.[3] For our purpose they may perhaps be more adequately defined as popular luxury goods, i.e. goods that do not contribute directly to the survival of their owner, but have nonetheless become so widely distributed that they can hardly be consid-

[1] For a recent survey, see Duplessis, *Transitions*, chapt. 4 whichh focuses specifically on the Low Countries, see Van der Wee, *The rise and decline of urban industries*.
[2] This section is a summary of Prak, 'Guilds'.
[3] Fairchilds, 'The production', pp. 228-248.

ered special. The car and the television are, in our own day, populuxe
goods. It cannot be doubted that paintings had become such goods in the
Netherlands in the seventeenth century. An Amsterdam petition, submitted
to the burgomasters in 1608, used the following expressions when com-
plaining about paintings imported from Brabant: 'rubbish and bad chil-
dren's works', 'mostly bad copies', and perhaps most significantly, 'a huge
mass of paintings'.[4] Estimates of the size of the market for paintings in the
Dutch Republic suggest that as many as five to ten million copies may have
been produced during the seventeenth and eighteenth centuries.[5] Our
knowledge of the arts market suggests that the bulk of this production was
concentrated in the towns of Holland. Even assuming an equal distribution
among all Dutch households, this suggests that every single household
owned, on average, the incredible number of ten paintings.[6] In the absence
of comparable estimates for Brabant and Flanders, it is difficult to say any-
thing specific about the distribution of paintings in those markets, but the
evidence is increasing that mass production of paintings was already devel-
oping in those regions in the fifteenth and sixteenth centuries.[7] The Amster-
dam petition mentioned above indicates a similar scenario.

It is well known that this expansion of the market was accompanied by
a change in the relationship between producer and customer. Instead of the
direct relationship, where the customer placed an order for a specific work
of art with a specific artist, often specifying the execution of the work, an
indirect relationship developed which forced the artist to produce works ac-
cording to his own tastes in the hope of selling later on. Consumers were
confronted with a wider range of choice and might buy, not from the pain-
ter's studio, but through the intermediate offices of an art dealer.[8] Artists'
guilds played a significant role in the rise of this mass market in the Low
Countries, a role that is often underestimated. The guilds' importance can
be seen in the coincidence of their creation and the expansion of the market,
in their contribution to the transparency of the market, and in their role in
the training of new artists, which will be discussed in the second part of this
paper.

In the Northern Netherlands, the expansion of the market for works of
art was accompanied by the foundation of new guilds.[9] In 1579, Amsterdam
artists received a charter separating them from other occupations and giving

[4] Quoted after Sluijter, 'Over Brabantse vodden', p. 119.
[5] Van der Woude, 'The volume', p. 297.
[6] Farmers on the isle of Walcheren, in Zeeland, possessed between five and ten pain-
tings each in the eighteenth century, see *ibidem*, p. 296.
[7] Vermeylen, *Painting*, chapt. 6.
[8] *Ibidem*, pp. 62-79; Montias, 'Art dealers'.
[9] On artists' guilds, see the still indispensable Hoogewerff, *De geschiedenis*.

them a guild of their own. In Middelburg, which had a dynamic economy at the time, a separate artists' guild was created in 1585. The Twelve Years' Truce (1609-1621) opened the borders to foreign industrial products and caused a spate of new guild establishments. We noted above that Amsterdam painters complained about the import of works of art from Brabant, and similar complaints led to the creation of artists' guilds in Gouda and Rotterdam in 1609, and in Utrecht and Delft in 1611. An initial request to establish an artists' guild in Leiden was turned down by the burgomasters, but when the Leiden painters tried again in the 1640s, they received a more positive response. Although the trade was not formally incorporated, the Leiden market was regulated as requested and the painters acted as if they had received a guild statute, inscribing their first records as belonging to 'Dean and Overseers of the guild of Saint Luke's order'.[10] The flowering of the arts in Bruges and Antwerp also took place within corporate structures.[11]

Guilds themselves often claimed that they provided a measure of quality for customers by, for example, requiring their members to produce a masterpiece to demonstrate their skills. Woollen cloths, and many other products, were checked and labelled to ensure their quality before entering the market. The Amsterdam goldsmiths and silversmiths' guild regularly smashed its members' work if it proved to be made of substandard metals.[12] Remarkably, however, the guilds of Saint Luke in the Dutch Republic refrained from the application of any such measures. There was no requirement to produce a masterpiece, nor were any quality controls applied to members' output. Nonetheless, the guilds did try to control access to the market. The records of the Haarlem guild, which have been published by Hessel Miedema, demonstrate that the pursuit of illegal producers and products was perhaps the single most important item on the agenda of the meetings of the guild's board of overseers. The guild repeatedly petitioned the Haarlem burgomasters for tighter market controls.[13] These were successful insofar as about three-quarters of the paintings in Haarlem homes were indeed made by Haarlem painters.[14] At the same time, the Haarlem guild accepted art dealers into its ranks and exported paintings to other towns in Holland.

Some of the most popular painters in Haarlem asked for a relaxation of the market regulations. They considered the guild too strict, for example, in

[10] *Deecken ende Hooftmans van 't gilde van st. Lucas ordre.* Cf. Sluijter, 'Schilders', pp. 29-31.

[11] Vermeylen, *Painting*, pp. 127-139.

[12] Hesselink, 'Goud en zilversmeden', p. 143.

[13] Miedema, *De archiefbescheiden*, pp. 236-255, 289-291, 522, 532-536, 562-575, 616-617.

[14] Montias, 'Art dealers', pp. 248-249.

its resistance to auctions. The guild's overseers were opposed to auctions because they were difficult to regulate and it was feared that, under the cover of a local collection of paintings, newly imported works would be marketed in Haarlem. Their opponents, among whom Salomon van Ruysdael and Pieter Molyn were the most active, argued that too narrow a view was particularly harmful to their younger colleagues:

> who are satisfied with small profits that will allow them to continue in the trade, but [when the rules are too strict] might find it difficult to sell their works and will then get a distaste for the arts, so that as a result of [financial] incapacity many a promising career will be suppressed.[15]

The established painters would not be bothered by some relaxation of the rules as they would sell well anyway. Note, however, that these opponents of the guild's board did not propose to introduce free trade. They merely wanted a wider range of channels through which their paintings could be marketed, under the supervision of the guild, i.e. of the local painters themselves. It seems that Ruysdael and Molyn saw the guild as providing much-needed protection to young painters, for whom it was to create an attractive environment that would encourage them to stay in the trade and develop their talents. Once they had succeeded, they no longer needed that protection.

Thus it appears that neither the producers nor the customers could expect full and effective support from the guild's activities. This forces us to reconsider other contributions guilds made to the development of the market for the arts. One important contribution was to create market transparency. Our own exposure to top quality art from the period under discussion has perhaps diminished our sensitivity to the problems inherent in the marketing of art. Those problems are related to what economists call 'information asymmetry'.[16] In plain language this means that there is an imbalance in knowledge about a product between buyer and seller. The resulting insecurity on the part of the buyer may ultimately make him decide to spend his money on a safer product. This problem is easily understood when it comes to modern art. Why would anyone want to spend a small fortune on a work by Karel Appel if, by his own admission, Appel is 'just messing about'? The seventeenth-century equivalent of this problem is the indignant com-

[15] *[D]ie met weynig winste te vreden syn ende aangelokt werden in haar begonnen conste te continueren, daar sy anders met al haar dingen beset blyvende, dickwyls de walg vande const crygen, ende menig eedel geest door onvermogentheyd onderdrukt werden* (Miedema, *Archiefbescheiden*, p. 281).

[16] The argument has been inspired by Romijn, 'Knollen en citroenen'.

ment of a French traveller passing through Delft in 1663 who was confronted with one of Vermeer's works and heard that 'they have paid six hundred guilders, even though it displays only one figure, while I believe that six pistols [about one tenth] would have been already too much'.[17] To combat such insecurity, and hence to promote the sale of art, guilds applied various strategies. In the first place they offered customers an opportunity to compare a range of paintings. The opening of Our Lady's Pand (building) in Antwerp in 1482 provided an outlet for painters and other producers of luxury products, whilst at the same time helping customers making an informed choice.[18] A similar Pand was opened in Bruges in 1482. In several Dutch towns similar opportunities were created in the seventeenth century. The statutes of the Utrecht guild from 1644, for example, required all members to supply the 'Paintings Room' with one work. After it had been sold, a replacement had to be supplied within six months. In 1664 further details were added to these rules stipulating that the work had to be 'in their own hand, completely finished, with the usual colours, and at a designated format' and when it sold, a replacement had to be supplied within three months.[19] In Amsterdam, Haarlem and The Hague, the guilds maintained similar rooms.[20] In The Hague, prices were set by the overseers of the guild.[21]

Guilds were open to so-called enthusiasts, who thus had access to the informal discussions between artists that are such an important factor in the establishment of artistic reputations. Philips Angel's famous Leiden lecture from 1641 has recently been interpreted as an initiation, for both artists and their potential customers, into the theoretical foundations of the appreciation of art.[22] In addition, the guild could offer mediation for dissatisfied customers. When Rembrandt had completed a portrait of the daughter of Diego d'Andrada, the latter was dissatisfied with the likeness and therefore withheld payment. Rembrandt took legal action, insisting on full and immediate remuneration for his work, but adding that he was prepared to submit the finished work 'to the opinion of the overseers of the guild of Saint Luke to

[17] *[Q]u'on avait payé six cens livres quoyqu'il n'y est qu'une figure, que j'aurais cru trop payer de six pistoles* (Blankert *et al.*, *Vermeer*, p. 211).

[18] Ewing, 'Marketing Art in Antwerp', pp. 558-584; Vermeylen, *Painting*, pp. 19-28.

[19] *Schildersvereenigingen te Utrecht. Bescheiden uit het gemeentearchief*, pp. 73, 81.

[20] Hoogewerff, *De geschiedenis*, p. 153.

[21] Bredius, 'De boeken', pp. 52-53, 67.

[22] Romijn, 'Knollen en citroenen', pp. 86-94; for a translation of Angel's text, see also Angel, 'Praise'; Sluijter, *De lof der schilderkunst*.

judge if it looked like the daughter, and if they say that it does not look like her, he will change it'.[23] Having recourse to such independent authority should have helped to diminish customers' anxieties about getting value for their money.

In recapitulating the argument so far, two observations can be made. First, the market for works of art in the Low Countries had become a highly commercial and expanding market in which new groups of customers were found and offered an ever-widening range of products. As a result, the production of paintings developed into a proper industry. Second, despite this expansion, the market for paintings was regulated and supervised by guilds, which helped to create an attractive environment for investment in a painter's career and promoted sales by providing market transparency. Inevitably, in the context of a volume on wage labour and the arts, the next question has to be: What impact did all this have on the position of journeymen in the trade? Unfortunately, it is a topic that has received far less attention than the production and marketing of art. Therefore the next section of the paper has to be far more speculative.

The labour market

One might call the early modern period the age of proletarianisation.[24] Every attempt at quantification is bound to be defeated by problems of definition and lack of data, but let us for a moment assume that there is some validity in the estimates presented by the American historical-sociologist Charles Tilly. These estimates clearly suggest that on the eve of the Industrial Revolution, a majority of the European population was already dependent on a wage income. They also suggest that in this respect the situation had clearly changed since the sixteenth century, when wage labour only concerned a minority of the population. It should be added that wage labour was comparatively common at a relatively early stage in the Low Countries.

[23] *[S]tellen aen 't oordeel van de overluyden vant St. Lucasgilde of het de dochter gelijckt dan niet, en soo sij seggen dat het haer niet en gelijckt soo sal hij 't veranderen*, quoted after Van Eeghen, 'Het Amsterdamse Sint Lucasgilde', p. 72.
[24] A survey in Soly, 'Proletarisering'.

Table 1. *Estimates of the percentage of wage labour in the European population, based on data from Saxony (Germany), 1550, 1750, 1843.*[25]

	1550	1760	1843
countryside	25.6	60.6	79.1
towns	15.5	44.8	51.7
weighted average	*24.3*	*58.4*	*70.8*

At the same time, it is important to realise that wage labour five or seven hundred years ago was markedly different from its modern equivalent. Most significantly, wage labour in the late Middle Ages was temporary in two respects. First, labour was usually hired by the week, or even the day, rather than for extended periods or indefinitely and, in addition, much work was seasonal and would come to an end anyway within some weeks or at best a few months. One has only to think of harvest time in the countryside or seasonal fluctuations in harbours. Second, many wage labourers saw their proletarian status as temporary because they expected to be independent at some point in the future, by inheriting the farm or establishing themselves as master craftsmen. As a result of this double temporality, wage labour and independent work were thus much more difficult to distinguish then than in modern society. In any given year, one individual might work independently part of the time and as a wage labourer part of the time. In other words, a very complicated reality lurks behind the straightforward figures in the table.

Like labour itself, the labour market was not homogeneous. Labour economists have therefore developed the concept of the dual or segmented labour market.[26] One can conceptualise this segmentation as roughly or as detailed as one might wish, but most authors applying it use a dual model consisting of a protected and a free segment in the market. The free segment is defined by lowly or unskilled work and loosely defined labour relations. In other words, this is the type of work that basically everyone can do. The protected segment, on the other hand, deals with skilled labour and is bound to offer its participants more stable labour relations. Labour contracts from seventeenth-century Amsterdam suggest periods of up to three consecutive

[25] See for this Tilly, 'Demographic Origins', p. 33.

[26] De Vries, 'How did pre-industrial labour markets function?' As far as I know, this concept was first introduced in Dutch social history in Van Zanden, 'Lonen en arbeidsmarkt', pp. 12-13. See Knotter, 'De Amsterdamse bouwnijverheid', pp. 124-125 and *idem, Economische transformatie*, p. 16 and *passim*, has further elaborated and applied the concept.

years.[27] The free segment was more or less open to anyone willing to work, even though employers' preferences, for instance for workers from a certain region, might create some distinctions between labourers. To enter the protected segment, on the other hand, one had to overcome certain barriers. Such efforts were, however, compensated, most obviously financially. For the Dutch Republic, at least in the building trades, indications are that the so-called skill premium might have been as much as 50 to 80 per cent.[28]

It seems obvious that we should expect to find journeymen in artists' workshops in the protected rather than in the free segment. In the parlance of the age, however, it was exactly the other way around: the protected segment was known as 'free', whilst the unskilled labourers were called 'unfree'.[29] This distinction was part of the corporate idiom and discourse of the trade guilds. 'Free' was defined as being inside the corporate world, while 'unfree' described those outside it. The corporate system also helped to shape the labour market in a variety of other ways.

The first, and perhaps most important, contribution of the guilds to the shaping of the labour market was their involvement with training.[30] In the absence of state regulation, the guilds acted as regulators of vocational training. All guild regulations had several clauses on apprenticeship. Usually, apprentices had to be properly registered and most guilds specified the duration of the apprenticeship. It was also common practice to include rules for apprentices who wanted to change masters during their training. Regulations for the painters in Utrecht, from 1611, stipulated that the registration of apprentices would cost 42 pennies, 30 of which were for the guild's coffers and 12 for the overseers and the guild's servant. Masters' children could be apprenticed free of charge. Those who only wanted to learn the art of drawing were charged a mere 6 pennies, and if the boy decided to continue for the whole programme, those 6 pennies would be deducted from the fee he had to pay his master. Apprentices could only change to another workshop with the approval of their master.[31]

Remarkably, neither these nor comparable regulations discussed the content of the education. Even apprenticeship contracts, which were sometimes concluded, were seldom specific when it came to defining the education the apprentice was supposed to receive. Some contain the significant

[27] Van Dillen, *Bronnen*, nos. 254, 645, 851, 1736.

[28] De Vries, 'The labour market'; De Vries, Van der Woude, *First Modern Economy*, p. 633.

[29] Scholliers, 'Vrije en onvrije arbeiders'. See also Deceulaer, 'Arbeidsregulering', p. 28.

[30] On guilds and apprenticeship in general, see Epstein, 'Craft Guilds'. For the Low Countries, De Munck, *Leerpraktijken* and *idem*, 'Le produit du talent'.

[31] *Schildersvereenigingen te Utrecht*, p. 67.

clause that the master had to initiate his apprentice in the 'secrets' of the trade.[32] An Amsterdam contract from 1635 specifies that seventeen-year old Adrian Carman would learn 'like all other apprentices usually do: rub paints for himself and his master, also to prepare canvasses as best as he can'.[33] The guild did not indicate how much time would have to be spent on one or the other aspect of the apprenticeship, but provided a framework that allowed the creation of such contracts and the execution of a proper training programme. The brokering of the guild, in cases of conflict, and the certification of the education through the registration process seem to have been especially significant for all parties involved.

This was particularly relevant because an apprenticeship as a painter could be expensive. There were missed years of income to reckon with, and the apprentice also had to pay his master. On average the tuition fee, in the order of fifty guilders, may not have exceeded the costs to the master of room and board for the apprentice, so the master could only recoup his efforts by exploiting the apprentice's contribution to his shop's workload. Those who wanted to work with a reputed master would have to reckon with far higher rates. Rembrandt charged as much as one hundred guilders and, on top of that, reserved the right to the proceeds of his pupils' work.[34] The strong connection between guild and apprenticeship is underscored by the fact that, in Utrecht in the first half of the seventeenth century, the four artists who each trained at least ten pupils between 1611 and 1639 (and a grand total of 65 out of 105 painters' apprentices in those years), were also members of the guild of Saint Luke's board in 18 of the 29 years of this period.[35] With a board of three, this was a substantial over-representation, suggesting that popular masters tended to see the guild as a significant institution.

Another way in which the guilds influenced labour markets was by the restrictions they imposed on the size of workshops. Members of the Amsterdam cloth-shearers' guild were not permitted to employ more than eight journeymen, a number that was however raised to ten in 1661.[36] In other branches, journeymen were clamouring for similar regulations. In 1633, the Amsterdam hat-makers' journeymen were even trying to limit the number of apprentices in their trade. They were firmly opposed to the permission that the employers had received from the Amsterdam burgomasters to si-

[32] De Jager, 'Meester, leerjongen, leertijd', p. 97.
[33] ... als de andere leerknechts gewoon sijn te doen: verwen te wrijven voor hem ende sijn meester, item doecken te plumuyren naer sijn vermogen (ibidem, p. 98).
[34] Ibidem, pp. 75-77.
[35] Compare Schildersvereenigingen te Utrecht, pp. 127-28 with Bok, "Nulla dies sine linie", p. 65.
[36] Van Dillen, Bronnen, no. 61.

multaneously educate two, instead of one, apprentice per workshop. The journeymen, apparently afraid of a significant increase in the supply of skilled labour in their trade and the depression of wages that would inevitably follow, refused to work for masters with more than one apprentice.[37] Such activities also point to another remarkable phenomenon, the organisation of journeymen in the skilled segment of the labour market.

During the fourteenth century, journeymen in several European countries started to create formal organisations. In the past the emergence of such organisations has been interpreted as a reaction to restricted access to the mastership.[38] In the more recent historical literature there is a tendency to look at it from the opposite perspective and explain their emergence as attempts by labourers to corner the profits from a general scarcity of labour in the decades after the Black Death.[39] Almost without exception, such journeymen's organisations – also known as *Gesellengilden* or journeymen's guilds in Germany – appeared in incorporated branches.[40] Journeymen's organisations were thus the mirror image of their employers' guilds.[41] When we apply the definition of unions as labour cartels to these journeymen's organisations, the similarities are striking.[42] Like modern unions, journeymen's organisations were looking to raise wages and tried to force employers into compliance by strikes. Journeymen's organisations tried to influence and correct the behaviour of their members and thus improve the quality of their 'product', as unions would later on.[43] Journeymen's organisations attempted to drive women out of their markets, afraid as they were of competition from women's low wages. Unions in the nineteenth and twentieth centuries would do exactly the same.[44] Journeymen's organisations tried to control the labour market as far as they were able by establishing fixed meeting places, usually inns, where they could supervise the recruitment of labour, as unions would later do through their labour exchanges.

[37] *Ibidem*, no. 57. For similar examples of organised protest in other towns in the Low Countries, see also Lis and Soly, 'De macht'.

[38] This still happens in Bräuer, *Gesellen*, pp. 20, 68, 71, 82.

[39] Reininghaus, *Die Entstehung*, pp. 36, 41-42; Schulte Beerbühl, *Vom Gesellenverein zur Gewerkschaft*, p. 32.

[40] Lis and Soly, '"An Irresistible Phalanx"', pp. 22, 24.

[41] Bräuer, *Gesellen*, p. 107.

[42] This idea was first developed by the Dutch social historian Van Tijn, 'Bijdrage tot de wetenschappelijke studie van de vakbondsgeschiedenis'.

[43] Compare Reininghaus, *Gesellengilden*, p. 95, with Roberts, 'Drink and Industrial Discipline'.

[44] Wiesner, 'Guilds'; Van Eijl, *Het werkzame verschil*, p. 350.

For reasons that have not been sufficiently explored so far, journeymen in the Low Countries refrained from creating their own 'guilds'. Instead, they organised themselves around journeymen's insurance 'boxes', i.e. common funds used for the disbursement of small weekly payouts to sick members and more substantial support to the relatives of the deceased.[45] These journeymen's boxes should also be understood as attempts by the workers to control the market for wage labour. The financial support given to impoverished members created mutual solidarity, but at the same time prevented those same members from selling their labour below the going rate. In the Antwerp hat-making industry, the journeymen's box also served as a platform for protests concerning wage rates.[46] In the arts sector, however, such organisations seem to be completely absent, both in the Southern and in the Northern Netherlands. This may be related to the scale of the industry and the organisation of its production process.

One new feature of early modern labour relations was the expansion in scale occurring in a variety of branches. In the seventeenth-century Dutch Republic, the VOC ['Dutch East India Company'] had over 10,000 employees, the Dutch army had more than 100,000 soldiers at times, and the Dutch merchant navy employed over 20,000. In Amsterdam, some tobacco companies had workforces numbering in the dozens; the largest was reported to employ as many as 200.[47] At times, the VOC wharf in Amsterdam gave work to over 1,000 men. Much of this work was unskilled. The VOC mostly employed soldiers and sailors, and the same obviously applied to the army and the merchant navy. But some of these large-scale industries did employ skilled labour. The shipwrights of Amsterdam prided themselves on their skills and it is perhaps no coincidence that shipwrights, the majority of whom were working for wages, still had a powerful guild.[48] Expansion of the workforce in individual units was, however, far from a general phenomenon. In small towns it was highly unusual, and in larger towns it was generally the non-incorporated trades that were affected. In the Dutch Republic, painting is a case in point: workshops seem to have remained small.[49] In this respect, the trade was not markedly different from other craft industries. For instance, in 1806, Amsterdam tailors numbered 546 with a workforce of 1,006, or two workers on average for each employer. In Bois-le-Duc (in the South) and Zwolle (in the East) employers and workers in the

[45] Timmer, *Knechtsgilden*.
[46] Lis and Soly, 'Macht', p. 23.
[47] Lourens and Lucassen', ' Ambachtsgilden', p. 135.
[48] Deurloo, 'Bijltjes en klouwers'; Unger, *Dutch shipbuilding*.
[49] As other contributions to this volume demonstrate, some painters' workshops in the Southern Netherlands did expand.

tailoring industry were finely balanced.[50] According to an official record from 1738, 350 master tailors in Antwerp employed 387 journeymen, whilst in Ghent 226 masters provided work for 244 journeymen. Only in Brussels did one find, as in Amsterdam, on average two workers per workshop.[51]

This is not to say that the tendency to expand the scale of production did not affect craft industries. As it was, there were other ways of achieving a similar result. Cissie Fairchilds, the inventor of the term 'populuxe good', has pointed out how many such goods were produced in eighteenth-century Paris by companies that used subcontracting.[52] Umbrellas, to name but one example, were made by a string of firms that each contributed a part of the final product. In Amsterdam we see the same phenomenon in the coach-making industry. In 1786, a petition was filed by 20 coachmakers and 77 of their journeymen, 19 blacksmiths and 66 journeymen, ten saddle-makers with 30 workers, two painters, and finally five sculptors with nine of their journeymen, complaining about the importation of English coaches. These people, who were organised in four different guilds, were all working on the same product.[53] Such practices may have occurred in painters' workshops in the Southern Netherlands, but seem to be conspicuously absent from the Dutch studios of the Golden Age.

An alternative option for the expansion of production without a con-comitant expansion of individual workshops was 'putting-out'. While the relationships between the parties involved in subcontracting were more or less equal, with all firms operating independently and contributing their ex-pertise to the final product, putting-out implied a hierarchical relationship between a principal, usually a merchant, and the craftsman who actually performed the work. In the Dutch Republic, as far as the arts were con-cerned, this type of relationship was known as 'painting on the galley' (*op de galey schilderen*). The implicit hint at slave labour is probably no coinci-dence.[54] A nice example of this practice is the well-known conflict between 'art dealer in Rotterdam' Leendert Hendrixsen and Isaac van Ostade in Haarlem. In January 1643, the overseers of the Haarlem guild of St Luke were asked to arbitrate in a conflict between the two men. Van Ostade had accepted a commission to produce '6 pieces of paintings ... and on top of that 7 little rounds' for a total price of 77 guilders. In the meantime how-ever, Van Ostade claimed, his reputation had increased and therefore he was

[50] Panhuysen, *Maatwerk*, p. 285.
[51] Deceulaer, *Pluriforme Patronen*, p. 222.
[52] On subcontracting, see Lis and Soly, 'Corporatisme' and by the same authors, 'Subcontracting'.
[53] Amsterdam Municipal Archive, arch. 5061: burgemeesters, inv. no. 723: rekest 1786, no. 23
[54] Bok and Schwartz, 'Schilderen in opdracht', p. 193.

entitled to more money.[55] We find that Van Ostade, at the age of 19, had entered into a wage-relationship with Hendrixsen, but now, at the age of 22, had become an independent producer who wanted to renegotiate his contract. It is doubtful, however, if his contemporaries and fellow members of the Haarlem guild, Philips Bol and Jan Coelembier, were in a similar position to renegotiate.

A third option for employers who wanted to expand their business was to exploit the potentials of the apprenticeship system. Some successful masters were educating such numbers of apprentices that one is inclined to ask where their education ended and their contribution to workshop production began. The classic example from the Dutch seventeenth century is Rembrandt. He only worked with pupils who had already finished their basic training with another master. It is well known that Rembrandt used accomplished painters to contribute to the output of his studio, causing lots of confusion and concern to modern researchers and museum directors.[56] Rembrandt's reputation was such that he could command a substantial fee from his pupils and claim the proceeds of their work. Rembrandt's pupils, in other words, provided him with a double source of income. Nonetheless, they were strictly speaking not his workforce as he was not paying them. They were instead paying him for the privilege of working with him.

A fourth possibility was, of course, hiring workers, in other words, using journeymen. Were Dutch painters of the seventeenth century actually using this method to expand their production? In the absence of a thorough and wide-ranging investigation, it is perhaps too early to say. However, a review of the present literature has resulted in only one unambiguous reference to journeymen. In the Amsterdam guild of Saint Luke, part of the task of the guild servant (*gildeknecht*) was to accompany journeymen looking for work on an itinerary to the painters' workshops in the city.[57] Even here we are dealing with a supposition because the reference does not say that there actually were journeymen who needed to be accompanied. Of course, we should not expect to find journeymen working with an artist like Vermeer. It is highly doubtful that Vermeer ever had an apprentice. What is more remarkable is that in the literature on more successful artists with a large output, such as Rembrandt or Abraham Bloemaert in Utrecht, we find no trace of journeymen.[58]

In Haarlem, a new draft regulation for the guild of Saint Luke distinguished between masters, free journeymen (*vrije gasten*), dealers, 'disci-

[55] Miedema, *Archiefbescheiden*, nos. 582-583.
[56] Brown, Kelch and Van Thiel, *Rembrandt*.
[57] Timmer, *Knechtsgilden*, p. 3.
[58] Roethlisberger and Bok, *Abraham Bloemaert*, pp. 618-644; Liedtke, 'Rembrandt'.

ples', apprentices and boys, or drawing boys (*conterfeyt jongens*).[59] Most interesting for our purposes are the journeymen and the disciples. The latter category actually deals with what I have called post-docs, i.e. pupils who had mastered the basic skills of the trade but wanted to improve their skills and perhaps build up a repertoire before setting out on their own. Rembrandt's collaborators would fit this description. The 'free journeymen', on the other hand, are pictured as young painters who have not yet set up a shop of their own and have not become masters of the guild either, but who are, nonetheless, permitted to sell their own work and establish a name for themselves. Before we decide that these are indeed the people we are looking for, two ambiguities should be pointed out. Firstly, this definition does not say anything about wage employment. On the contrary, the suggestion is that these 'journeymen' are independent masters without the full legal status. Secondly, the draft regulation does not make any reference to the actual existence of such individuals, nor do they figure elsewhere in the Haarlem sources.

In his book on the painting industry in seventeenth-century Delft, Montias discusses 'servants' but this includes both journeymen and apprentices. If we assume that all people referred to as painters in the sources but not listed as members of the local guild must have been 'servants', their numbers are not insignificant. For the years 1620-1649 Montias uncovered 89 painters who were guild members and 54 non-members. The latter, he assumes, must have been 'servants'. It is unclear, however, how many of them were apprentices who simply failed to enter the trade, and how many were proper journeymen, i.e. workers in the pay of a master painter.[60] Presumably, some of them were no longer apprentices in the proper sense and more like the post-docs that Rembrandt preferred to work with, but what about the rest?

What we do know is that, in a variety of trades, the number of apprentices far exceeded the number of masterships, without the necessary implication that the trade employed many journeymen. Abraham Bloemaert trained 29 apprentices known to us by name. Of these, only 15, i.e. half the group, became professional painters. Four died before they matured in the profession. Four others went into different types of employment: two who had only taken drawing lessons became goldsmiths, one became a cloth merchant and one pursued a military career. Of the remaining six all traces have vanished.[61] And of course, Bloemaert, with his great reputation as an artist and teacher, must have attracted the more talented and ambitious ap-

[59] The data for Haarlem come from Goosens, *Schilders en de markt*, pp. 77-83.
[60] Montias, *Artists*, pp. 106-111.
[61] Roethlisberger and Bok, *Abraham Bloemaert*, pp. 645-651.

prentices. This attrition rate suggests that the number of non-guild painters that Montias identified in Delft could well have been apprentices who failed to enter the trade by establishing themselves as independent masters. The situation in the Dutch Republic seems to differ in this respect from that in the fifteenth and sixteenth-century Southern Netherlands. It was recently calculated that 71 per cent of all apprentices in fifteenth-century Bruges ultimately failed to become masters.[62] Here again, however, there is the underlying assumption that all apprentices survived and stuck with the trade.

Conclusion

We are now in a much better position to answer our initial question whether, and to what extent, the expansion of the production of paintings was accompanied by an increase in wage labour in painters' workshops in the Dutch Republic. Let me summarise the results of our investigation. Firstly, as in other industrial branches, the fifteenth, sixteenth and seventeenth centuries saw a substantial expansion in the production of paintings in the Low Countries. Instead of the traditional small market, dominated by institutions and the well-to-do, painters managed to find a much wider audience for their products. The relationship between artist and customer, originally shaped by patronage and personalised networks, was replaced, although not completely, by the anonymous connection of supply and demand. This provided a radical change in the conditions of production of works of art.

Secondly, this paper has tried to demonstrate that guilds played an important mediating role in the relationship between artists and their customers. On the one hand, by opening themselves up to those interested in the arts, by providing collective rooms where paintings were sold, and by arbitrating between producers and dissatisfied customers, they contributed to the transparency of the market and thus to the expansion of demand. On the other hand, by thus creating conditions for the marketing of painters, guilds helped to encourage relatively large numbers of people to invest in training to become painters and subsequently to set up shop. Guilds, in other words, stimulated both demand and supply.

Thirdly, the expansion of production helped to create a genuine market for wage labour. That market was, however, segmented. The market for artisanal labour enveloped a variety of measures that made access more difficult. Through formal requirements regarding training, formal organisation and informal mechanisms of exclusion, barriers were erected against outsiders, while at the same time those skilled labourers who were able to enter

[62] Martens, 'Some aspects', passim.

this market reaped the financial benefits in the shape of attractive wages. The arts sector, however, was only partially affected by this development. In the Southern Netherlands, the expansion of the sector coincided to some extent with an expansion of workshop sizes and the mobilisation of wage labour. In the North, on the other hand, this seems not to have been the case at all.

If it is true that Dutch painters hardly ever employed assistants, and if, for the sake argument, we assume that they differed in this respect from their Southern colleagues, what was the reason for this? Two related explanations present themselves, albeit very speculatively at this point. The craft of painting in the Southern Netherlands evolved from a situation where commissioned works dominated the market to one that also included works produced 'on spec', i.e. where painters produced works without having identified a customer in advance. However, the market for commissioned works remained very significant. Compared to their Northern colleagues, artists in the Southern Netherlands produced more History paintings on large panels and canvases.[63] Such works required a wide range of skills and huge investments of time. They were also expensive in terms of financial outlay, but with work starting only when a customer had placed a commission, those risks were substantially reduced. The Dutch market for works of art around 1600 started almost from a *tabula rasa*. Painting as a profession had practically been wiped out during the early stages of the Dutch Revolt.[64] The new market that arose in the early seventeenth century was one in which commissions took second place to production 'on spec'. Dutch artists were usually specialists in 'genre' subjects. Their works were smaller in size and required a more limited range of skills.[65] With the market being largely anonymous, painters were required to limit their risks by reducing the cost of individual pieces.[66] In the North, large commissions were limited to collective portraits, of militia officers and the like, and some prestigious building projects, such as Huis ten Bosch and town halls. That market remained limited and perhaps too small to risk the investments necessary for a large studio. There was, moreover, no real tradition in this respect in the North. Jan van Scorel in Utrecht and Maarten van Heemskerck in Haarlem

[63] Compare Montias, 'Works of Art' (pp. 350-351) with Martens and Peeters, 'Antwerp Painting before Iconoclasm', p. 894. See also Van der Woude, 'Volume and value', p. 323.

[64] Kloek, 'Northern Netherlandish', p. 16.

[65] For the difference in size between History paintings on the one hand, and 'genre', landscape and still-life on the other, see Van der Woude, 'The volume', pp. 306, 322.

[66] Montias, 'Cost and value in seventeenth-century Dutch art'.

ran studios according to the Southern model during the sixteenth century.[67] But when the new expansion of the market started around 1600, small, anonymous customers dominated the market. Under those circumstances it was difficult to accumulate sufficient capital, and those few who managed seem to have hesitated to risk such capital by expanding their business too much.

[67] Kloek, Halsema-Kubes and Baarsen, *Kunst*, p. 63.

BIBLIOGRAPHY

Absolon, M. *Prosopografische benadering van het ambacht van de timmerlieden en schrijnwerkers te Brugge op het einde van de achttiende eeeuw. Een analyse op basis van de historische informatiekunde* (Unpublished thesis, Brussels, 1993-1994).

Actes du colloque la sociabilité urbaine en Europe du nord-ouest du XIV^e au XVIII^e siècle (Douai, 1983).

Ainsworth, M.W., *Bernart van Orley as a designer of tapestry* (New Haven, unpublished Ph.D. dissertation, 1982).

Ainsworth, M.W. and Martens, M.P.J., *Petrus Christus, Renaissance Master of Bruges* (New York, 1994).

Ainsworth, M.W. and Christiansen, K., eds., *From van Eyck to Bruegel. Early Netherlandish Painting in The Metropolitan Museum of Art*, exhib. cat. (New York, 1998).

Ainsworth, M.W., *Gerard David, Purity of Vision in an age of transition* (New York 1998).

Ainsworh, M.W., ed., *Early Netherlandish Painting at the Crossroads. A Critical Look at Current Methodologies* (New York, 2001).

Alazard, F., 'Les tempos de l'histoire: à propos des arts dans l'Italie de la Renaissance', *Revue d'Histoire Moderne et Contemporaine* 49-49 bis, supplément (2002), pp. 17-37.

Ames-Lewis, F., 'Training and Practice in the Early Renaissance Workshop: Observations on Benozzo Gozzoli's Rotterdam Sketchbook', in: Currie, S., ed., *Drawing 1400-1600, Invention and Innovation* (Aldershot, 1998), pp. 26-44.

Ames-Lewis, F., *The Intellectual Life of the Early Renaissance Artist* (New Haven/ London, 2000).

Angel, P., 'Praise of Painting', transl. M. Hoyle, with an introduction and commentary by H. Miedema', *Ten essays for a friend: E. de Jongh at 65, Simiolus* 24 (1996), pp. 125-147.

Asemissen, H.U. and Schweikhart, G., *Malerei als Thema der Malerei* (Berlin, 1994).

Baetens, R., 'Indian Summer of a Golden Age. Antwerp after 1585', in: Meij, A.W.F.M., ed., *Rubens, Jordaens, Van Dijck and their Circle. Flemish Master Drawings from the Museum Boijmans van Beuningen* (Rotterdam, 2001), pp.

Balis, A., 'De nieuwe genres en het burgerlijk mecenaat', in: Van der Stock, J., ed., *Stad in Vlaanderen. Cultuur en Maatschappij, 1477-1787* (Brussels, 1991), pp. 238-253.

———, "Fatto da un mio discepolo": Rubens's studio practices reviewed', in: Nakamura, t., ed., Exh. Cat.: *Rubens and his workshop, The flight of Lot and his family from Sodom, The National Museum of Western Art* (Tokyo, 1994), pp. 97-127.

————, 'Working it out: Design Tools and Procedures in Sixteenth- and Seventeenth-century Flemish Art', in: Vlieghe, H., Balis, A. and Van de Velde, C., eds., *Concept, Design & Execution in Flemish Painting (1550-1700)* (Turnhout, 2000), pp. 129-151.

Baroni-Vannucci, A., *Jan Van Der Straet detto Giovanni Stradano: flandrus pictor et inventor* (Rome, 1997).

Berg, M., 'Product Innovation in Core Consumer Industries in Eighteenth-Century Britain', in: Berg, M. and Bruland, K., eds., *Technological Revolutions in Europe. Historical Perspectives* (Cheltenham, 1998), pp. 138-157.

————, 'New Commodities, Luxuries and their Consumers in Eighteenth-Century England', in: Berg, M. and Clifford H., eds., *Consumers and Luxury: Consumer Culture in Europe, 1650-1850* (Manchester/New York, 1999), pp. 63-87.

————, 'From imitation to invention: creating commodities in eighteenth-century Britain', *Economic History Review* 55 (2002), pp. 1-30.

Bergmans, S., 'Jan van Amstel, dit Jean de Hollande', *Revue Belge d'Archéologie et d'Histoire de l'Art* XXVI (1957), pp. 25-36.

Bergmans, S., 'Le problème Jan van Hemessen – Monogrammiste de Brunswick', *Revue Belge d'Archéologie et d'Histoire de l'Art* XXIV (1955), pp. 133-157.

Blockmans, W., 'Regionale Vielfalt im Zunftwesen in den Niederlanden vom 13. Bis zum 16. Jahrhundert', in: Schulz, K. and Müller-Luckner, E., eds., *Handwerk in Europa. Vom Spätmittelalter bis zur Frühen Neuzeit* (Munich, 1999), pp. 51-63.

Blondé, B., 'Art and Economy in Seventeenth- and Eighteenth-Century Antwerp: a view from the Demand side', in: Cavaciocchi, *Economia e arte*, pp. 379-391.

Bok, M.J., '"Nulla dies sine linie". De opleiding van schilders in Utrecht in de eerste helft van de zeventiende eeuw', *De Zeventiende Eeuw* 6 (1990), pp. 58-68.

Bok, M.J. and Schwartz, G., 'Schilderen in opdracht in Holland in de 17ᵉ eeuw', *Holland* 23 (1991), pp. 183-195.

Bok, M.J., 'De schilder in zijn wereld. De sociaal-economische benadering van de Nederlandse zeventiende-eeuwse schilderkunst', in: Grijzenhout, F. and Van Veen, H., eds., *De Gouden Eeuw in perspectief. Het beeld van de zeventiende-eeuwse schilderkunst in later tijd* (Heerlen, 1992), pp. 330-359.

————, 'The rise of Amsterdam as a cultural centre: the market for paintings, 1580-1680', in: O'Brien, P., Keene, D., 't Hart M., and Van der Wee, H., eds., *Urban Achievement in Early Modern Period. Golden Ages in Antwerp, Amsterdam and London* (Cambridge, 2001), pp. 186-209.

Boon, K.G., 'De glasschilder David Joris', *Mededelingen van de Koninklijke Academie voor Wetenschappen, Letteren en Schone Kunsten, Academiae Analecta* 44/1 (1988), pp. 115-137.

————, *The Netherlandish and German Drawings of the XVth and XVIth centuries of the Frits Lugt collection*, 3 vols. (Paris, 1992).

Boone, M., 'Métiers dans les villes flamandes au bas moyen âge (XIVᵉ-XVIᵉ siècles): images normatives, réalités socio-politiques et économiques', in: Lambrechts, P. and Sosson, J.-P., eds., *Les métiers au moyen âge. Aspects*

économiques et sociaux (Louvain-la-Neuve, 1994), pp. 1-21.

Borchert, T. H., 'Rogier's St. Luke: The case for corporate identification', in: *Rogier van der Weyden, St. Luke drawing the Virgin, The Museum of Fine Arts, Boston, Selected essays in context* (Turnhout, 1997), pp. 61-88.

———, 'Inleiding: de invloed van Jan van Eyck en zijn atelier', in: Borchert, T.H., ed., *De eeuw van Van Eyck. De Vlaamse primitieven en het Zuiden, 1430-1530* (Brugge, 2002), pp. 9-31.

Borgreffe, H., Hans Vredeman de Vries, 1526-1609, in: Borgreffe, H., Fusening, T., Uppenkamp, B., eds., *Tussen stadspaleizen en luchtkastelen. Hans Vredeman de Vries en de Renaissance* (Amsterdam, 2002), pp. 15-40.

Bornstein, D. 'Provincial Painters: local artists in Quattrocento Cortona and the origins of Luca Signorelli', *Renaissance Studies* 14 (2000), pp. 435-452.

Bowen, K.L. and Imhof, D., 'Reputation and Wage: the Case of the Engravers who worked for the Plantin-Moretus Press', *Simiolus* 30 (2003), pp. 161-195.

Braudel, F., *Civilisation matérielle, Economie et Capitalisme, XV^e-XVIII^e siècles*, II: *Les jeux de l'échange* (Paris, 1979).

Bräuer, H., *Gesellen im sächsischen Zunfthandwerk des 15. und 16. Jahnrhunderts* (Weimar, 1989).

Bredius, A., ed., 'De boeken der Haagsche schildersconfrerye', in: Obreen, F.D., ed., *Archief voor Nederlandsche Kunstgeschiedenis* 4 (Rotterdam, 1881-82), pp. 45-221.

Brown, C., Kelch, J. and Van Thiel, P., eds., *Rembrandt, the Master and his Workshop* (New Haven, 1991).

Cahill, J., *The Painter's Practice. How Artists lived and worked in Traditional China* (New York, 1994).

Campbell, L., 'The Art Market in the Southern Netherlands in the Fifteenth Century', *The Burlington Magazine*, 118 (1976), pp. 188-198.

———, 'The Early Netherlandish painters and their workshops', in: Van Schoute and Verougstraete, *Le problème Maître de Flémalle*, pp. 43-61.

———, 'The Early Netherlandish painters and their workshops', in: Van Schoute and Verougstraete, *Le problème Maître de Flémalle*, pp. 45-46.

Campbell, L., Foister, S. and Roy, A. *et al.*, eds., 'Methods and materials of Northern European painting in the National Gallery, 1400-1550', *The National Gallery Technical Bulletin* 18 (1997), pp. 6-55.

Campbell, Th., 'Netherlandish designers, 1530-1560', in: Campbell, Th., ed., *Tapestry in the Renaissance. Art and Magnificence* (New York, 2002), pp. 379-405.

Campbell Hutchison, J., 'Coecke van Aelst, Pieter, I', in: Turner, J., ed., *The Dictionary of Art*, vol. 7 (New York, 1996), p. 518.

Cassagnes, S., *D'Art et d'argent. Les artistes et leurs clients dans l'Europe du Nord, XIV^e-XV^e siècles* (Rennes, 2001).

Cassanelli, R., 'L'artiste et son atelier', in: Cassanelli, R., ed., *Ateliers de la Renaissance* (Milan, 1998), pp. 7-30.

Cavaciocchi, S., ed., *Economia e arte secc. XIII-XVIII. Atti della "Trentatreesima Settimana di Studi" 30 Aprile- 4 maggio 2000* (Florence, 2002).

Ceninni, C.A., *Het handboek van de kunstenaar. Il Libro dell'Arte*, transl. by H. van der Bossche and H. Theuns, (Amsterdam/Antwerp, 2002).

———, (transl. D.V. Thompson), *The craftsman's handbook* (New York, 1933/

1960).

Charron, P., 'Les peintres, peintres verriers et enlumineurs lillois au début du XVIe siècle d'après les statuts inédits de leur corporation', *Revue du Nord* 337 (2000), pp. 723-738.

Châtelet, A., *Robert Campin, Le Maître de Flémalle. La fascination du quotidien* (Antwerp, 1996).

Cieraad, I., *De elitaire verbeelding van volk en massa. Een studie over cultuur* (Muiderburg, 1988).

Cocquery, N., Hilaire-Perez, L., Tesseyre-Sallmann, L. and Verna, C., 'Les révolutions industrielles: du modèle à la diversité des expériences', in: Cocquery, N., Hilaire-Perez, L., Tesseyre-Sallmann, L. and Verna, C., eds., *Artisans, industrie. Nouvelles révolutions du Moyen Âge à nos jours* (Paris, 2004), pp. 8-17.

Coeckelberghs, H., 'Peiling naar het niveau van de lonen en de levensstandaard te Brussel in de 16e eeuw' (Unpublished MA thesis, Brussels, 1973-1974).

Conway, M., *The Van Eycks and their Followers* (London, 1921).

Cornelis, E., 'De Kunstenaar in het laat-Middeleeuwse Gent, II, De sociaal-economische positie van de meesters van het Sint-Lucasgilde in de 15de eeuw', *Handelingen van de Maatschappij voor Geschiedenis en Oudheidkunde te Gent* 42 (1988), pp. 95-138.

Cowan, A., *Urban Europe, 1500-1700* (London-New York, 1998).

Craske, M. and Berg, M., 'Art and Industry. The Making of Modern Luxury in Eighteenth-Century Britain', in: Cavaciocchi, *Economia and Arte*, pp. 823-836.

Crossick, G. and Haupt, H.G., *The Petite Bourgeoisie in Europe, 1780-1914. Enterprise, Family and Independence* (London/New York, 1995).

Crossick, G., ed., *The Artisan and the European Town, 1500-1900* (Aldershot, 1997).

Crouzet, F., 'Editor's Introduction', in: Crouzet, F., ed., *Capital Formation in the Industrial Revolution* (London, 1972), pp. 1-70.

Currie, C., 'Technical Study of Paintings by Pieter Brueghel the Younger in Belgian Public Collections: Preliminary Results', in: Van Schoute, R. and Verougstraete, H., eds., *Le dessin sous-jacent et la technologie dans la peinture. Colloque XIII. La peinture et le laboratoire. Procédés. Méthodologie. Applications* (Louvain-la-Neuve, 2001), pp. 121-130.

Currie, C., 'Demystifying the process: Pieter Brueghel the Younger's 'The census at Bethlehem'. A technical study', in: [Exh. Cat.] *Brueghel Enterprises* (Maastricht/Brussels, 2001), pp. 80-124.

Cuvelier, J., 'De tapijtwevers van Brussel uit de XVe eeuw', *Verslagen en mededeelingen der Koninklijke Vlaamsche Academie voor Taal- en Letterkunde* (1912), pp. 373-385.

———, 'Le graveur Corneille van den Bossche', *Bulletin de l'Institut Historique Belge de Rome* XX (1939), pp. 5-49.

D'Hondt, E., *Extraits des comptes du domaine de Bruxelles des XVe et XVIe siècles concernant les artistes de la cour* (Brussels, 1989).

Daenens, L., 'De meubelkunst', in: *Gent. Duizend jaar kunst en cultuur*, vol. 3 (Ghent, 1975), p. 443-454.

Dambruyne, J., 'De Gentse bouwvakambachten in sociaal-economisch perspectief (1540-1795)', in: Lis and Soly, *Werken volgens de regels*, pp. 51-105.

————, 'Guilds, social mobility and status in sixteenth-century Ghent', *International Review of Social History* 43 (1998), pp. 31-78.

————, *Mensen en centen. Het 16^{de}-eeuwse Gent in demografisch en economisch perspectief* (Ghent, 2001).

————, *Corporatieve middengroepen. Aspiraties, relaties en transformaties in de 16de-eeuwse Gentse ambachtswereld* (Ghent, 2002).

————, 'De corporatief georganiseerde detailhandel' in het vroegmoderne Gent. Langetermijnevoluties in het meerseniersambacht (zestiende tot achttiende eeuw)', *Handelingen der Maatschappij voor Geschiedenis en Oudheidkunde te Gent*, nieuwe reeks LVIII (2004), pp. 205-212.

De Commer, P., 'De brouwindustrie te Gent, 1505-1622', *Handelingen der Maatschappij voor Geschiedenis en Oudheidkunde te Gent* 37 (1983), pp. 113-171.

De Jager, R., 'Meester, leerjongen, leertijd. Een analyse van zeventiende-eeuwse Noord-Nederlandse leerlingcontracten van kunstschilders, goud- en zilversmeden', *Oud-Holland* 104 (1990), pp. 69-111.

De La Fontaine Verwey, H., 'Pieter Coecke van Aelst and the publication of Serlio's book on architecture', *Quaerendo* VI (1976), pp. 166-194.

De Laborde, L., *Les Ducs de Bourgogne. Etudes sur les lettres, les arts et l'industrie pendant le XV^e siècle, Preuves*, vol. I (Paris, 1851).

De Munck, B., 'Le produit du talent ou la production de talent? La formation des artistes à l'Académie des beaux-arts à Anvers aux XVII^e et XVIII^e siècles', *Paedagogica Historica* 37 (2001), pp. 569-605.

————, *Leerpraktijken. Economische en sociaal-culturele aspecten van beroepsopleidingen in Antwerpse ambachtsgilden, 16de-18de eeuw* (unpublished PhD-thesis, Brussels 2001-2).

————, 'Al doende leert men. Leertijd en ambacht in het Ancien Régime', in: [Exh. cat.], De Munck and Dendooven, *Al doende leert men*, pp. 11-52.

De Munck, B. and Dendooven, D., [Exh. cat.], *Al doende leert men. Leertijd en ambacht in het Ancien Régime (1500-1800)* (Bruges, 2003).

De Munck, B., Kaplan, S. and Soly, H., eds., *Apprenticeship from the Middle Ages to Modern Times*. (Forthcoming).

De Peuter, R., *Brussel in de achttiende eeuw. Sociaal-economische structuren en ontwikkelingen in een regionale hoofdstad* (Brussels, 1999).

De Voragine, Jacques, *The Golden Legend: readings on the Saints*, transl. W.G. Ryan (Princeton, 1993).

De Vos, D., *Rogier van der Weyden, het volledige œuvre* (Antwerp, 1999).

De Vries, J., *European urbanization, 1500-1800* (London, 1984).

————, 'The labour market', in: Davids, K. and Noordegraaf, L., eds., *The Dutch Economy in the Golden Age: Nine Essays* (Amsterdam, 1993), pp. 55-78.

————, 'How did pre-industrial labour markets function?', in: Grantham, G. and MacKinnon, M., eds., *Labour market evolution. The economic history of market integration, wage flexibility and the employment relation* (London, 1994), pp. 39-63.

————, 'Economic Growth before and after the Industrial Revolution', in: Prak M., ed., *Early Modern Capitalism. Economic and Social Change in Europe, 1400-1800* (Londen/New York, 2001,) pp. 177-195.

————, With a coarse brush: Pieter Bruegel's Brooding artist', *Source, Notes in the*

History of Art 23 (2004), pp. 38-48.

De Waardt, H., 'De geschiedenis van de eer en de historische antropologie. Een voorbeeld van een interdisciplinaire aanpak', *Tijdschrift voor Sociale Geschiedenis* 23 (1997), pp. 334-354.

Deceulaer, H., 'Arbeidsregulering en loonvorming in de Antwerpse haven, 1585-1796', *Tijdschrift voor Sociale Geschiedenis* 18 (1992), pp. 22-47.

———, 'Guildsmen, Entrepreneurs and Marketsegments. The Case of the Garment Trades in Antwerp and Ghent (sixteenth to eighteenth centuries), *International review of Social History* 43 (1998), pp. 1-29.

———, 'Entrepreneurs in the Guilds. Ready-to-wear Clothing and Subcontracting in late Sixteenth- and early Seventeenth-century Antwerp', *Textile History* 31 (2000) pp. 133-149.

———, *Pluriforme patronen en een verschillende snit. Sociaal-economische, institutionele en culturele transformaties in de kledingsector in Antwerpen, Brussel en Gent, 1585-1800* (Amsterdam, 2001).

Dekker, R.M., '"Getrouwe broederschap". Organisatie en actie van arbeiders in pre-industrieel Holland', *Bijdragen en Mededelingen betreffende de Geschiedenis der Nederlanden* 103 (1988), pp. 1-19.

DeMarchi N. and Van Miegroet,H., 'Art, Value, and Market Practices in the Netherlands in the Seventeenth century', *The Art Bulletin* 76 (1994), pp. 451-464.

———, 'Introduction', in: De Marchi, N. and Van Miegroet, H., eds., *Mapping Markets for paintings in Europe, 1450-1750* (Turnhout, 2006), pp. 3-13.

———, 'The Antwerp-Mechelen Production and Export Complex', in: *Album Amicorum J. Michael Montias.* (Forthcoming).

Denucé, J., *Bronnen voor de Geschiedenis van de Vlaamsche Kunst. IV: Antwerpsche Tapijtkunst en handel* (s.l., 1936).

Des Marez, G., 'L'Organisation du travail à Bruxelles au XVᵉ siècle', *Mémoires de la classe des lettres de l'Académie Royale de Belgique* 65 (1901), s.p.

Deurloo, A.J., 'Bijltjes en klouwers. Een bijdrage aan de geschiedenis der Amsterdamse scheepsbouw, in het bijzonder in de tweede helft der achttiende eeuw', *Economisch- en sociaal-historisch jaarboek* 34 (1971), pp. 4-71.

D'Hulst, R.A., 'Over enkele tekeningen van Marten de Vos', in: *Miscellanea Jozef Duverger, Bijdragen tot de kunstgeschiedenis der Nederlanden* (Ghent, 1968), vol. II, pp. 505-517.

Diels, A., 'Van opdracht tot veiling. Kunstaanbestedingen naar aanleiding van de Blijde Intrede van aartshertog Ernest van Oostenrijk te Antwerpen in 1594', *De zeventiende eeuw* 19 (2003), pp. 25-54.

———, *De familie Collaert en de prentkunst in Antwerpen (1550-1630)* (unpublished PhD thesis, Brussels, 2004).

———, 'Introduction', in: Diels, A. and Leesberg, M., eds., *The Collart Dynasty, Part I: The New Hollstein Dutch and Flemish Engravings and Woodcuts, 1450-1700* (Ouderkerk aan den IJssel, 2005), pp. 37-95.

Duplessis, R.S., *Transitions to Capitalism in Early Modern Europe* (Cambridge, 1997).

Duverger, E., 'Enkele gegevens over de Antwerpse schilder Pauwels Coecke van Aelst (d. 1569), zoon van Pieter en Anthonette van Sant', *Jaarboek Koninklijk Museum voor Schone Kunsten Antwerpen* (1979), pp. 211-226.

Ebeling, D. and Mager, W., *Protoindustrie in der Region. Europäische Gewerbe-landschaften vom 16. bis zum 19. Jahrhundert* (Bielefeld, 1997).

Eckardt, G., *Selbstbildnisse niederländischer Maler des 17 Jh* (Berlin, 1971).

Ehmer, J., 'Worlds of Mobility. Migration Patterns of Viennese Artisans in the Eighteenth Century', in: Crossick, G., ed., *The Artisan and the European Town, 1500-1900* (Aldershot, 1997), pp. 121-134.

――――, 'Traditionelles Denken und neue Fragestellungen zur Geschichte von Handwerk und Zunft', in: Lenger, F., ed., *Handwerk, Hausindustrie und die Historische Schule der Nationalökonomie. Wissenschafts- und Gewerbe-geschichtliche Perspektiven* (Bielefeld, 1998), pp. 19-77.

Epstein, S.R., 'Craft Guilds, Apprenticeship and Technological Change in Pre-Industrial Europe', *Journal of Economic History* 58 (1998), pp. 684-713.

Espinas, G. and Pirenne, H., *Recueil des documents relatifs à l'histoire de l'indus-trie drapière en Flandre. Première partie: des origines à l'époque bour-guignonne*, vol. 2 (Brussels, 1909).

Ewing, D.C., *The paintings and drawings of Jan de Beer* (Ann Arbor, 2003) (PhD-dissertation, University of Michigan, 1978).

――――, 'Marketing Art in Antwerp, 1460-1560: Our Lady's *Pand*', *The Art Bulletin* 72 (1990), pp. 558-584.

Exh. Cat., *Kunst voor de Beeldenstorm. Noordnederlandse kunst 1525-1580*, Am-sterdam Rijksmuseum (Amsterdam/The Hague, 1986).

Eyüp Özveren, Y., 'An Institutional Alternative to Neoclassical Economics?', *Re-view* 21 (1998), pp. 469-530.

Fairchilds, C., 'The production and marketing of populuxe goods in eighteenth-cen-tury Paris', in: Brewer, J. and Porter, R., eds., *Consumption and the World of Goods* (London, 1993), pp. 228-248.

Faries, M. and Jansen, L., 'Ecce Rex Vester – Aanschouw uw koning. Een vroeg meesterwerk van Maarten van Heemskerck', *200 jaar verzamelen. Collec-tieboek Museum voor Schone Kunsten Gent* (Ghent/Amsterdam, 2000), pp. 65-69.

Faries, M., 'Underdrawings in the workshop production of Jan van Scorel: a study with infrared reflectography', *Nederlands Kunsthistorisch Jaarboek* 26 (1975), pp. 89-229.

――――, 'Reshaping the Field: The Contribution of Technical Studies', in: Ainsworth, M.W., ed., *Early Netherlandish Painting at the Crossroads. A Critical Look at Current Methods* (New York, 2001), pp. 70-105.

――――, 'Some Thoughts in the Infrared reflectography Workshop experience', *Record of the Art Museum Princeton University* 59 (2000), pp. 33-37.

――――, ed., *Making and Marketing: Studies of the Painting Process in Fifteenth-and Sixteenth-Century Netherlandish Workshops* (Turnhout, 2006).

Faries, M. and Spronk, R., eds., *Recent Developments in the Technical Examination of Early Netherlandish Painting* (Turnhout, 2003).

Farmer, J.D., *Bernard van Orley of Brussels* (Ann Arbor, Ph.D. thesis Princeton University, 1981).

Farr, J., *Hands of Honor. Artisans and their World in Dijon, 1550-1650* (Ithaca/Lon-don, 1988).

――――, *Artisans in Europe, 1300-1914* (Cambridge, 2000).

Filipczack, Z.Z., *Picturing Art in Antwerp, 1550-1700* (Princeton, 1987).

Floerke, H., *Studien zur niederländischen Kunst- und Kulturgeschichte, die Formen des Kunsthandels, das Atelier und die Sammler in die Niederlanden vom 15.-18. Jahrhundert* (Munich, 1905).

Fontaine, L., *History of Pedlars in Europe* (Oxford, 1996).

——, 'Economies et "mondes de l'art"' in: Cavaciocchi, *Economia e arte*, pp. 55-72.

Fox, R. and Turner, A., eds., *Luxury Trades and Consumerism in Ancien Régime Paris. Studies in the History of a Skilled Workforce* (Aldershot, 1998).

Freedberg, D. and De Vries, J., eds., *Art in History. History in Art. Studies in Seventeenth-Century Dutch Culture* (Santa Monica, 1991).

Friedländer, M.J., 'Pieter Coecke van Alost', *Jahrbuch der Königlich Preuszischen Kunstsammlungen* 830 (1917), pp. 73-94.

——, *Die altniederländische Malerei, Joos van Cleve, Jan Provost, Joachim Patenier* (Leyden, 1934).

——, *Die altniederländische Malerei, Pieter Bruegel und nachträge zu den früheren Bänden*, vol. XIV (Leyden, 1937).

——, *Early Netherlandish Painting*, vol. II, *Rogier van der Weyden and the Master of Flémalle* (Leyden, 1967).

——, *Early Netherlandish Painting*, vol. VII, *Quentin Massys* (Leyden, 1971).

——, *Early Netherlandish Painting. Joos van Cleve, Jan Provost, Joachim Patenier* (Leyden/Brussels, 1972).

——, *Early Netherlandish Painting*, vol. XI, *The Antwerp Mannerists* (Leyden, 1974).

Friedrichs, C.R., 'Capitalism, mobility and class formation in the early modern German city', *Past and Present* 69 (1975), pp. 24-49.

——, *The early modern city, 1450-1750* (London/New York, 1995).

Garrioch D., and Sonenscher, M., 'Compagnonnages, confraternities and asociations of journeymen in eighteenth-century Paris', *European History Quarterly* 16 (1986), pp. 25-45.

Genaille, R., 'Carel van Mander et la jeunesse de Bruegel l'Ancien', *Jaarboek Koninklijk Museum voor Schone Kunsten Antwerpen* (1982), pp. 119-152.

Gibson, W.S., *Mirror of the Earth, The World Landscape in Sixteenth-Century Flemish Painting* (New Jersey, 1989).

Gilté, S., *Het Brugse bakkersambacht in de Nieuwe Tijden* (unpublished master's thesis, Ghent, 1996).

Goosens, M.E.W., *Schilders en de markt. Haarlem 1605-1635* (Leiden, 2001).

Goovaerts, A., 'Les ordonnances données en 1480, à Tournai, aux métiers des peintres et des verriers (auxquels étaient affiliés ceux des enlumineurs, des peintres de cartes à jouer, de jouets d'enfants, de papiers de tenture et sur verre, des badigeonneurs à la colle et des mouleurs)', *Compte rendu des séances de la Commission Royale d'histoire* II (1896), pp. 97-182.

Grosshans, R., *Maerten van Heemskerck. Die Gemälde* (Berlin, 1980).

Guicciardini, L., *Beschrijvinghe van alle de Nederlanden, anderssins ghenoemt Neder-Duytschlandt* (Amsterdam, 1612 (1567)).

Guicciardini, Ludovico, *Descrittione di tutti I paesi bassi (1567) Edizione Critica*, by B. Aristodemo (Amsterdam, 1994).

Hanne, G., 'Le travail et son monde: transition historique (1750-1850) et représentations historiennes (1850-1900)', *Revue d'histoire moderne et contempo-*

raine 44 (1997), pp. 683-710.

Hesselink, L., 'Goud en zilversmeden en hun gilden in Amsterdam in de 17ᵉ en 18ᵉ eeuw', *Holland* 31 (1999), pp. 127-147.

Hirsch, J.P., and Minard, P., '"Laissez-nous faire et protégez-nous beaucoup": pour une histoire des pratiques institutionelles dans l'industrie française (XVIIIᵉ -XIXᵉ siècles)', in: Bergeron, L. and Bourdelais, P., eds., *La France n'est-elle pas douée pour l'industrie?* (Paris, 1998), pp. 147-157.

Hodnett, E., *Marcus Gheeraerts the Elder of Bruges* (London, 1971).

Hollstein, F.W.H., *Dutch & Flemish etchings engravings and woodcuts ca. 1450-1700*, vol. VII, 'Fouceel-Gole' (Amsterdam, s.d.).

Honig, E., *Painting and the market in Early Modern Antwerp* (New Haven/London, 1998).

Hoogewerff, G.J., *De geschiedenis van de St. Lucasgilden in Nederland* (Amsterdam, 1947).

——, 'De werken van Willem Key', *Belgisch Tijdschrift voor Oudheidkunde en Kunstgeschiedenis* XVII (1947-1948), pp. 41-49.

Hunt, E.K., *History of Economic Thought. A Critical Perspective* (New York/London, 2002).

Hunt, L. and Sheridan, G., 'Corporatism, Association and the Language of Labor in France, 1750-1850', *Journal of Modern History* 58 (1986), pp. 813-844.

Jacobs, M. and Vanbellinghen, M., 'Ambachten in de Zuidelijke Nederlanden (voor 1795). Een bijdrage tot de samenstelling van een bibliografische lijst van studies verschenen in de 19ᵈᵉ en 20ˢᵗᵉ eeuw', *Oost-Vlaamse Zanten* 74 (1999), pp. 185-320.

Jansen, L., 'Lancelot Blondeel', in: Martens, M.P.J., ed., *Bruges et la Renaisance, De Memling à Pourbus, Notices* (Bruges, 1998), pp. 111-112.

——, 'Unveiling the production method of a series of copies: *The Madonna with the veil* after Jan Gossaert', *Bulletin van de Koninklijke Musea voor Schone Kunsten van België*. (Forthcoming).

——, 'The *Last Supper* as a Starting Point for the Study of the Workshop Practices in the Group Pieter Coecke van Aelst', in: Verougstraete, H. and Van Schoute, R., eds., *Le dessin sous-jacent et la technologie dans la peinture. Colloque XIV: Jérôme Bosch et son entourage et autres etudes* (Louvain, 2003), pp. 165-174.

——, 'Shop Collaboration in the Painting of Landscape Backgrounds in the Workshop of Pieter Coecke van Aelst', in: Faries, *Making and Marketing*, (Turnhout, 2006), pp. 119-142.

——, 'The place of serial products in the workshop of Pieter Coecke van Aelst: a working hypothesis', lecture at: *Le dessin sous-jacent et la technologie dans la peinture. Colloque XV: Copies, répliques et pastiches*, Bruges, 11-13 September 2003 (Louvain-la-Neuve) (Louvain, 2006), pp. 173-180.

Juvenalis, *Satires*, ed. and transl. P. de Labriolle and F. Villeneuve (Paris, 1983).

Kaplan, S.L. and Koep, C., eds., *Work in France. Representations, Meanings, Organisation and Practice* (Ithaca/London, 1986).

Kaplan, S.L., *La fin des corporations* (Paris, 2001).

King, S., and Timmins, G., eds., *Making Sense of the Industrial Revolution. English Economy and Society, 1700-1850* (Manchester, 2001).

Kirby, J., 'The painter's trade in the Seventeenth century: theory and practice', *Painting in Antwerp and London: Rubens and Van Dyck - The National Gallery Technical Bulletin* 20 (1999), pp. 5-49.

Klein, D., *St.Lukas als Maler der Maria, Ikonographie der Lukas-Madonna* (Berlin, 1933).

Kloek, W.Th., Halsema-Kubes, W. and Baarsen, R.J., *Kunst voor de beeldenstorm* (The Hague, 1986).

Kloek, W.Th., 'Northern Netherlandish Art 1580-1620', in: Luijten, G. *et al.*, eds., *Dawn of the Golden Age. Northern Netherlandish Art, 1580-1620* (Amsterdam/ Zwolle, 1993), pp. 15-111.

Knotter, A., 'De Amsterdamse bouwnijverheid in de 19e eeuw tot ca. 1870. Loonstarheid en trekarbeid op een dubbele arbeidsmarkt', *Tijdschrift voor sociale geschiedenis* 10 (1984), pp. 123-154.

————, *Economische transformatie en stedelijke arbeidsmarkt. Amsterdam in de tweede helft van de negentiende eeuw* (Zwolle/Amsterdam, 1991).

Konowitz, E., 'D. Vellert', in: Turner, J., ed., *The Dictionary of Art* (New York, 1996), vol. 32, pp. 150-153.

Krausman-Ben Amos, I., 'Failure to become freemen: Urban Apprentices in Early Modern England', *Social History* 16 (1991), pp. 155-172.

Kraut, G., *Lucas Malt die Madonna, Zeugnisse zum Künstlerischen Selbstverständnis in der Malerei* (Worms, 1986).

Kunst voor de Beeldenstorm, Noord-Nederlandse kunst 1525-1580 (The Hague, 1983).

Lambrecht, T., *Een grote hoeve in een klein dorp. Relaties van arbeid en pacht op het Vlaamse platteland tijdens de 18de eeuw* (Ghent, 2002).

————, 'Reciprocal exchange, credit and cash: agricultural labour markets and local economies in the Southern Low Countries during the eighteenth century', *Continuity and Change* 18 (2003), pp. 237-261.

Lauwaert, R., 'Ambachten en nieuwe nijverheden', in: *Antwerpen in de XVIde eeuw* (Antwerp, 1975), pp. 143-160.

Lavin, I., 'David's sling and Michelangelo's bow', in: Winner, M., ed., *Der Künstler über sich in seinem Werk* (Weinheim, 1992), pp. 161-190.

Le dessin sous-jacent, colloque XV (2003) (Louvain, 2006). (Forthcoming).

Leeflang, M., 'The San Donato-altarpiece by Joos van Cleve and His Workshop' in: Simonetti F. and Zanelli G., eds., *Indagini techniche sulle opere genovesi di Joos van Cleve* (Florence, 2003), pp. 35-47.

————, 'Serial Production in Joos van Cleve's workshop', in: Vander Auwera, J., ed., *Bulletin van de Koninklijke Musea voor Schone Kunsten van België* (Forthcoming).

————, 'Workshop Practices in Joos van Cleve's workshop', in: Van den Brink, P., ed., *Extravagant! Antwerp Paintings for the Market* (Antwerp/Maastricht, 2005), pp.232-273.

Leeflang, M. and Klein, P., 'Information on the Dating of the Paintings made in the Workshop of Joos van Cleve: A Dendrochronological and Art Historical Approach', in: Verougstraete, H. and Van Schoute, R., eds., *Colloque XV pour l'étude du dessin sous-jacent et de la technologie dans la peinture "Copies, répliques, pastiches"* (Louvain, 2006), pp. 121-130.

Leeflang, M., 'The Reinhold-altarpiece by Joos van Cleve and his workshop: The Influence by Albrecht Dürer on the Underdrawing', in: Faries, M., *Making and Marketing*, pp.15-42.

Liedtke, W., 'Rembrandt and the Rembrandt Style in the Seventeenth Century', in: Liedtke, W., *et al.*, eds., *Rembrandt/Not Rembrandt*, vol. II: *Paintings, Drawings, and Prints: Art-Historical Perspectives* (New York, 1995), pp. 3-39.

Lis, C. and Soly, H., 'An irresistible phalanx': journeymen associations in Western Europe, 1300-1800', in: Lis, Lucassen and Soly, *Before the unions*, pp. 11-52.

————, eds., *Werken volgens de regels. Ambachten in Brabant en Vlaanderen, 1500-1800* (Brussels, 1994).

————, 'Corporatisme, onderaanneming en loonarbeid. Flexibilisering en deregulering van de arbeidsmarkt in Westeuropese steden (veertiende-achttiende eeuw), *Tijdschrift voor sociale geschiedenis* 20 (1994), pp. 365-390.

————, 'De macht van "vrije arbeiders": collectieve acties van hoedenmakersgezellen in de Zuidelijke Nederlanden (zestiende–negentiende eeuw', in: Lis and Soly, *Werken volgens de regels*, pp. 15-50.

————, eds., *Werelden van verschil. Ambachtsgilden in de Lage Landen* (Brussels, 1996).

————, 'Subcontracting in guild-based export trades (13th-18th centuries)', in: Epstein, S.R. and Prak, M., eds., *The Guilds and the Economy*. (Forthcoming).

Lis, C., Lucassen, J. and Soly, H., eds., 'Before the Unions. Wage earners and collective action in Europe, 1300-1850, *International Review of Social History* (Supplement) 39/2 (1994).

Logan, A.-M. and Plomp, M.C., eds., [Exh. Cat.]: *Peter Paul Rubens, The drawings*, (The Metropolitan Museum) (New York, 2004), pp. 2-35.

Lourens, P. and Lucassen, J., 'Ambachtsgilden binnen een handelskapitalistische stad: aanzetten voor een analyse van Amsterdam rond 1700', *NEHA-Jaarboek voor economische, bedrijfs- en techniekgeschiedenis* 61 (1998), pp. 121-162.

Lucassen J., 'Labour and early modern economic development', in: Davids, K., and Lucassen, L., eds., *A Miracle Mirrored. The Dutch Republic in European Perspective* (Cambridge, 1995), pp. 367-409.

Marlier, G., *La Renaissance flamande: Pierre Coeck d'Alost* (Brussels, 1966).

Martens, M.P.J., ed., Exh. cat. *Bruges and the Renaissance: From Memling to Pourbus* (Bruges, 1998).

————, 'Some aspects of the Origins of the Art Market in Fifteenth-Century Bruges', in: North, M. and Ormrod, D., eds., *Art Markets in Europe, 1400-1800* (Aldershot, 1998), pp. 19-28.

————, 'The Position of the Artist in the fifteenth century: Salaries and Social Mobility', in: Blockmans, W. and Janse, A., eds., *Showing Status: Representation of Social Positions in the Late Middle Ages* (Turnhout, 1999), pp. 387-414.

Martens, M.P.J., 'Architectuur en beeldende kunsten', in: Prevenier, W. and Van Eenoo, R., eds., *Geschiedenis van Deinze*, vol. I (Deinze, 2003), pp. 443-460.

Martens, M.P.J. and Peeters, N., 'Antwerp Painting before Iconoclasm: Considera-

162 BIBLIOGRAPHY

tions on the Quantification of Taste', in: Cavaciocchi, S., ed., *Economia e arte, seccolo XIII-XVIII* (Florence, 2002), pp. 875-894.

————, 'A tale of two cities': Antwerp artists and artisans in London in the Sixteenth century, *Leids Kunsthistorisch Jaarboek (Dutch and Flemish Artists in Britain 1550-1800)* 13 (2003), pp. 31-42.

————, 'Artists by numbers: quantifying artists' trades in sixteenth-century Antwerp', in: Faries, *Making and Marketing*, pp. 211-222.

————, 'Masters and Servants, Workshop assistants in artists' workshops (1453-1579): a statistical approach to workshop size and labour division', in: Verougtraete, H., ed., *Le dessin sous-jacent, colloque XV (2003) (Louvain la Neuve, 2006)*, pp. 115-120.

Mathieu, C., 'Le métier des peintres à Bruxelles aux XIV^me siècle', *Bruxelles au XV^me siècle* (Brussels, 1951).

Mensger, A., *Jan Gossaert. Die niederländische Kunst zu Beginn der Neuzeit* (Berlin, 2002).

Miedema, H., *Kunst, kunstenaars en kunstwerk bij Karel van Mander. Een analyse van zijn levensbeschrijvingen* (Alphen aan de Rijn, 1981).

————, *De archiefbescheiden van het St. Lukasgilde te Haarlem 1497-1798* (Alphen a/d Rijn, 1983).

————, 'Over vakonderwijs aan kunstschilders in de Nederlanden tot de zeventiende eeuw', *Academies of Art between Renaissance and Romanticism. Leids Kunsthistorisch Jaarboek* V-VI (1986-1987).

————, 'Over vakonderwijs aan kunstschilders in de Nederlanden tot de 17e eeuw', in: Boschloo A.W.A. *et al*, eds., *Academies of Art between Renaissance and Romanticism* (The Hague, 1989), pp. 268-282.

————, ed., *Karel van Mander. The Lives of the illustrious Netherlandish and German painters*, 6 vols. (Doornspijk, 1994-1999).

————, 'Pieter Bruegel weer: en de geloofwaardigheid van Karel van Mander', *Jaarboek van het Koninklijk Museum voor Schone Kunsten Antwerpen* (1998), pp. 309-327.

Mielke, H., *Pieter Bruegel, Die Zeichnungen* (Turnhout, 1996).

Monballieu, A., 'Bij de interpretatie en de datering van Jan Gossaert's Lucas en de Madonna uit Mechelen', *Miscellanea Jozef Duverger* (Ghent, 1968), vol. I, pp. 125-138.

————, 'Documenten van het Mechels schilders- en beeldsnijdersambacht I, De Rolle van 1564', *Handelingen van de Koninklijke Kring voor Oudheidkunde, Letteren en Kunstgeschiedenis van Mechelen* 73 (1969), pp. 88-106.

————, 'Documenten van het Mechels schilders- en beeldsnijdersambacht II, Het rekwest van 1562 en het probleem van de 51 of 150 ateliers', *Handelingen van de Koninklijke Kring voor Oudheidkunde, Letteren en Kunstgeschiedenis van Mechelen* 75 (1971), p. 71-82.

————, 'De kunstenaarsfamilie Verhulst-Bessemeers', *Handelingen van de Koninklijke kring voor Oudheidkunde, Letteren en Kunstgeschiedenis van Mechelen* 78 (1974), pp. 105-121.

Monbeig Goguel, C., *Francesco Salviati (1510-1563) ou la Bella Maniera* (Paris, 1998).

Montias, J.M., *Artists and Artisans in Delft. A Socio-Economic Study of the Seven-*

teenth Century (Princeton, 1982), pp. 106-111.

———, 'Cost and value in seventeenth-century Dutch art', *Art History* 10 (1987), pp. 455-466.

———, 'Art dealers in the seventeenth-century Netherlands', *Simiolus* 18 (1988), pp. 244-256.

———, 'Works of Art in Seventeenth-Century Amsterdam: An Analysis of Subjects and Attributions', in: Freedberg and De Vries, *Art in History*, pp. 331-72.

———, *Le marché de l'art aux Pays-Bas, XVᵉ-XVIIᵉ siècles* (Paris, 1996).

———, 'Commentary: Fine-tuning Interpretations', in: Ainsworth, M.W., ed., *Netherlandish Painting at the Crossroads. A Critical Look at Current Methodologies* (New York, 2001), pp. 62-65.

———, 'Socio-Economic Aspects of Netherlandish Art from the Fifteenth to the Seventeenth Century: A Survey', *The Art Bulletin* 72/3 (1990), pp. 358-373.

———, 'Notes on Economic Development and the Market for Paintings in Amsterdam', in: Cavaciocchi, *Economia e arte*, pp.115-130.

Mulders, C. van, 'Peter Paul Rubens en Jan Brueghel de Oude: de drijfveren van hun samenwerking', in: Vlieghe, H., Balis A. and Van de Velde, C., eds., *Concept, Design & Execution in Flemish Painting (1550-1700)* (Turnhout, 2000), pp. 111-126.

Muylle, J., 'Pieter Bruegel en de kunsttheorie. Een interpretatie van de tekeningen 'De schilder voor zijn ezel': ideël zelfportret en artistiek credo', *Jaarboek Koninklijk Museum voor Schone Kunsten Antwerpen* (1984), pp. 189-202.

Neelen, P., *Het Antwerpse meerseniersambacht in de zestiende eeuw* (unpublished master's thesis, Ghent, 1997).

North, M. and Ormrod, D.,'Introduction: Art and its Markets', in: North, M. and Ormrod, D., eds., *Art Markets, 1400-1800* (Aldershot, 1998), pp. 1-6.

Nuland, S.B., *Leonardo da Vinci* (Louvain, 2002).

Nunez, C.E., ed., *Guilds, Economy and Society* (Sevilla, 1998).

Ogilvie S.C. and Cerman M., eds., *European Proto-industrialisation* (Cambridge, 1996).

Onclincx, G., 'A propos d'un dessin-message du Louvre, Un peintre devant son chevalet: Pierre Bruegel l'Ancien, ses enfants et son oncle (par alliance) Merten Verhulst de Malines', *Belgisch Tijdschrift voor Filologie en Geschiedenis* 67 (1989), pp. 272-283.

Ormrod, D., 'Art and its Markets', *Economic History Review* LII (1999), pp. 544-551.

Panhuysen, B., *Maatwerk. Kleermakers, naaisters, oudkleerkopers en de gilden (1500-1800)* (Amsterdam, 2000).

Parmentier, R.A., *Documenten betreffende Brugsche Steenhouwers uit de 16e eeuw* (Bruges, 1948).

Peeters, N., 'Marked for the Market? Continuity, Collaboration and the Mechanics of Artistic Production of History Painting in the Francken Workshops in Counter-Reformation Antwerp', *Nederlands Kunsthistorisch Jaarboek* 50 (1999), pp. 59-80.

———, *Tussen continuïteit en vernieuwing. De bijdrage van Frans en Ambrosius Francken I, en de jonge generatie Francken, tot de historieschilderkunst te Antwerpen ca 1570-1620* (unpubl. PhD-thesis, Brussels, 2000).

————, 'A corporate image? Decoration for the Saint Luke's altarpiece for the Cathedral of Our Lady in Antwerp (1589-1602)', in: A. Balis, P. Huvenne et al. (eds.), *Florissant: Bijdragen tot de kunstgeschiedenis der Nederlanden, (15ᵉ – 17ᵉ eeuw), Liber amicorum Carl van de Velde* (Brussels, 2005), pp. 239-252.

————, 'Family matters. An integrated biography of Pieter Breughel II', in: *Bulletin Koninklijke Musea voor Schone Kunsten van België*. (Forthcoming).

Penny, N., 'Le peintre et l'atelier dans l'Italie de la Renaissance', in: Cassanelli, R., ed., *Ateliers de la Renaissance* (Milan, 1998), pp. 31-54.

Pfister, U., 'Craft guilds and proto-industrialisation in Europe, 16th-18th centuries', in: Nunez, *Guilds*, pp. 11-24.

Piot, C., *Rapport à Mr. Le Ministre de l'Intérieur sur les tableaux enlevés à la Belgique en 1794 et restitués en 1815* (Brussels, 1883).

Pollard, S., *Peaceful Conquest. The Industrialisation of Europe* (Oxford, 1981).

Prak, M., 'Ambachtsgilden vroeger en nu', *NEHA-Jaarboek voor economische, bedrijfs- en techniekgeschiedenis* 57 (1994), pp. 10-33.

————, 'Gouden eeuwen: instituties en de bloei der kunsten in Europa (1400-1800)', *Bulletin van het Rijksmuseum* 49 (2001), pp. 29-44.

Prak, M., Lis, C., Lucassen, J. and Soly, H., eds., *Craft guilds in the early modern Low Countries. Work, power, and representation* (Aldershot, 2006).

Prims, F., 'Het altaar der linnenwevers', *Antwerpiensia 1938*, pp. 316-317.

————, 'Het altaar der houtbrekers', *Antwerpiensia 1939*, p. 334.

————, 'Het altaar van de chirurgijns', *Antwerpiensia 1939*, p. 317.

————, 'Het altaar van de metsers', *Antwerpiensia 1939*, pp. 353-354.

————, 'Het altaar van de timmerlieden', *Antwerpiensia 1939*, p. 415.

————, 'Het altaar van de zadelmakers', *Antwerpiensia 1939*, pp. 435-436.

Réau L., *Iconographie de l'art chrétien* (6 vols.) (Paris 1955-1959).

Reininghaus, W., *Die Entstehung der Gesellengilden im Spätmittelalter* (Wiesbaden 1981).

————, 'Zur Methodik der handwerkgeschichte des 14.-17. Jahrhunderts. Anmerkungen zu neuer Forschung', *Vierteljahrschrift für Sozial und Wirtschaftsgeschichte* 72 (1985), pp. 369-378.

Reith, R., 'Technische Innovationen im Handwerk der frühe Neuzeit? Traditionen, Probleme und Perspecktive der Forschung', in: Kaufhold, K.-H. and Reininghaus, W., eds., *Stadt un Handwerk in Mittelalter und früher Neuzeit* (Cologne/Weimar/Vienna, 2000), pp. 21-60.

————, 'Wage Forms, Wage Systems and wage Conflicts in Greman Crafts during the Eighteenth and early Nineteenth Centuries', in: Scholliers, P. and Schwarz, L, eds., *Experiencing Wages. Social and Cultural Aspects of Wage Forms in Europe since 1500* (New York/Oxford, 2003), pp. 113-138.

Roberts, J.S., 'Drink and Industrial Discipline in Nineteenth-Century Germany', *Journal of Social History* 15 (1981), pp. 25-38.

Roethlisberger, M.G. and Bok, M.J., *Abraham Bloemaert and his sons: Paintings and prints* (Doornspijk, 1993).

Rolf, R., *Pieter Coecke van Aelst en zijn architektuuruitgaves van 1539* (Amsterdam, 1978).

Rombouts, P. and Van Lerius, T., *De Liggeren en andere historische archieven der Antwerpsche Sint Lucasgilde*, 2 vols. (Antwerp, 1864-1876) (1961).

Rommé, B., 'Rationalisierungstendenzen in der Kunst um 1500 in Ulm und Antwerpen', in: Cavaciocchi, *Economia e arte*, pp. 703-728.

Romijn, E., 'Knollen en citroenen op de Leidse kunstmarkt: over de rol van kwaliteit in de opkomst van de Leidse fijnschilderij', *De Zeventiende Eeuw* 17 (2001), pp. 75-94.

Rosser, G., 'Craft, guilds and the negotiation of work in the medieval town', *Past and Present* 154 (1997), pp. 3-31.

Rouzet, A., *Dictionnaire des imprimeurs, libraires et éditeurs des XV^e et XVI^e siècles dans les limites géographiques de la Belgique actuelle* (Nieuwkoop, 1975).

Sabbe, M., 'De Plantijnsche werkstede, arbeidsregeling, tucht en maatschappelijke voorzorg in de oude Antwerpsche drukkerij', *Verslagen en mededeelingen der Koninklijke Vlaamsche Academie voor Taal- en Letterkunde* (1935), pp. 595-694.

Sabel, C. and Zeitlin, J., 'Historical Alternatives for Mass-Production: Politics, Markets and Technology in Nineteenth-Century Industrialization', *Past and Present* 108 (1985), pp. 133-176.

Scheller, R.W., *Exemplum. Model-Book Drawings and the Practice of Artistic Transmission in the Middle Ages (ca 900-ca 1470)* (Amsterdam, 1995).

Schildersvereenigingen te Utrecht. Bescheiden uit het gemeentearchief, ed. by S. Muller Fz (Utrecht, 1880).

Schneebalg-Perelman, S., *Les Chasses de Maximilien: Les Énigmes d'un chef-d'œuvre de la tapisserie* (Brussels, 1982).

Scholliers, E., 'Vrije en onvrije arbeiders voornamelijk te Antwerpen in de 16^e eeuw', *Bijdragen voor de Geschiedenis der Nederlanden* 11 (1956), pp. 285-322.

———, 'Lonen te Brugge en het Brugse Vrije', in: Verlinden and Scholliers, *Dokumenten*, pp. 87-160.

———, 'Lonen te Gent (15^de en 16^de eeuw)', in: Verlinden and Scholliers, *Dokumenten*, pp. 354-461.

———, 'Prijzen en lonen te Antwerpen (15^de en 16^de eeuw)', in: Verlinden, C., Scholliers, E., pp. 241-480.

———, *Loonarbeid en honger. De levensstandaard in de XV^e en XVI^e eeuw te Antwerpen* (Antwerp, 1960).

———, 'De lagere klassen. Een kwantitatieve benadering van levensstandaard en levenswijze', in: *Antwerpen in de XVI^de eeuw* (Antwerp, 1975), pp. 161-180.

Scholliers, E. and Vandenbroeke, C., 'Structuren en conjuncturen in de Zuidelijke Nederlanden, 1400-1800', in: *Algemene Geschiedenis der Nederlanden*, vol. 5 (Haarlem, 1980), pp. 252-310.

Scholten, F., 'The World of the Late Medieval Artist', in: Van Os, H., Filedt Kok, J.P., Luijten, G. and Scholten, F., eds., *Netherlandish Art in the Rijksmuseum, 1400-1600* (Amsterdam-Zwolle, 2000), pp. 233-252.

Schulte Beerbühl, M., *Vom Gesellenverein zur Gewerkschaft. Entwicklung, Struktur und Politik der Londoner Gesellenorganisationen 1550-1825* (Göttingen, 1991).

Schulz, H., *Das ehrbare Handwerk. Zunftleben in alten Berlin zur Zeit des Absolutismus* (Weimar, 1993).

Schulz, K., *Handwerkgesellen und Lohnarbeiter. Untersuchungen zur oberrheinischen und oberdeutschen Stadtgeschichte des 14. bis 17. Jahrhunderts* (Sigmaringen, 1985).

——, 'Verflechtungen des europaischen Handwerks vom 14. bis zum 16. Jahrhundert. Einführende Bemerkungen', in: Schulz, K. and Müller-Luckner, E., eds., *Handwerk in Europa. Vom Spätmittelalter bis zur Frühen Neuzeit* (Munich, 1999), pp. vii-xvii.

Sellink, M., *Cornelis Cort* (The New Hollstein, Dutch & Flemish etchings, engravings and woodcuts 1450-1700) (Rotterdam, 2000).

Sewell, jr., W.H., 'Visions of labor: illustrations of the Mechanical Arts before, in and after Diderot's Encyclopédie', in: Kaplan and Coep, *Work in France*, p. 259.

Shammas, C., 'Changes in English and Anglo-American Consumption from 1550 to 1800', in: Brewer, J. and Porter, R., eds., *Consumption and the World of Goods* (London/New York, 1992), pp. 177-220.

Silver, L., *The paintings of Quinten Massys, with catalogue raisonné* (Oxford, 1984).

Sluijter, E.J., 'Schilders van "cleyne, subtile ende curieuse dingen". Leidse "fijnschilders" in contemporaine bronnen', in: Sluijter, E.J., Enklaar, M. and Nieuwenhuizen, P., eds., *Leidse fijnschilders. Van Gerrit Dou tot Frans van Mieris de jonge 1630-1760* (Zwolle/Leiden, 1988), pp. 15-55.

——, *De lof der schilderkunst. Over schilderijen van Gerrit Dou (1613-1675) en een traktaat van Philips Angel uit 1642* (Hilversum, 1993).

——, 'Over Brabantse vodden, economische concurrentie, artistieke wedijver en de groei van de markt voor schilderijen in de eerste decennia van de zeventiende eeuw', in: Falkenburg, R. *et al.*, eds., *Kunst voor de markt / Art for the market 1500-1700*, Nederlands Kunsthistorisch Jaarboek 50 (1999) 113-143.

Smit, J.W., 'History in Art', in: Freedberg D. and De Vries, J., eds., *Art in History. History in Art. Studies in Seventeenth-century Dutch Culture* (Santa Monica, 1991), pp. 17-25.

Smith, J.C., 'Neufchatel, Nicolas', in: Turner, J., ed., *Dictionary of Art*, vol. 22 (New York, 1996), pp. 924-925.

Snodin, M. and Styles, J., *Design & the Decorative Arts. Britain 1500-1900* (London, 2001).

Soly, H., 'Proletarisering in West-Europa, 1450-1850', in: Van Besouw, F. *et al.*, eds., *Balans en perspectief. Visies op de geschiedwetenschap in Nederland* (Groningen, 1987), pp. 101-118.

——, 'Sociale relaties in Antwerpen tijdens de 16de en 17de eeuw', in: Van der Stock, J., ed., *Antwerpen, verhaal van een metropool, 16de-17de eeuw* (Ghent, 1993), pp. 37-47.

Sonenscher, M., *Work and Wages. Natural Law, Politics and the Eighteenth-Century French Trades* (Cambridge, 1989).

Sosson, J.-P., 'La structure sociale de la corporation médiévale. L'exemple des tonneliers de Bruges de 1350 à 1500', *Revue belge de Philologie et d'Histoire* 44 (1966), pp. 457-478.

————, 'Une approche des structures économiques d'un métier d'art: la corporation des Peintres et Selliers de Bruges (XVe-XVIe siècles)', *Revue des Archéologues et Historiens d'Art de Louvain* (1970), pp. 91-100.

————, *Les travaux publics de la ville de Bruges, XIVe-XVe siècles. Les matériaux. Les hommes* (Brussels, 1977).

————, 'Corporation et paupérisme aux XIVe et XVe siècles. Le salariat du bâtiment en Flandre et en Brabant et notamment à Bruges', *Tijdschrift voor Geschiedenis* 92 (1979), pp. 557-575.

————, 'A propos des aspects socio-économiques des métiers d'art aux anciens Pays-Bas méridionaux (XIVe-XVe s.)', *Revue belge d'Archéologie et d'Histoire de l'art* 51 (1982), pp. 17-25.

————, 'La production artistique dans les anciens Pays-Bas méridionaux, XIVe-XVIe siècles', in: Cavaciocchi, S, *Economia e arte*, pp. 675-701.

Spike, G.T. *et al.*, *Portrait de l' artiste 1600-1890* (Paris, 1991).

Styles, J., 'Manufacturing, Consumption and Design in Eighteenth-century England', in: Brewer, J. and R. Porter, eds., *Consumption and the World of Goods* (London, 1993), pp. 527-545.

Szmydki, R., 'Pieter Coecke van Aelst or Pierre Fabry dit van Aelst', in: *Essays in Honor of Professor Erik Larsen at the Occasion of his 90th Birthday* (Turin, 2002), pp. 147-152.

Tamis, D., 'The Genesis of Albert Cornelis's "Coronation of the Virgin", in: Bruges', *The Burlington Magazine* 142 (2000), pp. 672-680.

Thijs, A.K.L., 'Minderheden te Antwerpen (16de/20ste eeuw)', in: Soly, H. and Thijs, A.K.L., eds., *Minorities in Western European cities (sixteenth-twentieth centuries)* (Brussels, 1995), pp. 17-42.

————, *Van "werkwinkel" tot "fabriek". De textielnijverheid te Antwerpen (einde 15de-begin 19de eeuw)* (Brussels, 1987).

————, 'Religieuze rituelen in het emancipatieproces van Vlaamse en Brabantse handwerksgezellen (16e-19e eeuw)', in: Lis and Soly, *Werken volgens de regels*, pp. 231-281.

Thomas, A., *The Painter's Practice in Renaissance Italy* (Cambridge, 1995).

Tillemans, D., 'Willem Key-Biografische gegevens', *Gentse Bijdragen tot de Kunstgeschiedenis* XXV (1979-1980), pp. 63-90.

Tilly, C., 'Demographic origins of the European proletariat', in: Levine, D., ed., *Proletarianization and family history* (New York, 1984), pp. 1-85.

Timmer, E.M.A., *Knechtsgilden en knechtsbossen in Nederland. Arbeidersverzekering in vroeger tijden* (Haarlem, 1913).

Unger, R.W., *Dutch shipbuilding before 1800. Ships and guilds* (Assen/Amsterdam, 1978).

Unverfehrt, G., *Zeichnungen von Meisterhand, Die Sammlung Uffenbach aus der Kunstsammlung der Universität Göttingen* (Göttingen, 2000).

Van de Casteele, D., 'Documents divers de la société S. Luc à Bruges', *Annales de la Société d'émulation pour l'étude de l'histoire et des antiquités de la Flandre*, troisième série I (1866), pp. 1-430.

Van de Velde, A., *De ambachten van de timmerlieden en de schrijnwerkers te Brugge, hun wetten, hun geschillen en hun gewrochten van de XIVe tot de XIXe eeuw* (Ghent, 1909).

Van de Velde, C., 'The Grotesque initials in the first Ligger and in the Busboek of

the Antwerp Guild of Saint Luke', *Bulletin van de Koninklijke Musea voor Kunst en Geschiedenis* 45 (1973), pp. 252-277.

———, *Frans Floris, Leven en Werken (1519/20-1570)* (Brussels, 1975).

———, 'Frans Pourbus the Elder and the diffusion of the style of Frans Floris in the Southern Netherlands', in: Mai, E. *et al.*, eds., *Die Malerei Antwerpens*, (Cologne, 1994), pp. 11-17.

Van den Branden, F.J., *Geschiedenis der Antwerpsche schilderschool* (Antwerp, 1883).

Van den Branden, L., 'Drukoctrooien toegekend door de raad van Brabant tot 1600', *De Gulden Passer* 68 (1990), pp. 5-88.

Van den Brink, P., 'De kunst van het kopiëren. Het waarom en hoe van het vervaardigen van kopieën en schilderijen in oplage in de Nederlanden in de zestiende en zeventiende eeuw', in: Van den Brink, P., ed., *De Firma Brueghel* (Maastricht, 2001), pp. 12-43.

———, 'Two Unknown Wings, from a triptych by the Master of the Antwerp Adoration', *Art Matters, Netherlands Technical Studies in Art* (Zwolle, 2002), pp. 6-20.

Van der Stighelen, K., 'De (atelier-)bedrijvigheid van Andries Snelllinck (1587-1653) en Co', *Jaarboek Koninlijk Museum voor Schone Kunsten Antwerpen* (1989), pp. 303-341.

———, 'Van Dijck's eerste Antwerpse periode. Proloog van een barok levensverhaal', in: Brown, C. and Vlieghe, H., eds., *Van Dijck, 1599-1641* (Antwerp, 1999), pp. 35-47.

Van der Stock, J., 'De organisatie van het beeldsnijders- en schildersatelier te Antwerpen. Documenten 1480-1530', in: Nieuwdorp, H., ed., *Antwerpse retabels, 15de-16de eeuw*, vol. II (Antwerp, 1993), pp. 47-53.

———, *Printing images in Antwerp. The introduction of Printmaking in a City. Fifteenth century to 1585* (Rotterdam, 1998).

Van der Straelen, J.B., *Jaerboek der vermaerde en kunstryke gilde van Sint Lucas binnen de stad Antwerpen, behelzende de gedenkweerdigste geschiedenissen in dit genootschap voorgevallen sedert het jaer 1434 tot het jaer 1795* (Antwerp, 1855).

Van der Velden, H., *The Donor's Image. Gerard Loyet and the votive portraits of Charles the Bold* (Turnhout, 2000).

Van der Wee, H., *The Growth of the Antwerp market and the European Economy (Fourteenth-Sixteenth centuries)*, vol. II (The Hague, 1963).

———, ed., *The rise and decline of urban industries in Italy and in the Low Countries (late middle ages – early modern times)* (Louvain, 1988).

Van der Woude, A., 'The volume and value of paintings in Holland at the time of the Dutch Republic', in: Freeberg and De Vries, *Art in History*, pp. 285-329.

Van Dillen, J.G., ed., *Bronnen tot de geschiedenis van het bedrijfsleven en het gildewezen van Amsterdam*, vol. 3 (1633-1672) (The Hague 1974).

Van Eeghen, I.H., 'Het Amsterdamse Sint Lucasgilde in de 17de eeuw', *Jaarboek Amstelodamum* 61 (1969), pp. 65-102.

Van Eijl, C., *Het werkzame verschil. Vrouwen in de slag om arbeid* (Hilversum, 1994).

Van Gelder, E., *De Nederlandse munten* (Utrecht, 1965).

Van Mander, Karel, *The Lives of the Illustrious Netherlandish and German Painters, from the first edition of the Schilder-boeck (1603-1604)*, introd. and transl. by H. Miedema (Doornspijk, 1994).

Van Miegroet, H., *Gerard David* (Antwerp, 1989).

Van Quathem, K., *Het Brugse schoenmakersambacht in de Nieuwe Tijden. De ontwikkeling van een middeleeuwse instelling in haar sociaal-economische context* (unpublished MA thesis, Ghent, 1993).

——, 'Sociale mobiliteit en machtsverdeling in het Brugse schoenmakersambacht (1570-1790)', in: Lis and Soly, *Werken volgens de regels*, pp. 107-134.

Van Schoute R. and Verougstraete, H., eds., *Le problème Maître de Flémalle – van der Weyden, Colloque III, Le dessin sous-jacent dans la peinture* 1979 (Louvain-la-Neuve, 1981).

Van Tijn, T., 'Bijdrage tot de wetenschappelijke studie van de vakbondsgeschiedenis', in: Geurts, P.A.M. and Messing, F.A.M., eds., *Theoretische en methodologische aspecten van de economische en sociale geschiedenis*, vol II (The Hague, 1979), pp. 159-187 (translated as 'A Contribution to the Scientific Study of the History of Trade Unions', *International Review of Social History* 21 (1976), pp. 212-239).

Van Uytven, R., ed., *Leuven. "De beste stad van Brabant", deel I: De geschiedenis van het stadsgewest Leuven tot omstreeks 1600* (Louvain, 1980).

Van Uytven, R., 'Splendour or Wealth: Art and Economy in the Burgundian Netherlands', in: Van Uytven, R., ed., *Production and Consumption in the Low Countries, 13th-16th centuries* (Aldershot, 2001), pp. 101-124.

Van Werveke, H., 'Ambachten en erfelijkheid', *Mededeelingen van de Koninklijke Vlaamsche Academie voor Wetenschappen, Letteren en Schoone Kunsten van België, klasse der letteren en der moreele en staatkundige wetenschappen* 4 (1942), pp. 5-24.

——, 'De medezeggenschap van de knapen (gezellen) in de middeleeuwse ambachten', *Medeelingen van de Koninklijke Vlaamsche Academie voor Wetenschappen, Letteren en Schoone Kunsten van België* 3 (1943), s.p.

Van Zanden, J.L., 'Lonen en arbeidsmarkt in Amsterdam, 1800-1865', *Tijdschrift voor sociale geschiedenis* 9 (1983), pp. 3-27.

Vander Auwera, J., *Leven, Milieu en Oeuvre van Abraham Janssen van Nuyssen (ca. 1571/75-Antwerpen 1632), 'een seer fameus meester ende schilder in synen levene'* (unpublished PhD-dissertation, University of Ghent, 2003).

Vandewalle, A., *Brugse ambachten in documenten. De schoenmakers, timmerlieden en schrijnwerkers (14de-18de eeuw)* (Bruges, 1985).

Veldman, I.M., 'Maarten van Heemskerck and St. Luke's medical books', *Simiolus* 7 (1974), nr. 2, pp. 91-100.

——, *Maarten van Heemskerck and Dutch humanism in the sixteenth century* (Maarssen, 1977).

——, *Crispijn de Passe and his Progeny (1564-1670): A Century of Print Production* (Rotterdam, 2001).

Verhavert, J., *Het ambachtswezen te Leuven* (Louvain, 1940).

Verleysen, F., '"Pretense Confrerieën"'? Devotie als communicatie in de Antwerpse corporatieve wereld na 1585', *Tijdschrift voor Sociale Geschiedenis* 27 (2001), pp. 153-174.

Verlinden, C. and Scholliers, E., eds., *Dokumenten voor de geschiedenis van prijzen en lonen in Vlaanderen en Brabant. A. Vlaanderen* (Bruges, 1965).

Vermaut, J., *De textielnijverheid in Brugge en op het platteland in westelijk Vlaanderen vóór 1800* (unpublished PhD-thesis, Ghent, 1974).

Vermeylen, F., 'Further Comments on Methodology', in: Ainsworh, *Early Netherlandish Painting*, pp. 66-69.

———, 'Marketing paintings in Sixteenth Century Antwerp: Demand for Art and the Role of the Panden', in: Stabel, P., Blondé, B., Greve, A., eds., *International Trade in the Low Countries (14th-16th centuries). Merchants, Organisation, Infrastructure. Proceedings of the International Conference Ghent-Antwerp, 12th-13th January 1997* (Louvain/Apeldoorn 2000), pp. 193-212.

———, 'The Commercialisation of Art: Painting and Sculpture in Sixteenth-Century Antwerp, in: Ainsworh, *Early Netherlandish Painting*, pp. 46-61.

———, *Painting for the Market. Commercialization of Art in Antwerp's Golden Age* (Turnhout, 2003).

Vlieghe, H., *Flemish Art and Architecture, 1585-1700* (New Haven/London, 1998).

———, 'The fine and decorative arts in Antwerp's golden age', in: O'Brien, P., Keene, D., 't Hart M. and Van der Wee, H., eds., *Urban Achievement in Early Modern Period. Golden Ages in Antwerp, Amsterdam and London* (Cambridge, 2001), pp. 173-185.

Voet, L., *The Golden Compasses. A history and evaluation of the printing and publishing activities of the Officina Plantiniana at Antwerp in two volumes* (Amsterdam, 1969).

Wells-Cole, A., *Art and Decoration in Elizabethan and Jacobean England. The influence of Continental Prints, 1558-1625* (New Haven/London, 1997).

Wiesner, M., 'Guilds, Male Bonding and Women's Work in Early Modern Germany', *Gender and History* 1 (1989), pp. 125-137.

Willems, B., 'Loon naar werken? Sociale mobiliteit in het Antwerpse kuipersambacht (1585-1793)', *Bijdragen tot de Geschiedenis* 82 (1999), pp. 31-64.

Wilson, J.C., *Painting in Bruges at the Close of the Middle Ages. Studies in Society and Visual Culture* (Pennsylvania, 1998).

Winner, M., *Die Quellen der Pictura-Allegorien in gemälten Bildergalerien des 17 Jh. zu Antwerpen* (Cologne, 1957).

———, catalogue entry in: (exh. Cat.) *Pieter Bruegel der Ältere als Zeichner, Herkunft und Nachfolge* (Berlin, 1975), pp. 82-83.

Wright, A., 'Mantegna and Pollaiulo: Artistic Personality and the Marketing of Invention', in: Currie, S., ed., *Drawing 1400-1600. Invention and Innovation* (Aldershot, 1998), pp. 72-90.

Wyffels, A., 'De omvang en de evolutie van het Brugse bevolkingscijfer in de 17[de] en de 18[de] eeuw', *Belgisch Tijdschrift voor Filologie en Geschiedenis* 36 (1958), pp. 1243-1274.

Zweite, A., *Marten de Vos als Maler* (Berlin, 1980).

INDEX

Other volumes in the series:

PRINTED ON PERMANENT PAPER • IMPRIME SUR PAPIER PERMANENT • GEDRUKT OP DUURZAAM PAPIER - ISO 9706

N.V. PEETERS S.A., WAROTSTRAAT 50, B-3020 HERENT